CUBA
ELLIOTT
ERWITT

FOREWORD BY
HENRY LOUIS GATES, JR.

teNeues

SEEING CUBA
Henry Louis Gates, Jr.

"Cuba" is a trope about the passage of time in the American cultural imagination. And Elliott Erwitt's stunning photographs explore this theme in remarkably compelling detail. There is a tendency among all-too-many people visiting Cuba to see its people, its social, and political institutions, through what we might think of as the gaze of an historical diorama, comprised of three-dimensional multi-ethnic and multi-colored figures, a veritable rainbow of brown faces, moving in their own rhythms, driving vintage American cars from the late fifties and early sixties, a large-scale historical museum flowing along the Malecon, viewed through the peephole of American objectification, frozen in time, like "the other" used to be displayed in the old days in exhibits at the Smithsonian.

A friend of mine likes to point out to her American friends, when she hears them complain—quite frequently of late—about the perilous state of our democracy, that they should try to envision living in a society in which the person who occupied the White House on January 1, 1959 had remained in power, followed recently by his brother, ever since. Dwight Eisenhower; imagine! The effect is sobering, to say the least. But she also goes on to point out that within this seemingly entrenched or bound political frame, Cuba has always been a society in motion, and social change there has been continuous, if one has a discerning eye, ever since the Revolution.

But not everyone agrees. My friends from Miami might say to a fellow American gushing with how much has changed in recent years in Cuba, that "The more things appear to change, the more they stay the same." My friends in Havana might say to a visiting American that "The more things appear to remain the same, the more they are changing." I've had many dinners in Miami with former Cuban citizens who can scarcely hide their outrage at American tourists smitten with the magic of the island, enamored of a country that sometimes reminds them of a late fifties movie set, static, wrapped in the sensual tropes of primitivism. And it's not only exiles and tourists who disagree about the state and future of the island: I once had the pleasure of asking two former Secretaries of State, Condoleezza Rice and Madeleine Albright (fellow board members of the Aspen Institute), what should come first in effecting meaningful change in Cuba: politics (one person, one vote, in free, democratic elections) or economic liberalization? Perhaps not surprisingly, Rice was adamant that politics must come first; Albright countered that if we should start with economics, political equality would follow. I would venture that there are few places on Earth capable of eliciting more passionate debate about its past, present, and future than the fascinating island that Columbus called "Juana," and described as "the most beautiful land that human eyes had ever seen."

Elliott Erwitt's splendid portfolio of photographs offer *prima facie* evidence of the changes in the course of Cuban history over the last half century. When he landed on Cuba to film for *Newsweek* magazine, he could have little idea that he would create what have become our most iconic images, through candid close-ups, of the young leaders of Cuba's new-born revolution, just six years old. That he was able to return, half a century later, and shoot a second round is a blessing both to history and to contemporary photographic art.

Erwitt once described himself this way: "I take photographs for a living and also for my pleasure. Fundamentally, I'm a professional amateur. I like to travel to see the world and to check out the human condition." [1]

His own journey began in interwar Europe, where, in 1928, he was born to Russian parents who had migrated to France. Raised there and in Italy, Erwitt moved to the United States when he was ten. It was in Los Angeles that he attended high school and published his first photographs before decamping for New York City to work and study at the New School for Social Research. With war erupting on the Korean Peninsula in the early 1950s, Erwitt was drafted into the US Army Signal Corps and deployed—camera in hand—from New Jersey to Europe. His association with Roy Stryker, former head of the Farm Security Administration's Information Division and later of Standard Oil, helped land Erwitt freelance work when he returned to the States, and in 1953 the legendary war photographer Robert Capa (killed in Indochina just a year later) recruited him to join Magnum Photos, the agency Capa had co-founded in 1947. Among Erwitt's other pivotal influences were Edward Steichen and Gjon Mili, and his peers at Magnum included a who's who of the era, among them Bruce Davidson, Cornell Capa, and Henri Cartier-Bresson.

What distinguished Erwitt's camera work was his extraordinary range and sense of humor. From capturing "the look" of New York City and Hollywood in their golden ages to knowing where to stand—and when to click—when history was being made, Erwitt gave us unforgettable eyewitness accounts of Nixon and Khrushchev in Moscow, a mourning Jacqueline Kennedy, Arthur Miller beneath the Brooklyn Bridge, and a radiant, though ever mysterious, Marilyn Monroe. He put his signature stamp on the world's greatest cities, from Paris to Rome and traveled the US seeing the truth of segregation and the quiet, often absurd moments of everyday life. As expert as he is prolific, Erwitt has published more than twenty books curated from his massive archives, enlightening us and making us laugh with his uncanny ability to sequence his snaps and find moments of transcendent glory in everything from nudists to popes to beach and museum-goers to his favorite creatures, dogs ("they don't ask for prints" of his work, he quips). [2]

In addition to his work at Magnum, where he served for three terms as president starting in the late 1960s, Erwitt is an award-winning documentary filmmaker, whose credits range from *Beauty Knows No Pain* (1971) to *Red, White, and Bluegrass* (1973) to *The Glassmakers of Herat* (1977) and a host of comedies for HBO. Winner of the International Center of Photography's Lifetime Achievement Infinity Award, Erwitt has had his photographs exhibited all over the world, and even has created his own alter ego, a French-Caribbean artiste named André S. Solidor, through whom Erwitt has relished poking fun at the contemporary art scene.

"What distinguishes Mr. Erwitt's work has been his keen eye for the comedy in everyday life," Ken Johnson wrote in the *New York Times* in 2011. In his prints one finds that "light humor thinly veils poetic profundity," and behind his lens is that "seeker of the 'decisive moment,' an instant in real time when people, animals, or objects appear before the camera in surprising and illuminating ways." Erwitt "delivers his visual gags with such economy and sweet-tempered lack of pretension," Johnson adds, "that it is easy to overlook just how good he is at what he does." [3]

"Any useful picture must be a good picture first, … a properly framed picture, combining the emotion and a proper composition," Erwitt once observed. [4] While he is at work, a photographer can never know what he is getting. Doubt is everywhere until he has his contact

sheets in hand and he is combing through them in search of something he can share. "It's a crap game really," he said in an interview with *Time*. "All photographers strive for that special moment that transcends the subject and transcends the place.... That's what is called magic." [5]

By this or any definition, Erwitt offers us magic on every page of this book, cataloguing his travels to an island that moves the heart as much as it delights the eyes. The series of photographs he presents traces the history of the Cuban Revolution from its freshest, most self-confident, and supremely optimistic moment, in the mid-sixties, when Fidel Castro and Che Guevara seemed to have every reason to believe that they were in the process of creating "a new man," a new kind of political being who was internalizing the principles of their nascent revolution, to the stark realities that five decades of experiment, failure, adjustment, crisis, and improvisation forced upon Castro's visions and the everyday realities of the resilient Cuban people.

Part one of the book captures the romance of revolution, when the Cuban Revolution was still enjoying what we might think of as its "glow" period (an adjective suggested by the feel of these photographs), when expectations and aspirations had not yet reached their apex, when anything still seemed possible, and when images of Fidel and Che seem to exude self-confidence, possibility, control, and command, and a certain aura of charisma that seems invitingly sensual. Indeed, Erwitt's photographs of the pair seem more like photographs of movie idols than political leaders, founding fathers as rock stars. The adoration in the faces of their citizens is genuine, pure, palpable.

Upon his return to the island, hopes and dreams of change have been tempered by the harsh actuality. Erwitt records a revolution in decline, perhaps at its nadir, a Cuba, its leaders and its people, colored by the complex realities—the hard-won successes and the failures—of social change half a century later. The pictures in the second half of the book exude the patina of disappointed expectations but also a people heartened by the promise of a measure of economic liberalization and a more open marketplace, and the markedly increased permeability of borders, under the Obama Administration.

Snapshots of a society in transition populate this section, leading up to portraits of the founding fathers, half a century "After the Revolution": an aging Fidel and his brother, Raul, arms raised in evergreen defiance, looking somewhat like their own father might have looked, half a century ago. The often-repeated government phrase, "Cuba no renunciara a las ideas...," appropriately summing up the passage of time visible on these men's faces. Only Che—killed at the age of 39—remains the same, unchanged, ageless, timeless, defiant, full of hope, enjoying a fate that neither he nor his comrade, Fidel, could have possibly imagined fifty years ago, universally immortalized as the ultimate icon of revolution, trapped in amber, forever present in a state of suspended animation.

Above all else, Elliott Erwitt's photographs candidly captured the soul of a nation through its astonishing historical arc from its dawning and to its twilight. Historians will study these images for generations to explicate the volumes of lessons that these silent images speak, and speak so very eloquently. At the same time, thanks to his work, and to the Elliott Erwitt Havana Club 7 Fellowship named in his honor, a new generation of photographers will be able to continue documenting this story with a firm grounding in the past and present Erwitt himself has seen through his favorite Leica camera.

1 Elliott Erwitt, quoted in *The Macallan Masters of Photography: Elliott Erwitt Edition*, published on November 6, 2013.

2 Elliott Erwitt, quoted in lecture, "EG5 Elliott Erwitt, photographer," published on March 10, 2012.

3 Ken Johnson, "Captured: A New York Minute, or One in Havana," *New York Times*, June 10, 2011.

4 Elliott Erwitt, quoted in video on "Photographer Technique and Process," published on September 12, 2015.

5 "First Take: Elliott Erwitt's Take on the Magic of Photography," Time.com, October 3, 2016.

KUBA SEHEN
Henry Louis Gates, Jr.

In der kulturellen Vorstellungswelt Amerikas ist „Kuba" eine Metapher für die vergehende Zeit. Elliott Erwitts Fotografien erkunden diese Metapher in bemerkenswert fesselnden Details. Allzu viele Besucher Kubas neigen dazu, die Menschen, aber auch die gesellschaftlichen und politischen Institutionen der Insel durch einen Schleier zu sehen, den Schleier eines historischen Dioramas, das aus dreidimensionalen Figuren unterschiedlichster Herkunft und Hautfarbe besteht. Mit einem wahren Regenbogen an braunen Gesichtern bewegen sich diese Figuren in einem eigenen Rhythmus und fahren amerikanische Oldtimer aus den späten 1950er- und frühen 1960er-Jahren – als lebten sie in einem großen historischen Museum, das den Malecón entlanggleitet, betrachtet durch das Guckloch der amerikanischen Verdinglichung, gefangen im Stillstand, so wie früher einmal „das Fremde" in den Ausstellungen des Smithsonian gezeigt wurde.

Eine Bekannte von mir fordert ihre amerikanischen Freunde, wenn sie sich – wie in letzter Zeit recht häufig – über den bedrohten Zustand unserer Demokratie beklagen, gerne zu dem Gedankenexperiment auf, sich ihr Leben in einer Gesellschaft auszumalen, in der die Person, die am 1. Januar 1959 im Weißen Haus saß, bis vor Kurzem an der Macht geblieben wäre, um dann durch den eigenen Bruder abgelöst zu werden. Dwight D. Eisenhower, man stelle sich das mal vor! Der Effekt ist, gelinde gesagt, ernüchternd. Doch dann fügt meine Bekannte auch hinzu, dass Kuba in diesem scheinbar eingefahrenen oder vorherbestimmten politischen Rahmen stets eine Gesellschaft in Bewegung war und der gesellschaftliche Wandel, wenn man genau hinsieht, seit der Revolution nicht aufgehört hat.

Doch das sieht nicht jeder so. Meine Freunde aus Miami entgegnen einem amerikanischen Landsmann, der von den Veränderungen der letzten Jahre auf Kuba schwärmt: „Je mehr sich die Dinge zu verändern scheinen, desto mehr bleiben sie gleich." Und meine Freunde in Havanna erklären gegenüber einem amerikanischen Besucher: „Je mehr die Dinge gleich zu bleiben scheinen, desto mehr verändern sie sich." Ich habe oft mit ehemaligen Kubanern in Miami zu Abend gegessen, die ihre Empörung kaum verbergen können – über amerikanische Touristen, die hingerissen sind von der Magie der Insel und verliebt in ein Land, das sie manchmal an eine Filmkulisse aus den späten 1950ern erinnert: statisch und eingehüllt in die sinnlichen Metaphern des Primitivismus. Doch nicht nur Exilkubaner und Touristen sind über den Zustand und die Zukunft des Inselstaates unterschiedlicher Meinung. Ich hatte einmal das Vergnügen, zwei ehemalige US-Außenministerinnen – Condoleezza Rice und Madeleine Albright (Kuratoriumskolleginnen am Aspen Institute) – zu fragen, was Priorität haben sollte, um auf Kuba einen bedeutsamen Wandel herbeizuführen: die Politik (das Prinzip „eine Person, eine Stimme" in freien, demokratischen Wahlen) oder die Liberalisierung der Wirtschaft? Vielleicht nicht überraschend, bestand Rice darauf, dass die Politik an erster Stelle stehen müsse; Albright hielt dagegen, die politische Gleichberechtigung würde folgen, wenn wir der Wirtschaft den Vorrang gäben. Ich wage zu behaupten, dass es nur wenige Orte auf der Welt gibt, die in der Lage sind, leidenschaftlichere Debatten über ihre Vergangenheit, Gegenwart und Zukunft auszulösen, als die faszinierende Insel, die Kolumbus „Juana" nannte und als „das schönste Land" beschrieb, „das Menschenaugen je erblickt haben".

Elliott Erwitts brillantes fotografisches Portfolio führt den unmittelbaren Nachweis über die Veränderungen, die sich in den letzten fünfzig Jahren auf Kuba zugetragen haben. Als Erwitt vor einem halben Jahrhundert als *Newsweek*-Fotograf auf der Insel landete, konnte er nicht ahnen, dass ihm Fotografien gelingen würden, die als unverstellte Nahaufnahmen der jungen Anführer einer erst fünf Jahre alten Revolution zu Ikonen geworden sind. Dass er ein halbes Jahrhundert später zurückkehren und ein zweites Mal auf Bilderjagd gehen konnte, ist ein Segen sowohl für die Geschichte als auch für die zeitgenössische Fotografie.

Erwitt selbst hat sich einmal so beschrieben: „Ich fotografiere beruflich und auch zu meinem Vergnügen. Im Grunde bin ich Berufsamateur. Ich reise gerne, um die Welt zu sehen und die menschliche Verfassung zu untersuchen." [1]

Seine eigene Reise begann zwischen den Weltkriegen in Europa, wo er 1928 als Kind russischer Emigranten in Frankreich geboren wurde. Dort und in Italien aufgewachsen, kam Erwitt im Alter von zehn Jahren in die USA. Er besuchte die High School in Los Angeles, wo er auch seine ersten Fotografien veröffentlichte, bevor er nach New York ging, um dort zu arbeiten und an der New School for Social Research zu studieren. Als Anfang der 1950er-Jahre der Koreakrieg ausbrach, wurde Erwitt zur Fernmeldetruppe der US-Armee eingezogen und – die Kamera in der Hand – von New Jersey nach Europa verlegt. Seine Verbindung zu Roy Stryker, der sich als ehemaliger Leiter der Informationsabteilung der Farm Security Administration und später bei Standard Oil einen Namen gemacht hatte, half Erwitt nach seiner Rückkehr in die USA, Aufträge als freiberuflicher Fotograf einzuwerben, bevor ihn 1953 der legendäre Kriegsfotograf Robert Capa (der nur ein Jahr später in Indochina ums Leben kam) zu Magnum Photos holte. Capa hatte die Agentur 1947 mitgegründet. Zu den Fotografen, die prägenden Einfluss auf Erwitt hatten, zählten auch Edward Steichen und Gjon Mili, und sein Kollegenkreis bei Magnum, dem unter anderem Bruce Davidson, Cornell Capa und Henri Cartier-Bresson angehörten, glich einem Who's who der Epoche.

Was Erwitts Arbeit mit der Kamera auszeichnete, waren seine außergewöhnliche Bandbreite und sein Sinn für Humor. Von der Begabung, den „Look" der goldenen Zeiten New Yorks oder Hollywoods einzufangen, bis zu dem Wissen, wo er stehen – und wann er abdrücken – musste, wenn Geschichte geschrieben wurde. Erwitt machte uns zu Zeugen unvergesslichen Augenblicke: von Nixon und Chruschtschow in Moskau, von einer trauernden Jacqueline Kennedy, von Arthur Miller unter der Brooklyn Bridge und von einer strahlenden, aber stets geheimnisvollen Marilyn Monroe. Den großartigsten Städten der Welt von Paris bis Rom drückte er seinen unverkennbaren Stempel auf. Er ist durch die USA gereist, hat die Realität der Rassentrennung gesehen und die stillen, oft absurden Augenblicke des Alltags. Ebenso erfahren wie produktiv, hat Erwitt mehr als zwanzig Bücher veröffentlicht, zusammengestellt aus den Beständen seines gewaltigen Archivs. Mit seiner verblüffenden Fähigkeit, Bilder in Serien anzuordnen und in allem und jedem Momente von überweltlichem Glanz zu erkennen – von Nudisten und Päpsten über Strand- und Museumsbesucher bis hin zu Hunden, seinen Lieblingskreaturen („sie fragen nicht nach Abzügen", pflegt er zu scherzen) [2] –, klärt Erwitt uns auf und bringt uns zum Lachen.

Neben seiner Arbeit für die Fotoagentur Magnum, der er in den späten 1960er-Jahren drei Amtszeiten lang als Präsident vorstand,

machte Erwitt als preisgekrönter Dokumentarfilmer mit Werken wie *Beauty Knows No Pain* (1971), *Red, White, and Bluegrass* (1973) oder *The Glassmakers of Herat* (1977) Karriere und war Comedy-Produzent bei HBO. Als Gewinner des vom International Center of Photography vergebenen Lifetime Achievement Infinity Award hat er nicht nur seine Fotografien weltweit ausgestellt, sondern sogar sein eigenes Alter Ego geschaffen, um sich in der Rolle des französisch-karibischen Künstlers André S. Solidor genussvoll über die zeitgenössische Kunstszene lustig zu machen.

„Was Mr. Erwitts Arbeit auszeichnet, ist sein waches Auge für das Komische im täglichen Leben", schrieb Ken Johnson 2011 in der *New York Times*. In seinen Abzügen erkenne man, wie „der sanfte Humor die poetische Tiefe mit einem dünnen Schleier überdeckt", und hinter dem Objektiv „sucht Erwitt nach dem ‚entscheidenden Augenblick', einem Moment der Echtzeit, in dem Menschen, Tiere oder Gegenstände in überraschender und erhellender Art und Weise vor der Kamera erscheinen." Der Fotograf „verabreicht seine optischen Gags mit solcher Sparsamkeit und einem so sanftmütigen Mangel an Überheblichkeit", so Johnson weiter, „dass man leicht übersieht, wie verdammt gut er in dem ist, was er tut."[3]

„Jedes brauchbare Bild muss zuerst ein gutes Bild sein, … ein gebührend erfasster Ausschnitt, der die Emotion und eine anständige Komposition in sich vereint", stellte Erwitt einmal fest.[4] Während der Arbeit kann ein Fotograf nie wissen, was er am Ende bekommt. Der Zweifel lauert überall – bis der Fotograf seine Kontaktbögen in den Händen hält und sie auf der Suche nach etwas Vorzeigbarem durchkämmt. „Das ist wirklich ein Glücksspiel", ließ Erwitt in einem *Time*-Interview wissen. „Jeder Fotograf trachtet nach dem besonderen Moment, der über das Motiv hinausgeht und über den Ort hinausweist. Das ist es, was wir Magie nennen."[5]

Nach dieser oder jeder anderen Definition erkennen wir Erwitts Magie auf jeder Seite dieses Buches, dieses Kataloges seiner Reisen auf eine Insel, die das Herz so sehr bewegt wie sie das Auge erfreut. Seine Fotoserien zeichnen die Geschichte der kubanischen Revolution nach: von ihrem unverbrauchtesten, vor Selbstbewusstsein strotzenden und in höchstem Maße optimistischen Moment Mitte der 1960er-Jahre – als Fidel Castro und Che Guevara allen Grund zu der Annahme zu haben schienen, dass sie dabei waren, „einen neuen Menschen" zu erschaffen, eine neue Art von politischem Wesen, das die Prinzipien ihrer im Werden begriffenen Revolution verinnerlichte – bis zu der nüchternen Realität, die fünf Jahrzehnte des Experimentierens, des Misserfolgs, der Anpassung, der Krise und der Improvisation den Visionen Castros und der Alltagswirklichkeit des unverwüstlichen kubanischen Volkes aufgezwängt haben.

Der erste Teil des Buches fängt die Revolutionsromantik einer Zeit ein, die sich vielleicht als die „glühende" Phase (ein von der Atmosphäre der frühen Fotografien angeregtes Adjektiv) der kubanischen Revolution beschreiben lässt, als die Erwartungen und Ambitionen noch nicht ihren Höhepunkt erreicht hatten, als noch alles möglich schien und die Bilder von Fidel und Che nicht nur Selbstvertrauen, Möglichkeit, Kontrolle und Führerschaft ausstrahlten, sondern auch eine gewisse charismatische Aura, die verlockend sinnlich wirkt. Tatsächlich scheinen Erwitts Fotografien die beiden Revolutionäre eher als Filmidole denn als politische Führer zu zeigen, die Gründungsväter der Republik als Rockstars.

Die Bewunderung in den Gesichtern ihrer Bürger ist echt, rein und mit Händen zu greifen.

Bei Erwitts Rückkehr auf die Insel hatte die raue Wirklichkeit die Hoffnungen und Träume von Veränderung gedämpft. Der Fotograf findet eine Revolution im Niedergang, vielleicht an ihrem Tiefpunkt, vor. Er dokumentiert ein Kuba, das mitsamt seinen Führern und Bewohnern gezeichnet ist von der vielschichtigen Realität des gesellschaftlichen Wandels ein halbes Jahrhundert später – von den hart erkämpften Erfolgen und den Misserfolgen. Die Aufnahmen in der zweiten Hälfte des Buches verströmen die Patina enttäuschter Erwartungen, zeigen zugleich aber ein Volk, das angesichts eines gewissen Maßes an ökonomischer Liberalisierung und Öffnung der Märkte und der deutlich gestiegenen Grenzdurchlässigkeit unter der Obama-Administration neuen Mut fasst.

Schnappschüsse einer Gesellschaft im Übergang bevölkern diesen Teil des Buches und gipfeln in Abbildern der Gründungsväter ein halbes Jahrhundert nach der Revolution: Ein alternder Fidel und sein Bruder Raul recken ungebrochen trotzig die Arme in die Höhe und sehen ein wenig so aus wie vielleicht ihr eigener Vater ein halbes Jahrhundert zuvor. Der oft wiederholte Regierungssatz „Cuba no renunciará a las ideas" fasst das in den Gesichtern dieser Männer erkennbare Vergehen der Zeit angemessen zusammen. Nur der mit 39 Jahren getötete Che bleibt derselbe, unverändert, alterslos, zeitlos, aufsässig, voller Hoffnung, sich eines Schicksals erfreuend, das er und sein Kamerad Fidel vor fünfzig Jahren unmöglich hätten vorhersehen können, allgemein unsterblich gemacht als ultimative Revolutionsikone, wie eingeschlossen in Bernstein, für immer gegenwärtig in einem Zustand vorübergehender Unbelebtheit.

Mehr als alles andere haben Elliott Erwitts Fotografien, von der Morgen- bis zur Abenddämmerung eines erstaunlichen historischen Bogens, in aller Offenheit die Seele einer Nation eingefangen. Die Geschichtswissenschaft wird diese Bilder über Generationen studieren, um die unzähligen Lektionen zu erklären, die diese stillen Aufnahmen uns so überaus eloquent erteilen. Gleichzeitig wird eine neue Fotografengeneration – fest verankert in der Vergangenheit und Gegenwart, die Erwitt selbst durch die von ihm bevorzugte Leica gesehen hat – dank seiner Arbeit, und dank des zu seinen Ehren benannten „Elliott Erwitt Havana Club 7 Fellowship", in der Lage sein, diese Geschichte weiter zu dokumentieren.

1 Zitiert nach *The Macallan Masters of Photography: Elliott Erwitt Edition*, veröffentlicht am 6. November 2013.

2 Zitiert nach *EG5 Elliott Erwitt, Photographer*, Vortrag von Elliott Erwitt, veröffentlicht am 10. März 2012.

3 Ken Johnson, „Captured: A New York Minute, or One in Havana", *New York Times*, 10. Juni 2011.

4 Zitiert nach *Elliott Erwitt – Photographer Technique & Process*, Video von Elliott Erwitt, veröffentlicht am 12. September 2015.

5 Zitiert nach „First Take: Elliott Erwitt's Take on the Magic of Photography", Time.com, 3. Oktober 2016.

REGARDS SUR CUBA
Henry Louis Gates, Jr.

« Cuba » est, dans l'imaginaire des Américains, un trope sur le temps qui passe, un thème que les photographies saisissantes d'Elliott Erwitt explorent de manière remarquablement fouillée et convaincante. On observe chez bien trop de personnes visitant Cuba une propension à voir ses habitants et ses institutions politiques et sociales par ce qui pourrait être le prisme d'un diorama historique composé de personnages à trois dimensions, multiethniques et bigarrés – un véritable arc-en-ciel de visages bruns, évoluant à leur propre rythme et conduisant des old-timers américains de la fin des années 1950 et du début des années 1960, tel un immense musée historique en plein air s'étirant le long du Malecón et vu par la lorgnette de l'objectivation américaine, gelé dans le temps, à la manière dont la Smithsonian Institution exhibait naguère « l'autre ».

Chaque fois qu'une de mes amies entend ses amis américains se plaindre – ce qui arrive souvent ces derniers temps – de l'état alarmant de notre démocratie, elle les invite à s'imaginer vivant dans une société dans laquelle le locataire de la Maison blanche au 1er janvier 1959 serait resté au pouvoir jusqu'à une date récente pour alors passer le flambeau à son frère. Dwight Eisenhower, essayez seulement d'imaginer ! Le moins qu'on puisse dire, c'est que cela donne à réfléchir. Mais elle ajoute que, dans les limites de ce cadre politique relativement figé, la société cubaine est, pour qui sait observer, en mutation depuis la Révolution, et ce de manière continue.

Mais ce n'est pas l'avis de tous. Mes amis de Miami pourraient rétorquer à un compatriote américain qui n'aurait à la bouche que les grands changements intervenus à Cuba ces dernières années que « plus ça change, plus c'est la même chose ». Et mes amis à La Havane pourraient dire à un visiteur américain : « Plus c'est la même chose, plus ça change ». J'ai souvent dîné à Miami avec des Cubains naturalisés Américains qui ne pouvaient guère dissimuler leur indignation face aux touristes américains entichés de la magie de l'île, amoureux d'un pays qui leur rappelle un décor de film de la fin des années 1950, immuable, gelé dans le temps, drapé dans les tropes sensuels du primitivisme. Touristes et exilés ne sont d'ailleurs pas les seuls à avoir des avis divergents sur la situation actuelle et l'avenir de l'île : j'ai un jour eu le plaisir de demander à deux anciennes Secrétaires d'État, Condoleezza Rice et Madeleine Albright (qui siègent avec moi au comité de l'Aspen Institute) ce qui devrait primer pour induire un véritable changement à Cuba : la politique (le suffrage universel dans le cadre d'élections libres et démocratiques) ou la libéralisation de l'économie ? Comme on pouvait peut-être s'y attendre, Rice ne démordait pas qu'il faille commencer par la politique, et Albright préconisait de commencer par l'économie, confiante que l'égalité politique suivrait. J'irais jusqu'à dire qu'il y a très peu de pays au monde susceptibles de susciter davantage de débats passionnés sur leur passé, leur présent et leur avenir que la fascinante île nommée « Juana » par Christophe Colomb, qui l'a décrite comme étant « la plus belle que les yeux de l'homme aient jamais contemplés ».

Le magnifique portfolio du photographe Elliott Erwitt apporte un commencement de preuve des changements dynamiques qui infléchissent le cours de l'histoire de Cuba depuis un demi-siècle. Lorsqu'Elliott Erwitt a foulé le sol cubain afin de réaliser un reportage pour le magazine *Newsweek*, il était sans doute à mille lieues d'imaginer qu'il créerait ce qui, par des gros plans ingénus, allait devenir les images les plus emblématiques des jeunes leaders de la toute jeune révolution cubaine, alors âgée de seulement 5 ans. Qu'il ait pu y retourner un demi-siècle plus tard pour prendre une seconde série de photos est une bénédiction tant pour l'Histoire que pour le huitième art.

Elliott Erwitt s'est un jour décrit en ces termes : « Je photographie pour gagner ma vie, mais aussi pour mon plaisir. Au fond, je suis un amateur professionnel. J'aime voyager pour voir le monde et prendre le pouls de la condition humaine. » [1]

Son parcours personnel a débuté dans l'Europe de l'entre-deux-guerres. Né en 1928 à Paris de parents russes, il a passé son enfance en France et en Italie, avant d'émigrer aux États-Unis à l'âge de dix ans. Après ses années de lycée à Los Angeles, où il a publié ses premières photos, il s'est installé à New York pour y travailler et étudier à la New School for Social Research. Incorporé dans le service des transmissions de l'armée américaine lorsque la guerre de Corée éclate au début des années 1950, Elliott Erwitt a été envoyé, appareil photo en bandoulière, du New Jersey en Europe. À son retour aux États-Unis, Roy Stryker, ancien directeur de la division Information de la Farm Security Administration puis du projet Standard Oil, l'a aidé à s'établir en free-lance. En 1953, le photographe de légende Robert Capa (tué en Indochine juste un an plus tard) l'a invité à rejoindre Magnum Photos, l'agence dont il a été le cofondateur en 1947. Influencé par d'autres mentors comme Edward Steichen et Gjon Mili, Elliott Erwitt a en outre côtoyé à l'agence Magnum de grandes figures de l'époque, parmi lesquelles Bruce Davidson, Cornell Capa et Henri Cartier-Bresson.

Elliott Erwitt s'est singularisé en tant que photographe par son répertoire et son sens de l'humour extraordinaires. Capable de capturer « le look » de New York et d'Hollywood à leurs heures de gloire, il savait aussi être au bon endroit – et appuyer sur le déclencheur quand il le fallait – dans les moments historiques. C'est ainsi qu'il nous a livré d'inoubliables témoignages visuels de la rencontre entre Nixon et Khrouchtchev à Moscou, de Jackie Kennedy en deuil, d'Arthur Miller sous le pont de Brooklyn et d'une Marilyn Monroe rayonnante, mais encore auréolée de mystère. Il a apposé sa marque sur les photographies des plus belles villes au monde, de Paris à Rome, mais aussi sillonné les États-Unis où il a observé la vérité de la ségrégation ainsi que le quotidien sans histoires et souvent absurde des petites gens. Aussi pointu que prolifique, Elliott Erwitt a publié une bonne vingtaine d'ouvrages à partir d'images choisies dans ses archives colossales, des images avec lesquelles il nous instruit et nous fait rire avec son talent inouï pour arranger ses clichés et mettre au jour des moments de gloire sublimes dans tous ses sujets, des nudistes jusqu'aux papes, aux baigneurs et visiteurs de musées, en passant par ses animaux préférés, les chiens (« Eux, ils ne demandent pas de tirages gratuits », dit-il en plaisantant). [2]

En dehors de son travail pour l'agence Magnum, dont il a été président pendant trois mandats à partir de la fin des années 1960, Elliott est un documentariste primé, à qui l'on doit notamment *Beauty Knows No Pain* (1971), *Red, White, and Bluegrass* (1973) et *The Glassmakers of Herat* (1977), et producteur d'émissions pour la chaîne américaine HBO. Ce photographe, dont les travaux ont été exposés dans le monde entier, est allé jusqu'à se créer un double, un artiste franco-antillais répondant au nom d'André S. Solidor et par le truchement duquel il s'est plu à ridiculiser l'art contemporain.

« Ce qui fait l'originalité du travail d'Elliott Erwitt, c'est son sens aigu du burlesque dans le quotidien », écrivait Ken Johnson dans

le *New York Times* en 2011. Dans ses tirages, on trouve un « humour fin recouvrant d'un voile léger la profondeur poétique ». Et derrière l'objectif, on trouve ce « chasseur du moment décisif, un de ces instants dans la vraie vie où des personnes, des animaux ou des choses apparaissent devant la caméra sous des angles surprenants et éclairants ». Et Johnson d'ajouter qu'Elliott Erwitt « accouche de ses gags visuels avec une telle économie de moyens et bonhommie dénuée de prétention qu'on oublie facilement combien il excelle dans ce qu'il fait ». [3]

« Pour être d'une quelconque utilité, toute photo doit être en premier lieu une bonne photo... une photo bien cadrée, qui allie l'émotion et la composition adéquate », a souligné un jour Elliott Erwitt. [4] Tandis qu'il est à l'œuvre, le photographe ignore ce qu'il va obtenir. Il n'est sûr de rien jusqu'à ce qu'il ait ses planches contact en main et les balaie du regard à la recherche de ce qu'il pourrait bien partager. « C'est vraiment comme une partie de craps, a-t-il déclaré dans une interview accordée au magazine *Time*. Tous les photographes s'emploient à trouver ce moment particulier qui transcende le sujet et le lieu... C'est ce qui s'appelle magie. » [5]

Quelle que soit la définition que l'on donne de la magie, Elliott Erwitt nous en offre à chaque page de cet album photos retraçant ses séjours dans une île qui parle au cœur autant qu'elle enchante les yeux. Cette sélection de photographies retrace l'histoire de la révolution cubaine, de sa prime jeunesse, empreinte d'une confiance en soi et d'un optimisme extrêmes, au milieu des années 1960, quand Fidel Castro et Che Guevara semblaient avoir toutes les raisons de croire qu'ils étaient en train de créer « un homme nouveau », un nouveau type d'être politique intériorisant les principes de la révolution naissante, pour arriver au bout du compte aux dures réalités que cinquante ans d'expérimentations, d'échecs, d'ajustements, de crises et d'improvisations ont imposées aux visions de Castro et à la vie quotidienne du résilient peuple cubain.

La première partie de cet ouvrage saisit pleinement le romantisme de la révolution. La Révolution cubaine connaissait alors ce que l'on pourrait considérer comme sa période « d'éclat » (un qualificatif suggéré par l'atmosphère qui émane de ces photographies), alors que les attentes et les aspirations n'avaient pas encore atteint leur paroxysme, que tout semblait encore possible. Les photographies réunissant Fidel et le Che semblent respirer la confiance en soi, les possibles, le contrôle et l'autorité ainsi qu'un certain charisme dans lequel on pourrait voir une sensualité attirante. De fait, sur les photographies prises par Eliott Erwitt, ce duo ressemble davantage à des vedettes de cinéma qu'à des leaders politiques, les pères fondateurs ayant des allures de stars du rock. L'adoration qui se lit sur les visages de leurs concitoyens est authentique, pure, palpable.

Au deuxième séjour sur l'île d'Elliot Erwitt, les espoirs et les rêves de changement ont été tempérés par la dure réalité. Le photographe a alors fixé sur la pellicule une révolution sur le déclin, voire à son point le plus bas, Cuba, ses leaders et ses habitants marqués par les réalités complexes – les réussites obtenues au prix de gros efforts et les échecs – de la transformation sociale un demi-siècle plus tard. Les images présentées dans la seconde moitié de l'ouvrage portent la patine des attentes déçues mais aussi d'un peuple réconforté par la promesse d'une certaine libéralisation de l'économie, d'une plus grande ouverture du marché et de la perméabilité nettement plus grande des frontières sous l'administration Obama.

Cette partie de l'ouvrage regorge d'instantanés d'une société en transition pour culminer dans des portraits des pères fondateurs, un demi-siècle « Après la Révolution » : un Fidel vieillissant et son frère Raul, le bras levé en un geste de défiance éternelle, vraisemblablement semblables à leur propre père cinquante ans plus tôt. Le slogan maintes fois clamé par le gouvernement selon lequel « Cuba no renunciará a las ideas... » résume de manière adéquate le passage du temps sur les visages de ces hommes. Seul le Che – exécuté à l'âge de 39 ans – reste le même, inchangé, sans âge, hors du temps, plein de défiance et d'espoir, connaissant un sort que ni lui ni son camarade Fidel n'aurait pu imaginer cinquante ans plus tôt, immortalisé comme l'icône par excellence de la révolution, figé dans le temps, présent dans un état temporaire de mort apparente.

Avant toute autre chose, les photographies d'Elliott Erwitt ont capturé de manière ingénue l'âme d'une nation, de l'aube au crépuscule de sa fascinante histoire. Des générations d'historiens étudieront ces images pour expliquer les innombrables enseignements que ces images muettes prodiguent, et l'éloquence avec laquelle elles le font. Grâce à son travail et à la bourse Elliott Erwitt Havana Club 7 ainsi appelée en son hommage, une nouvelle génération de photographes sera en mesure de poursuivre cette œuvre documentaire sur la base solide du passé et du présent qu'Elliott Erwitt a capturés avec son Leica préféré.

1 Elliott Erwitt, cité dans *The Macallan Masters of Photography: Elliott Erwitt Edition*, publié le 6 novembre 2013.

2 Elliott Erwitt, cité dans la conférence « EG5 Elliott Erwitt, photographer », publiée le 10 mars 2012.

3 Ken Johnson, « Captured: A New York Minute, or One in Havana », *New York Times*, 10 juin 2011.

4 Elliott Erwitt, cité dans une vidéo sur « Photographer Technique and Process », diffusée le 12 septembre 2015.

5 « First Take: Elliott Erwitt's Take on the Magic of Photography », Time.com, 3 octobre 2016.

1964

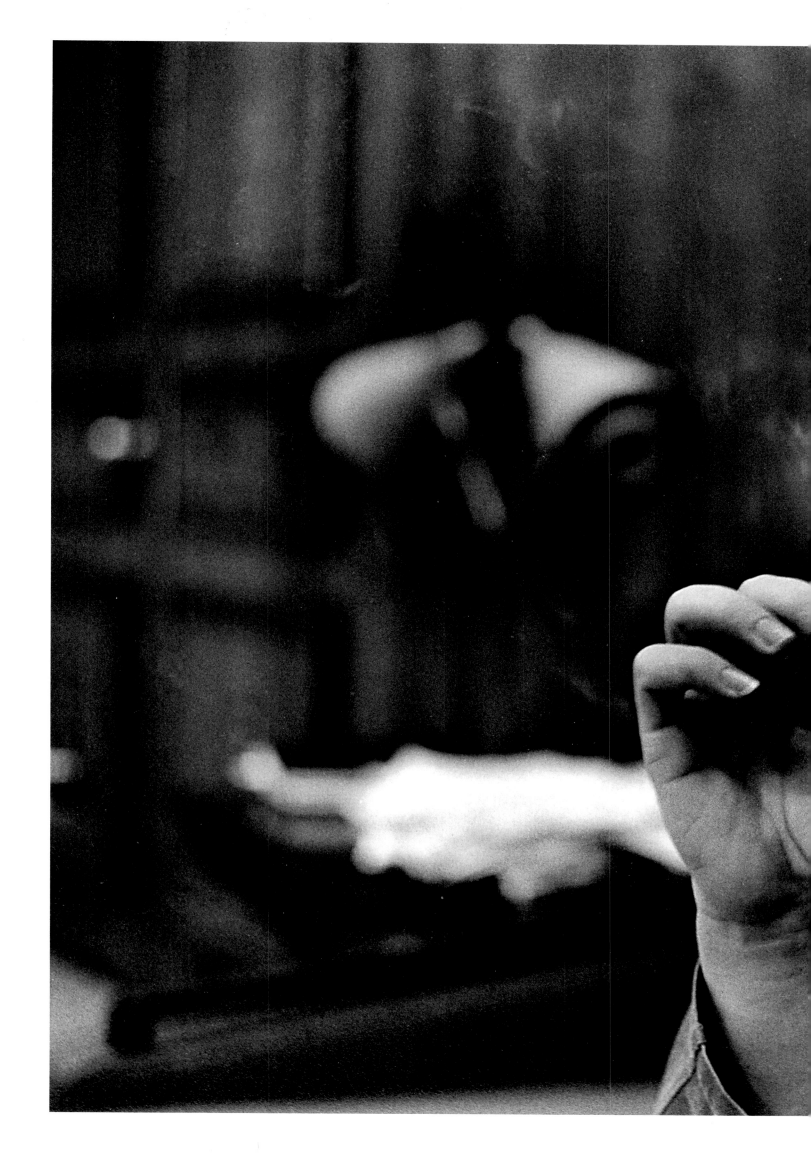

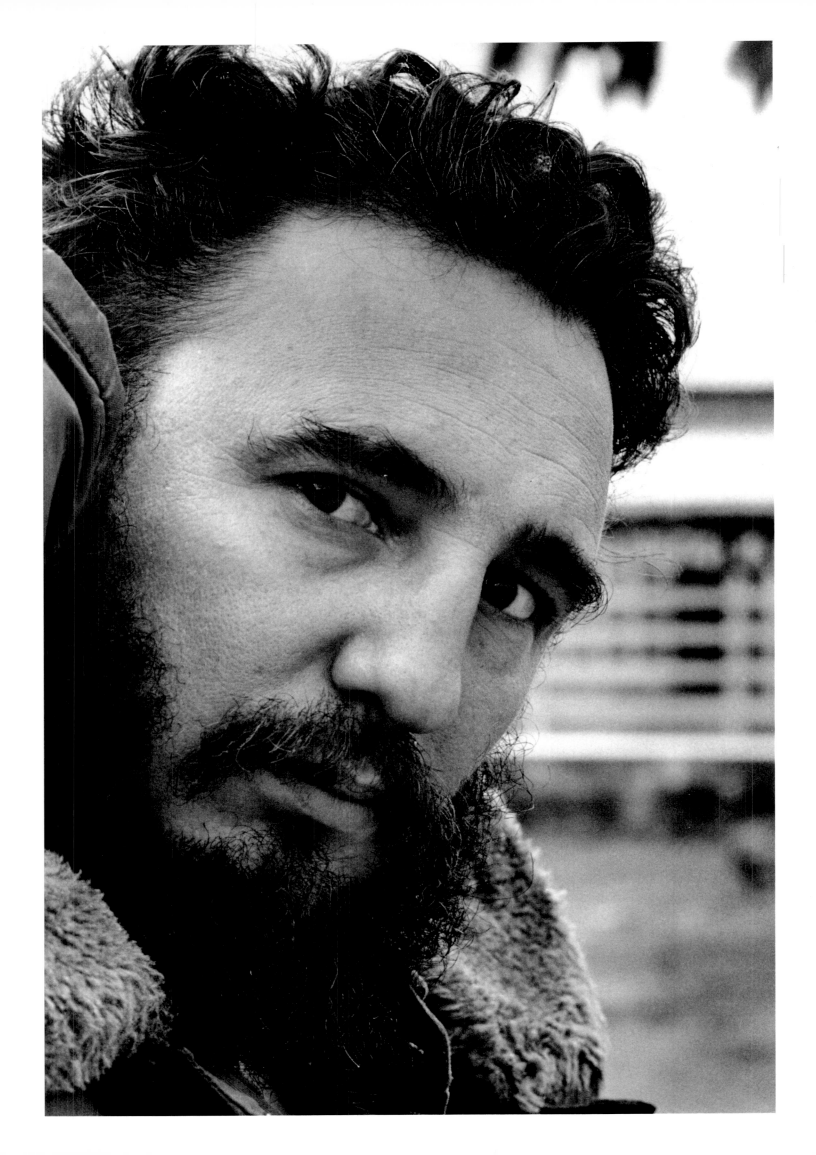

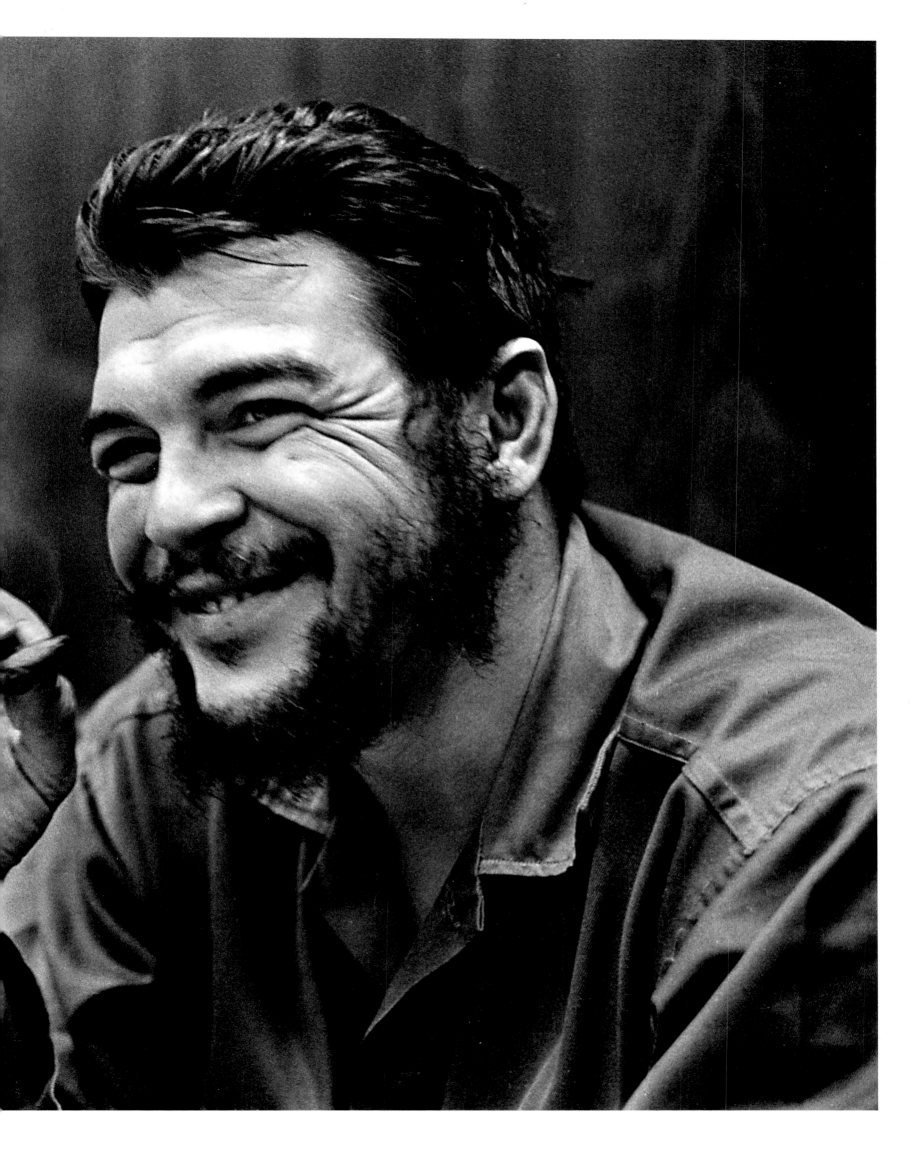

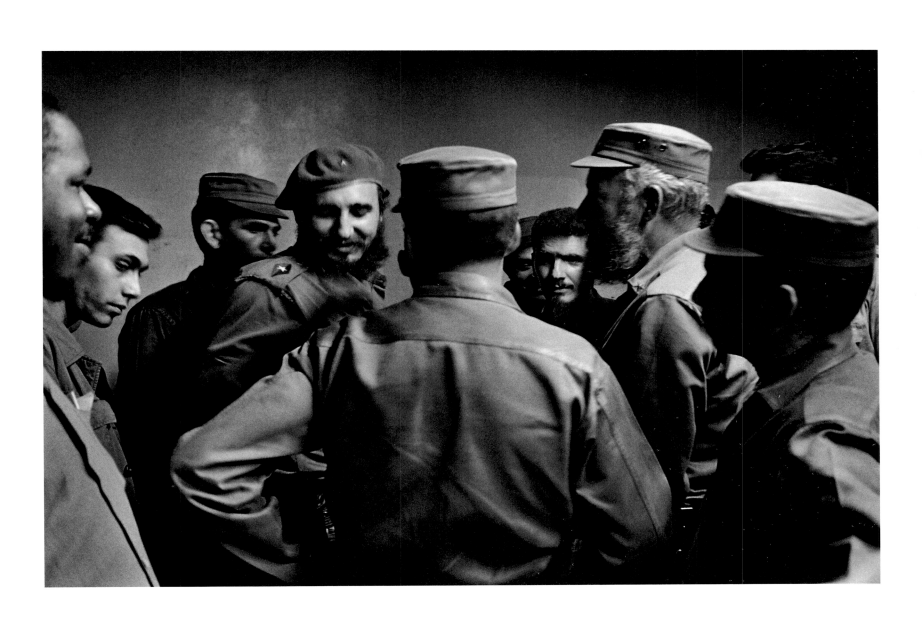

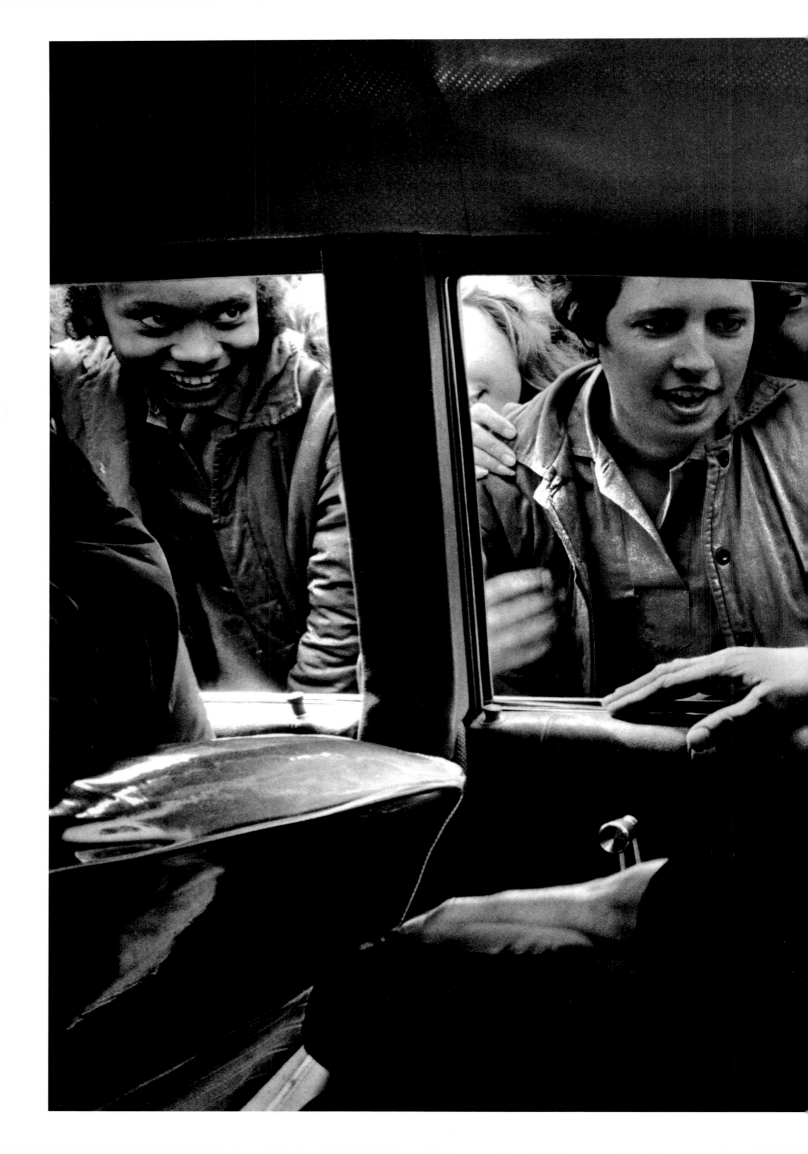

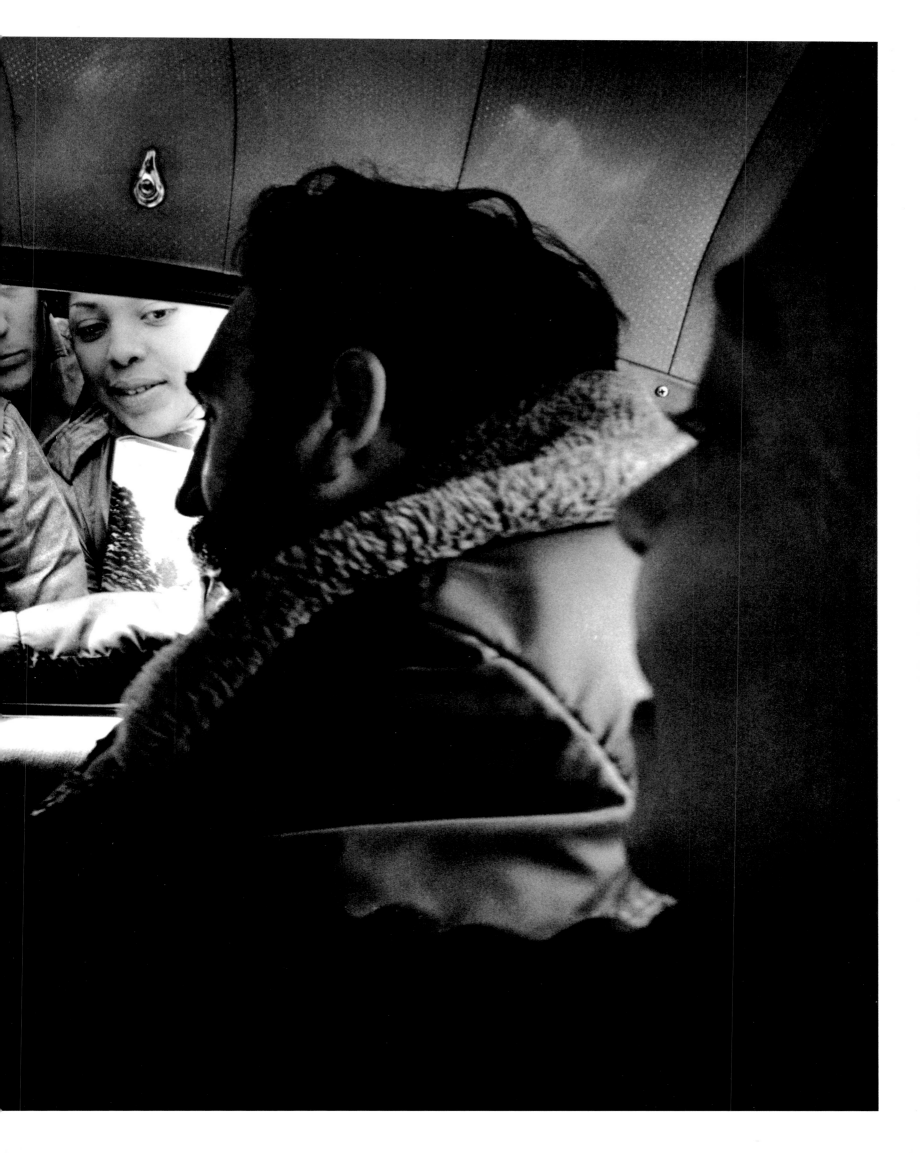

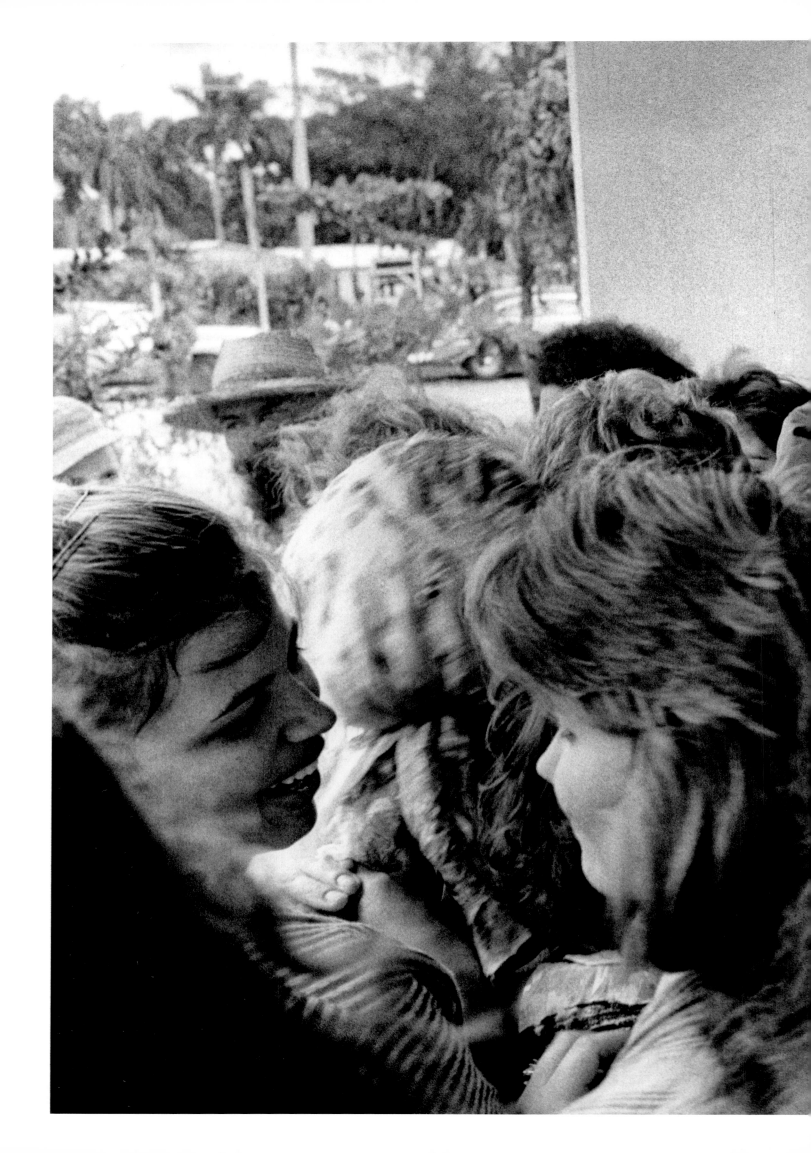

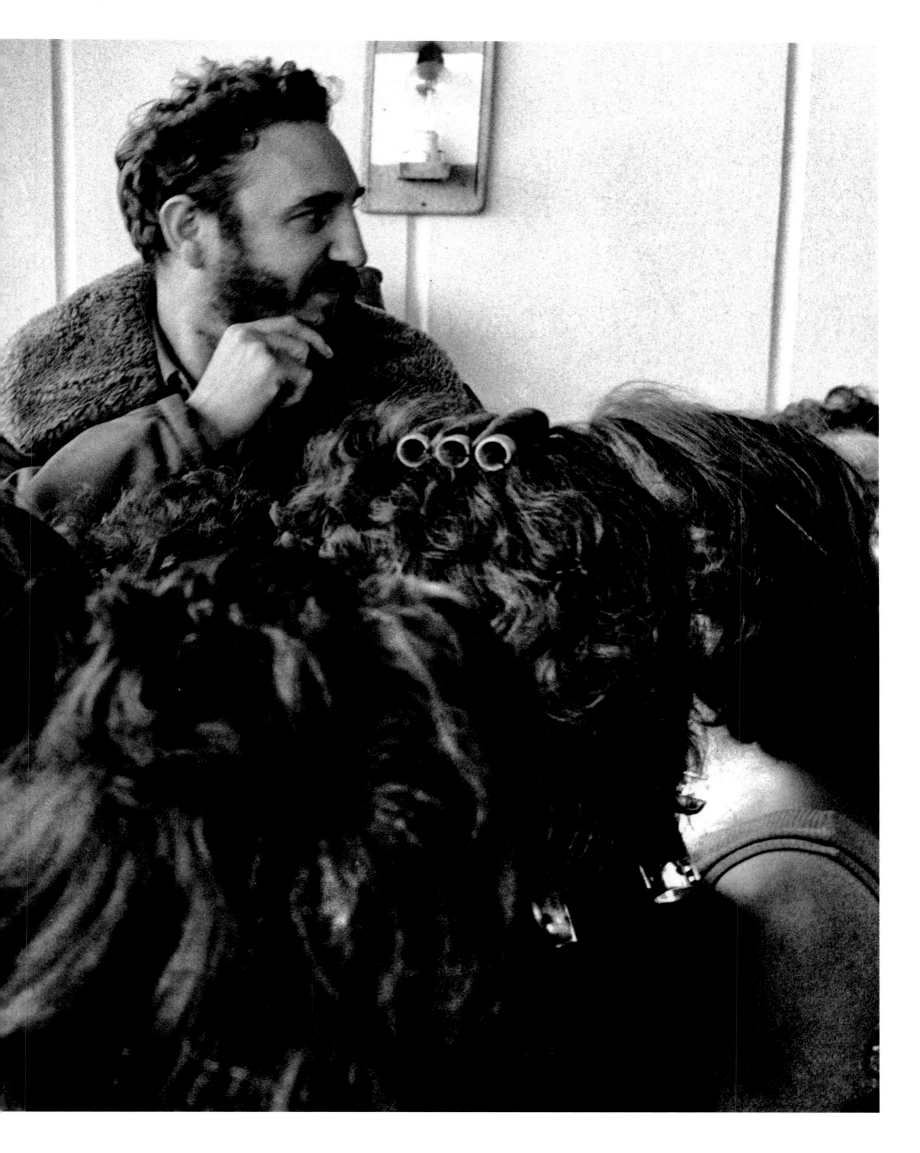

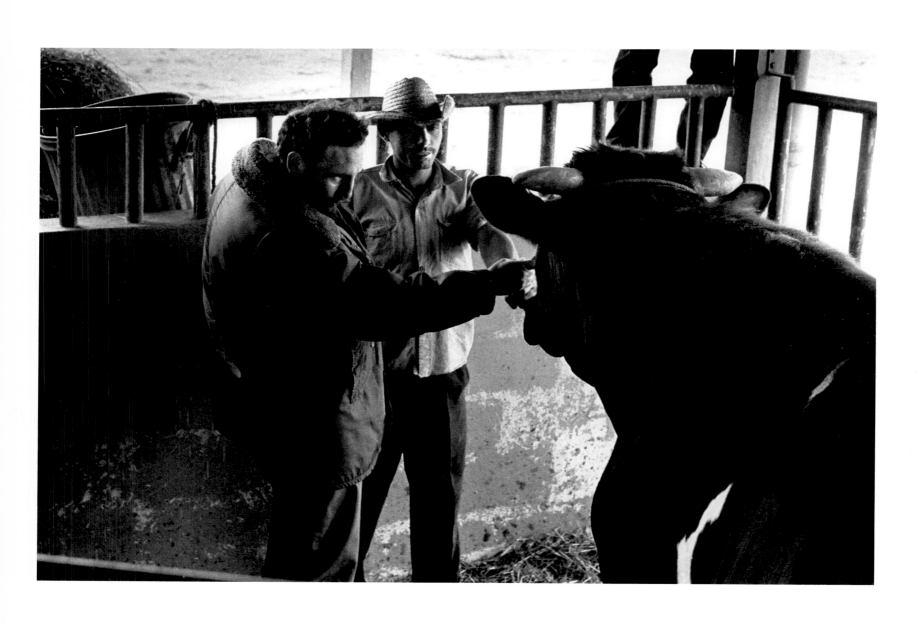

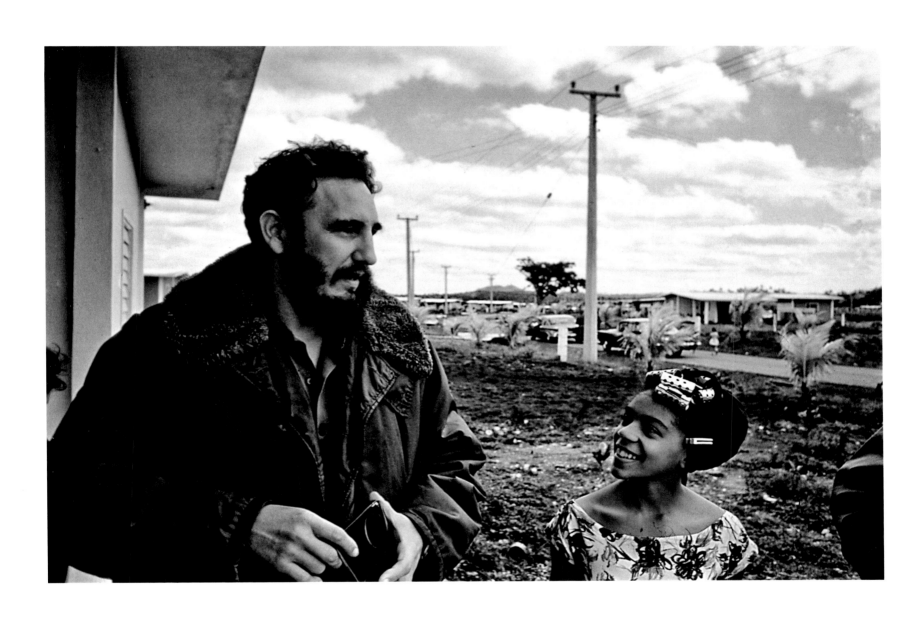

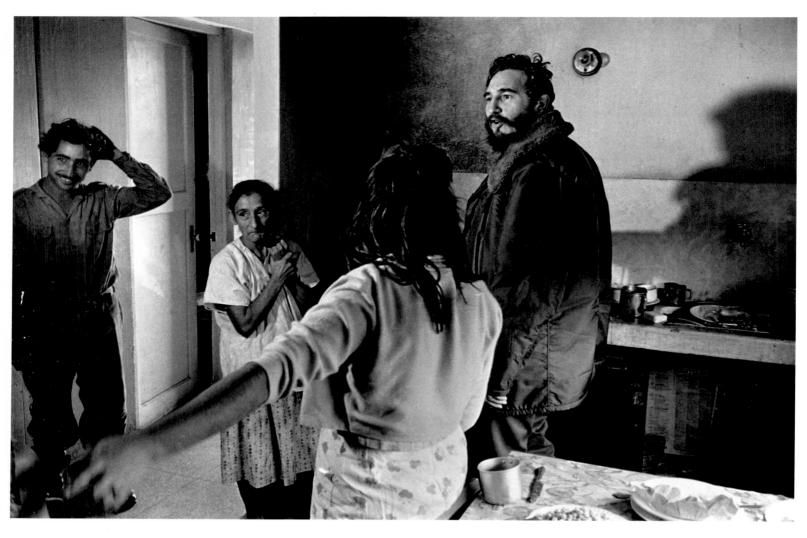

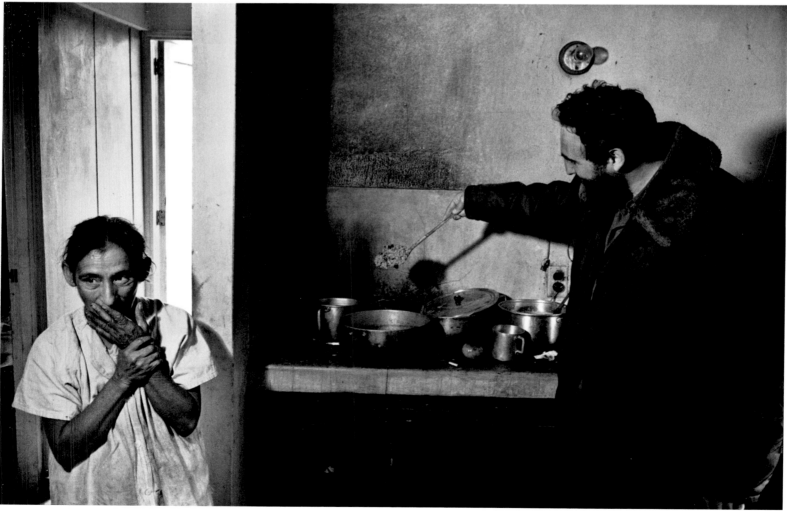

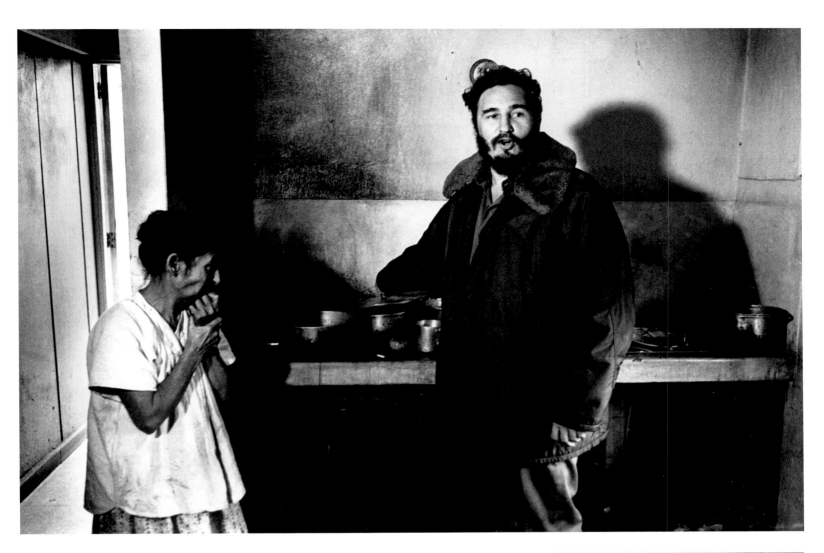

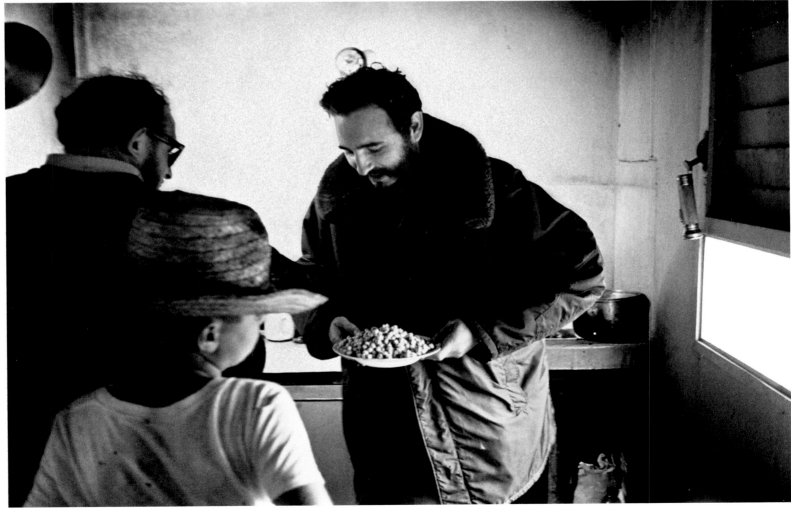

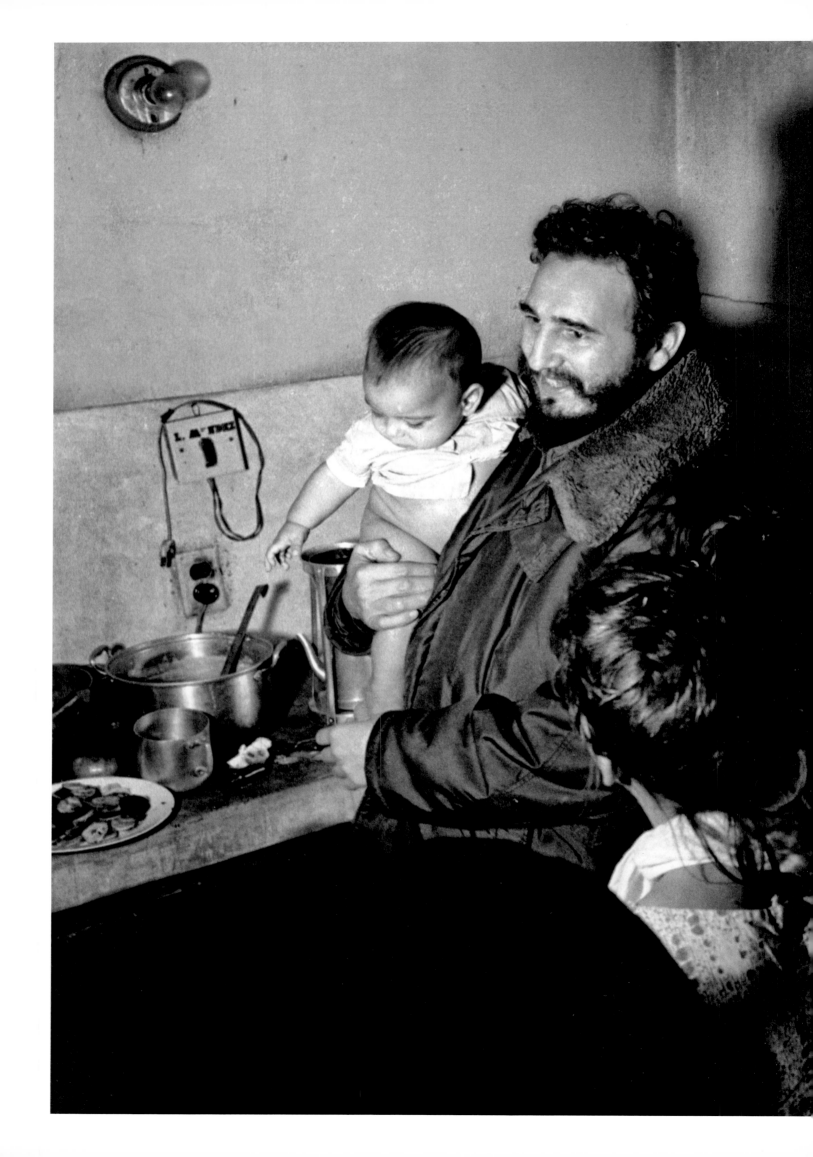

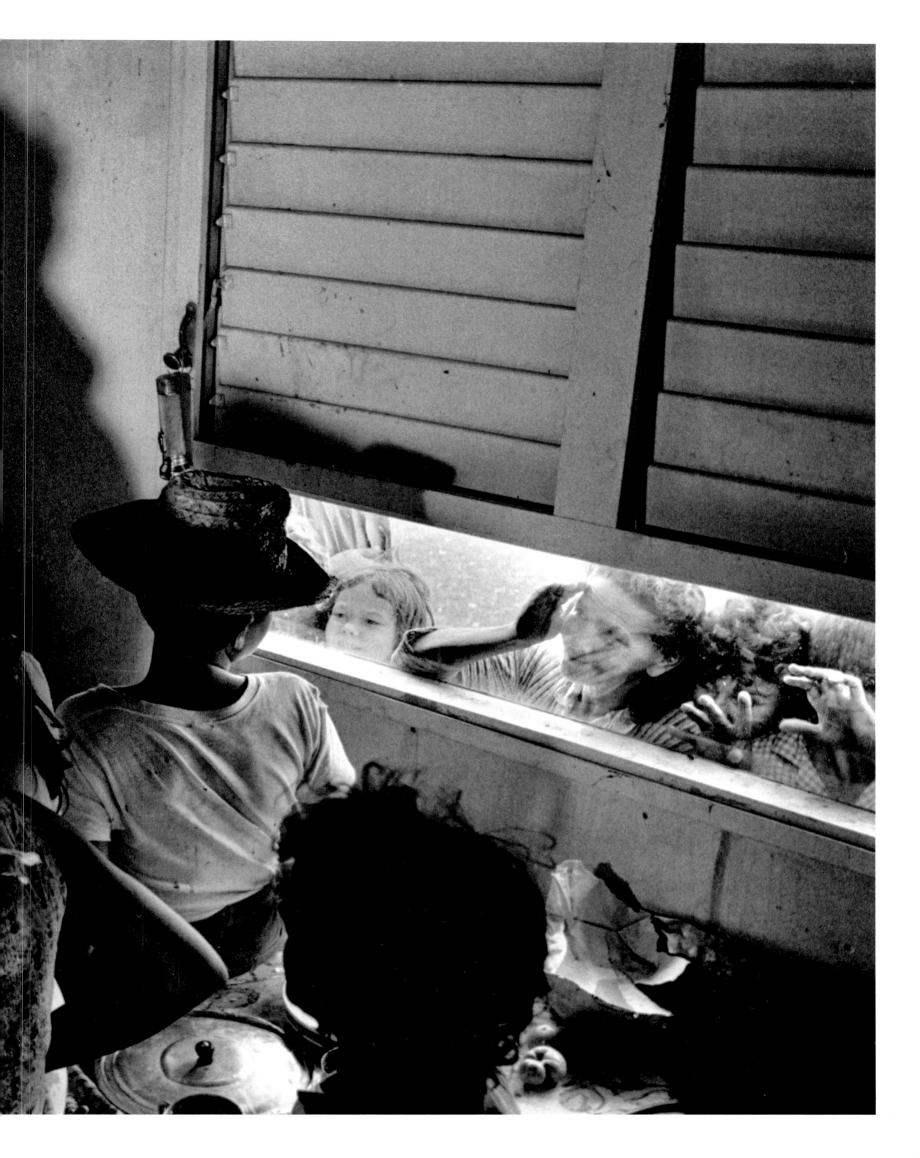

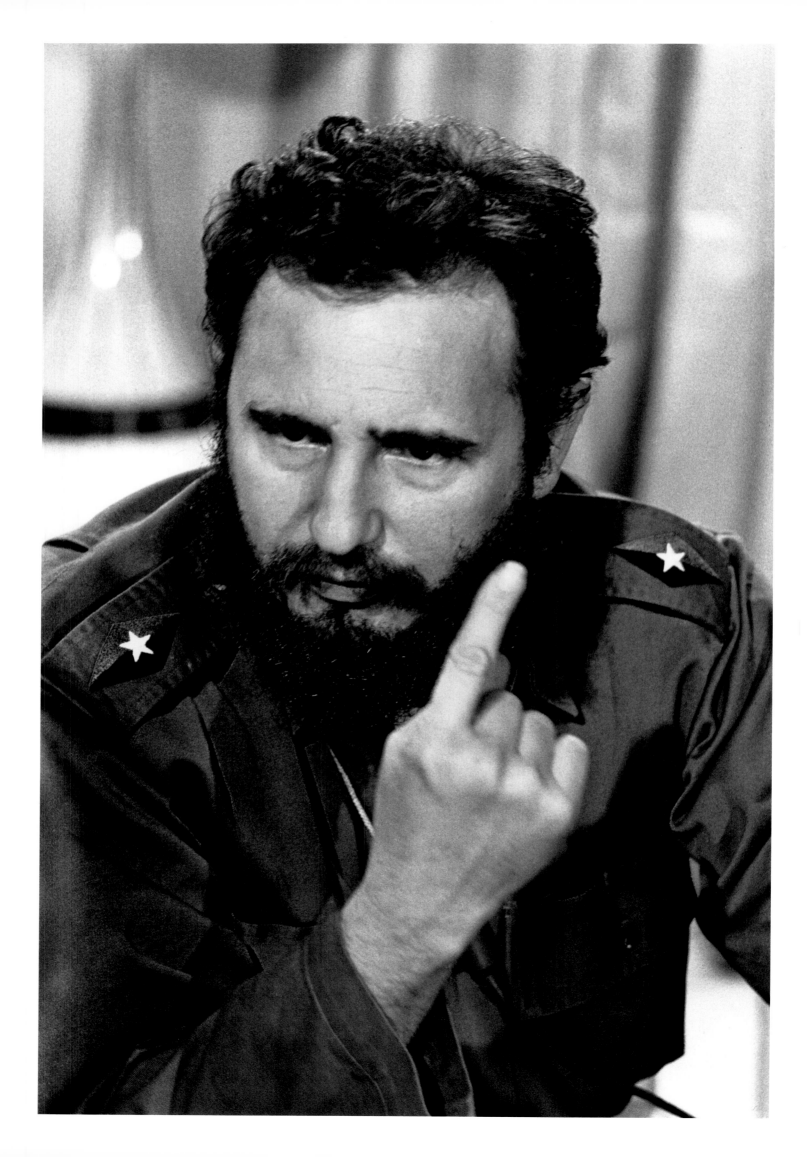

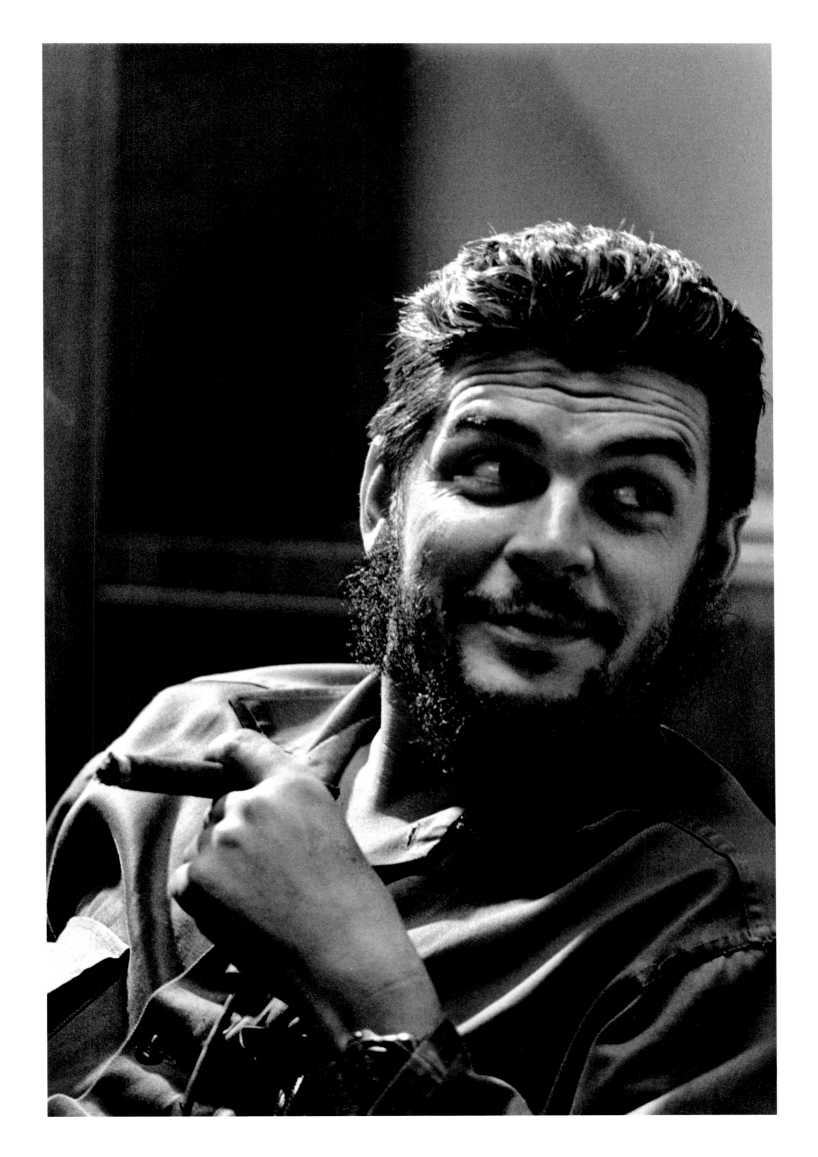

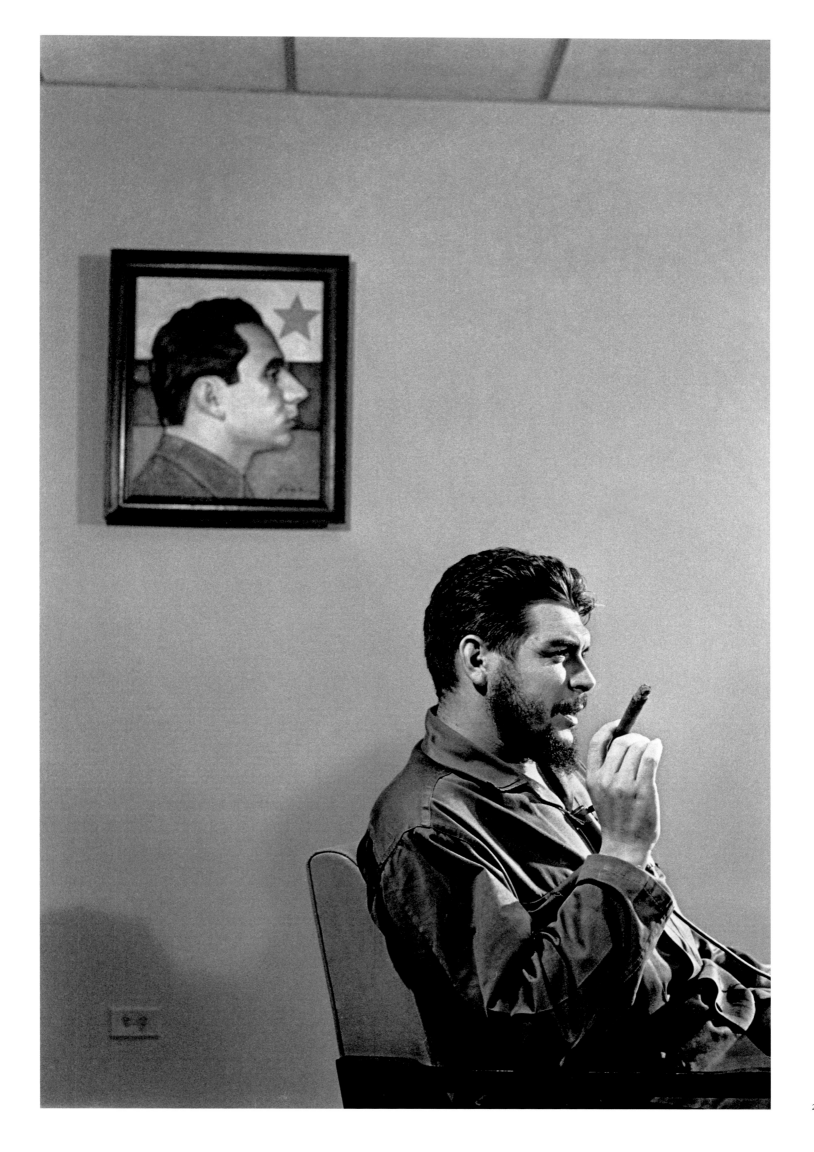

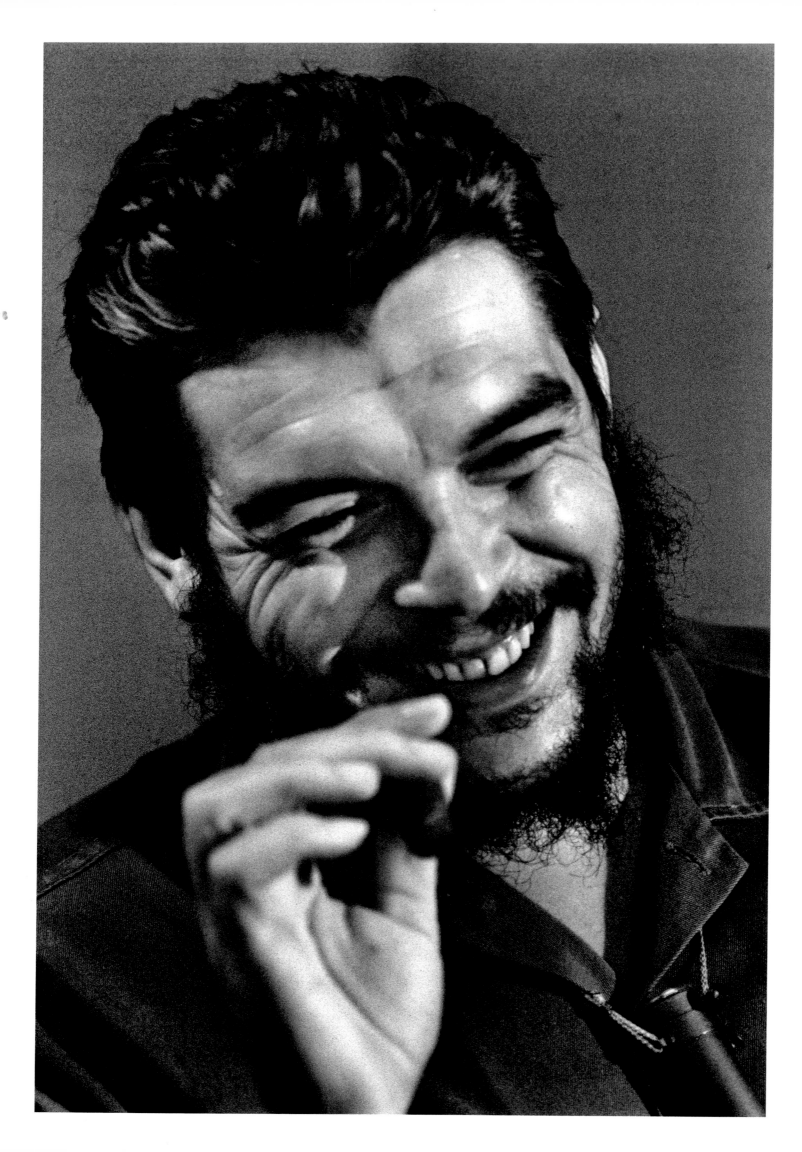

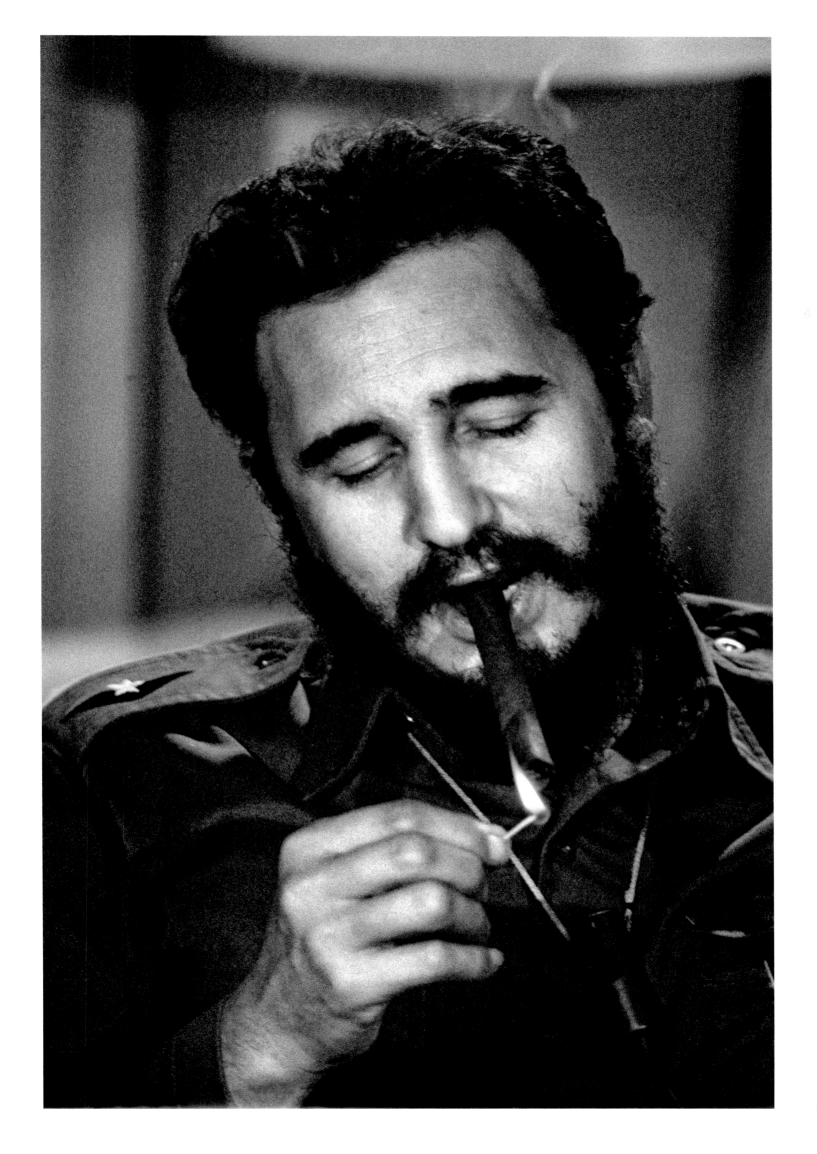

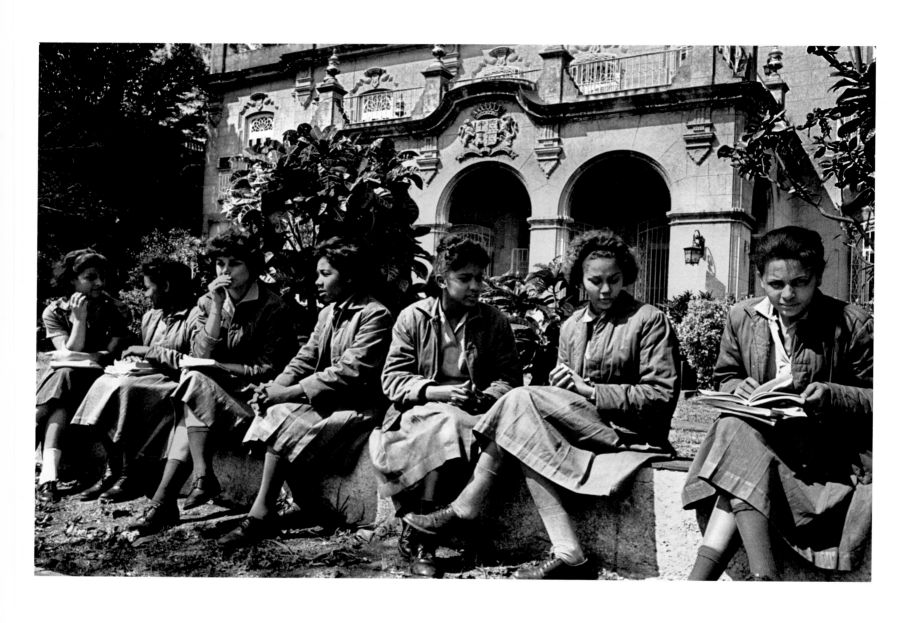

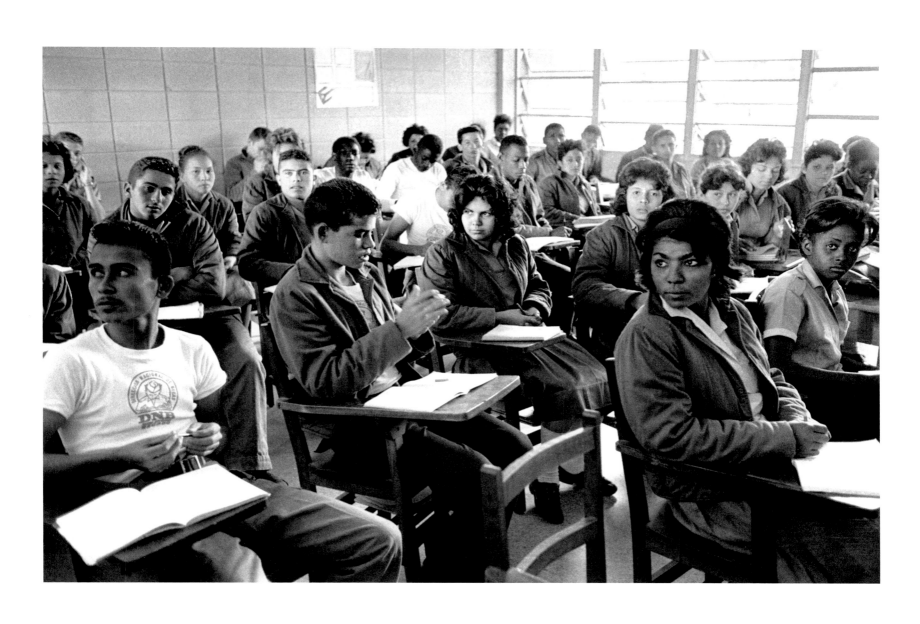

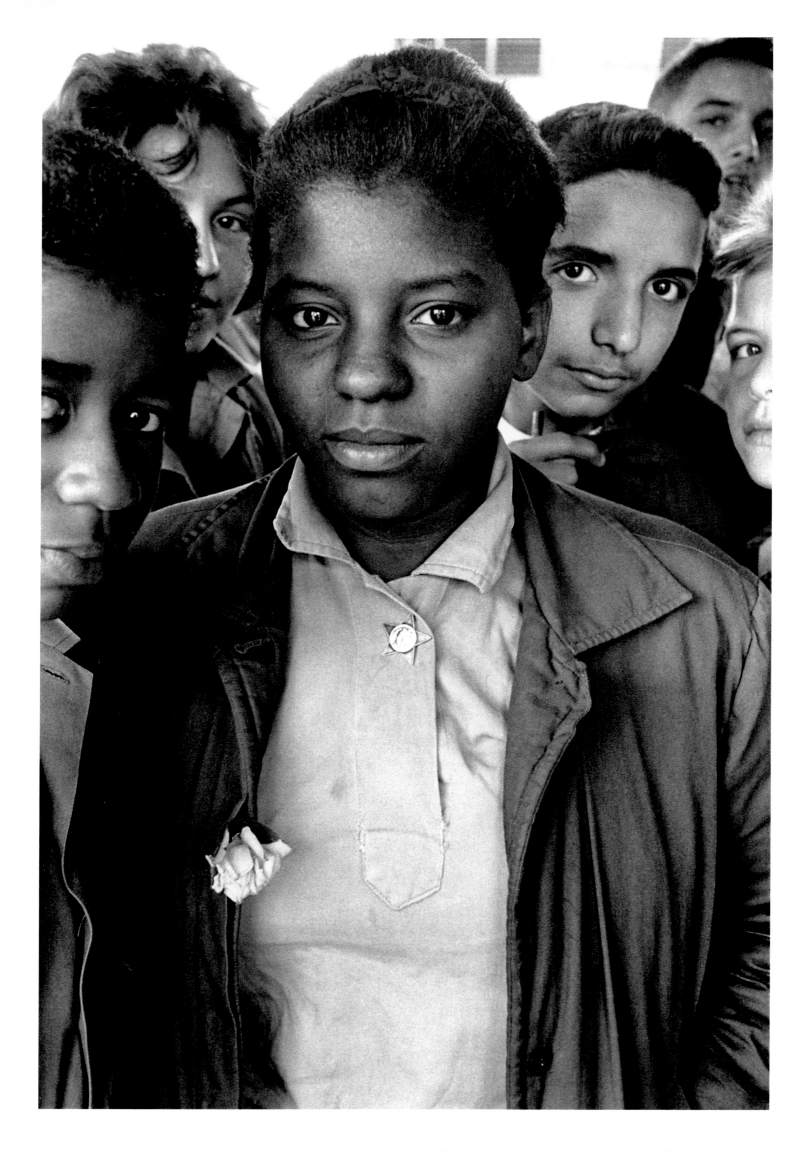

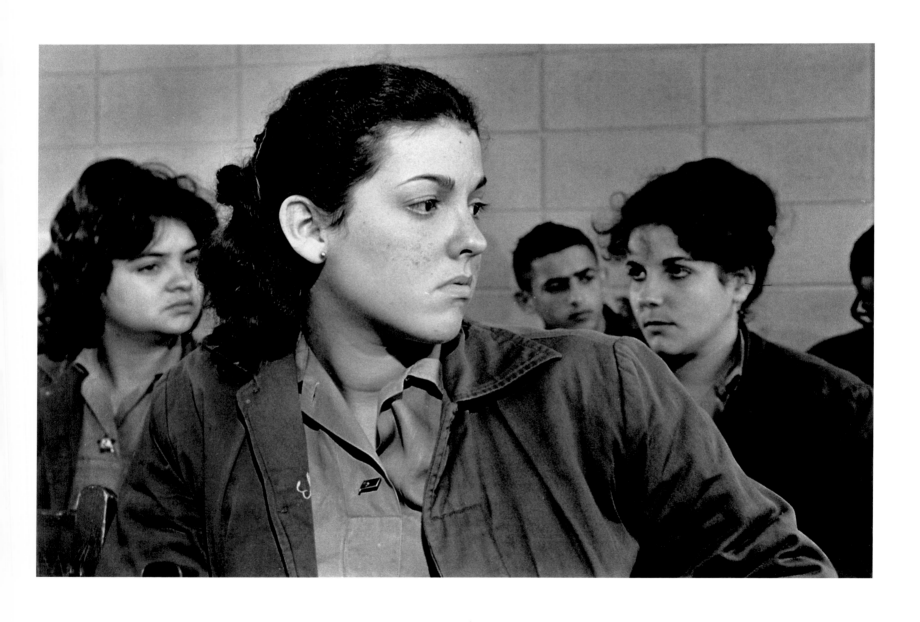

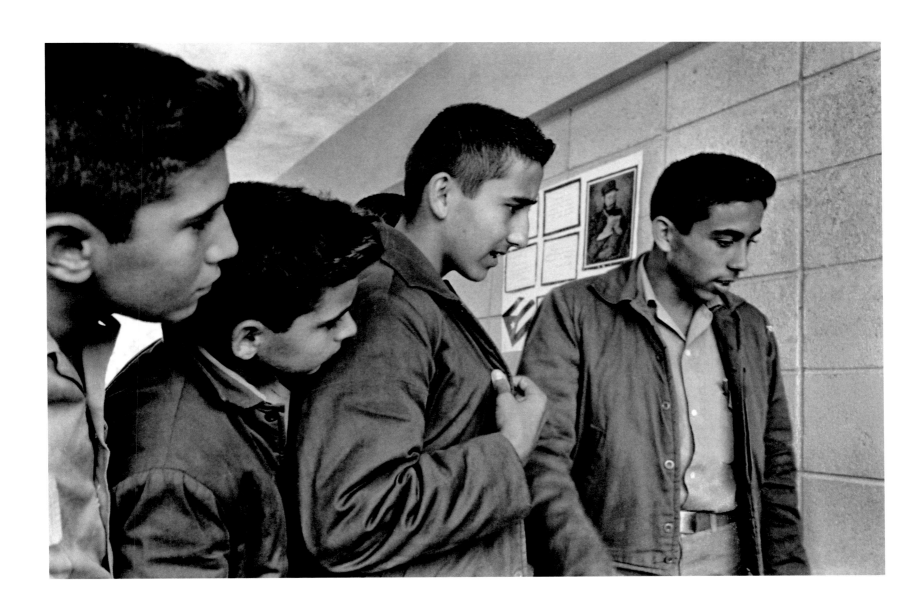

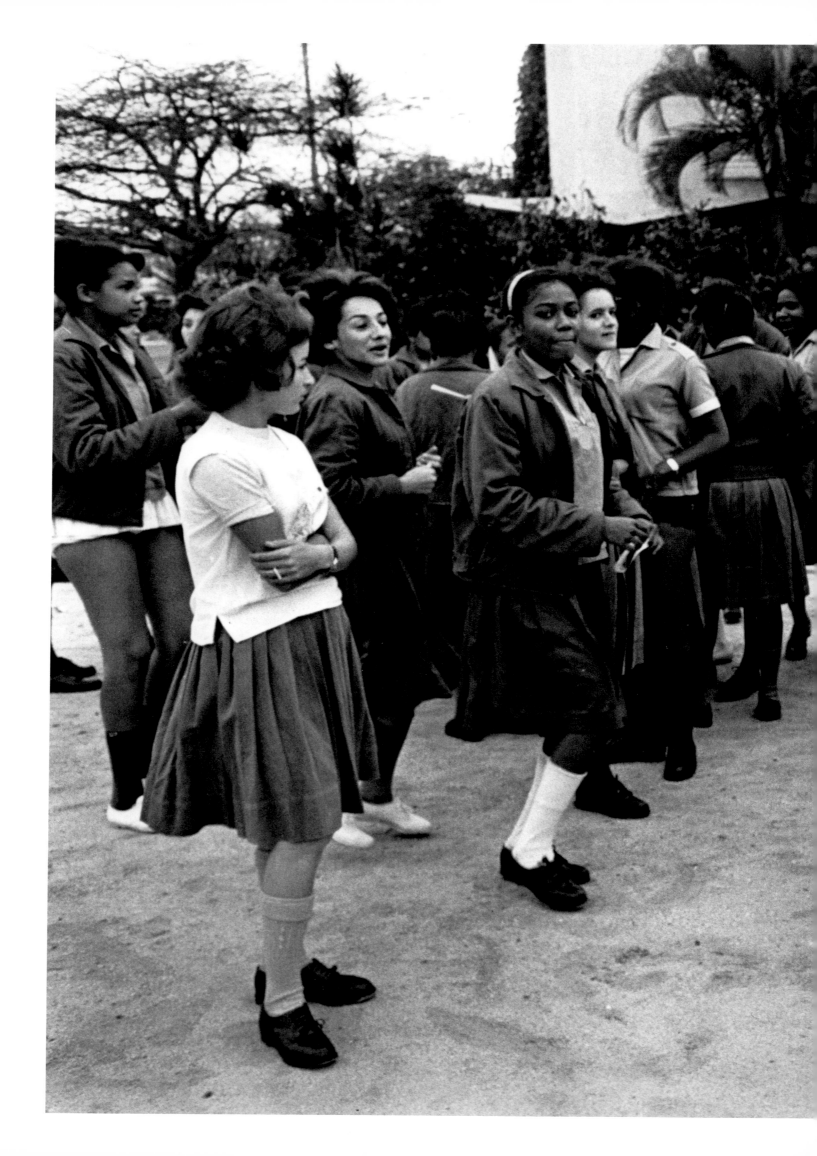

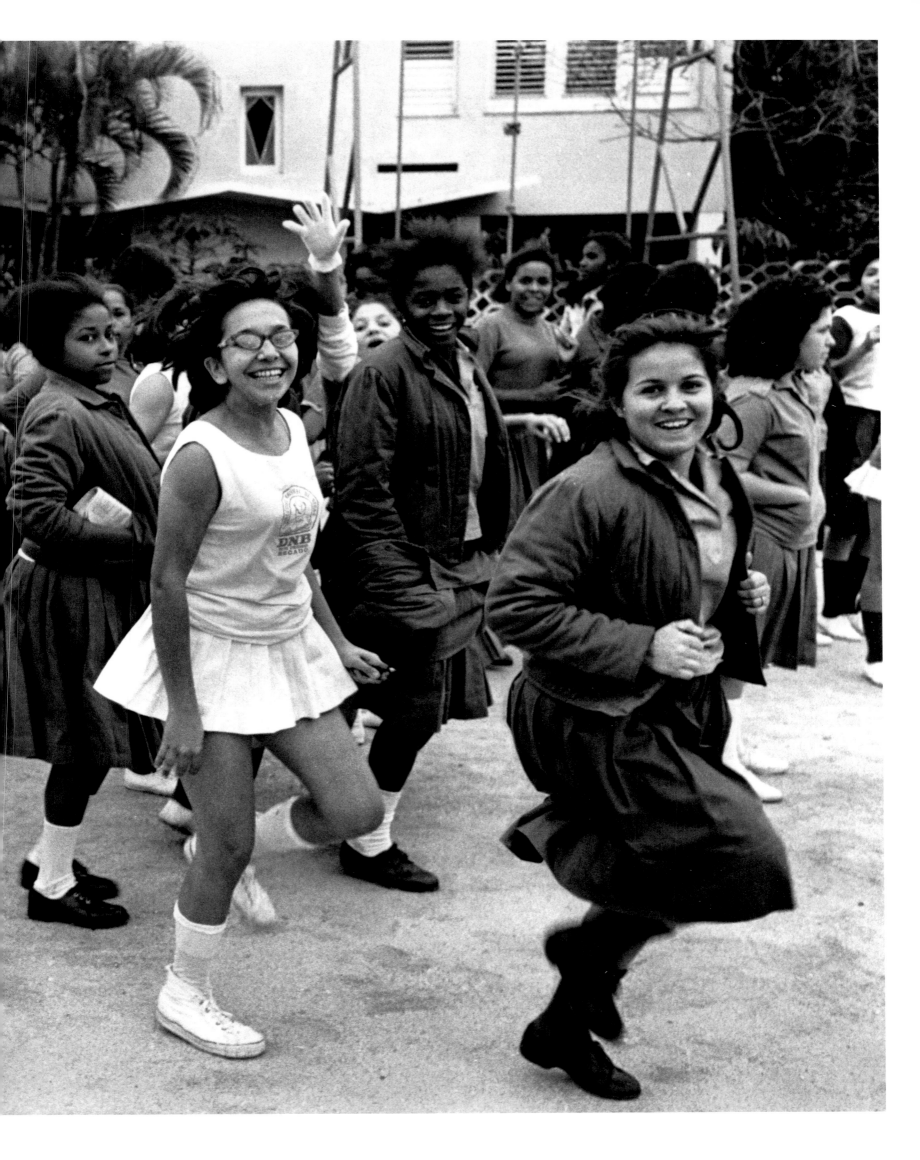

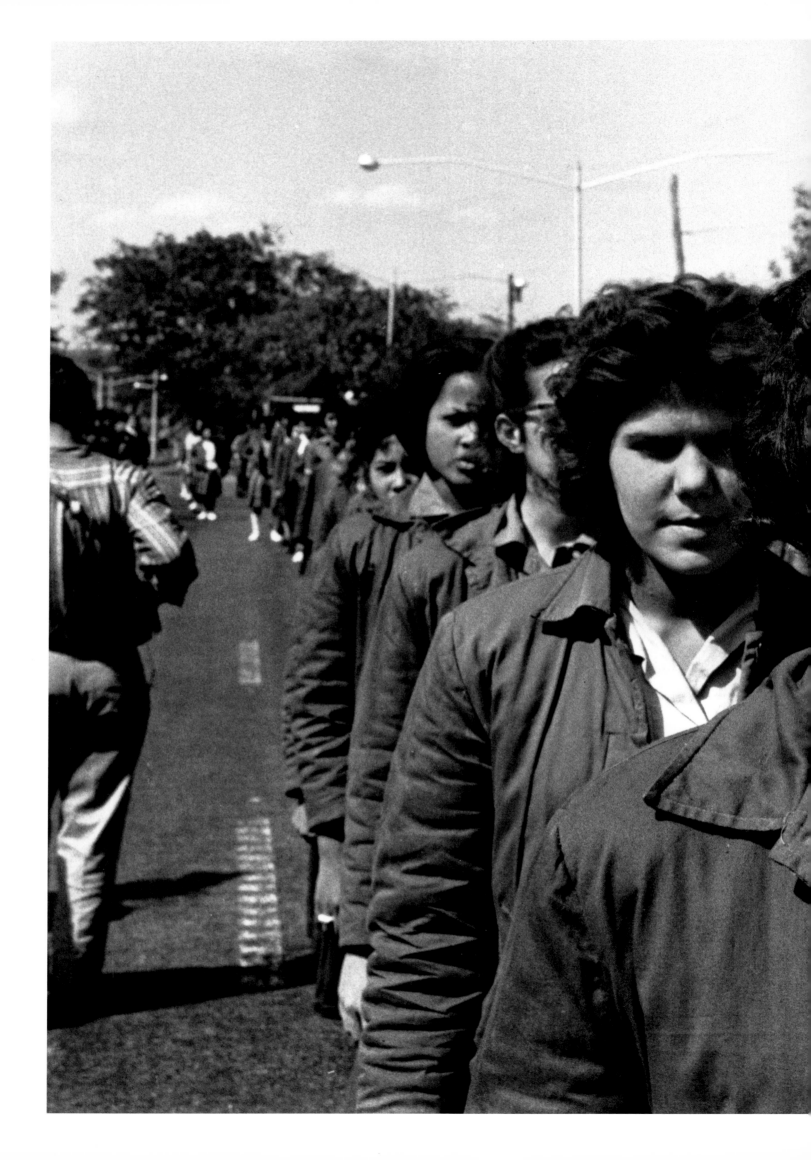

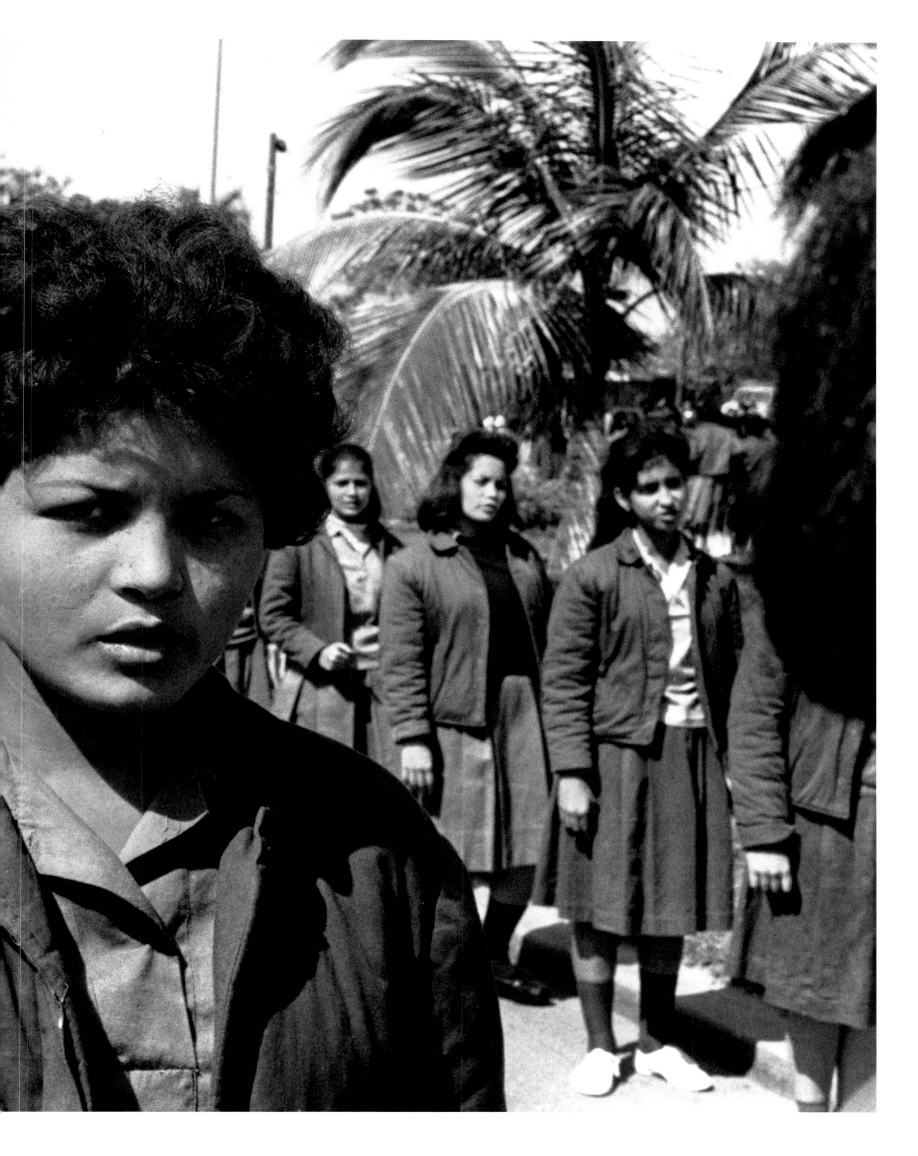

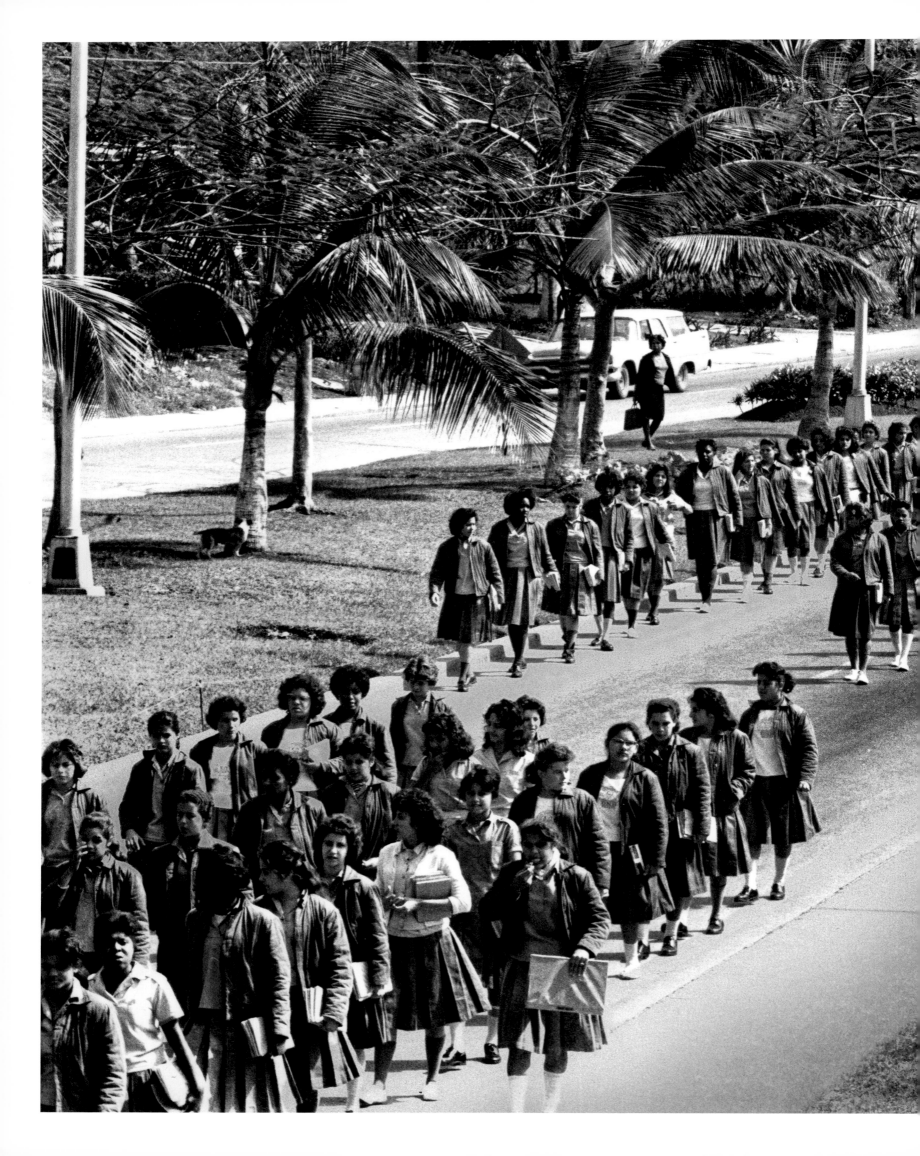

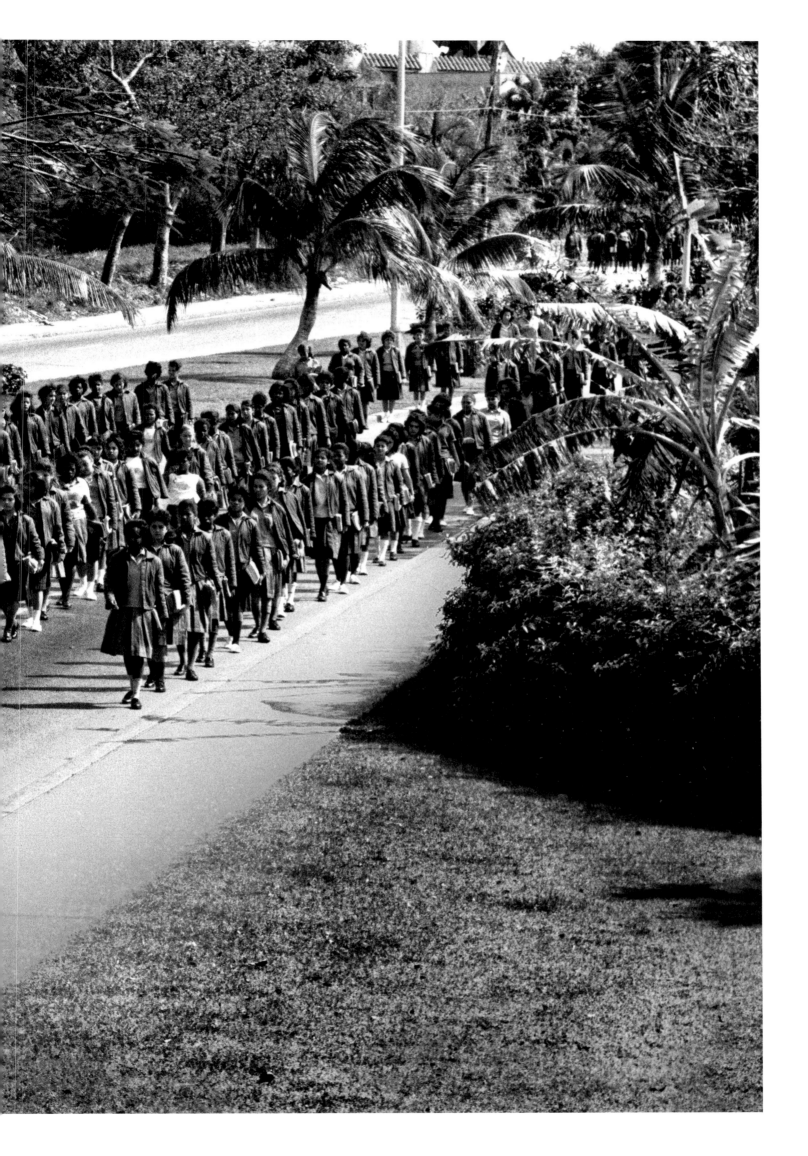

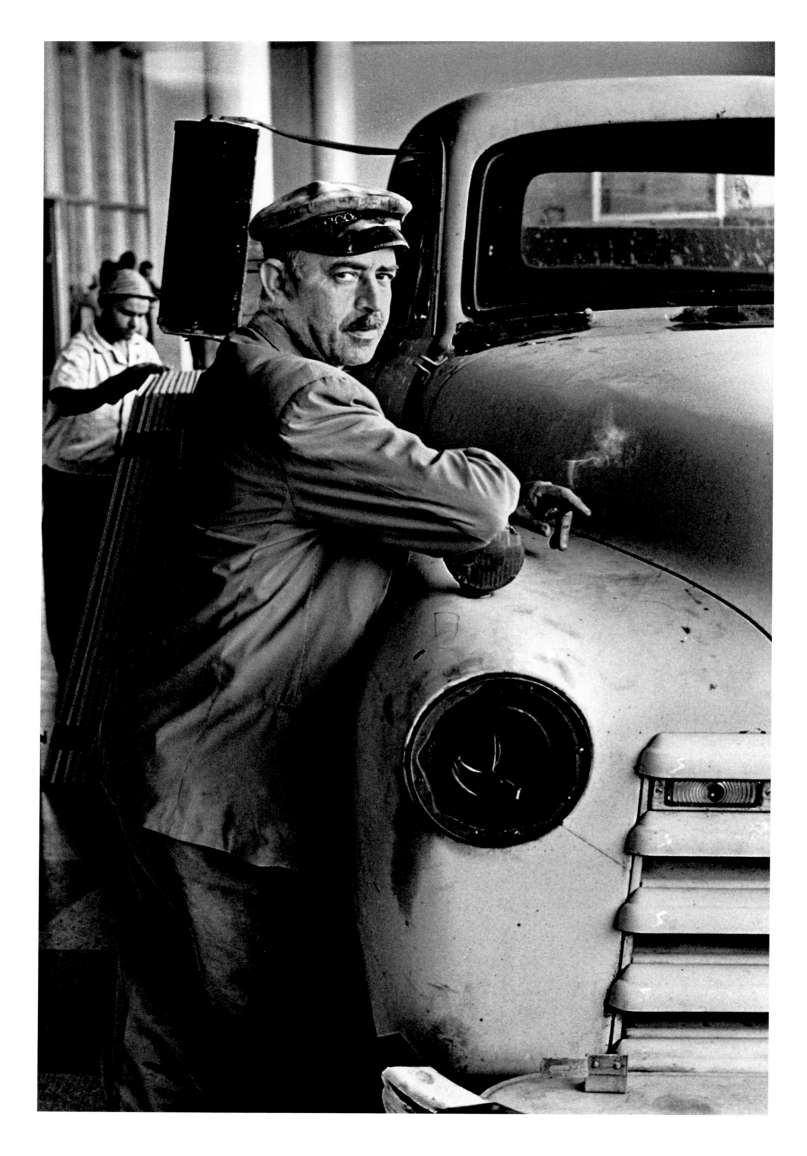

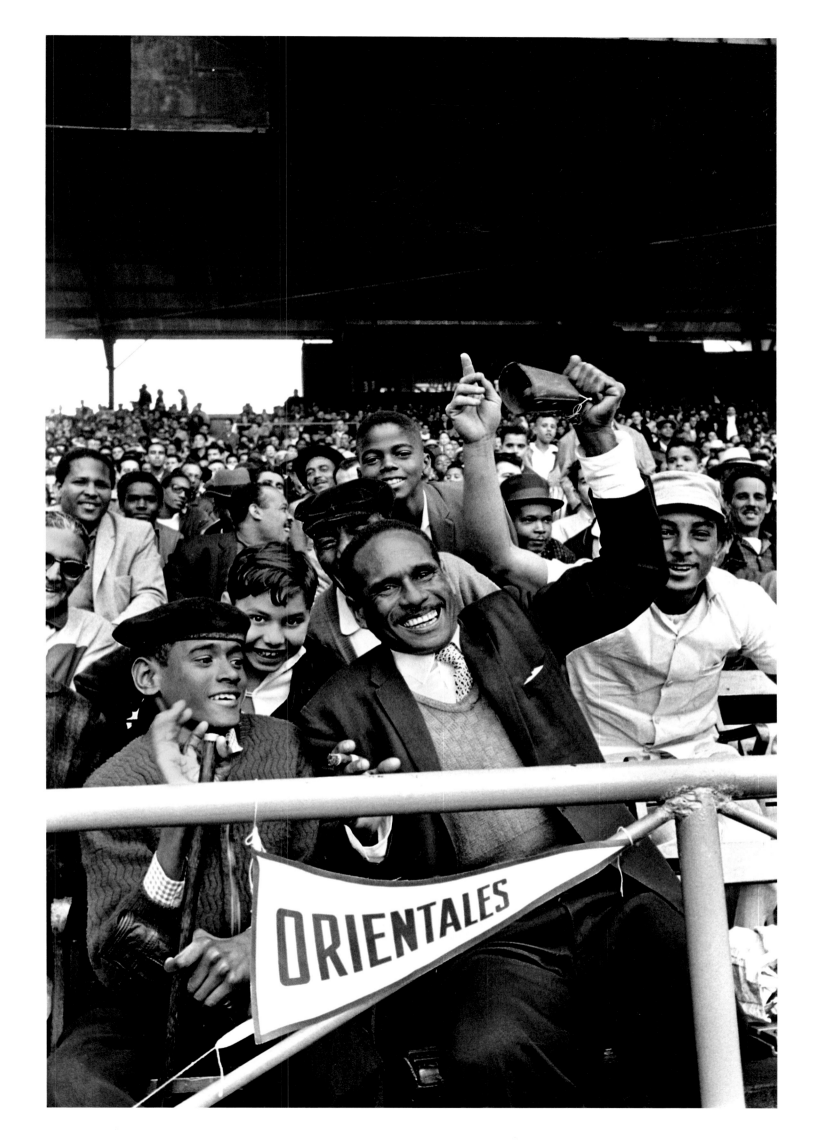

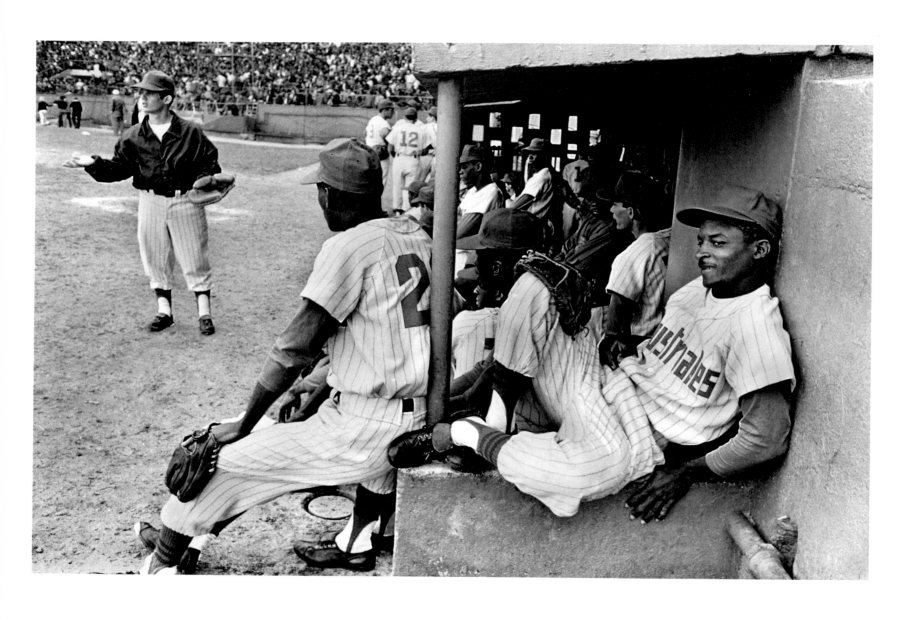

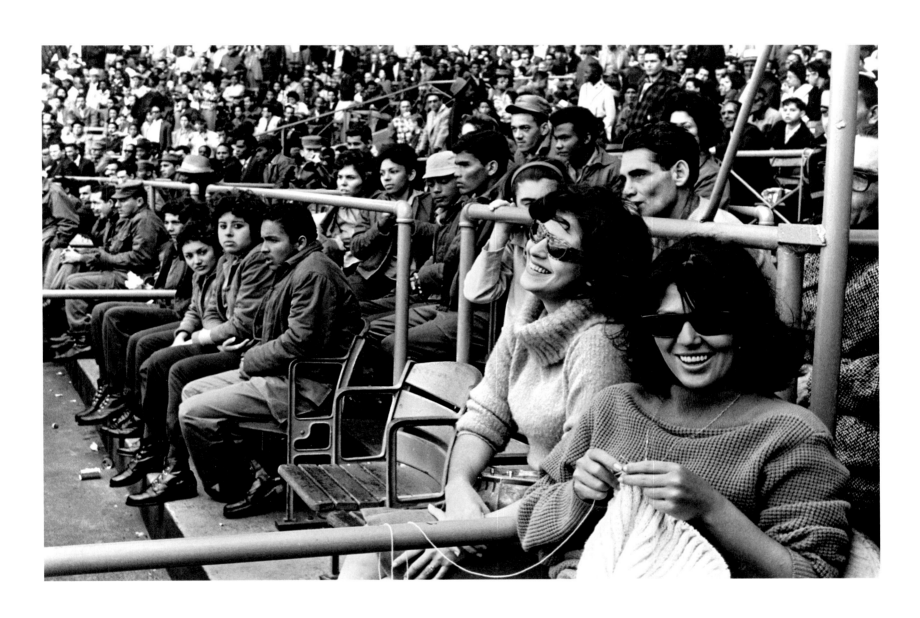

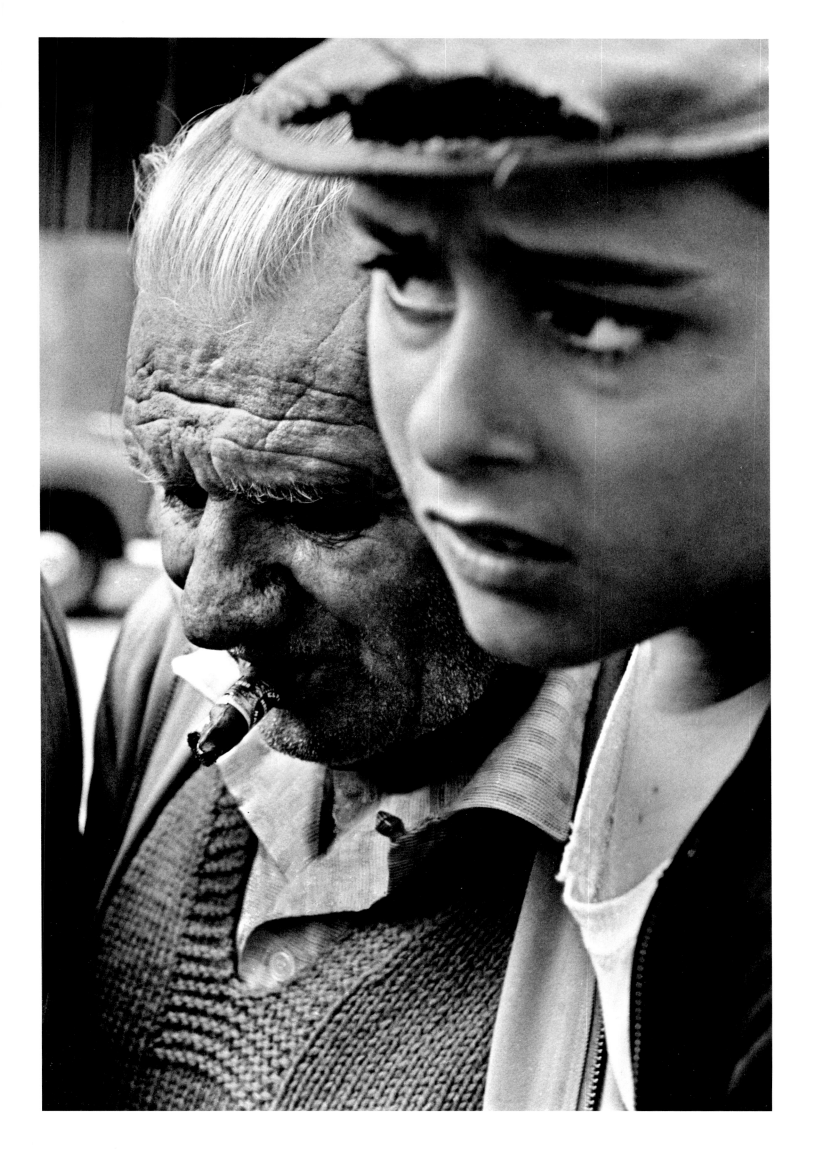

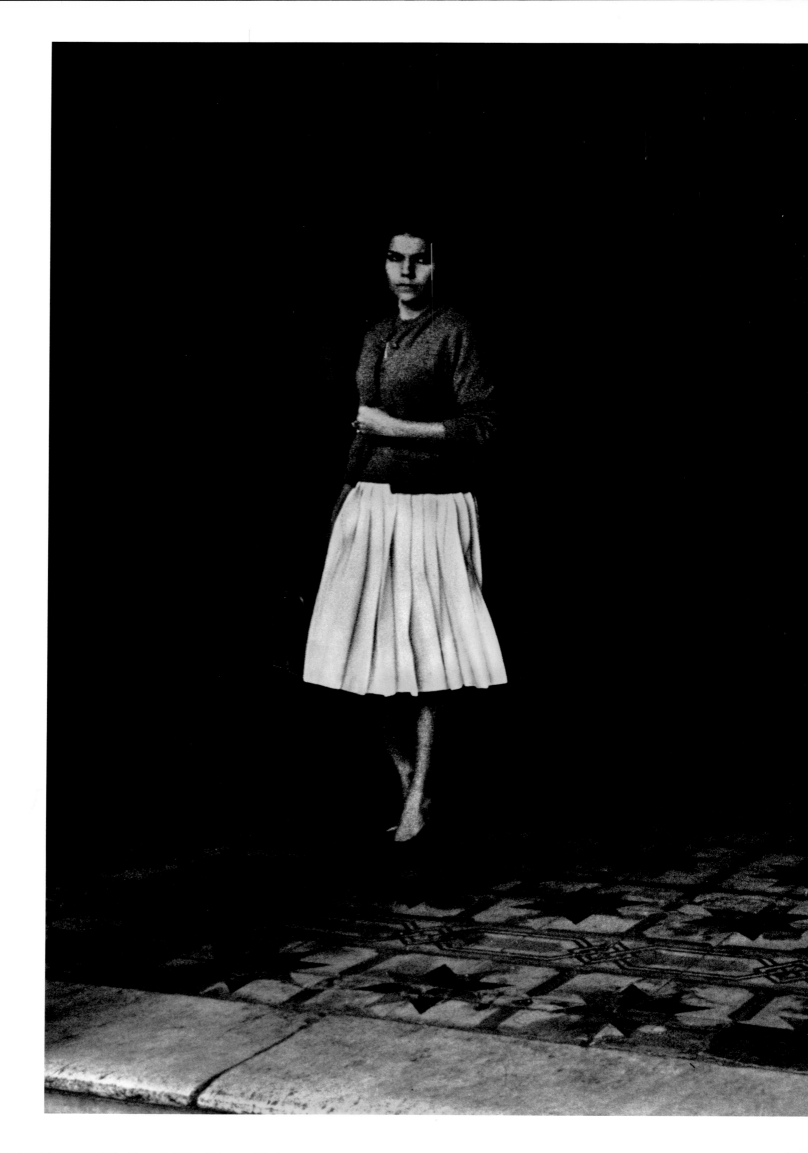

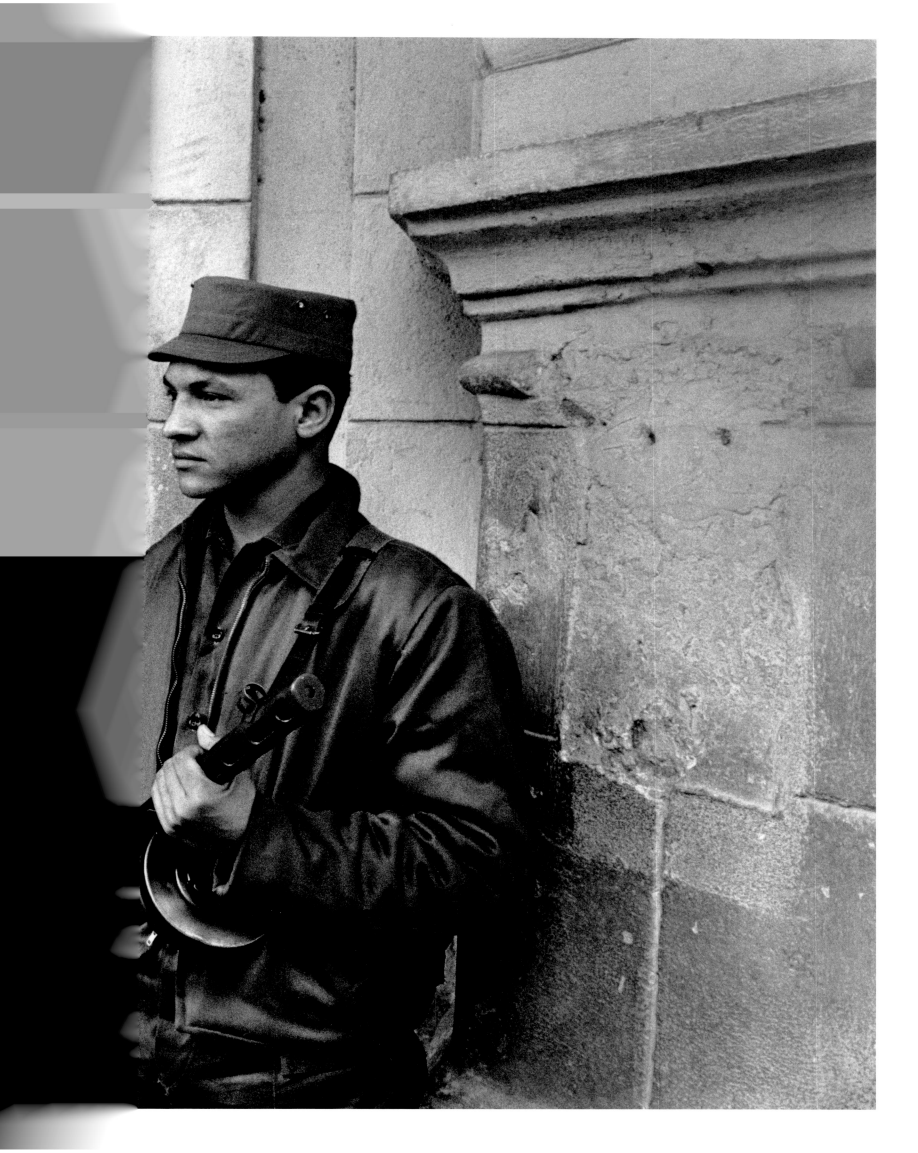

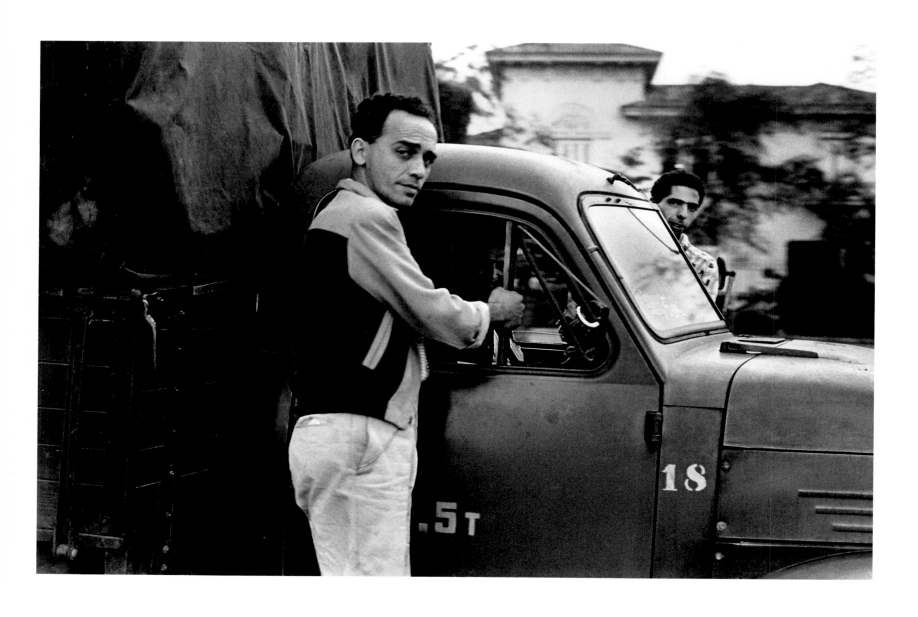

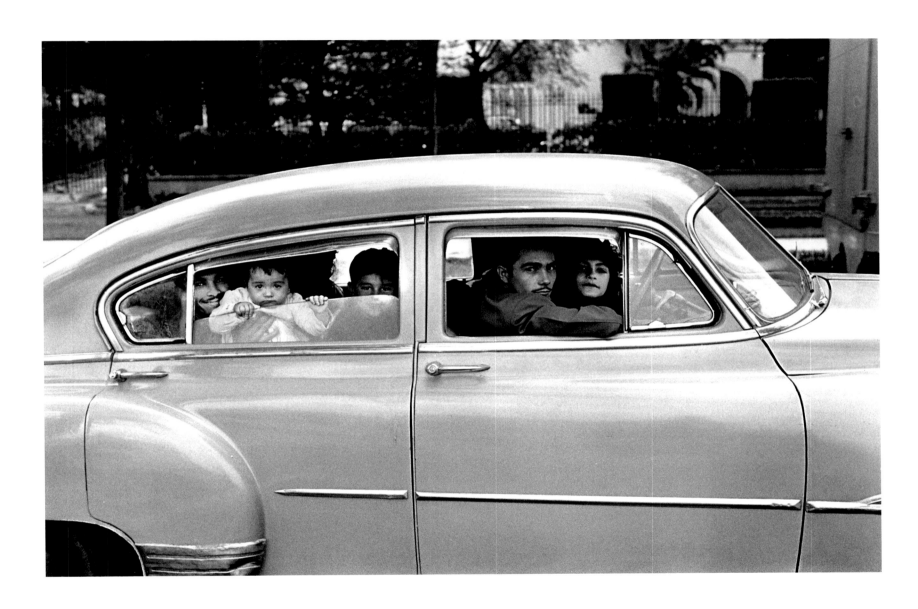

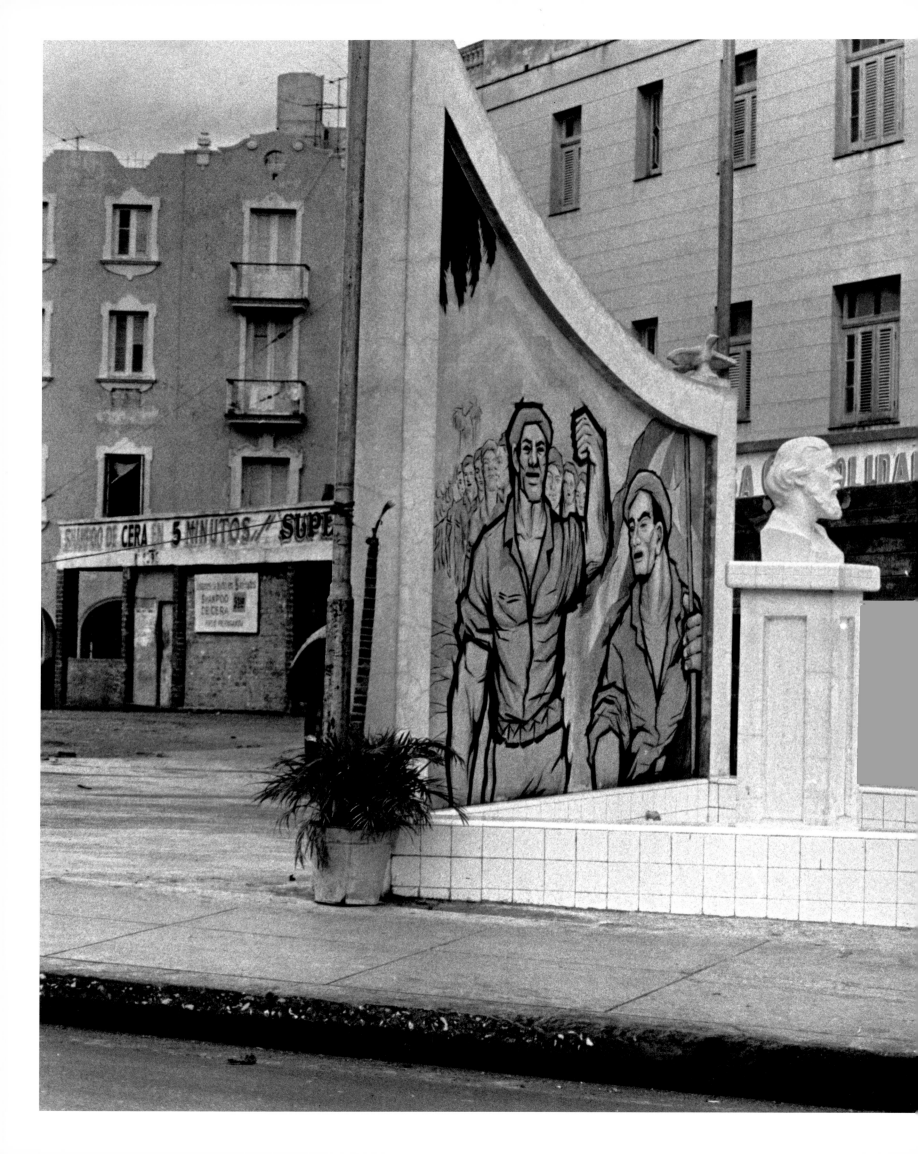

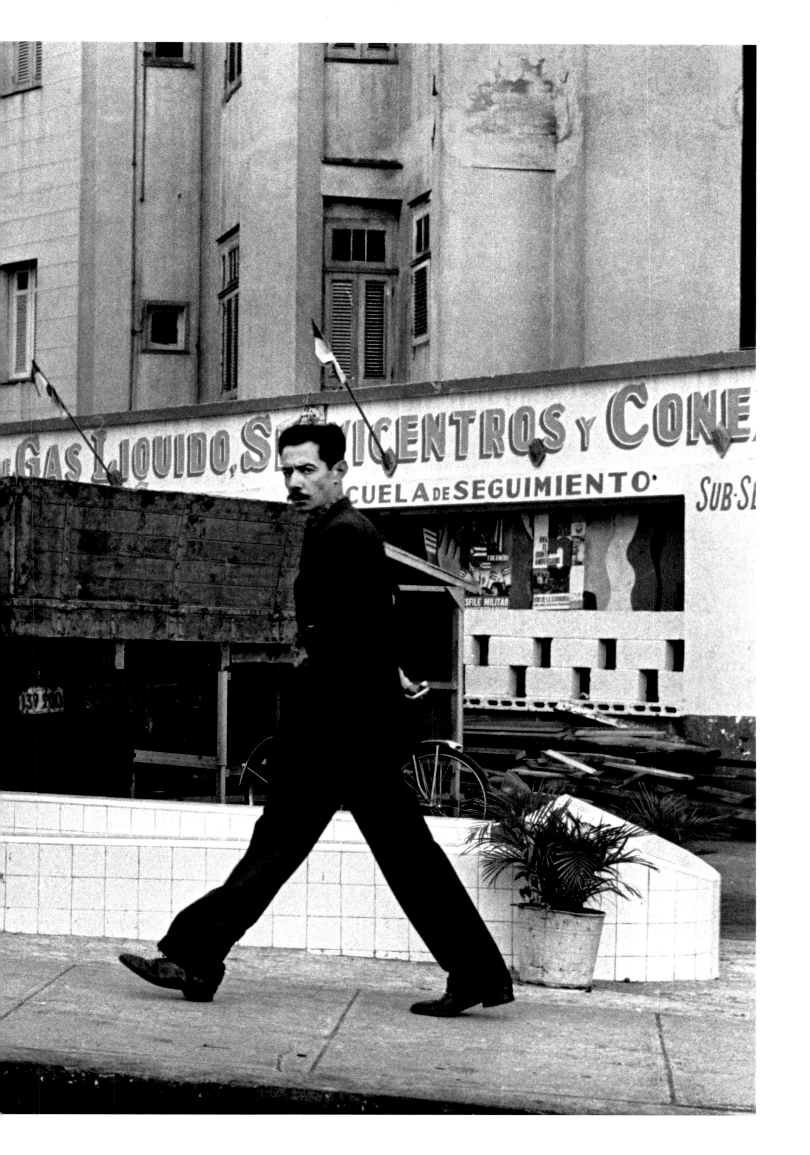

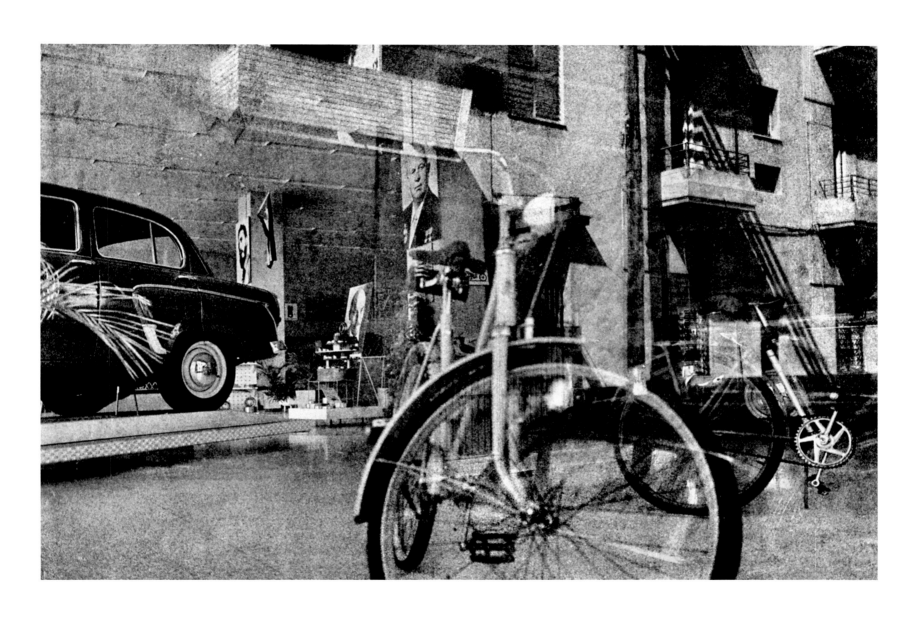

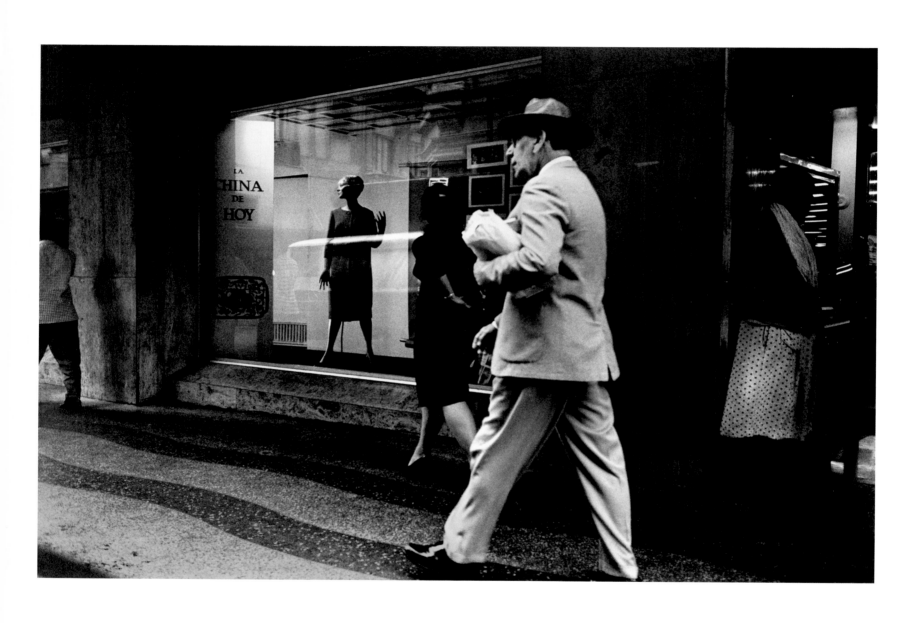

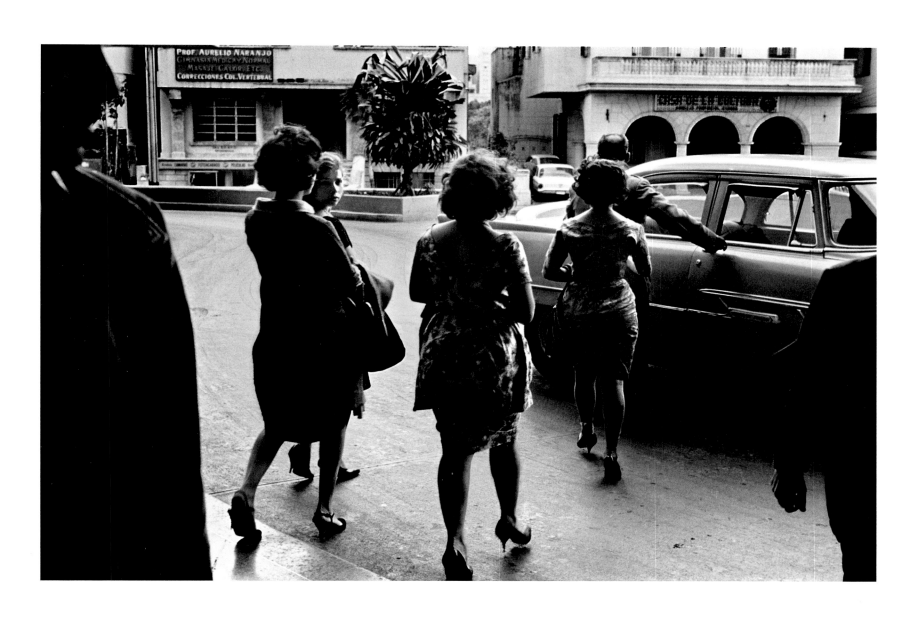

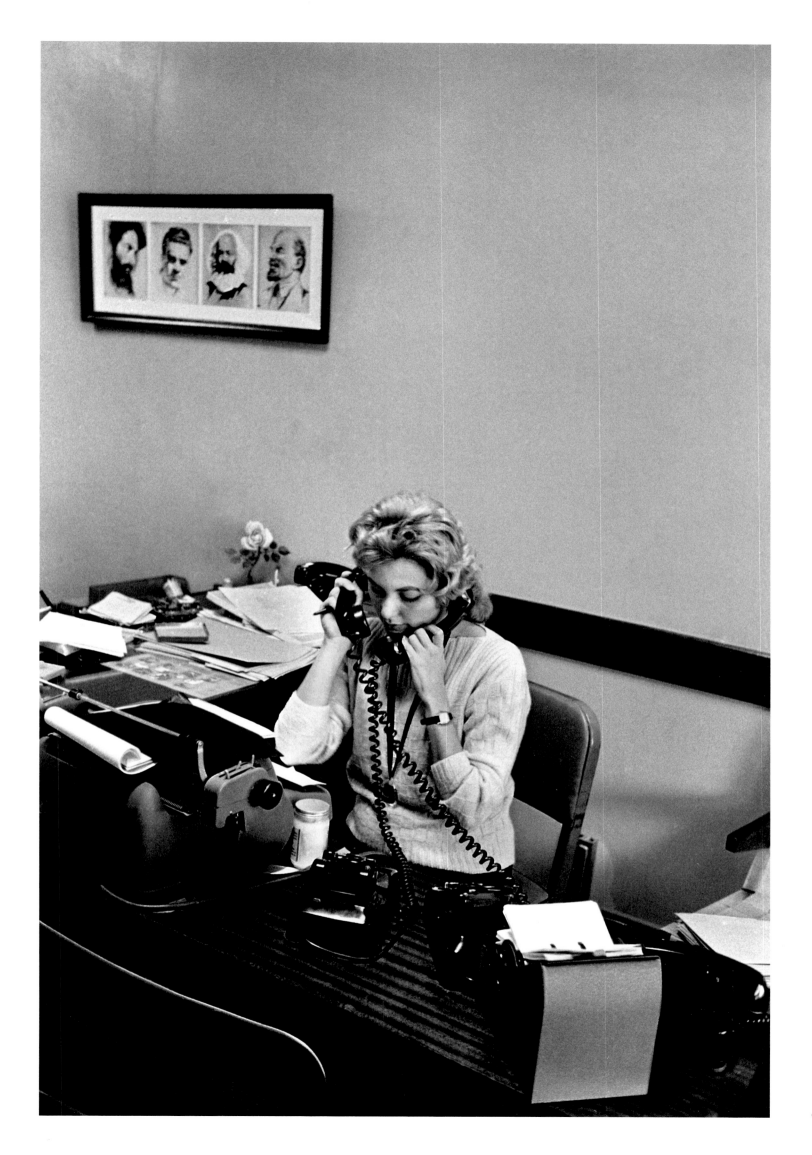

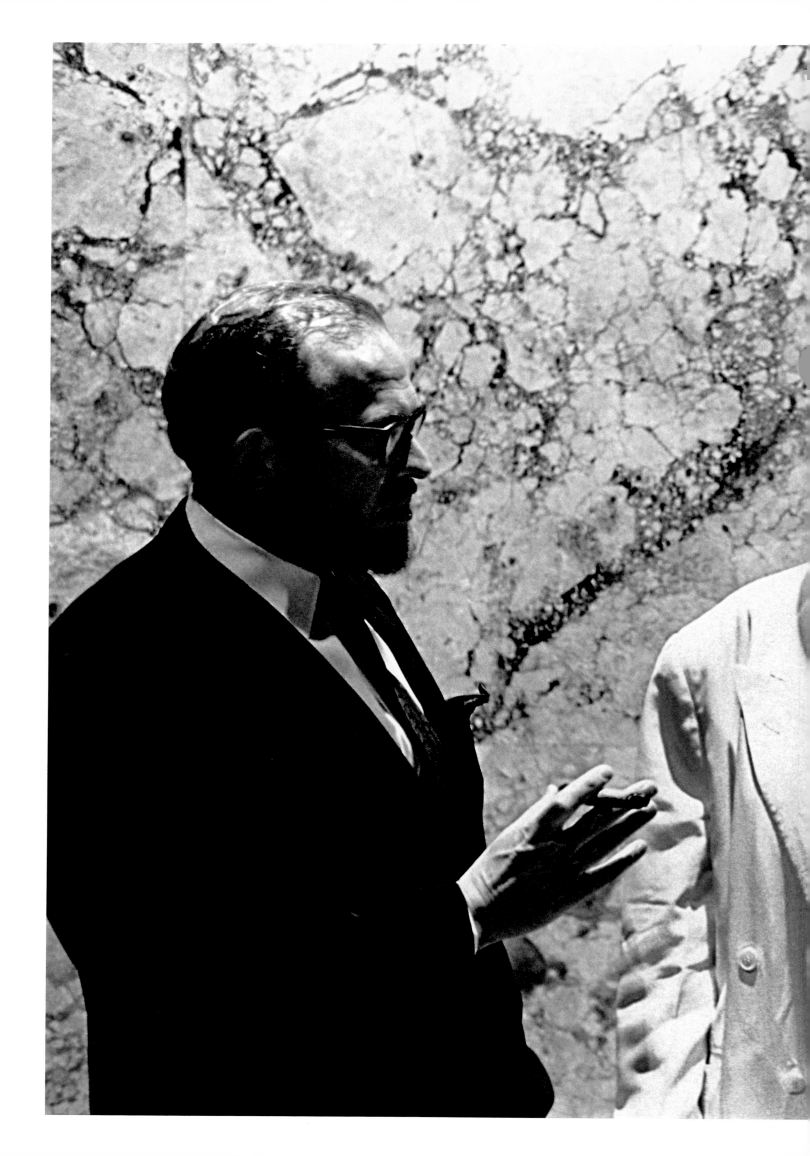

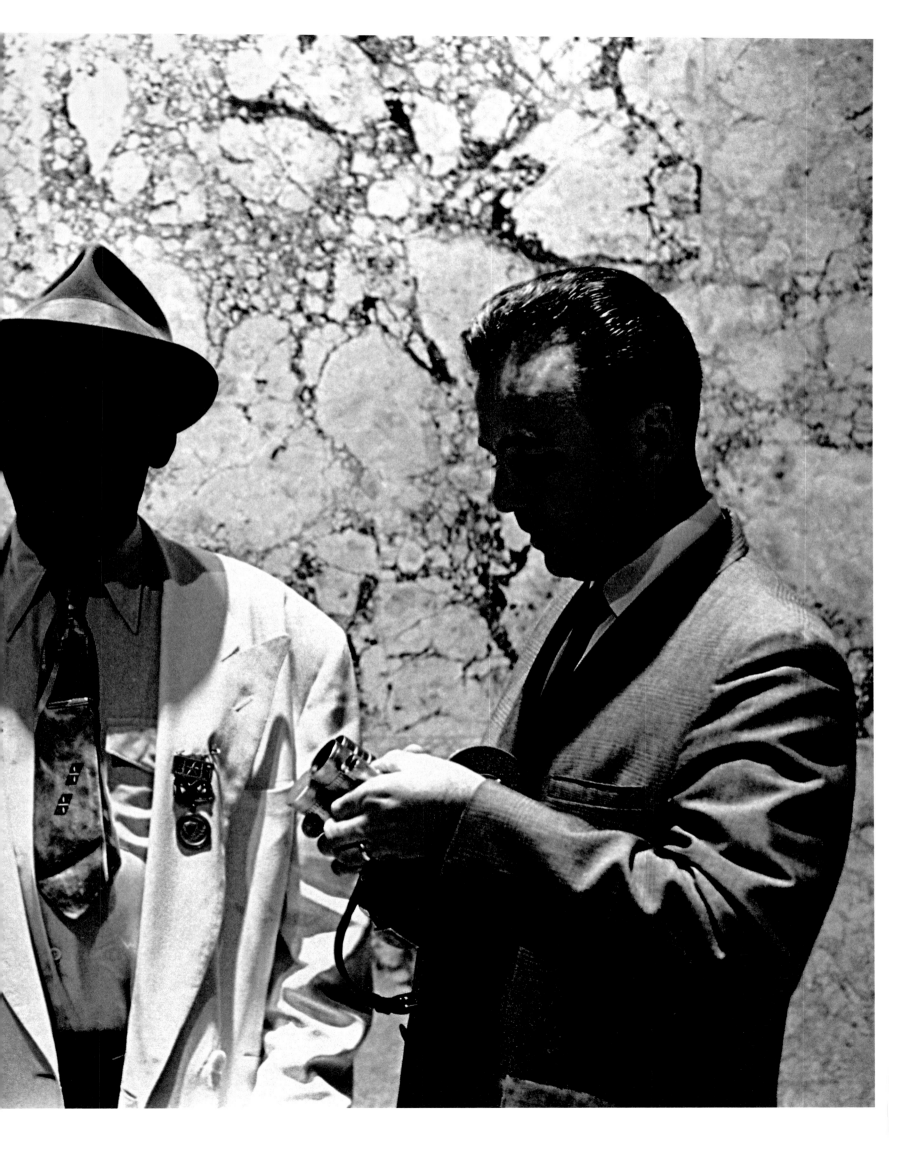

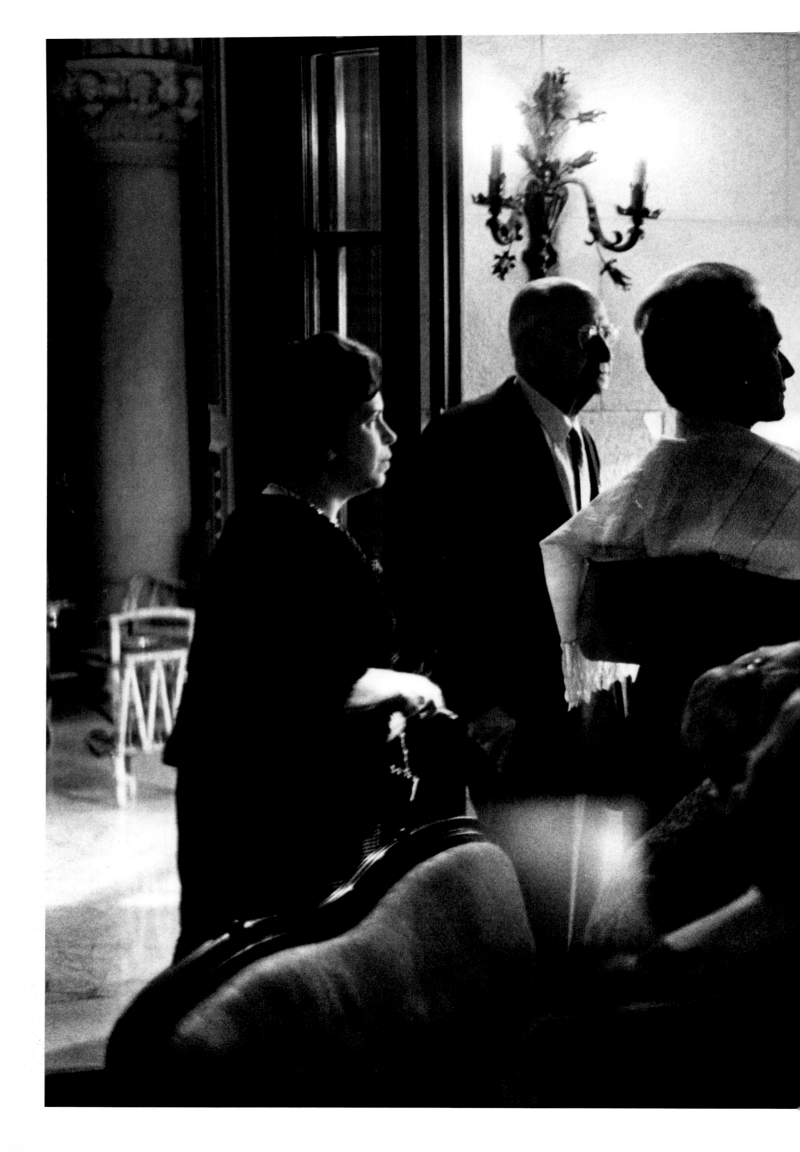

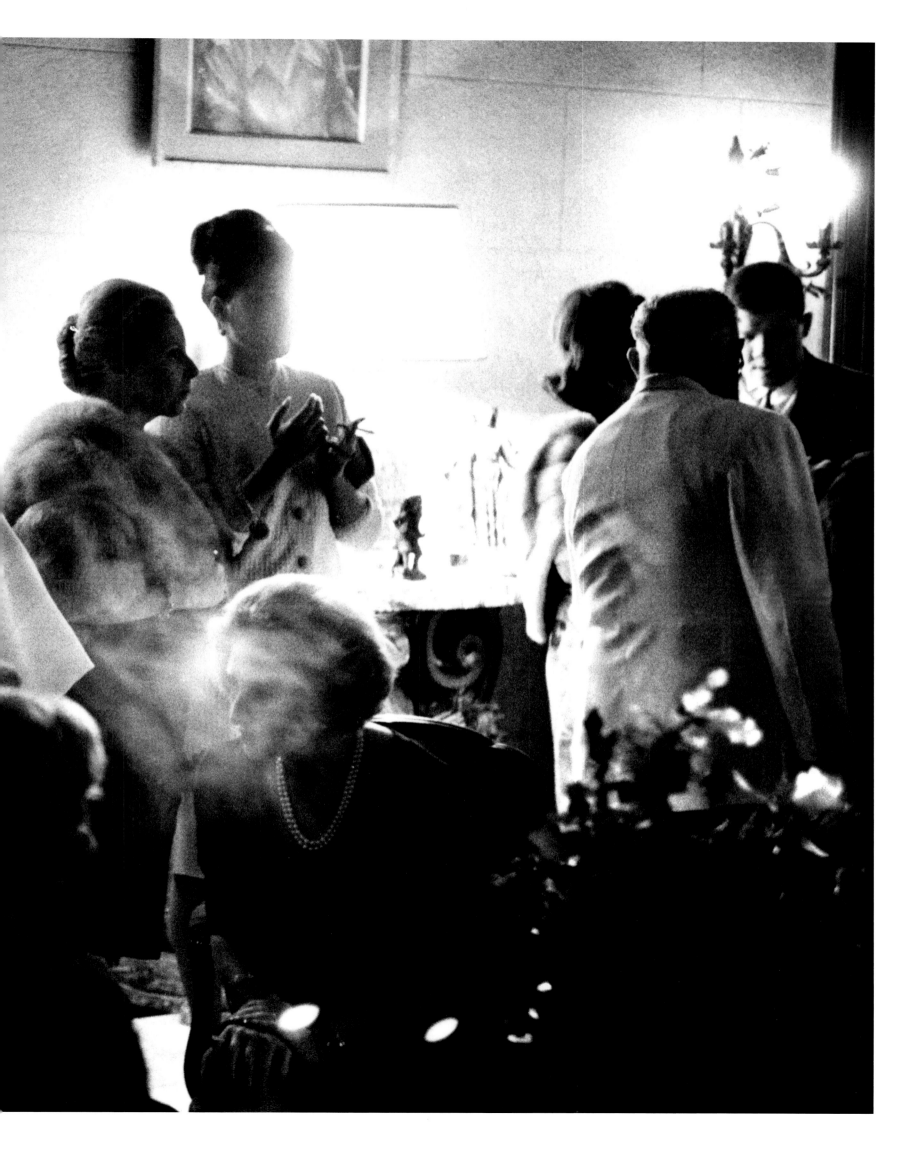

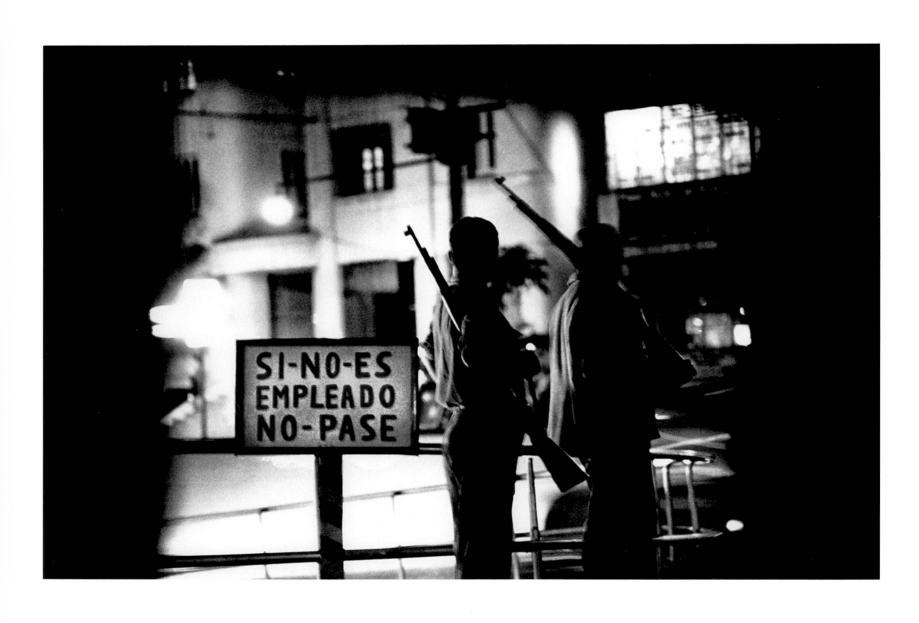

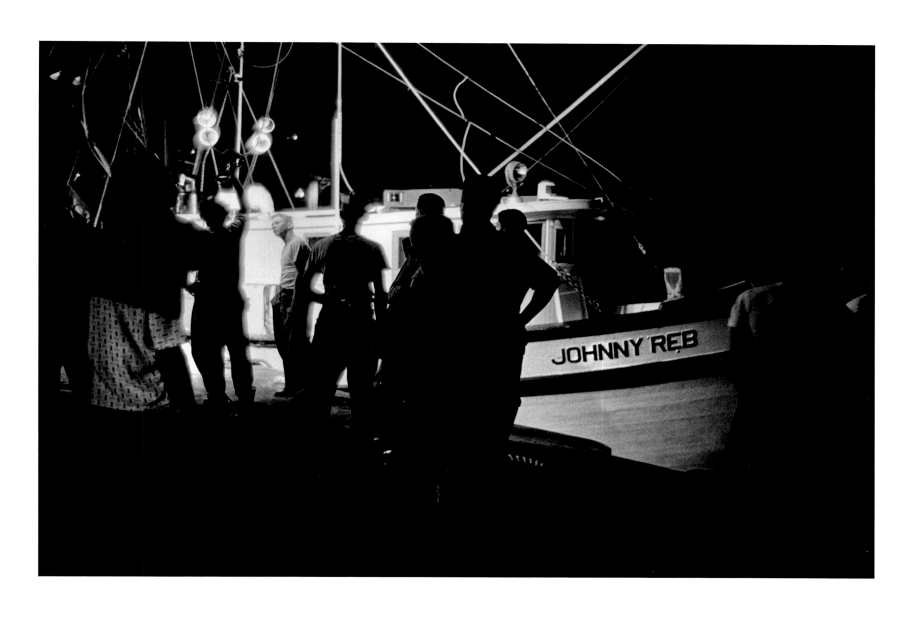

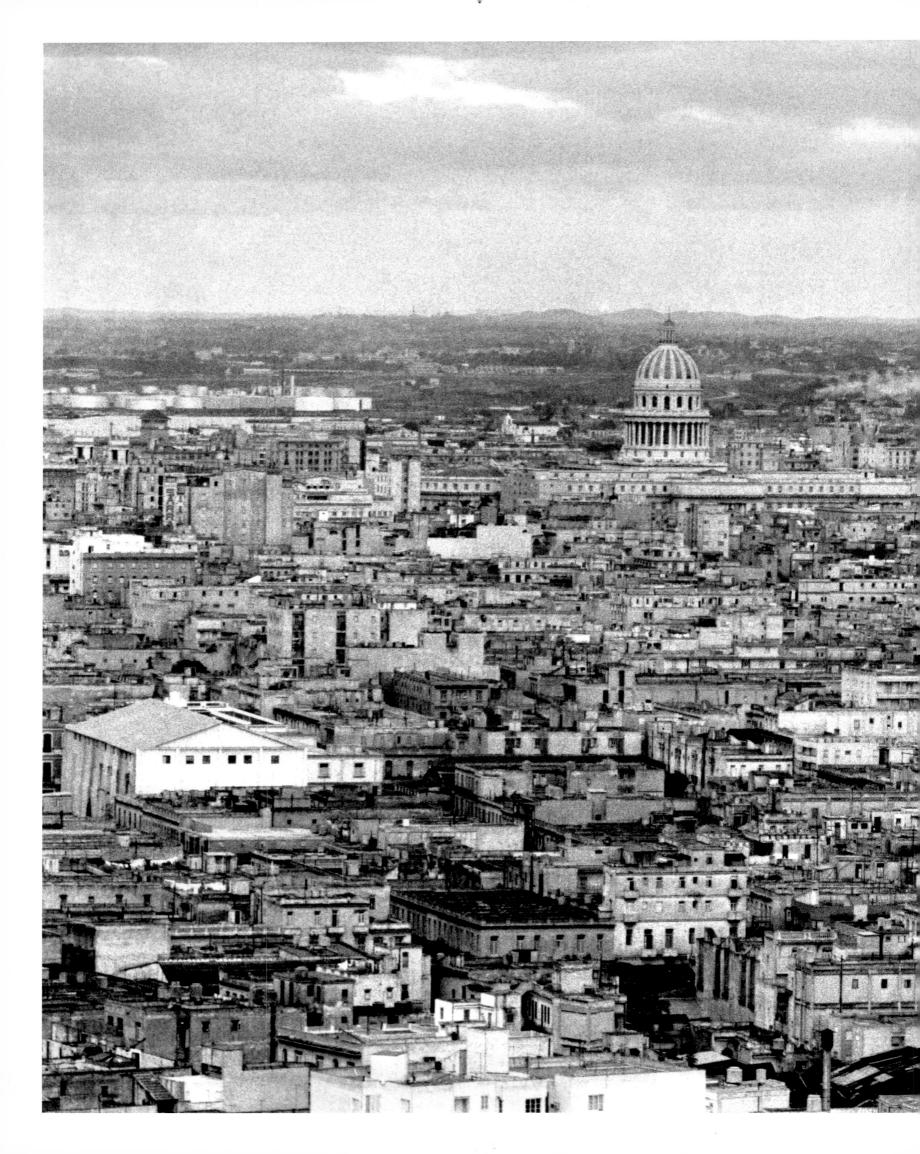

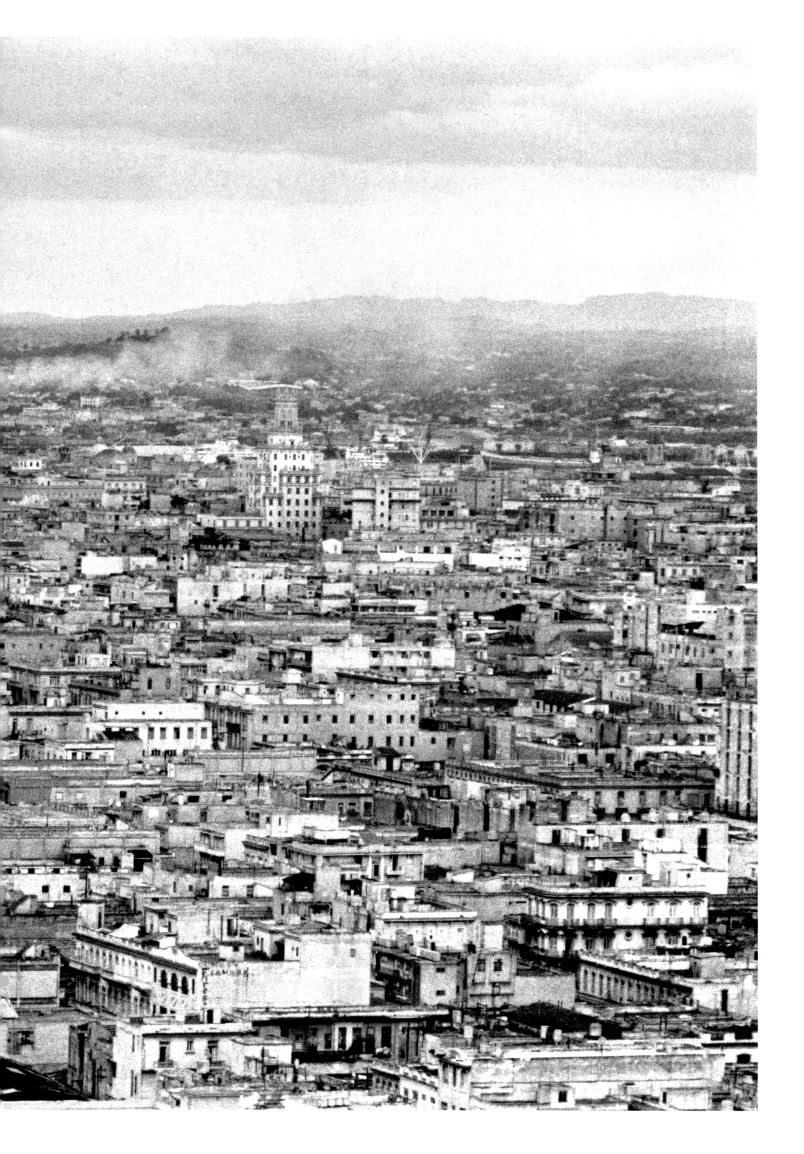

2015–16

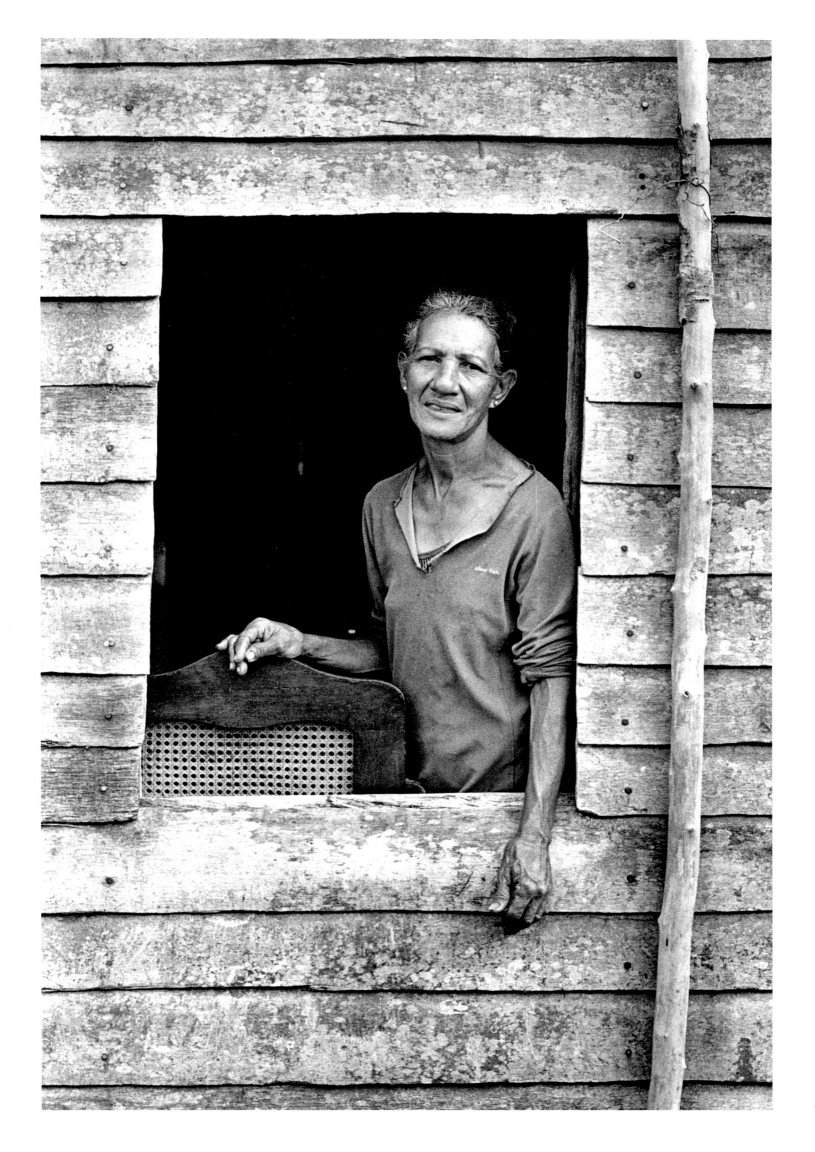

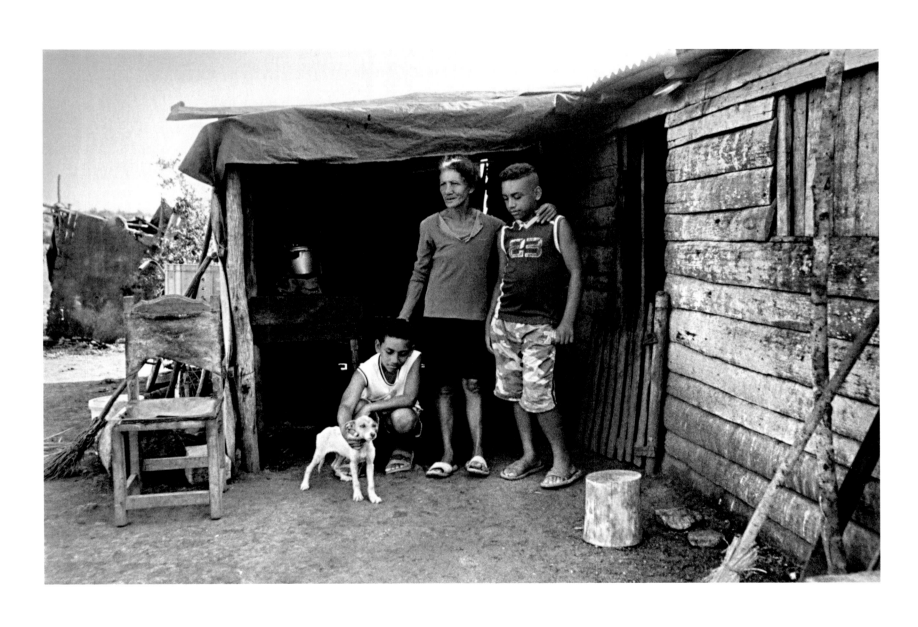

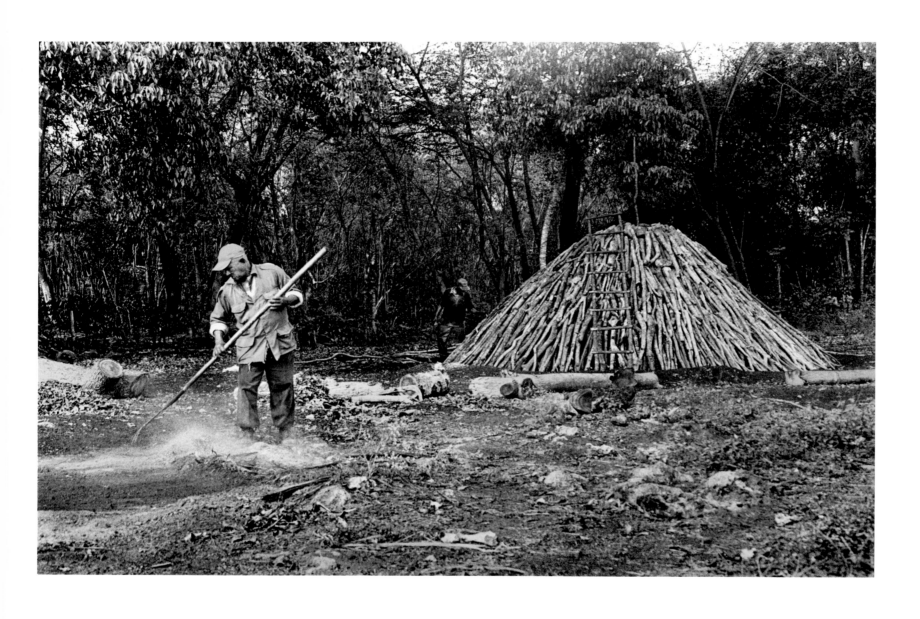

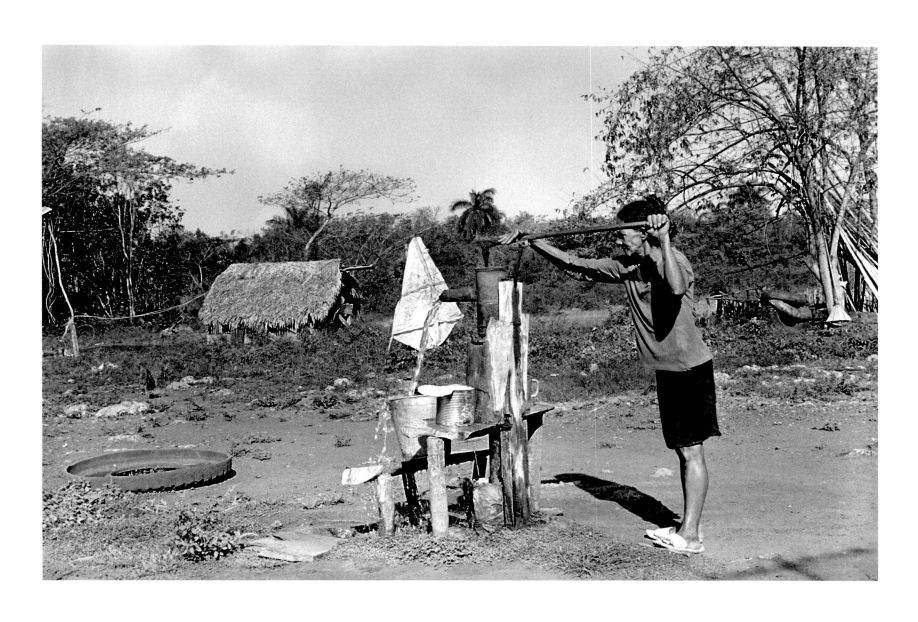

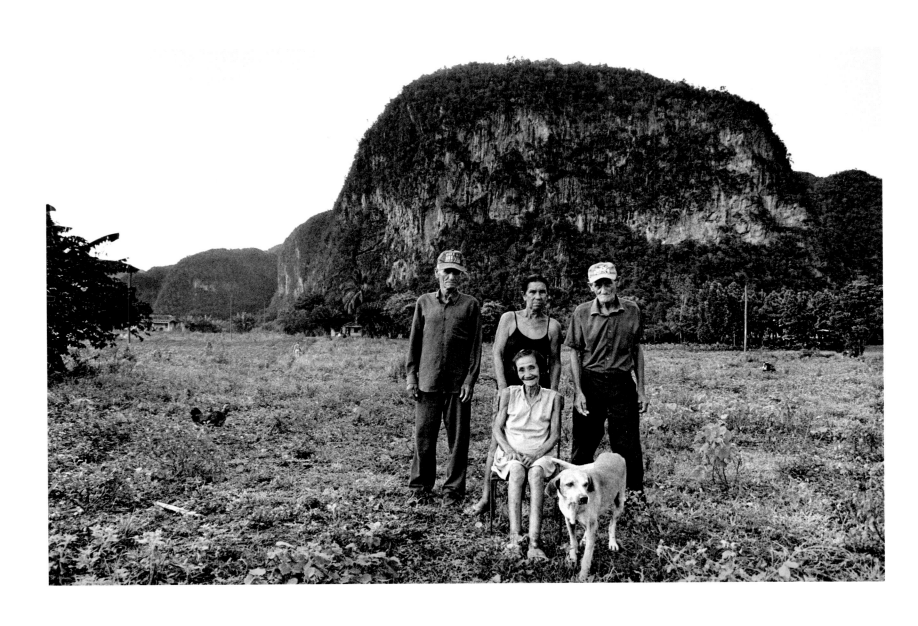

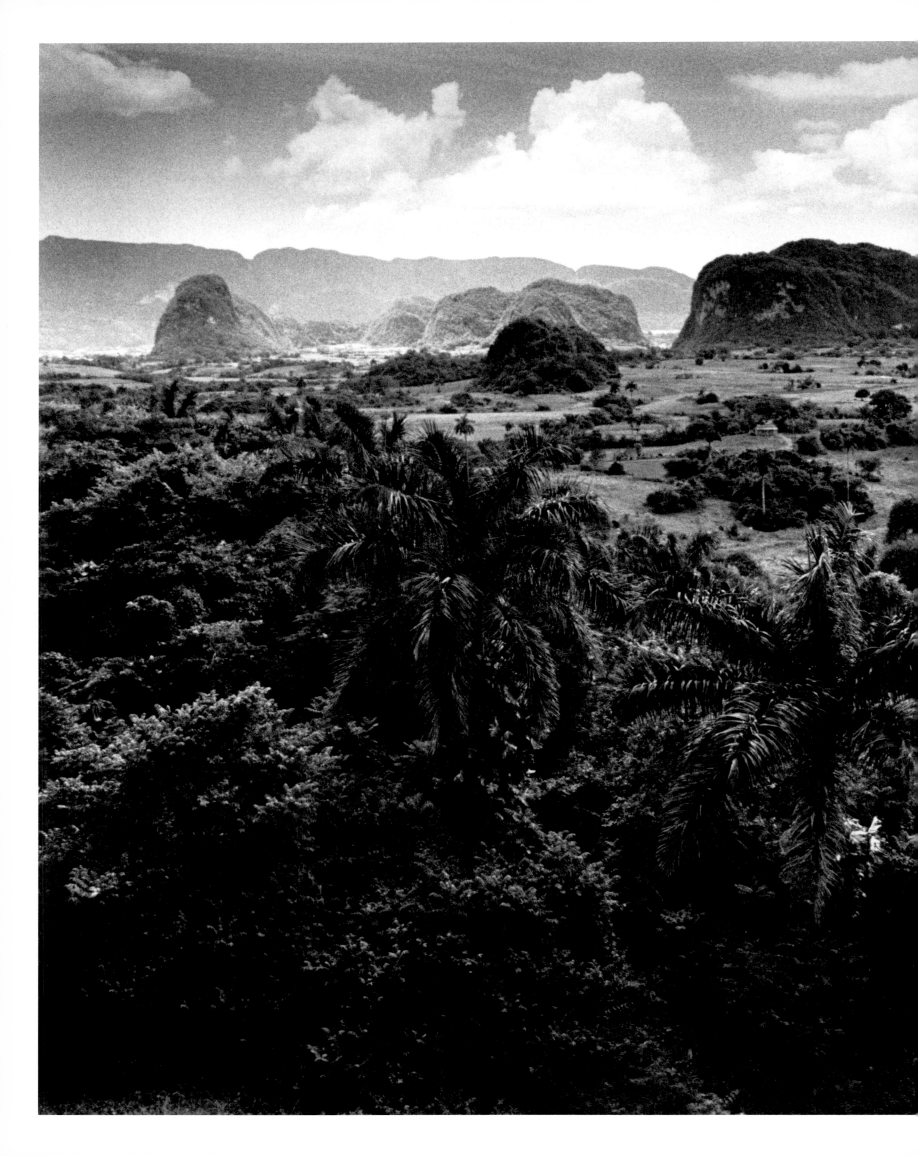

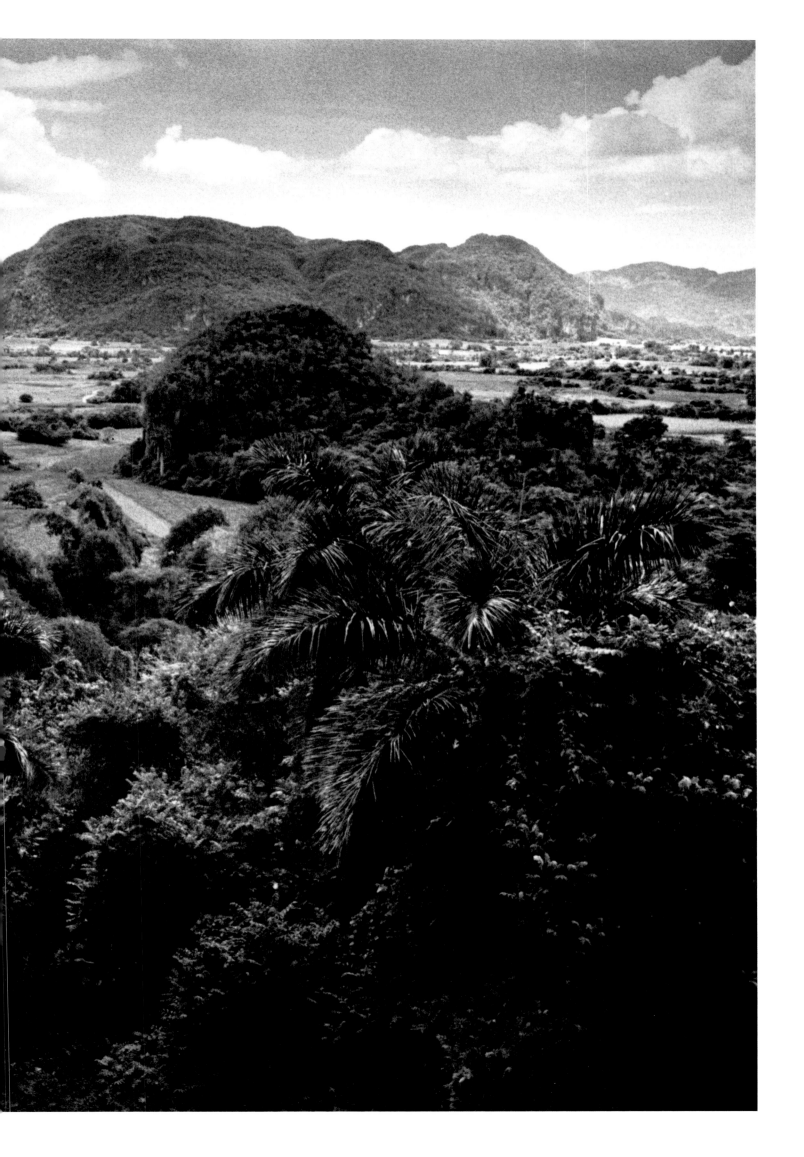

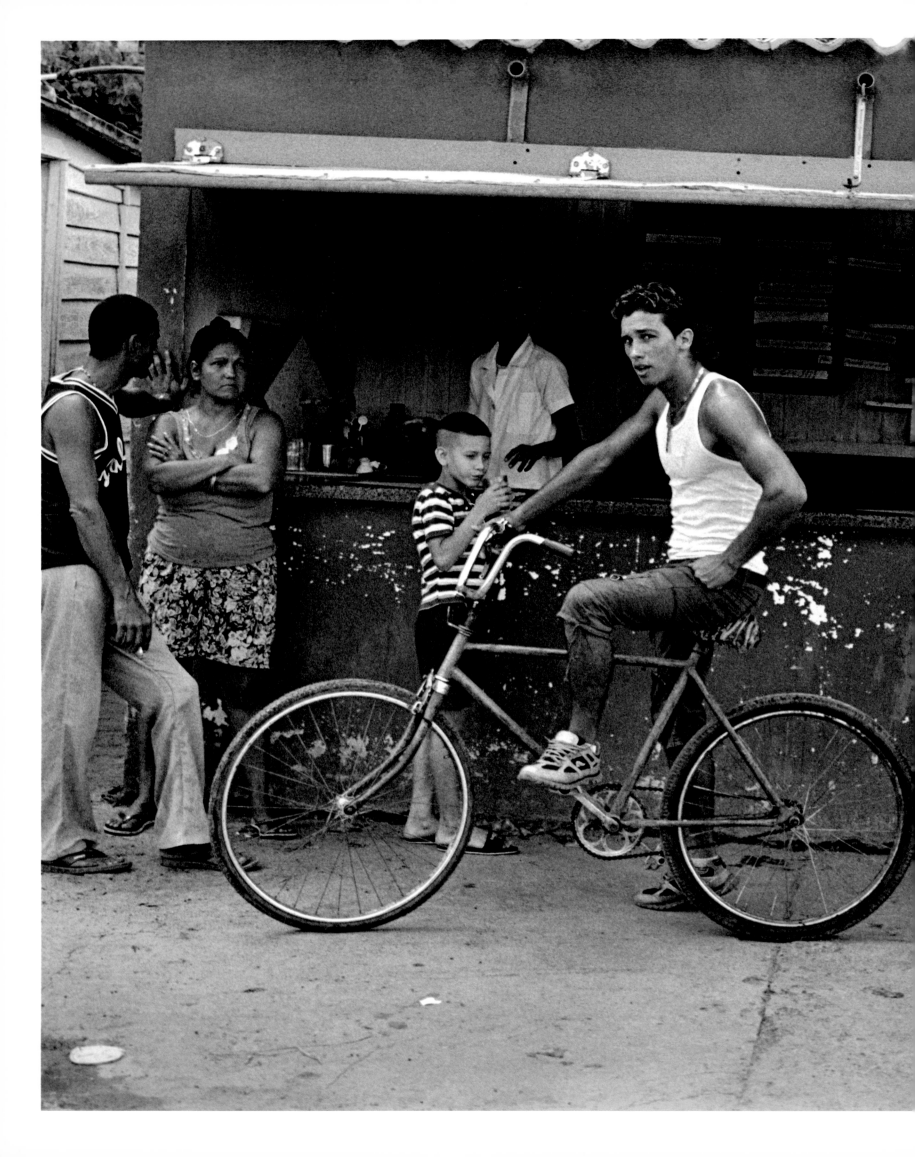

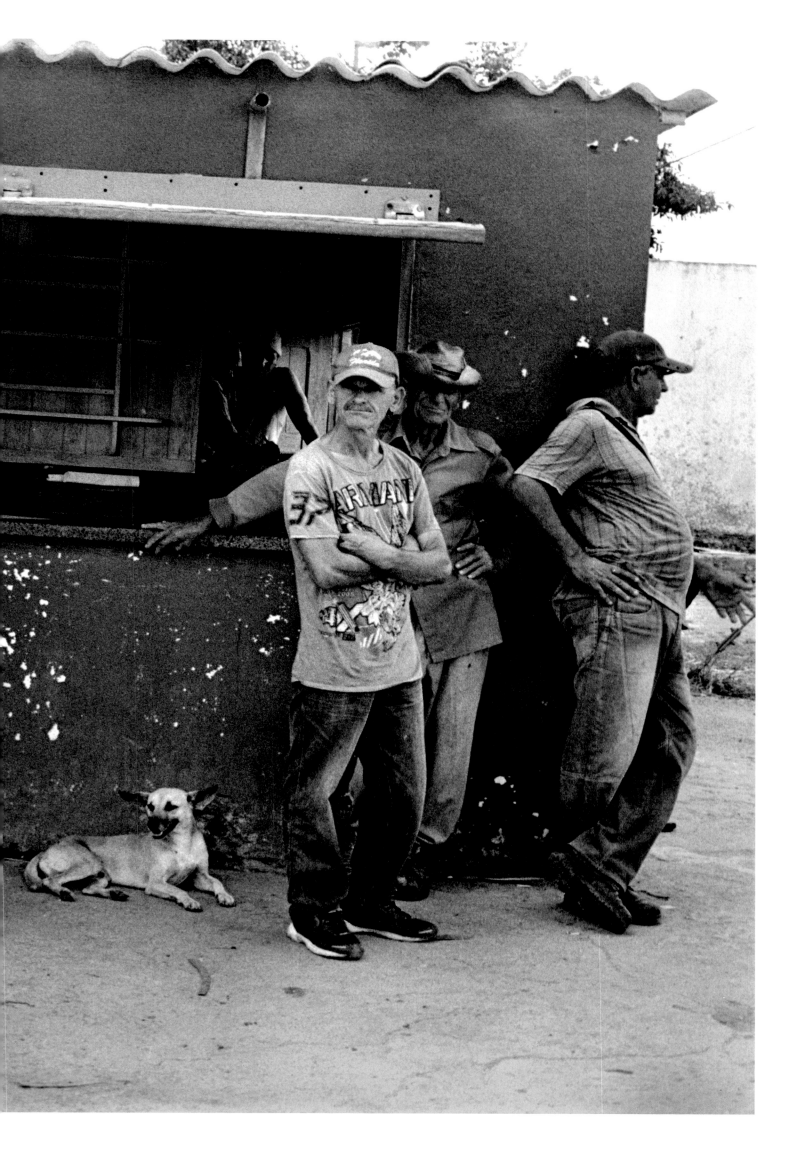

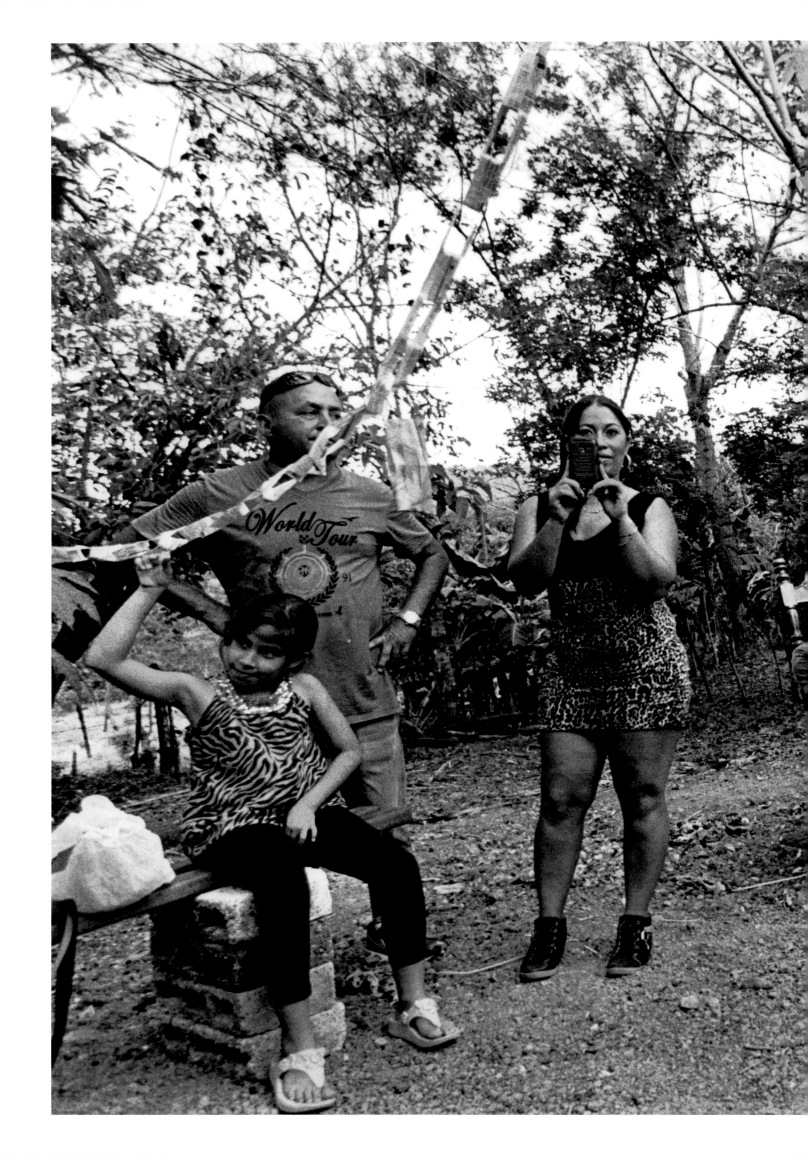

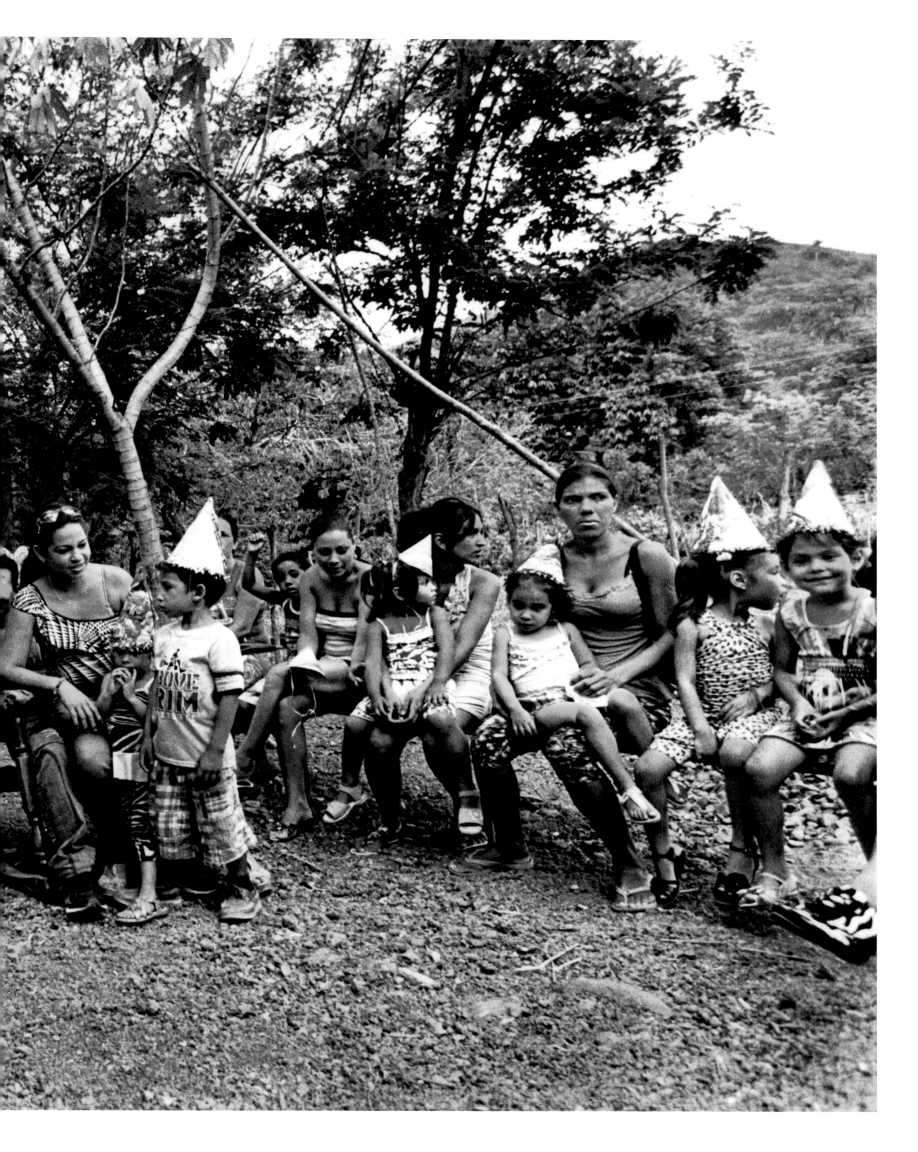

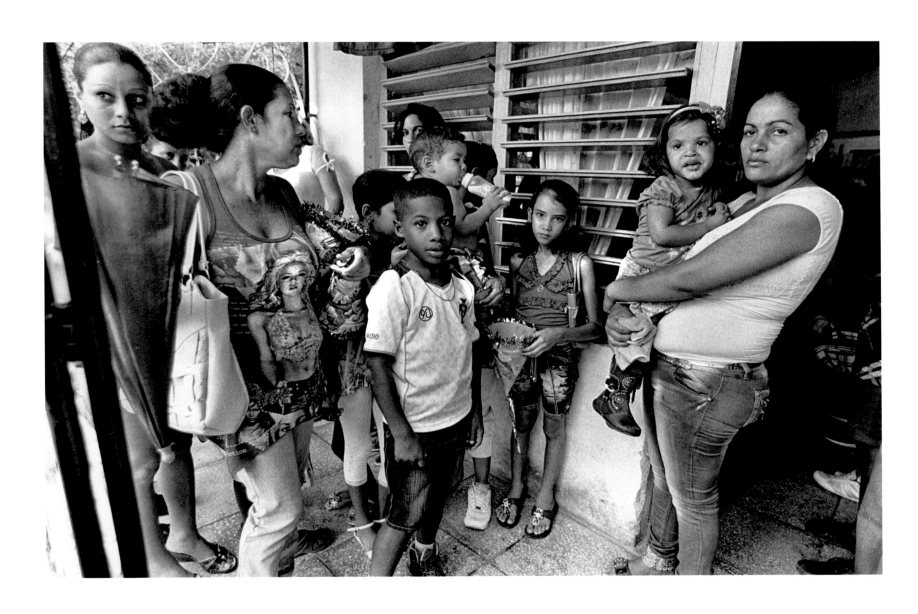

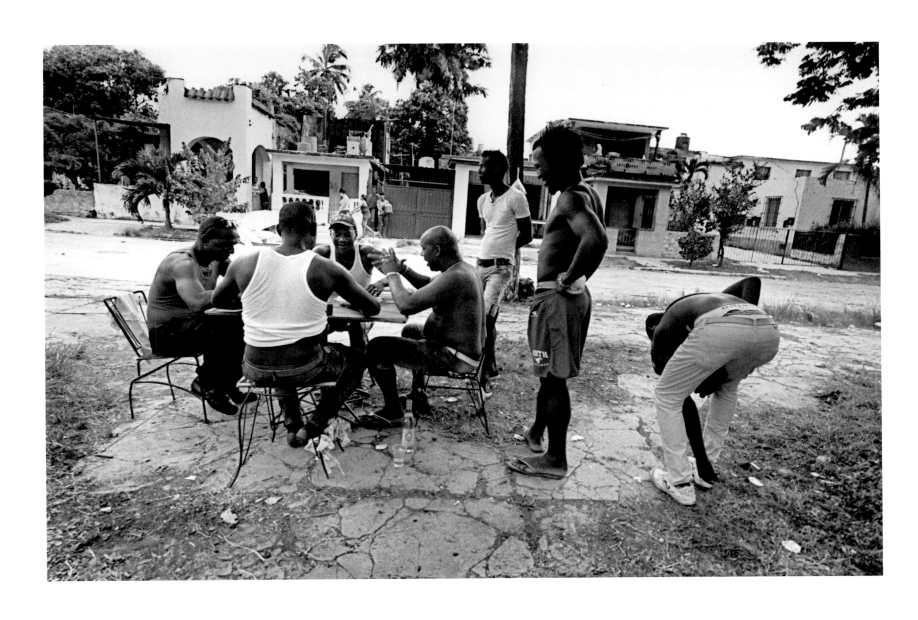

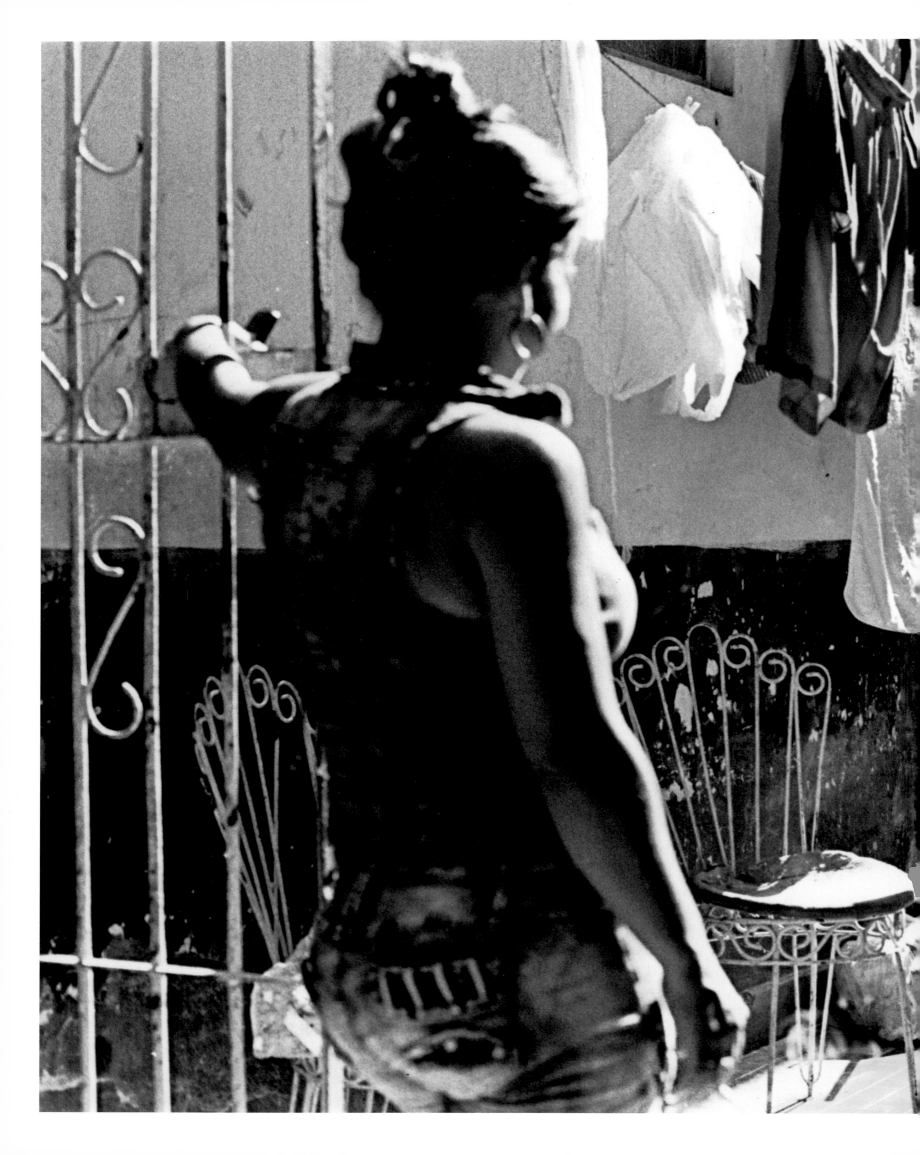

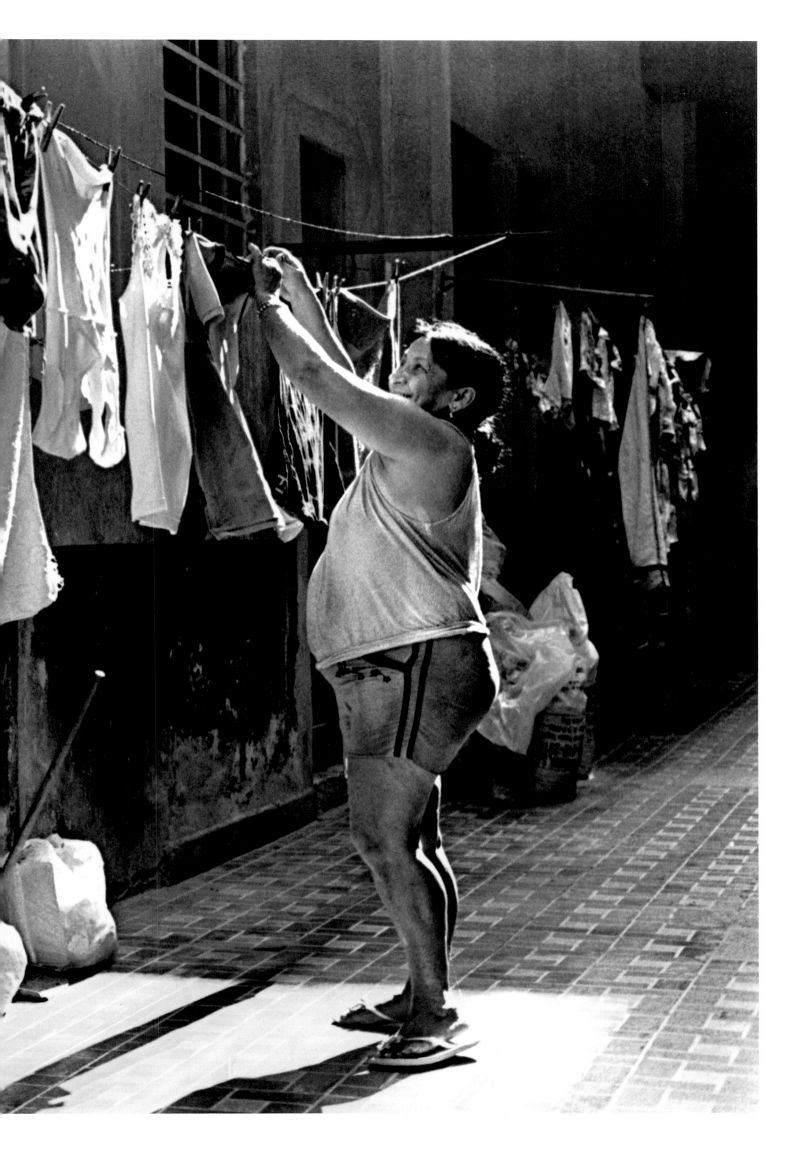

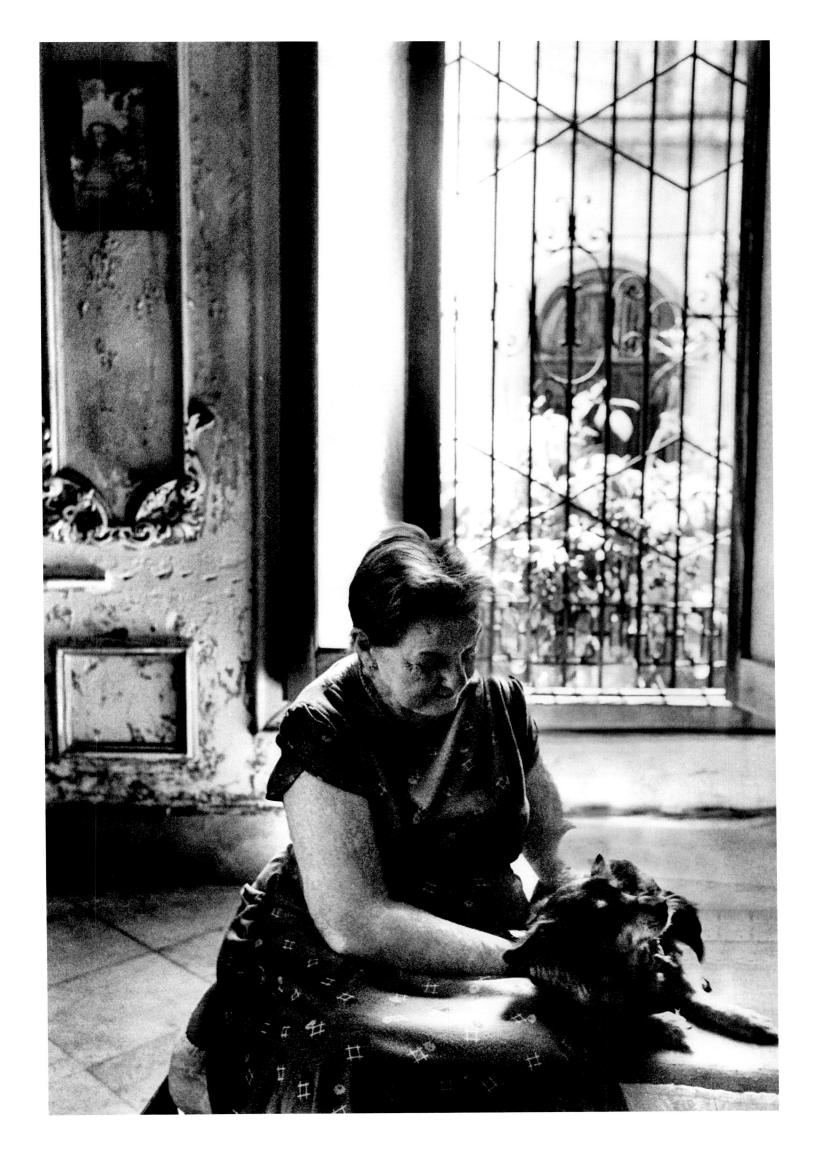

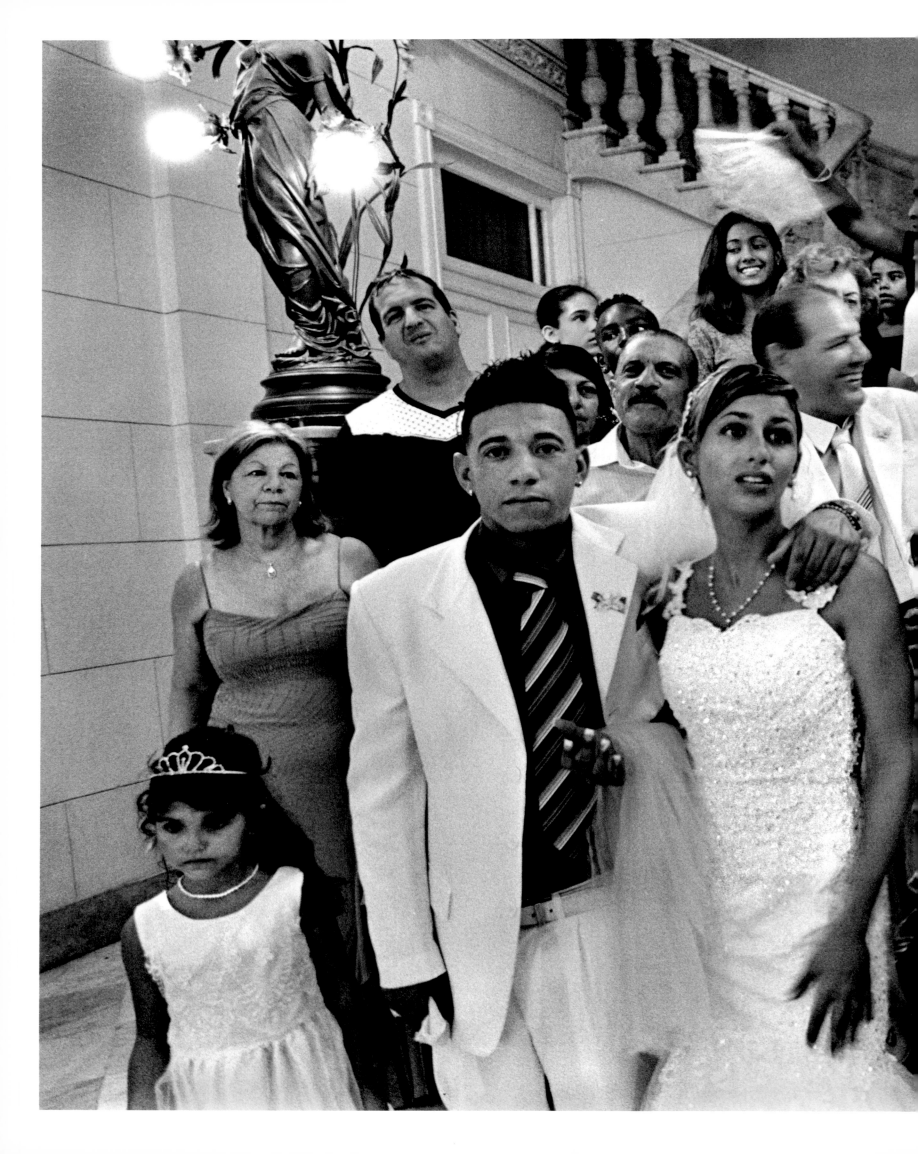

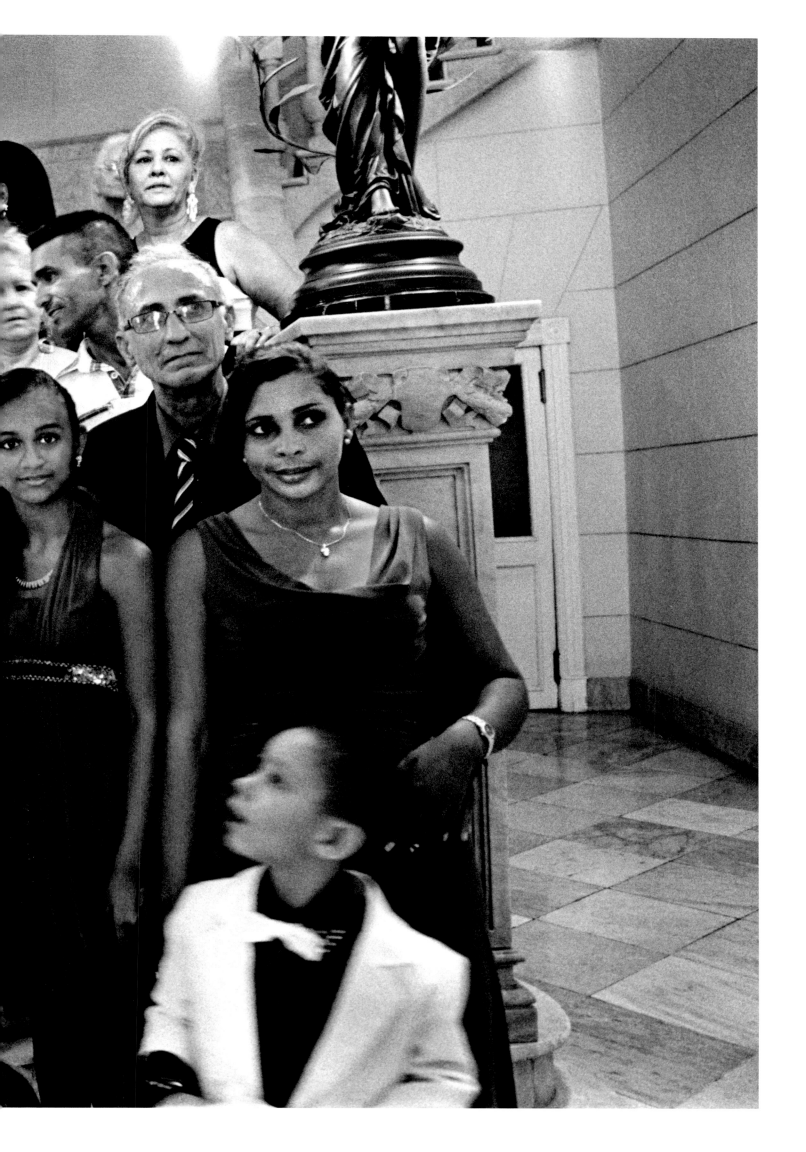

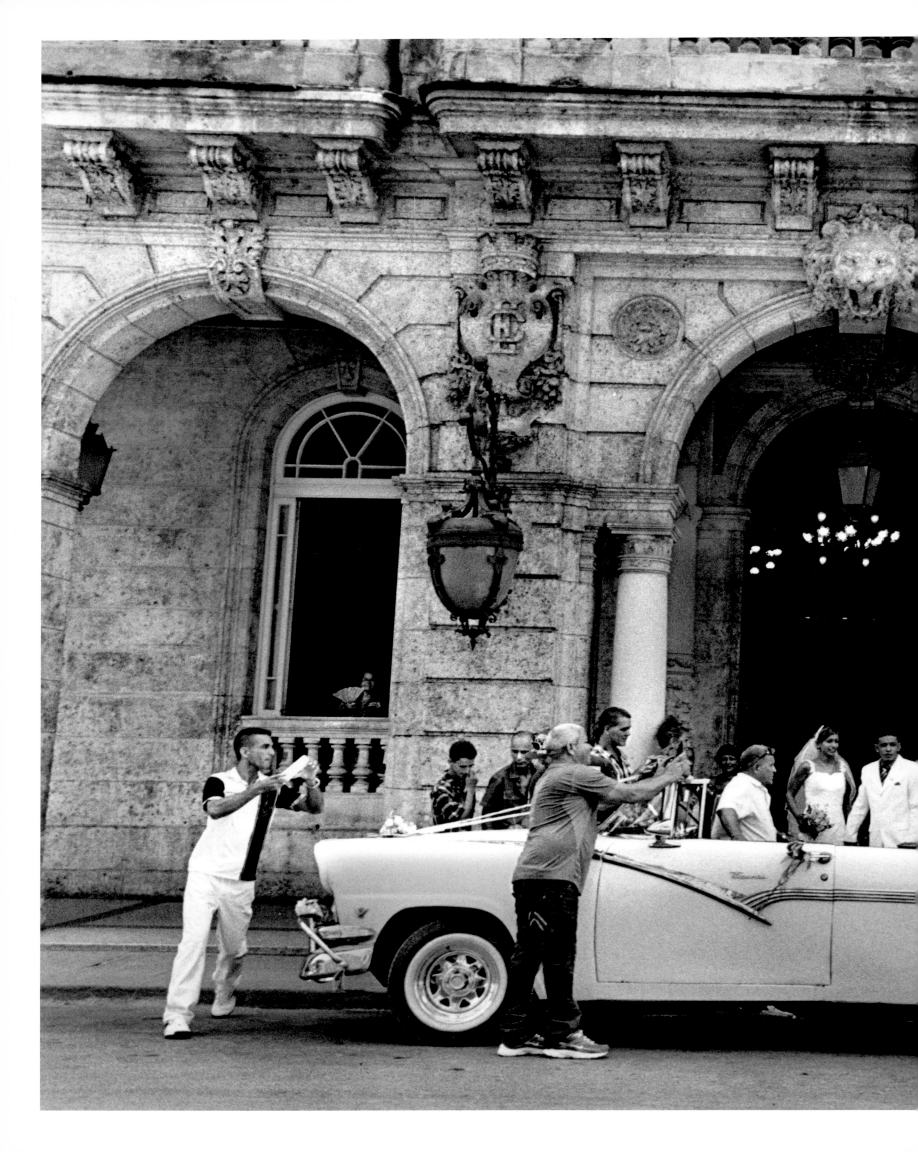

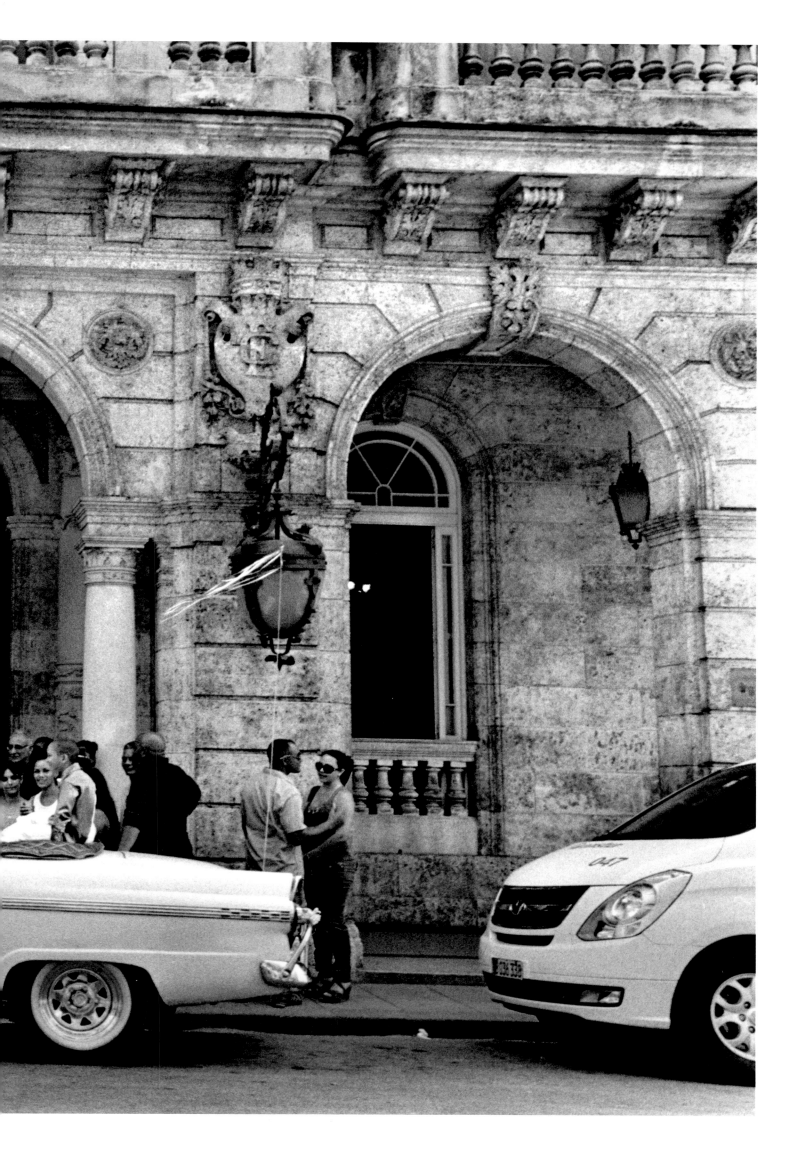

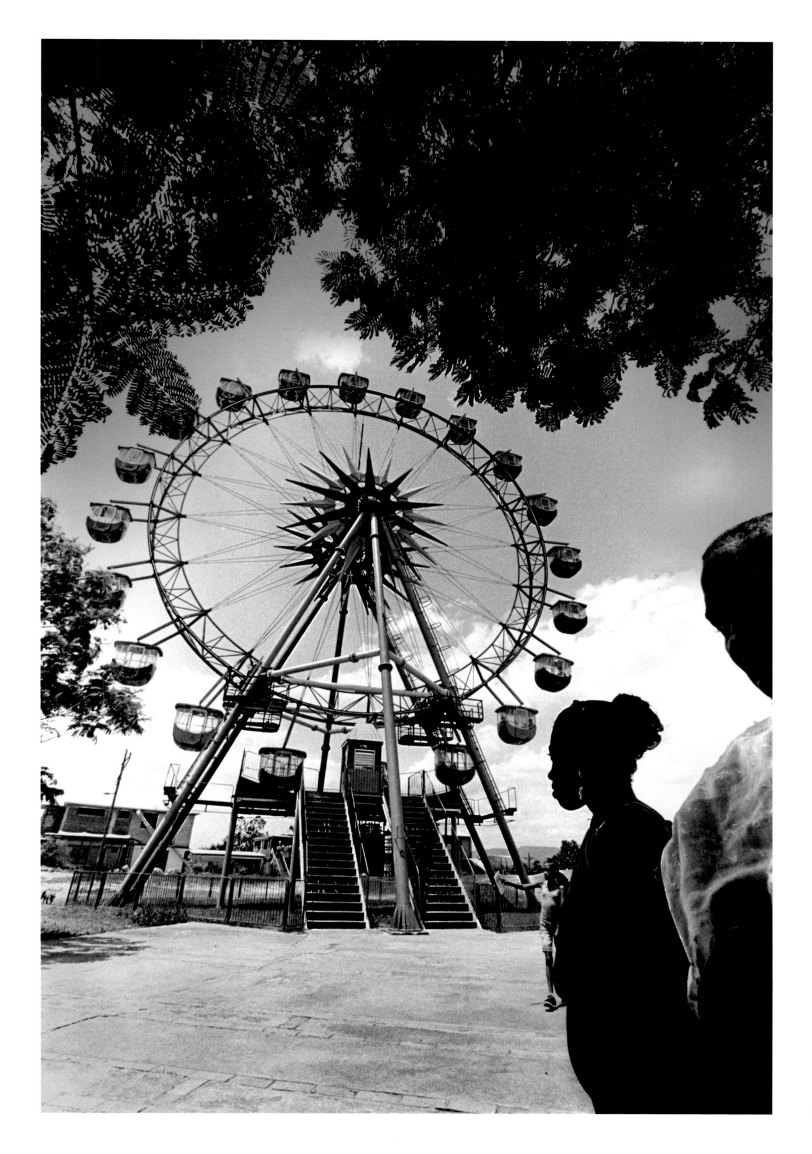

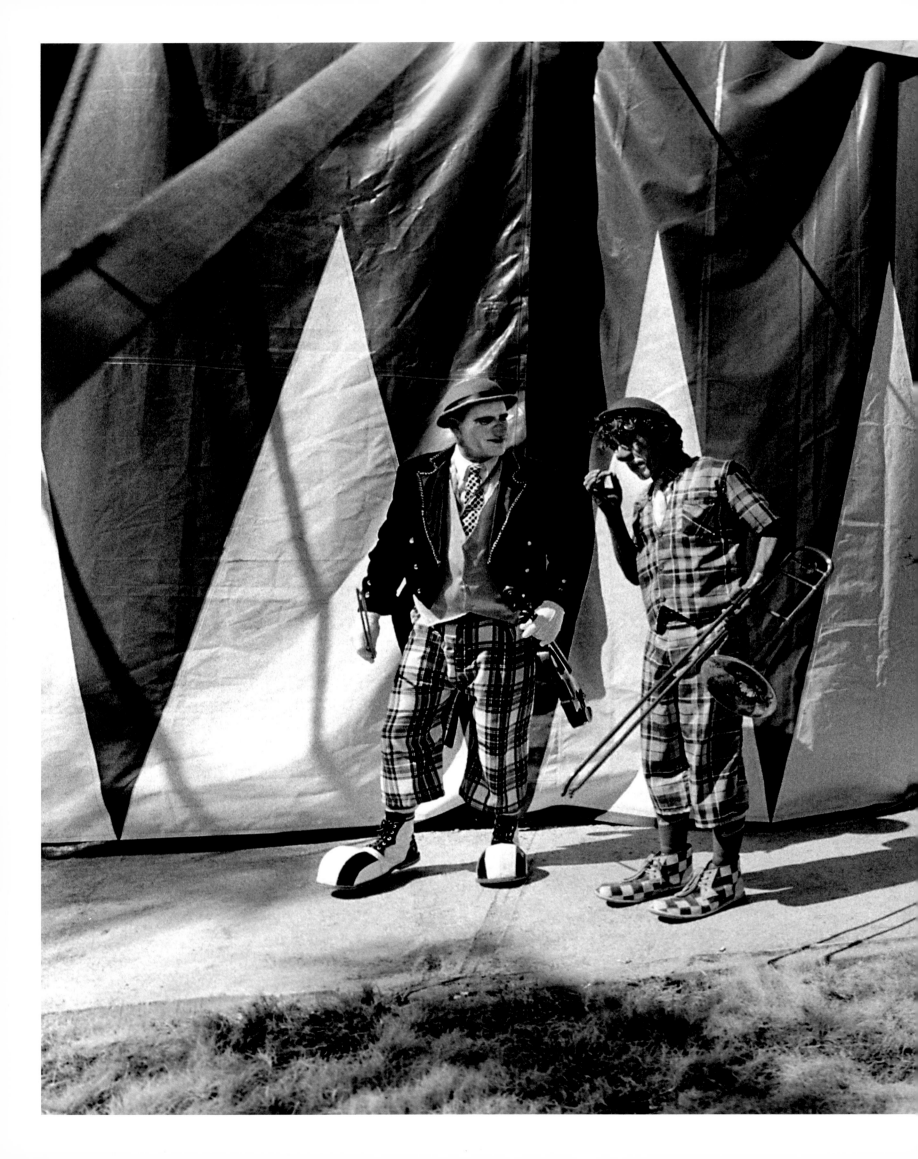

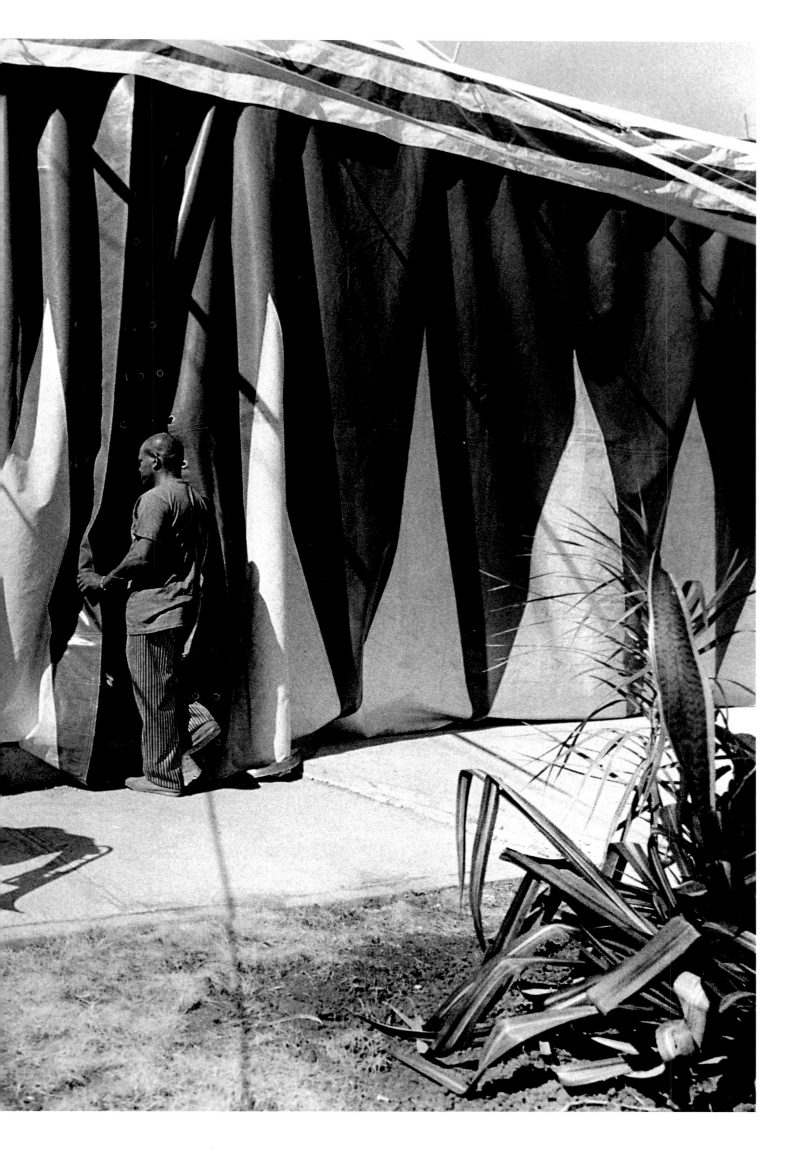

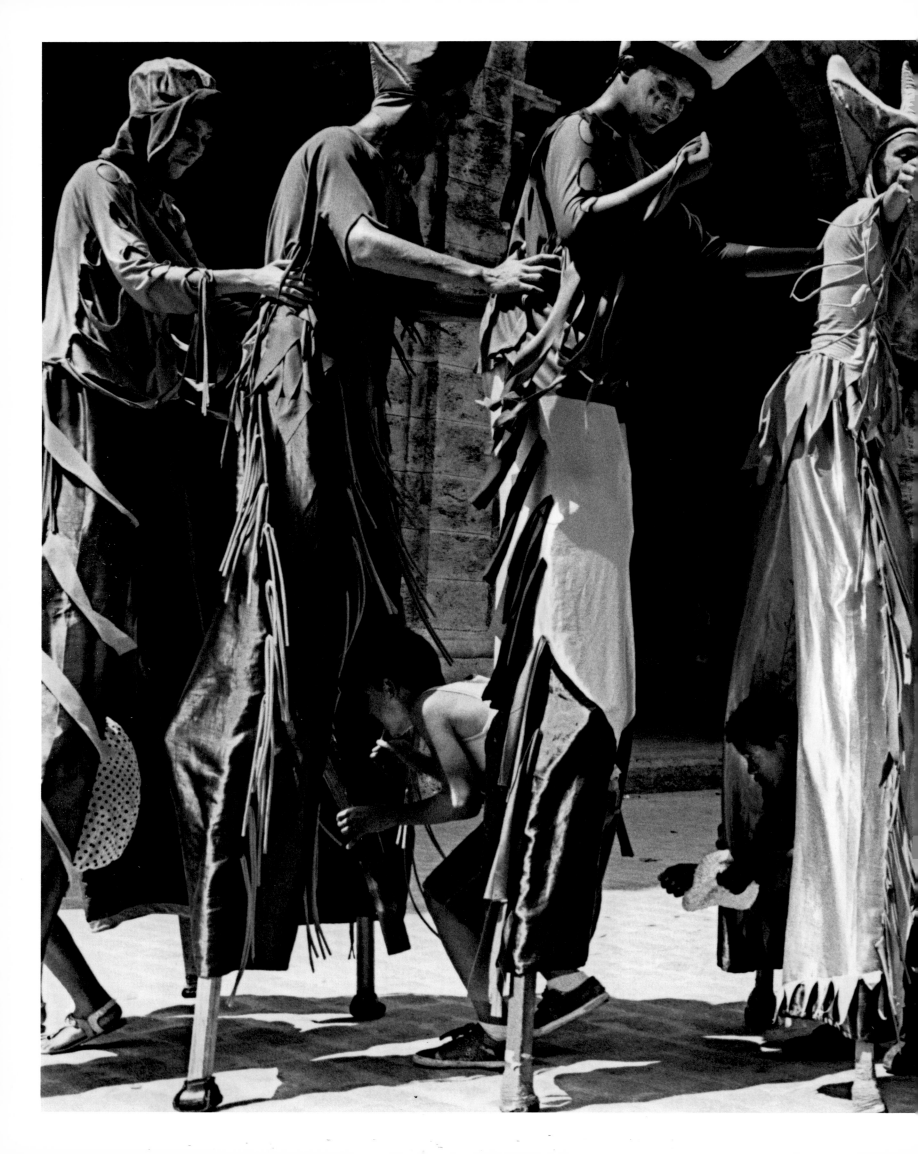

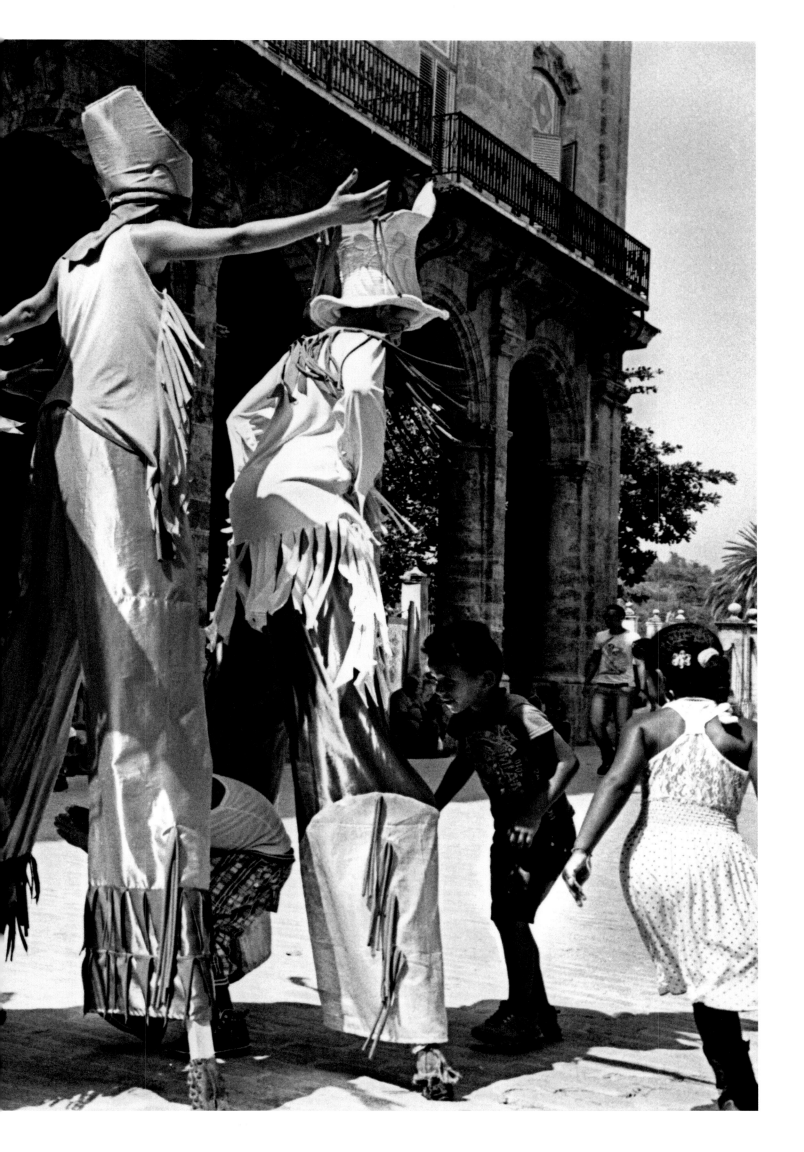

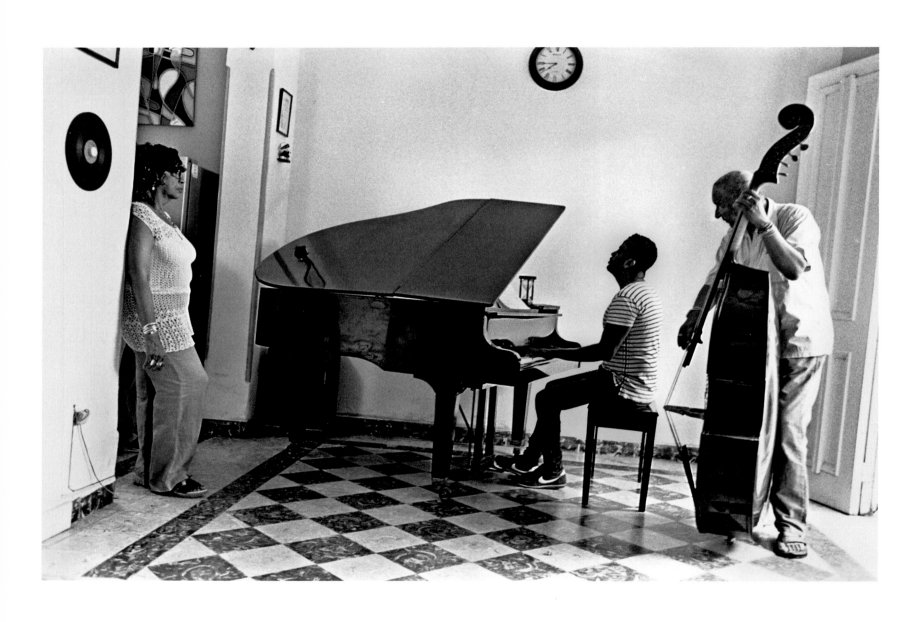

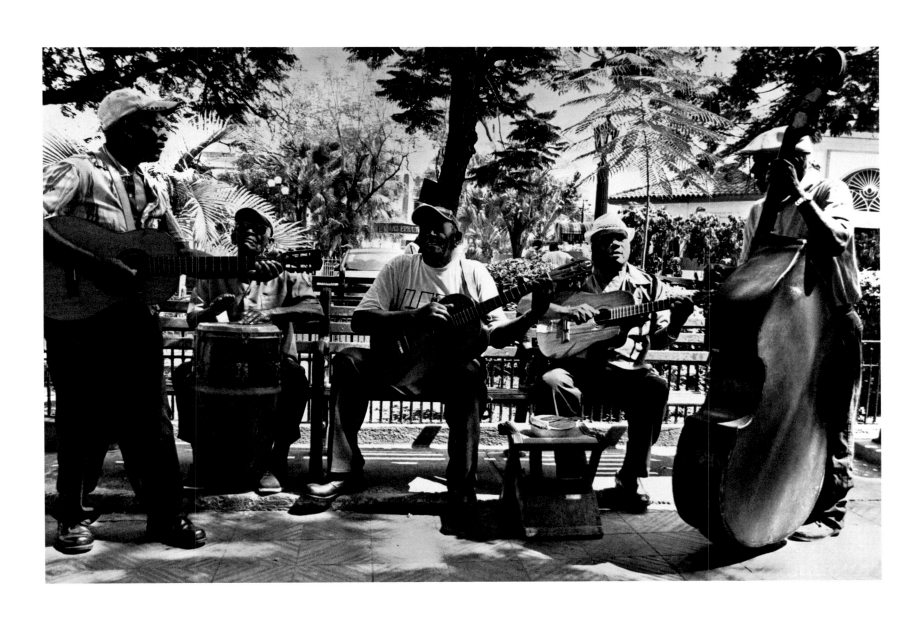

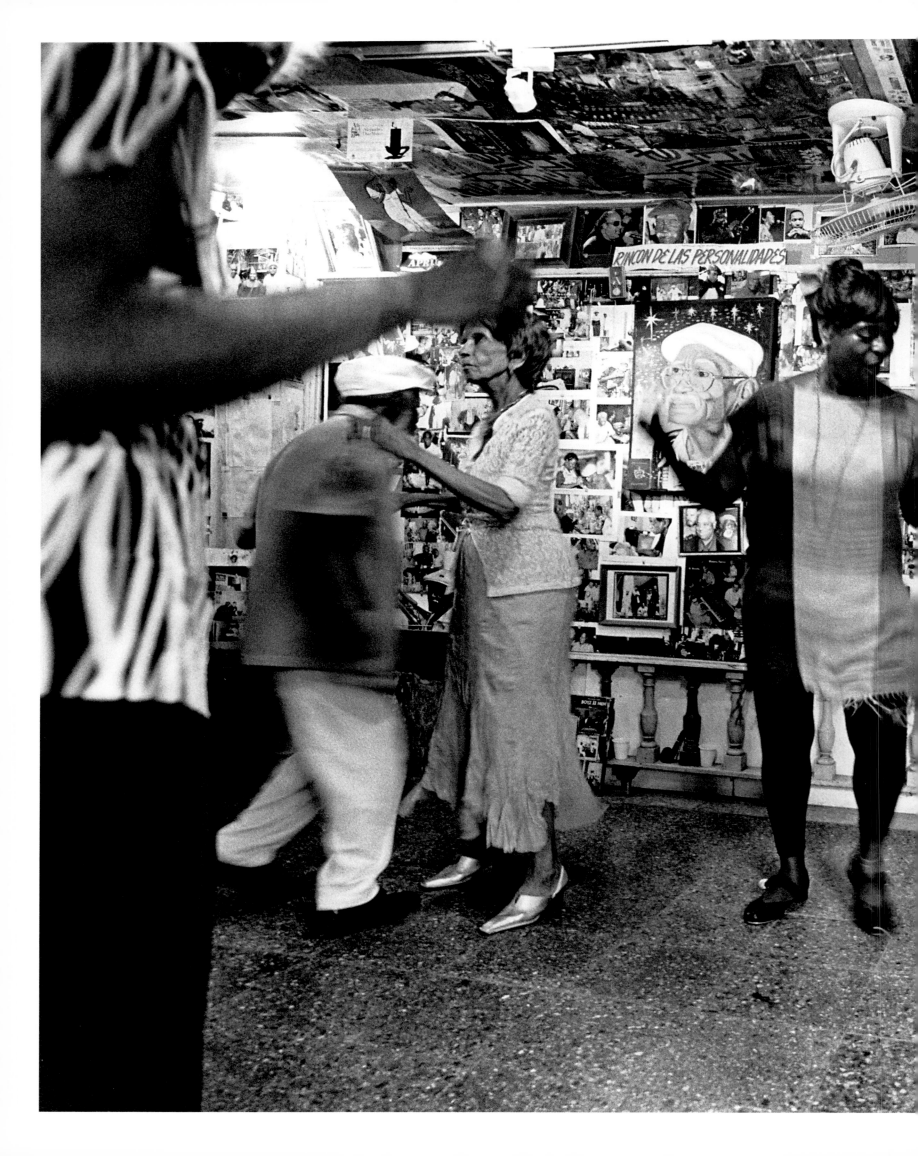

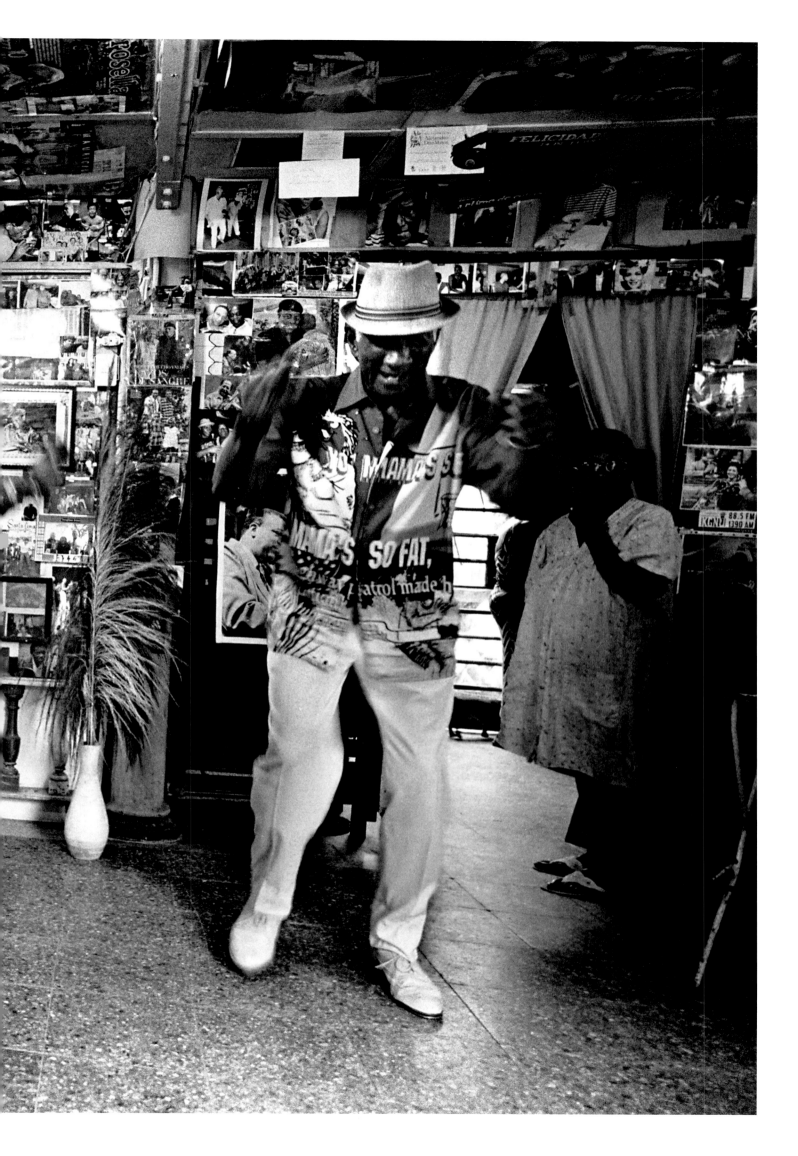

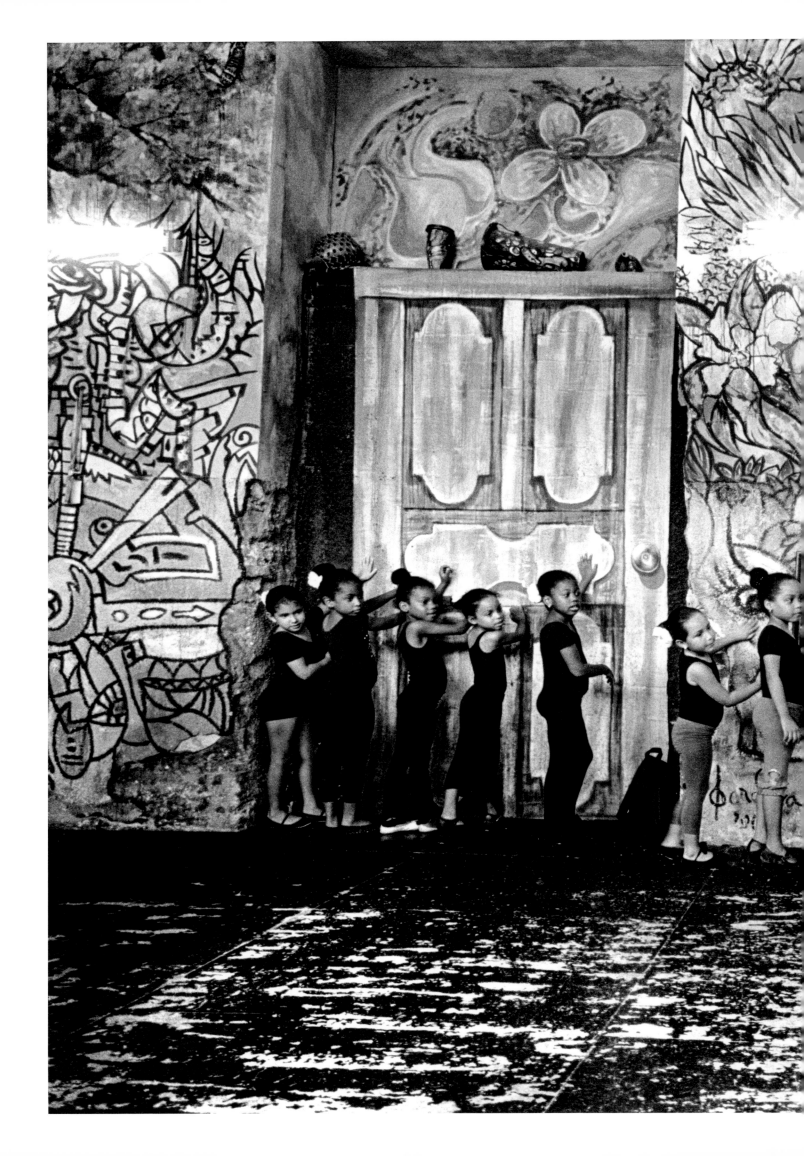

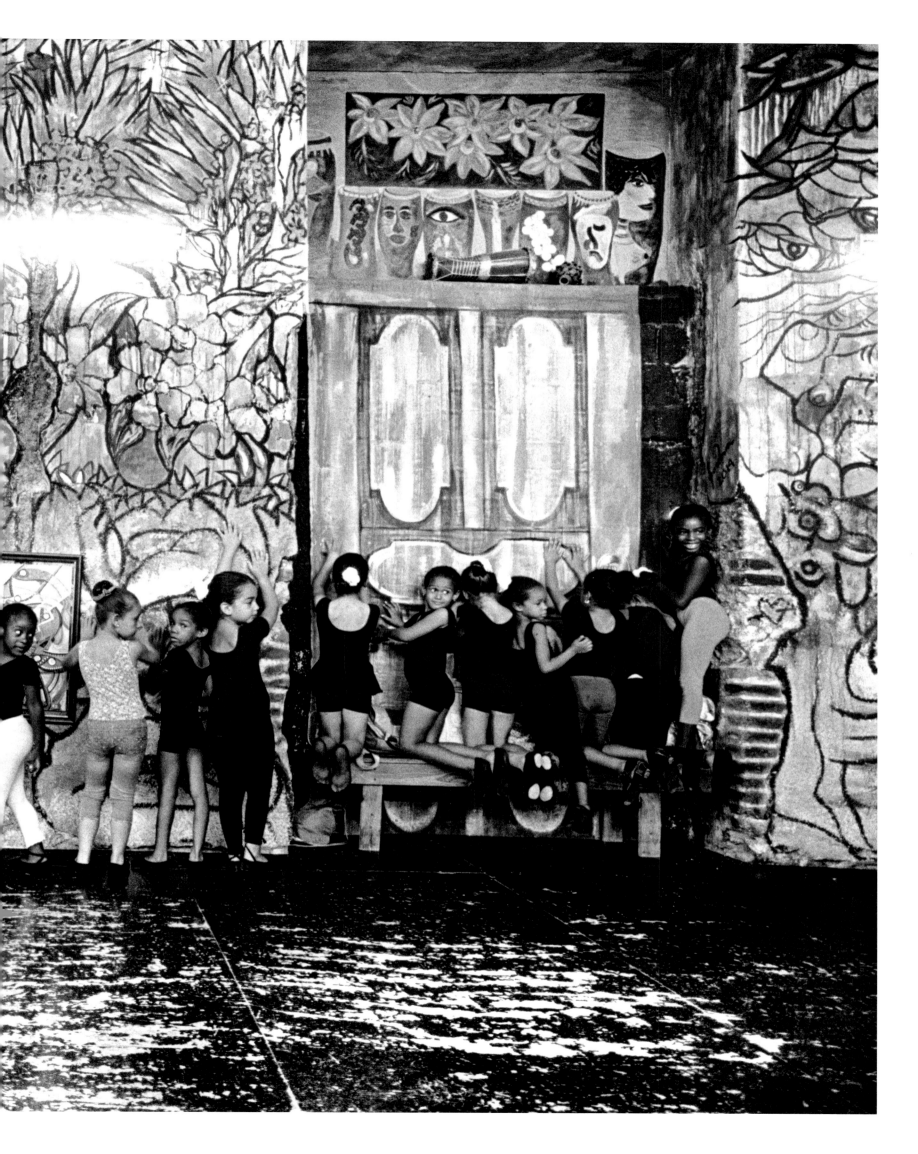

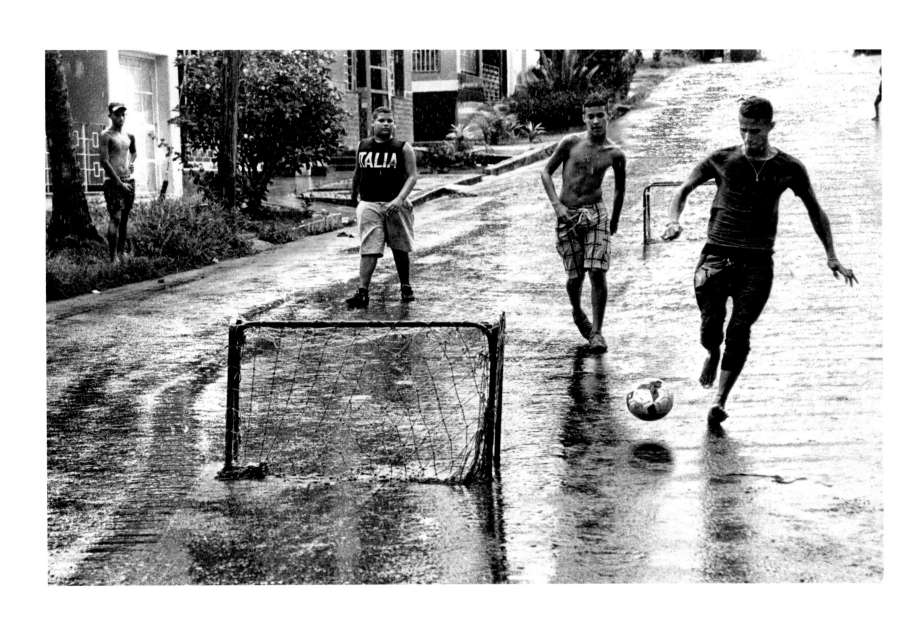

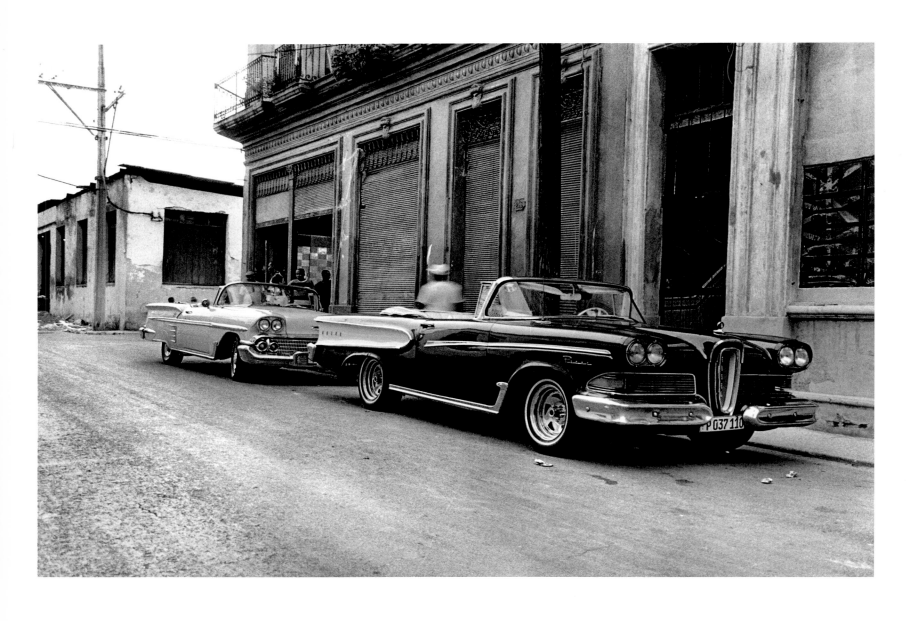

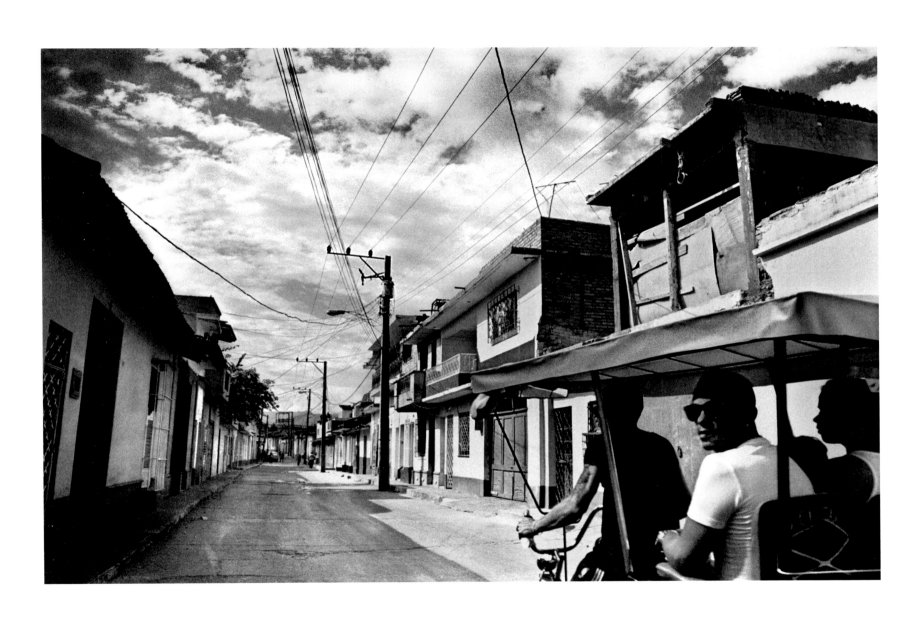

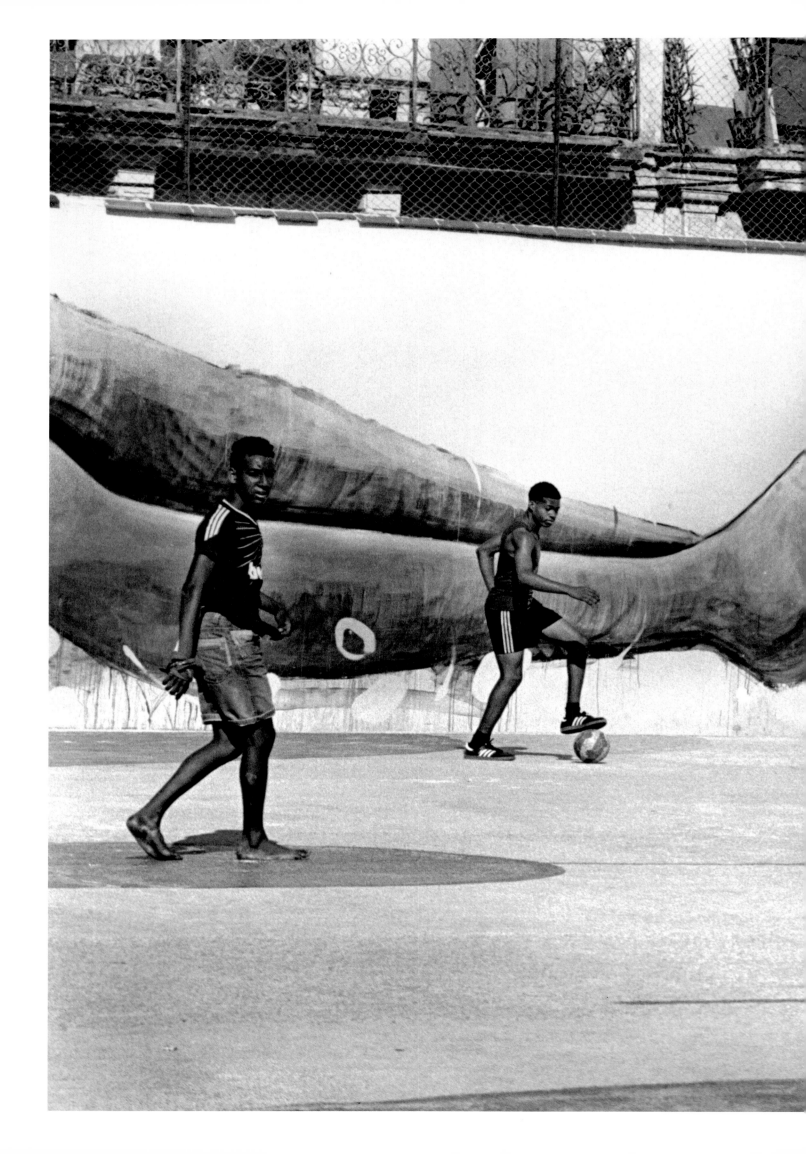

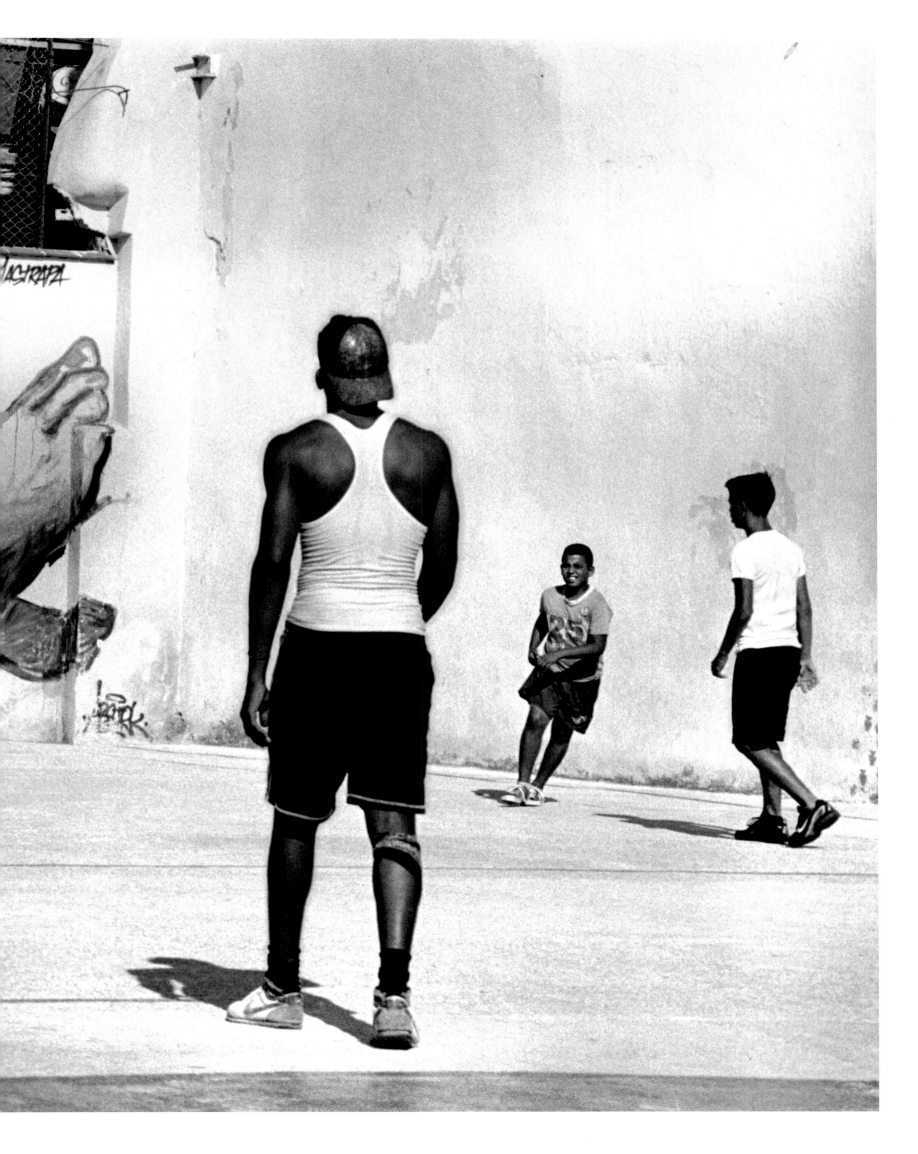

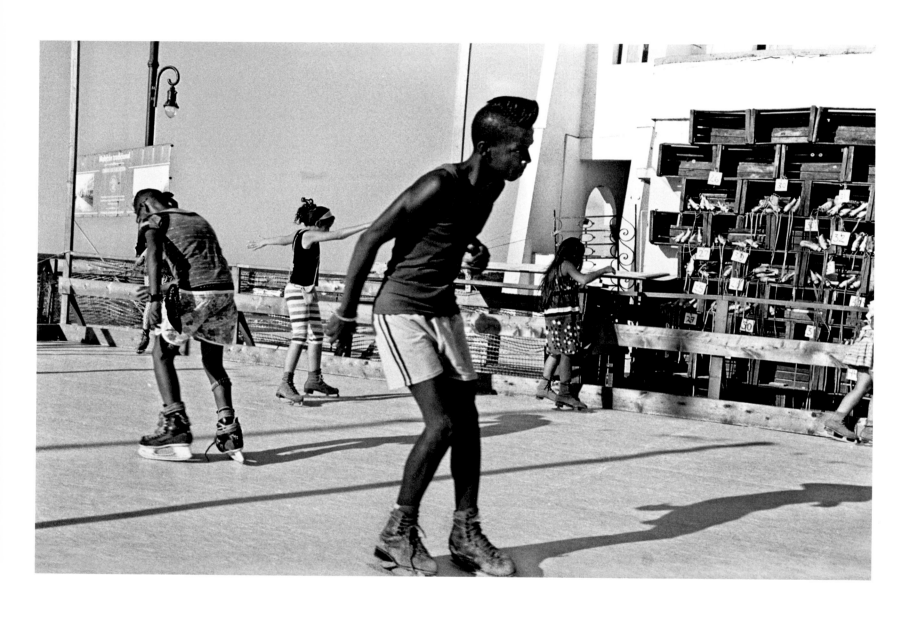

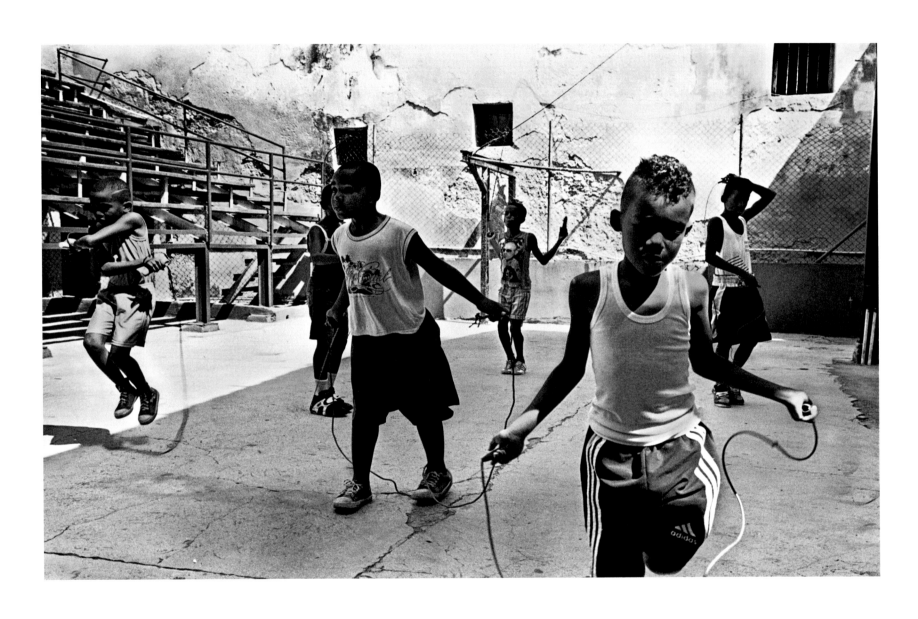

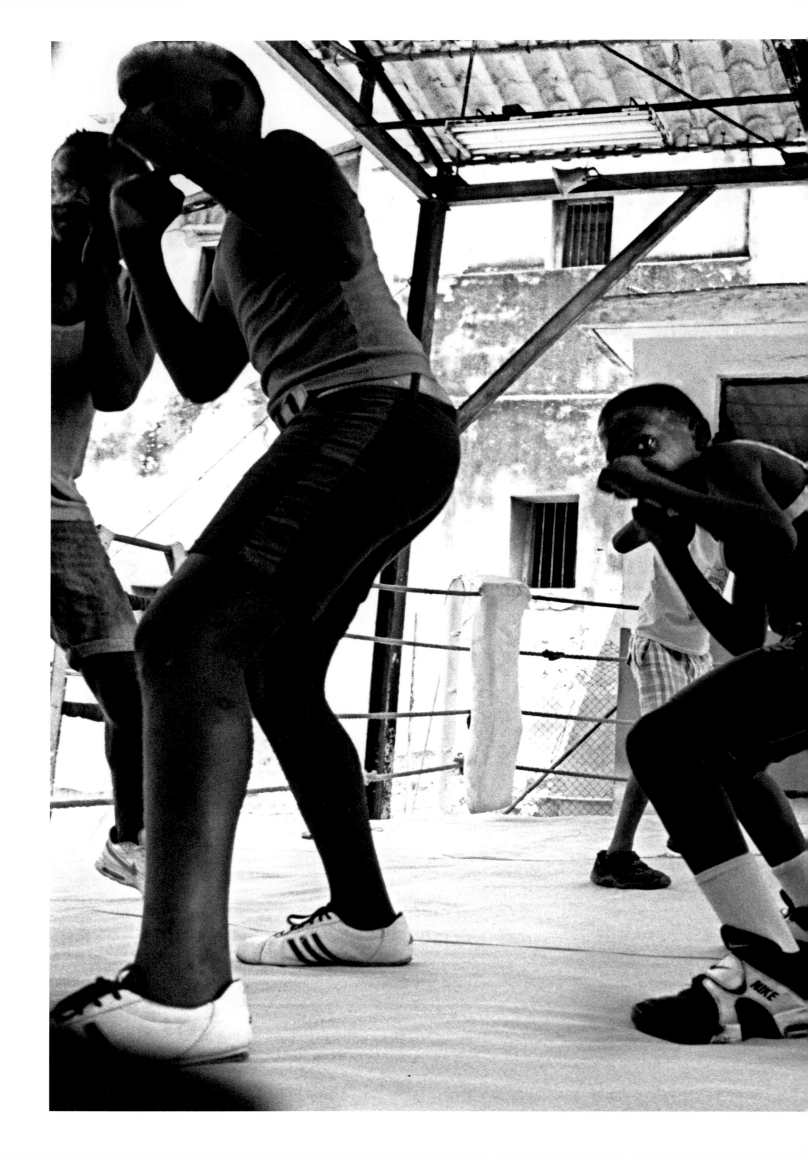

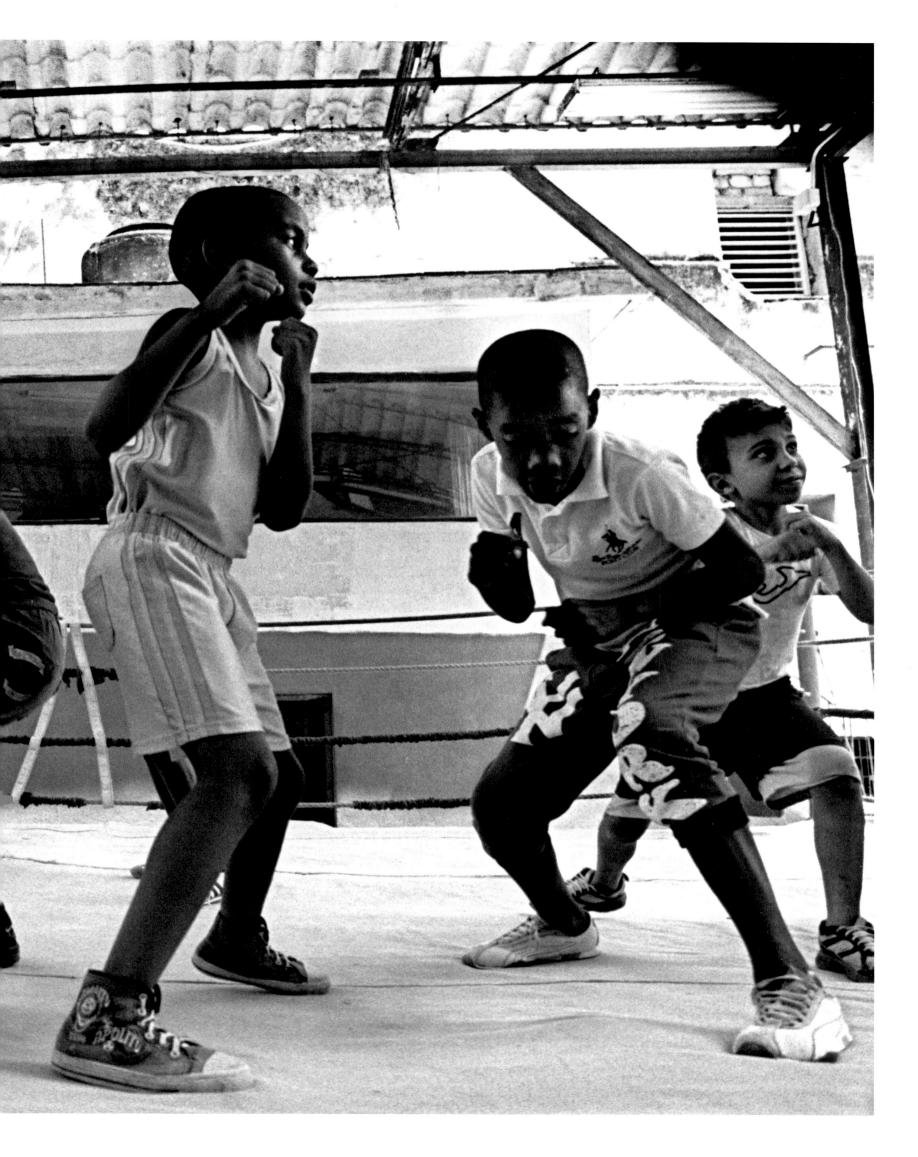

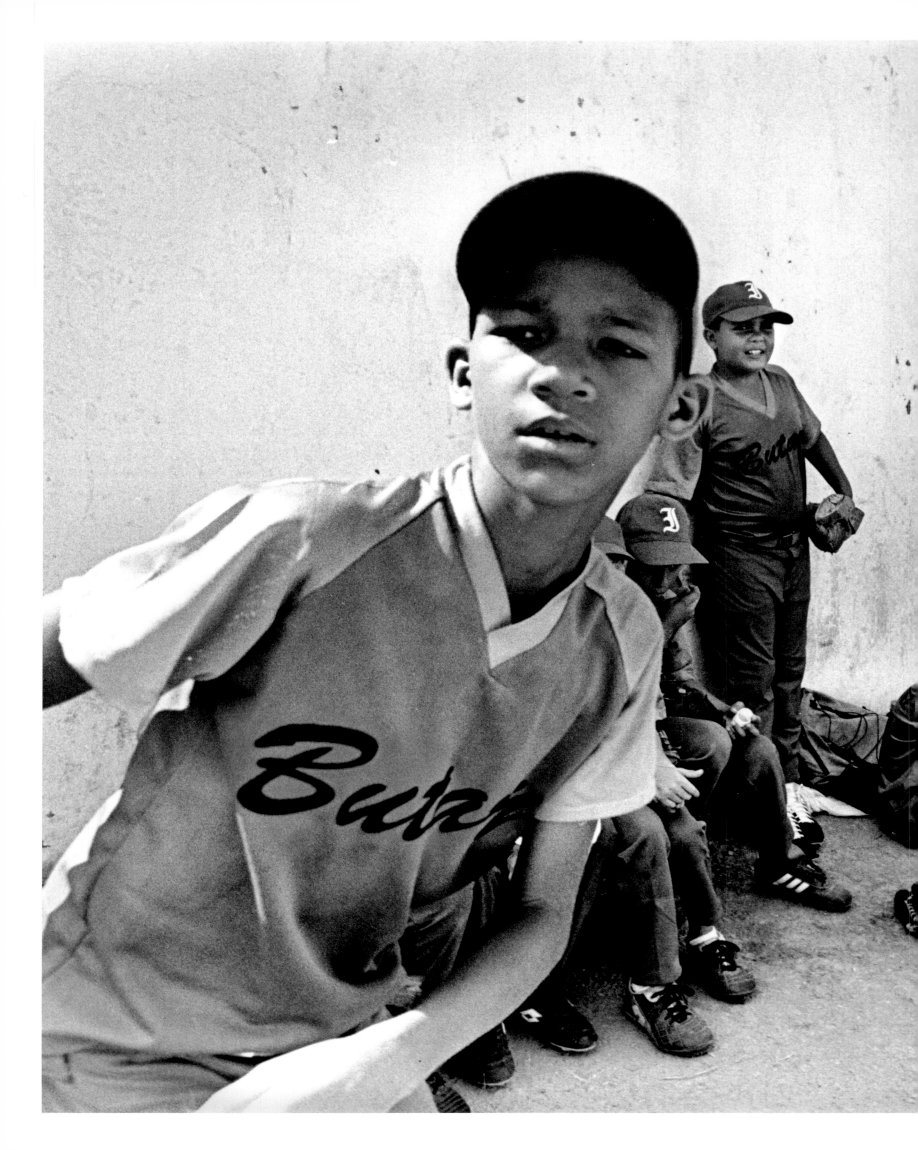

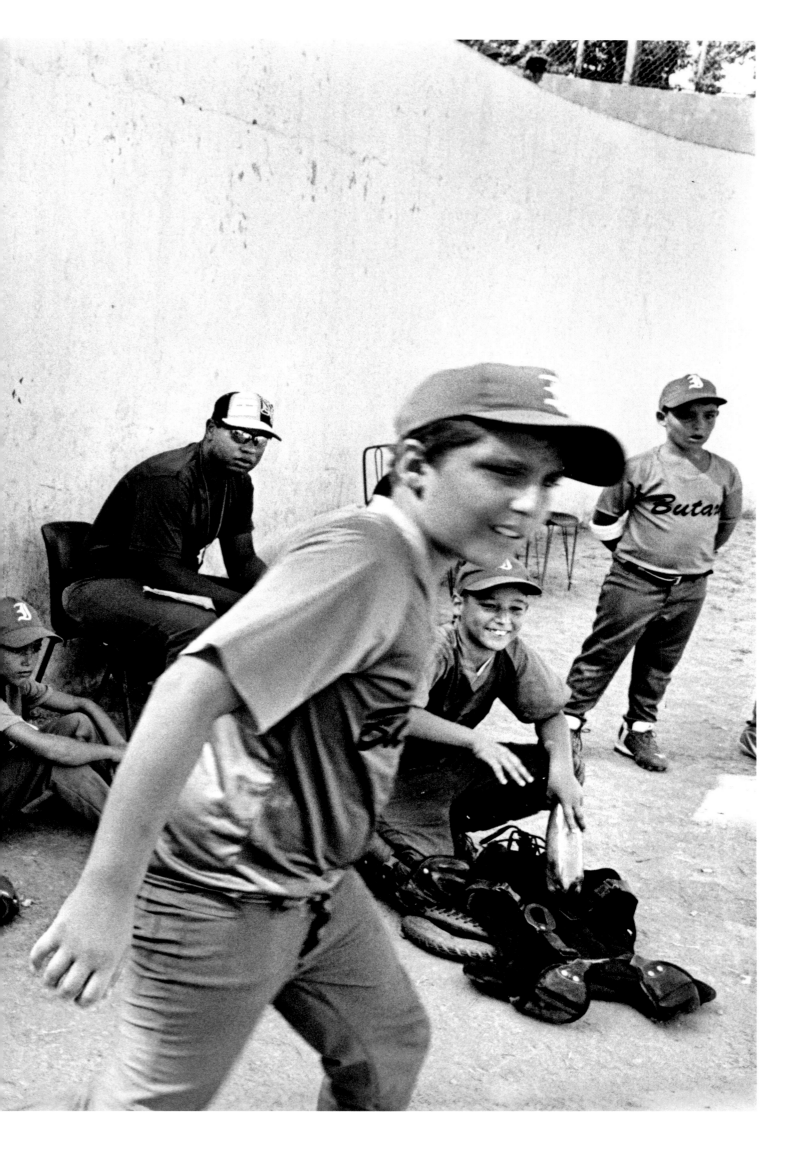

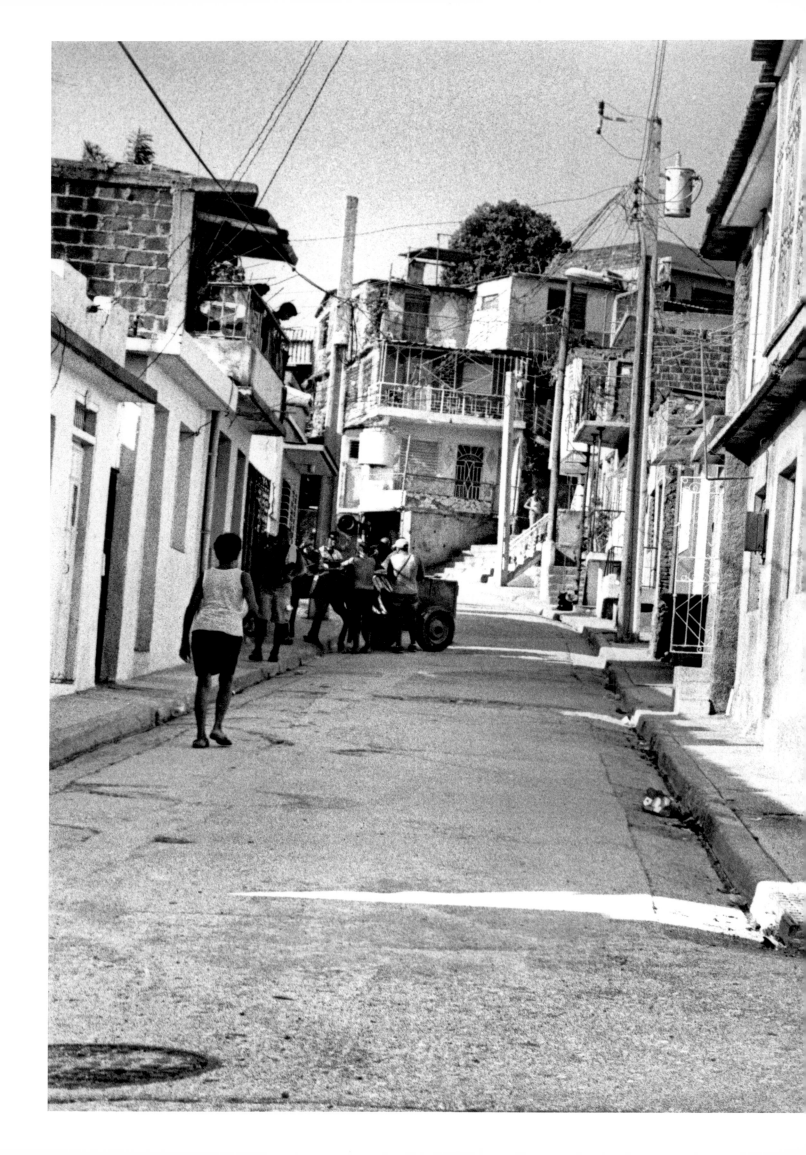

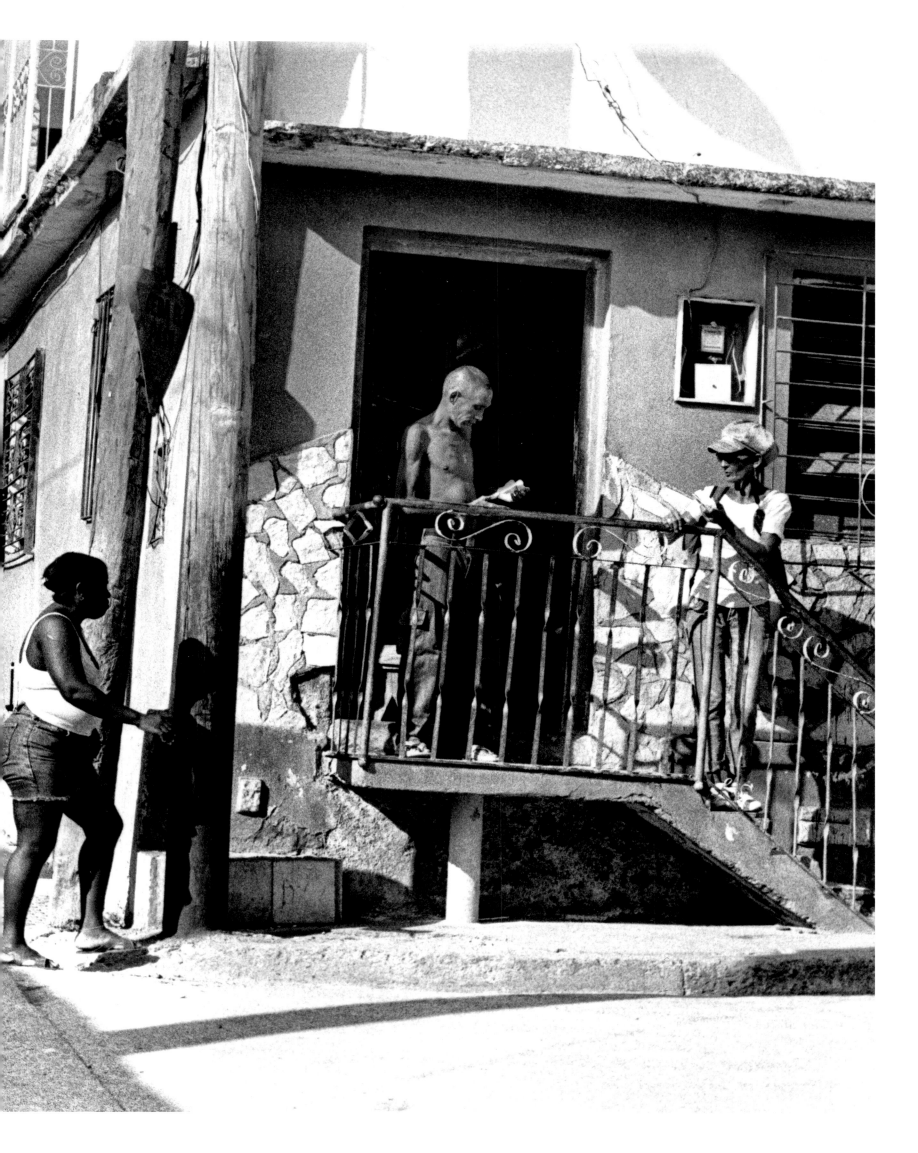

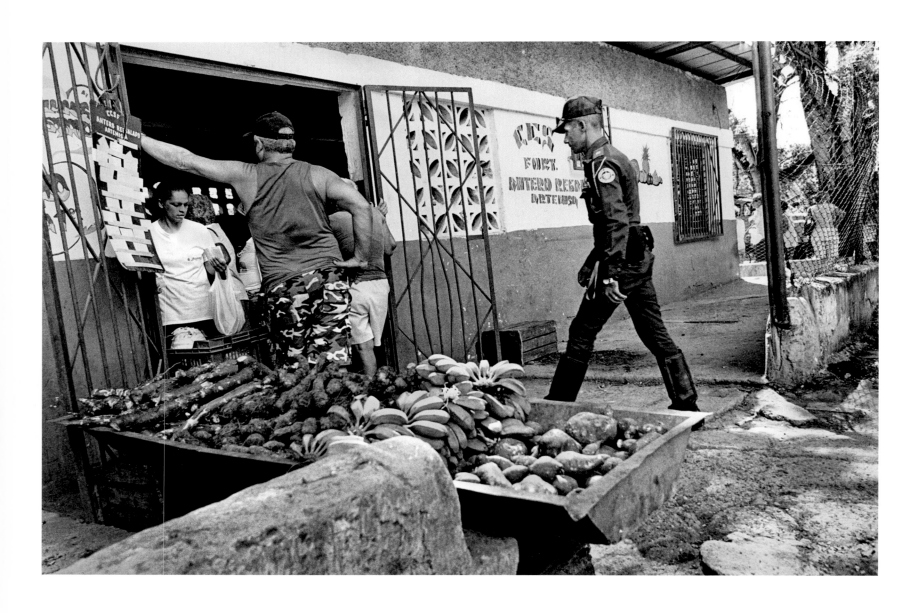

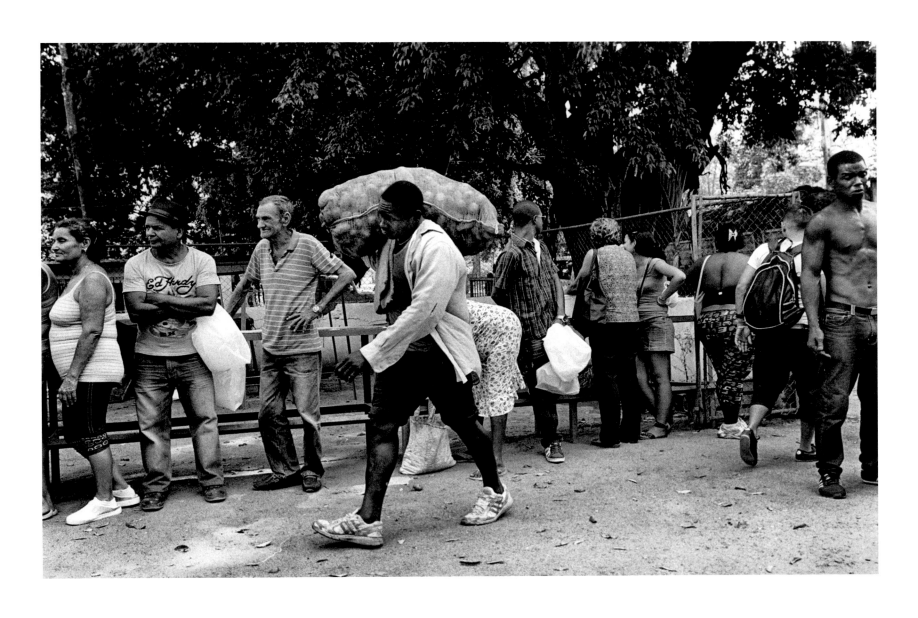

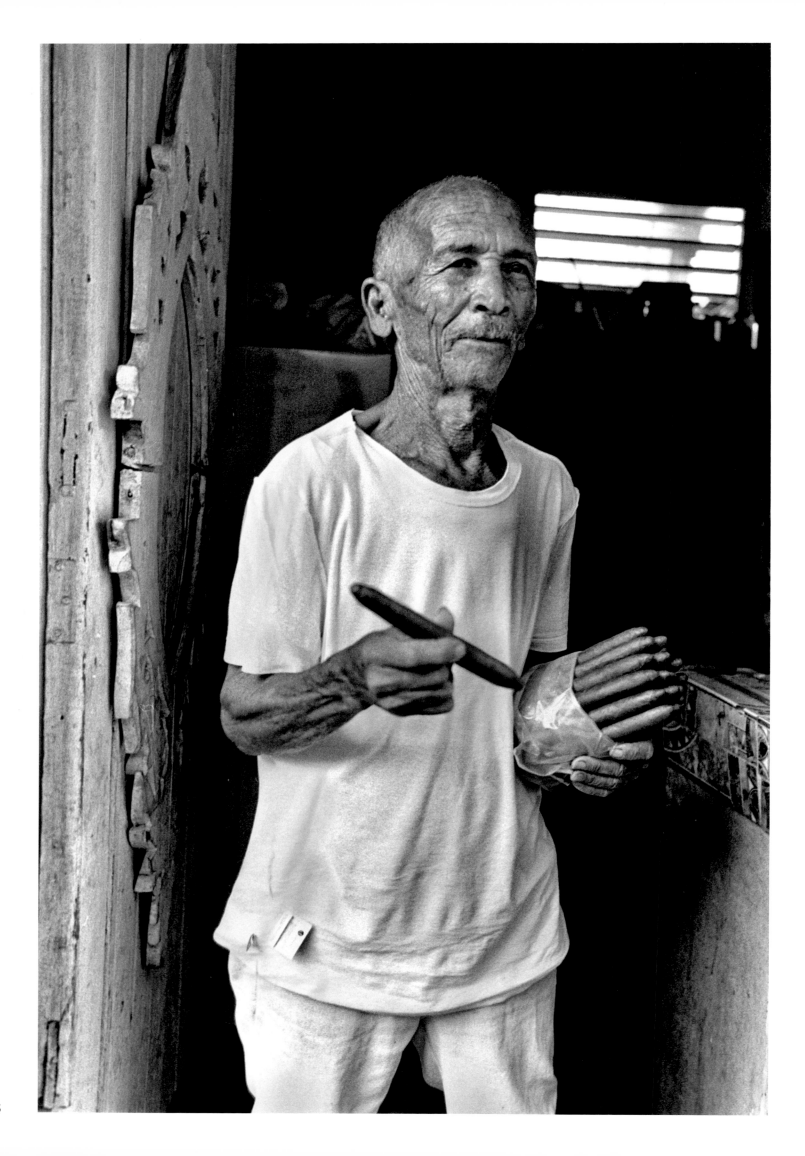

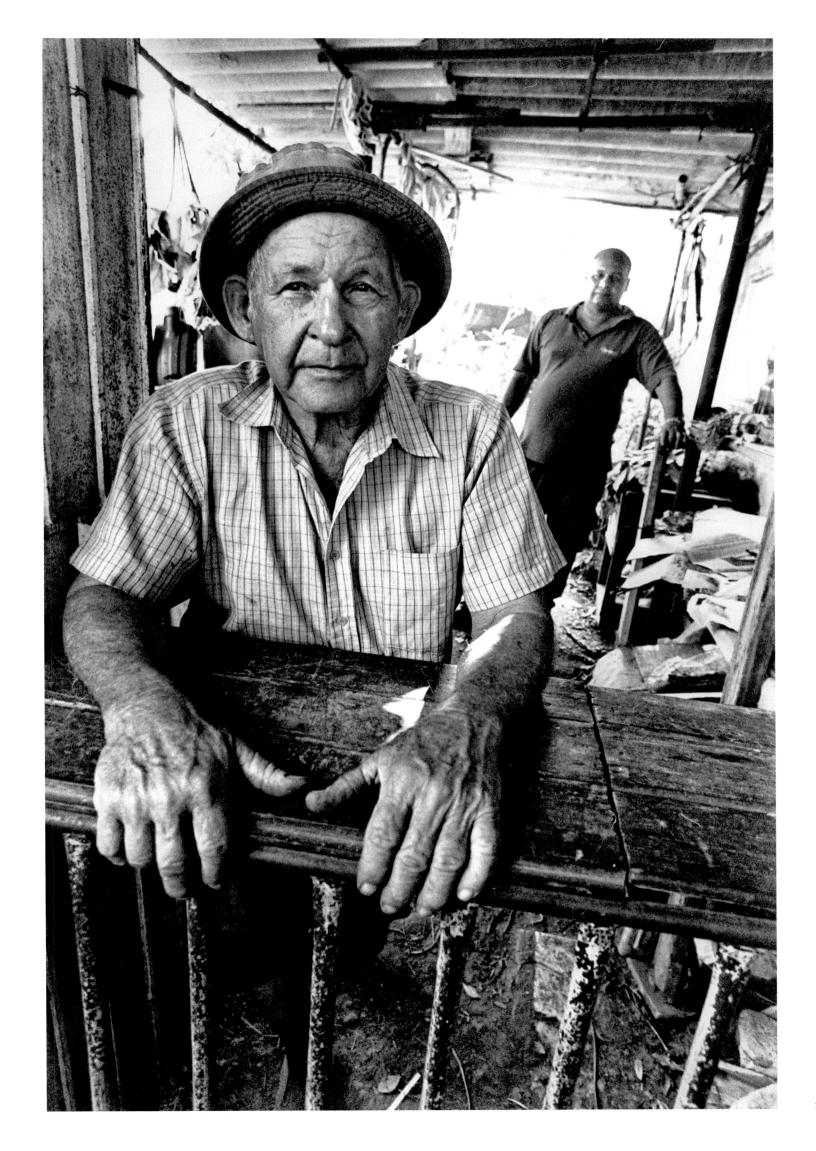

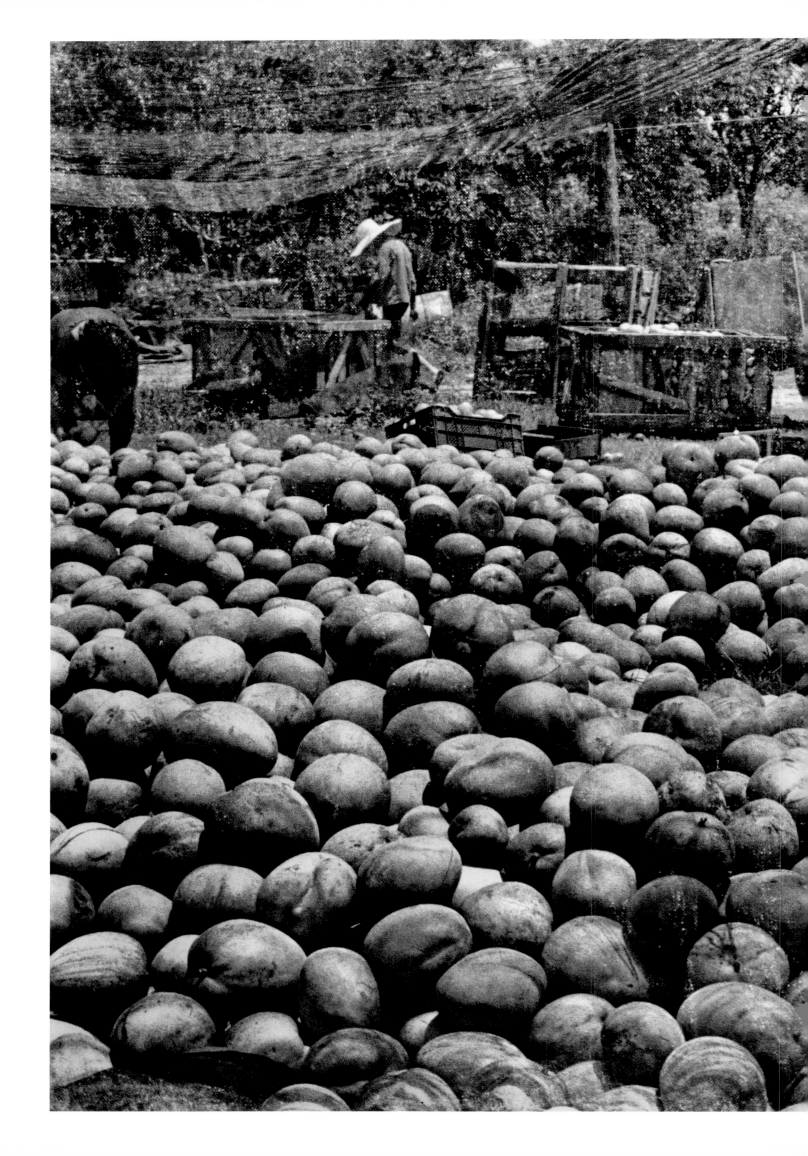

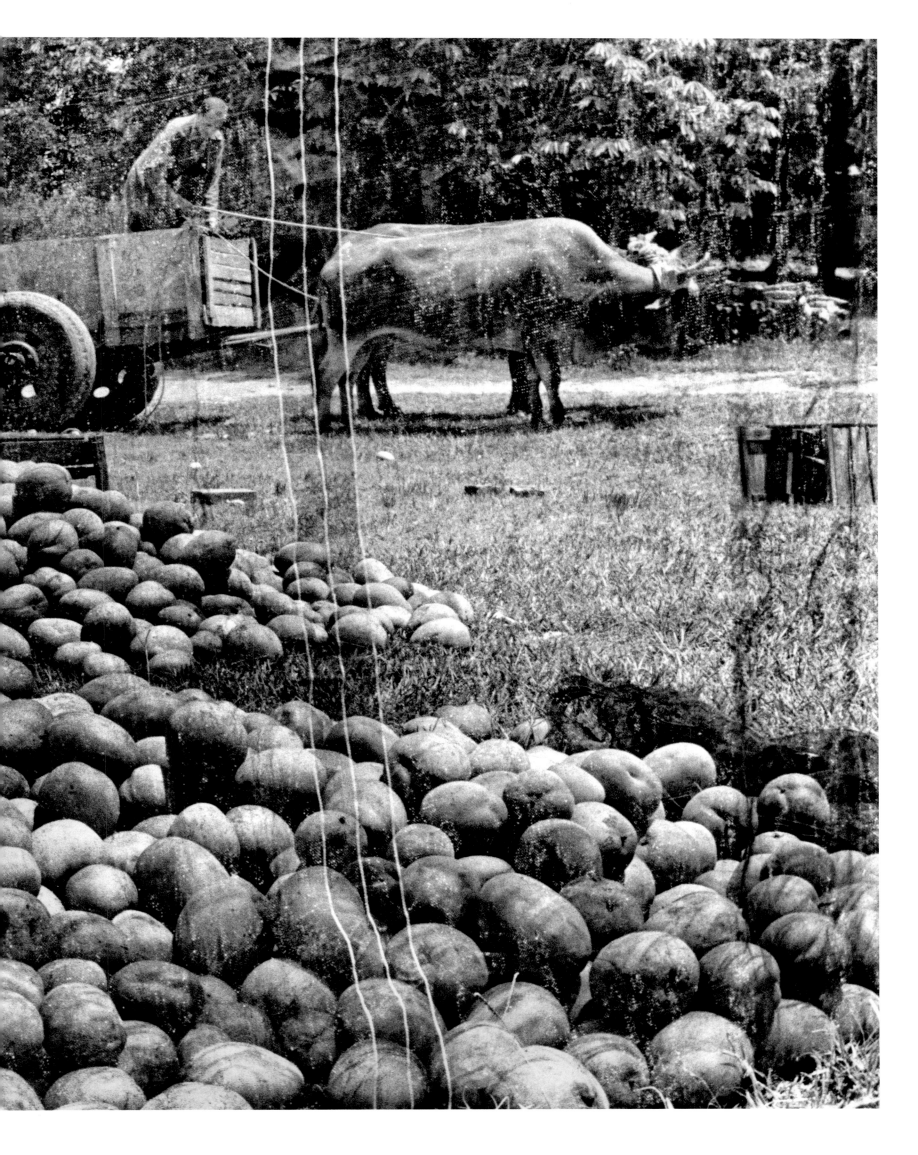

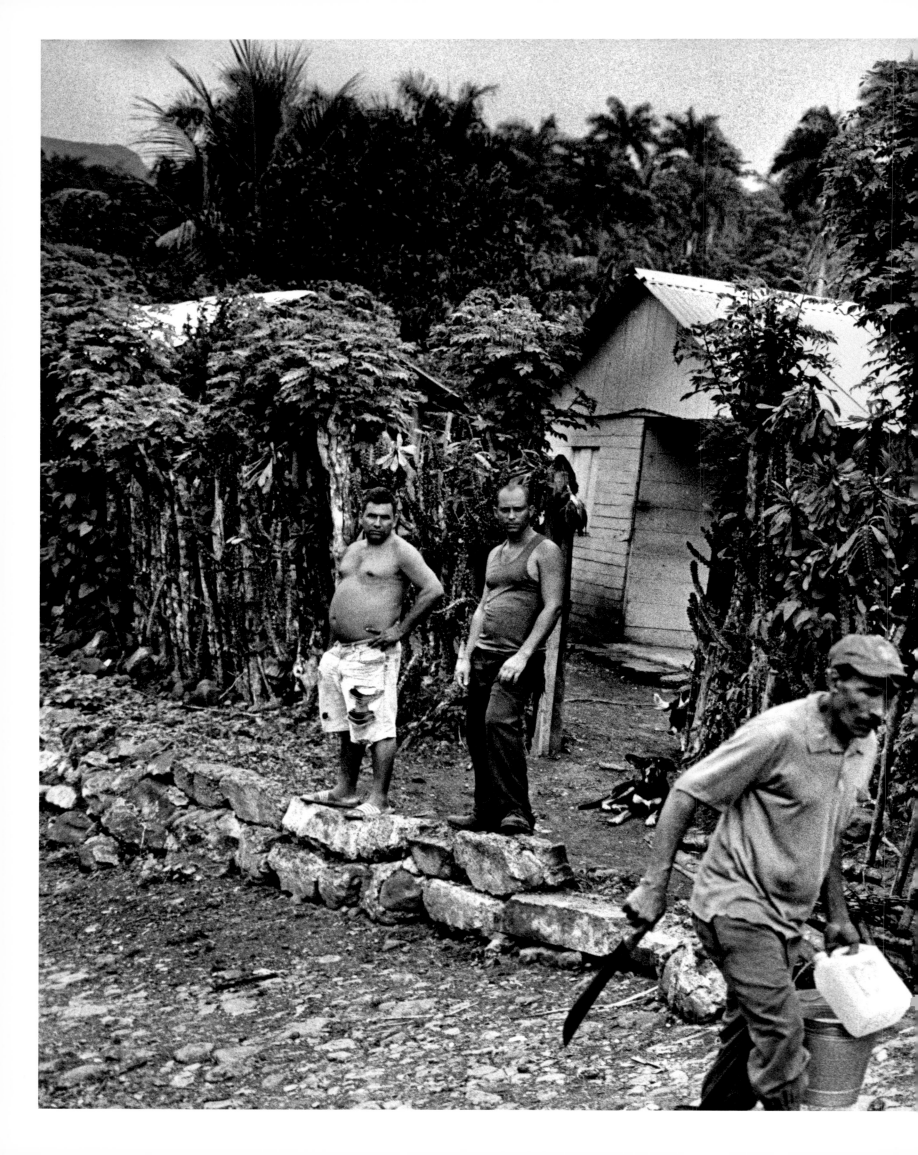

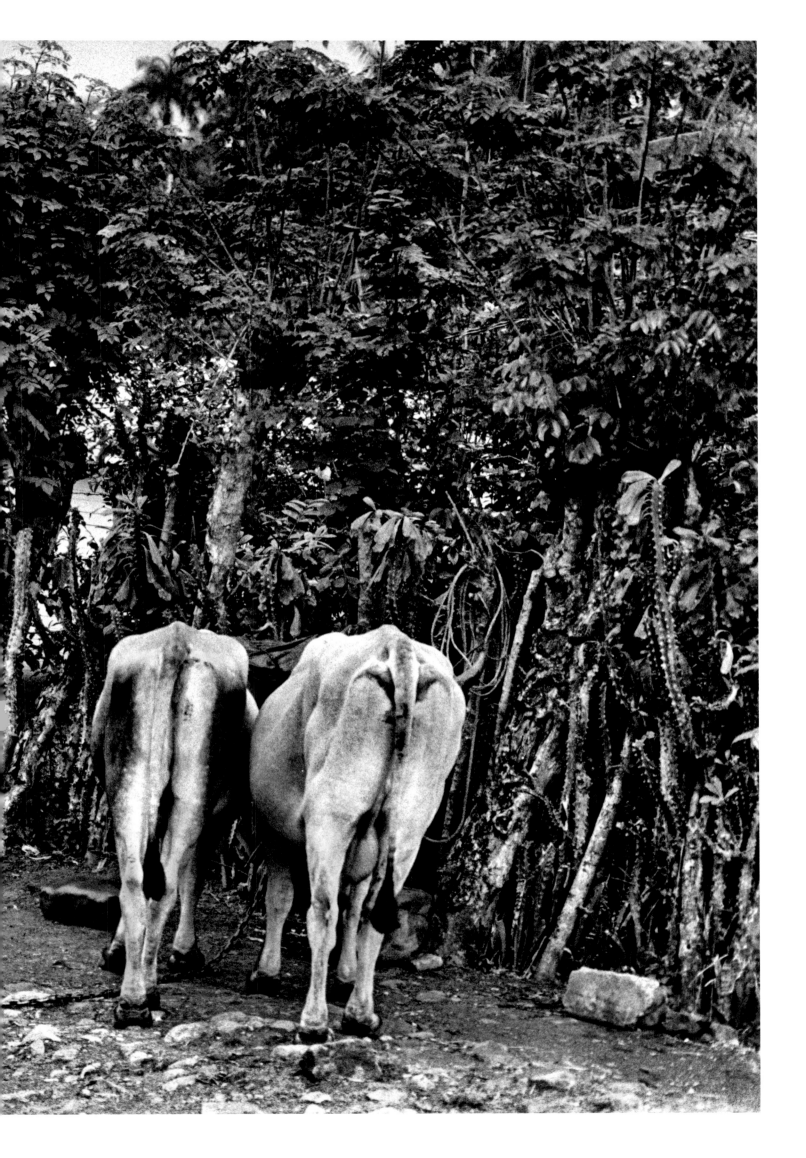

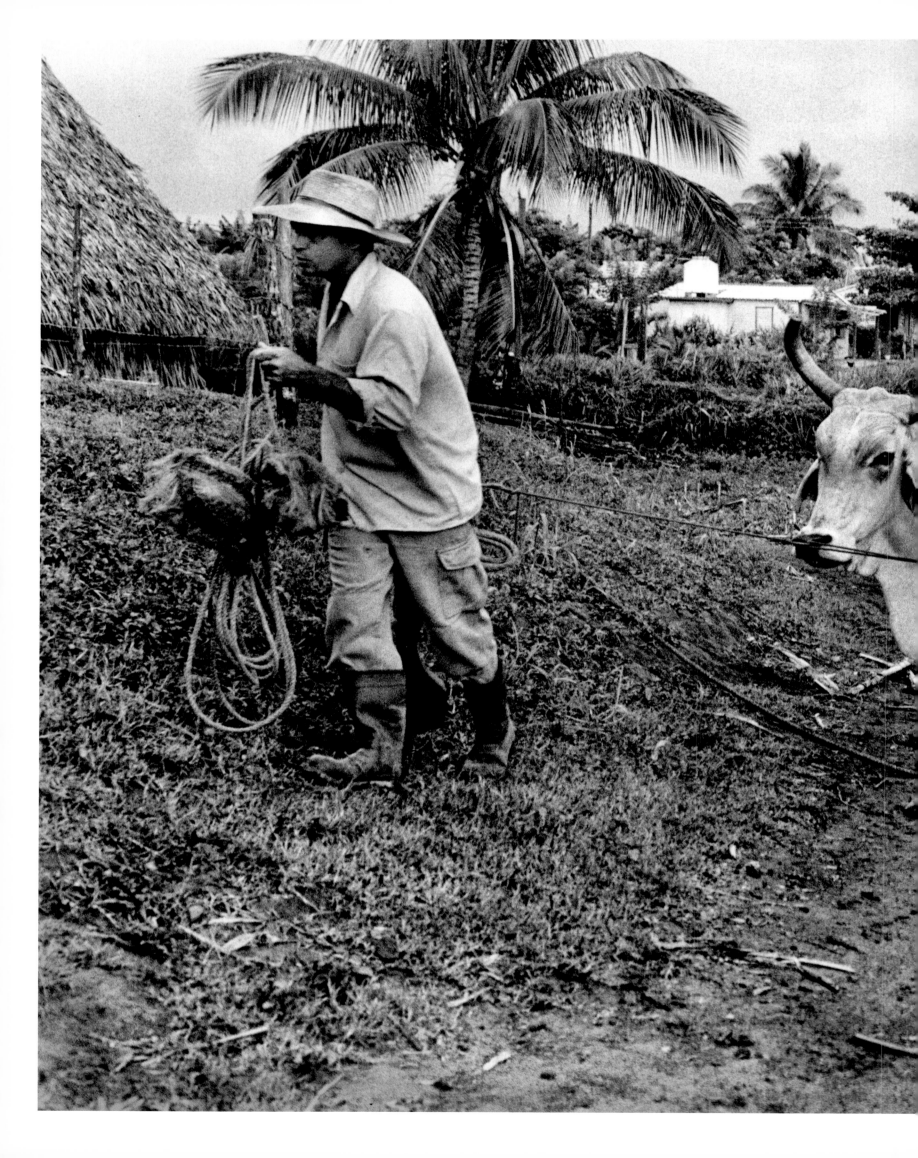

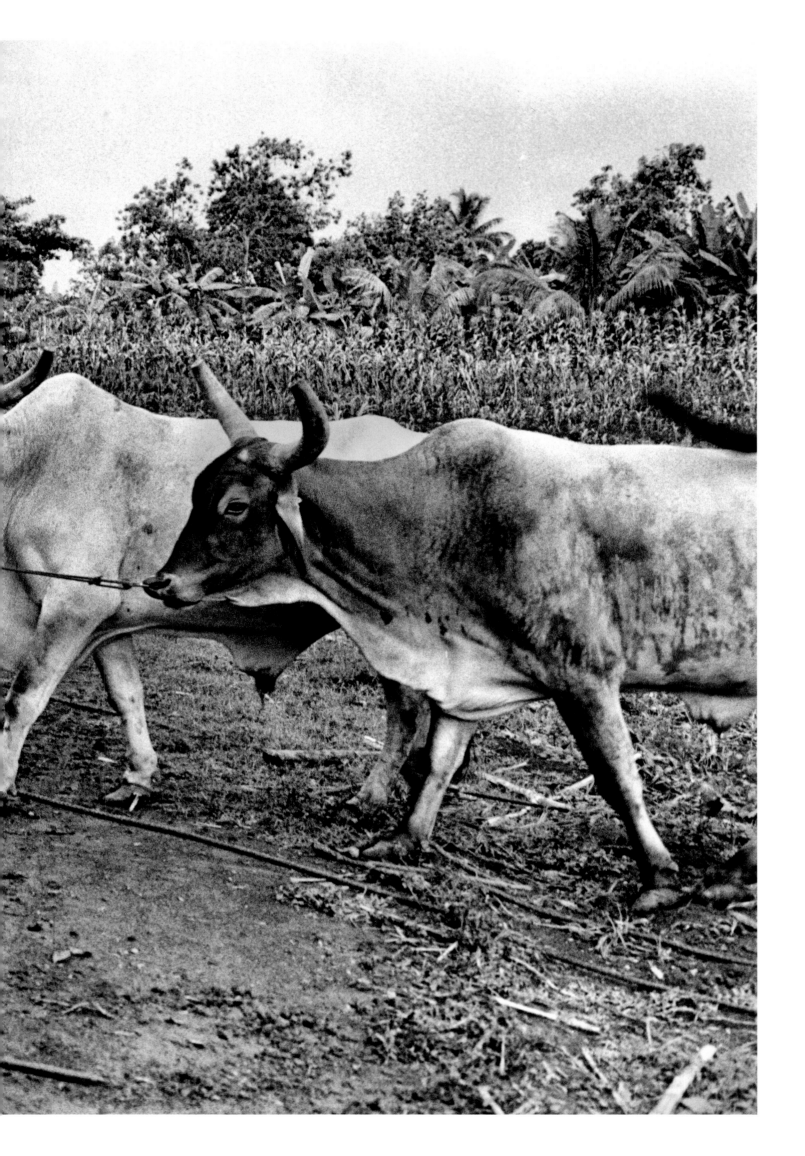

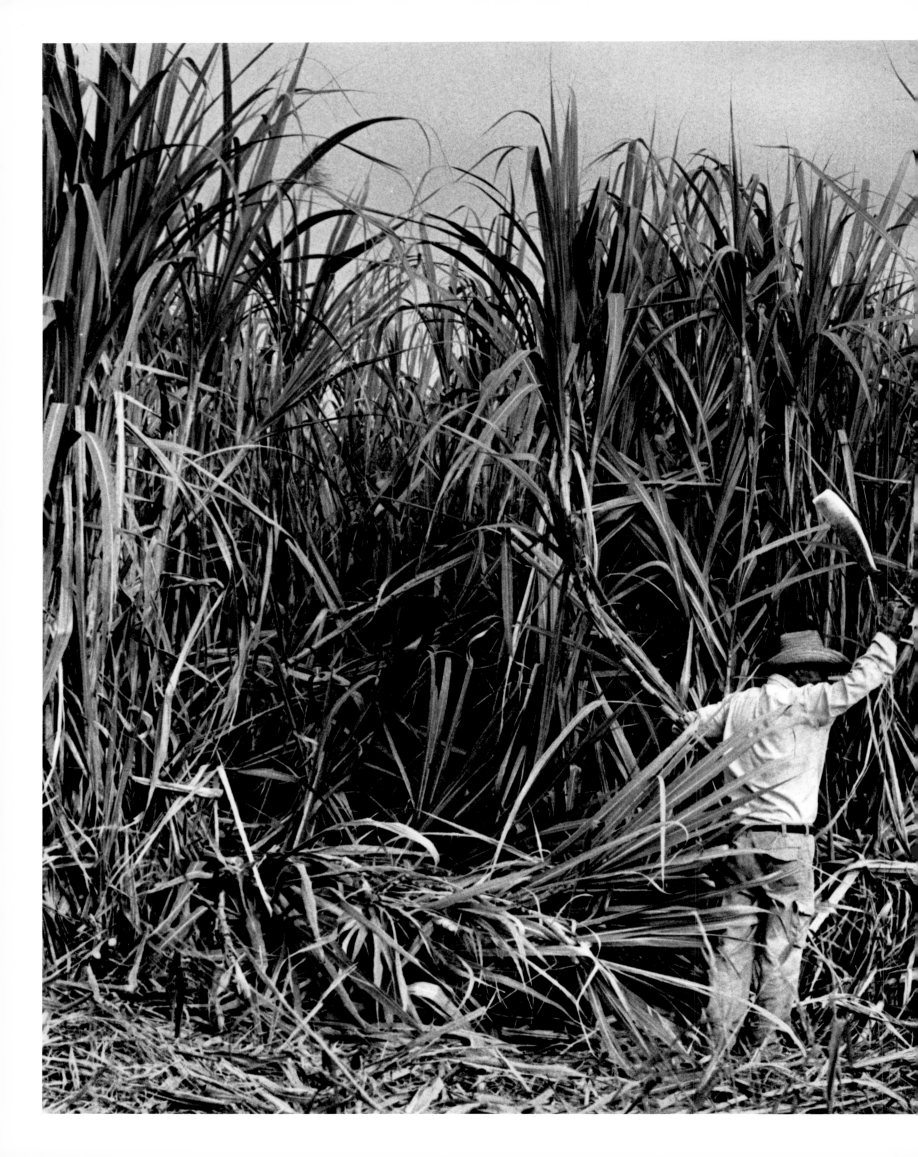

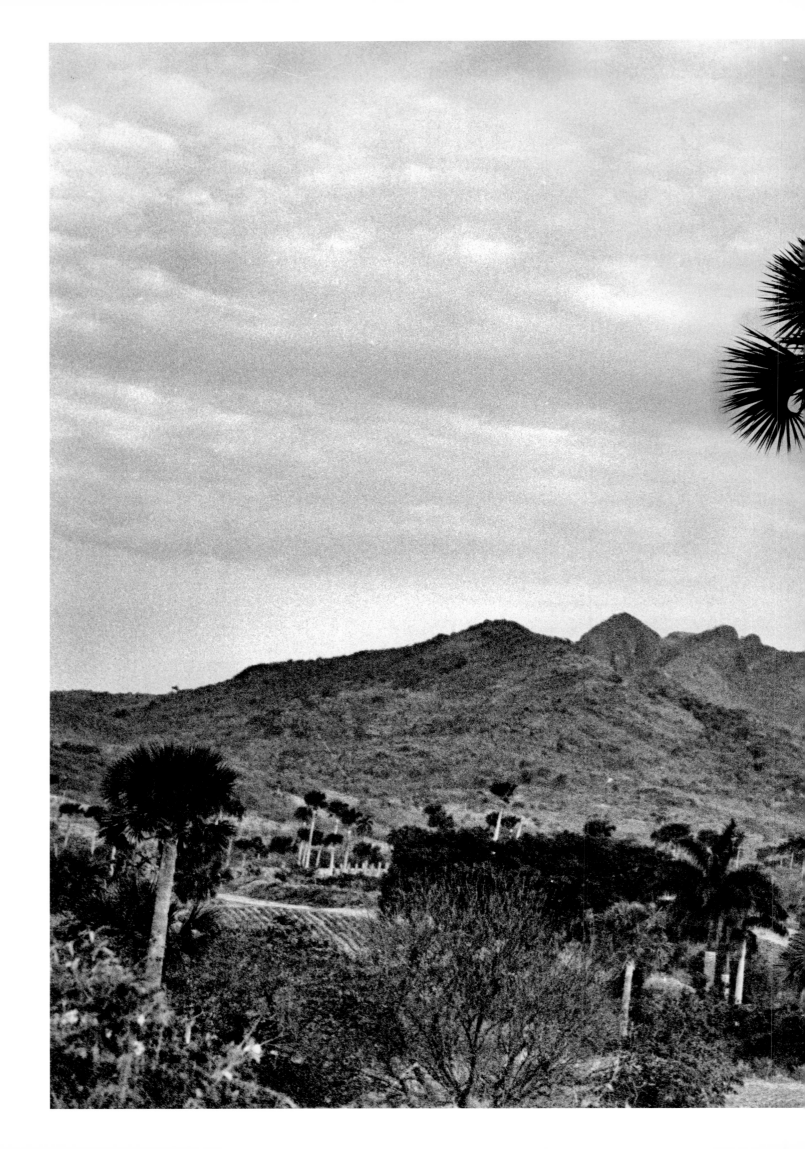

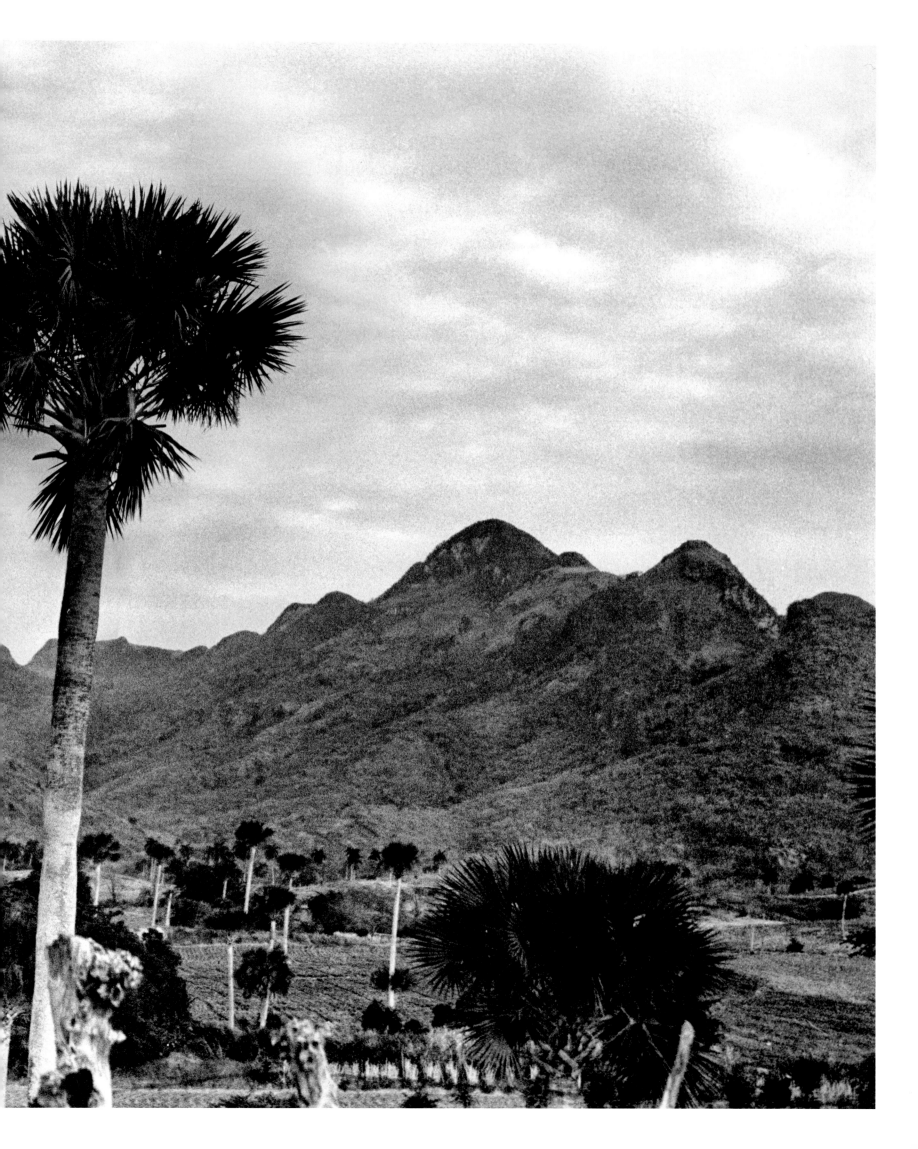

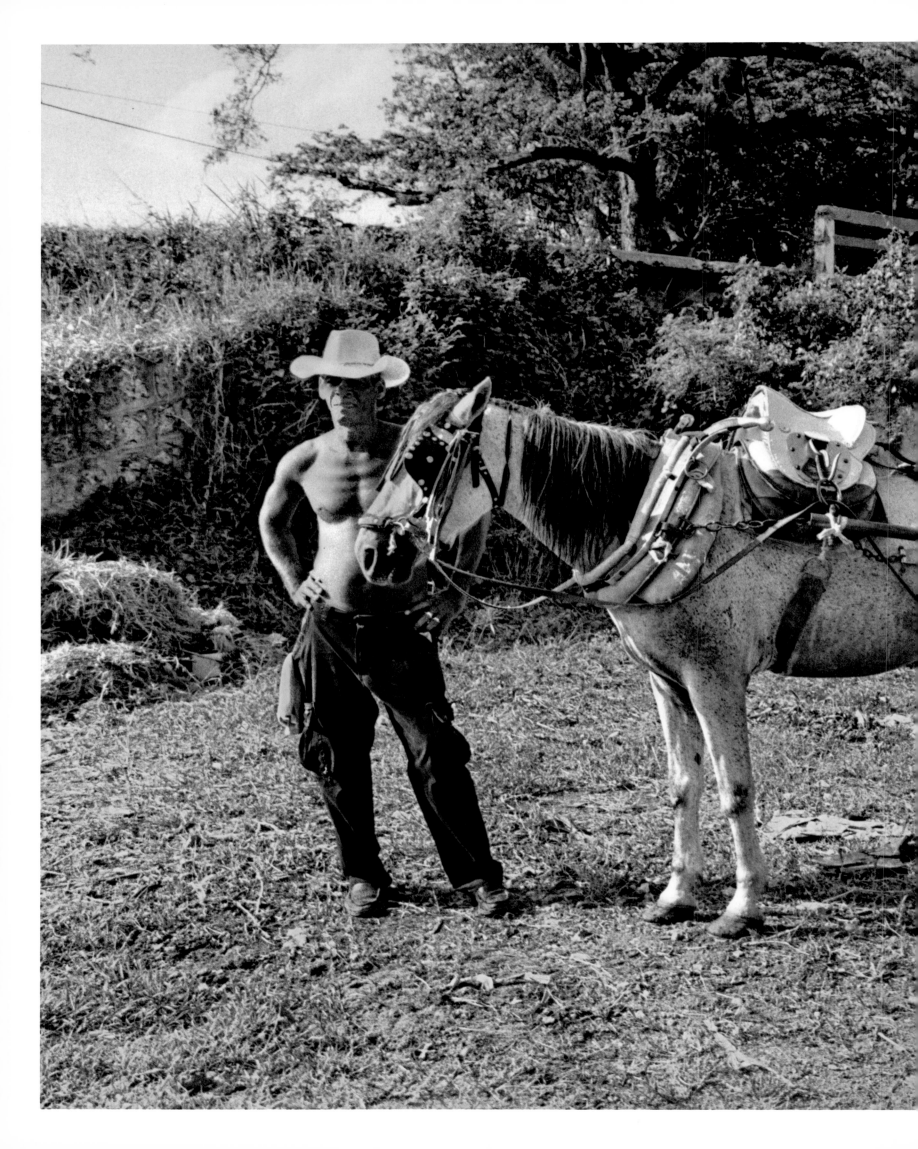

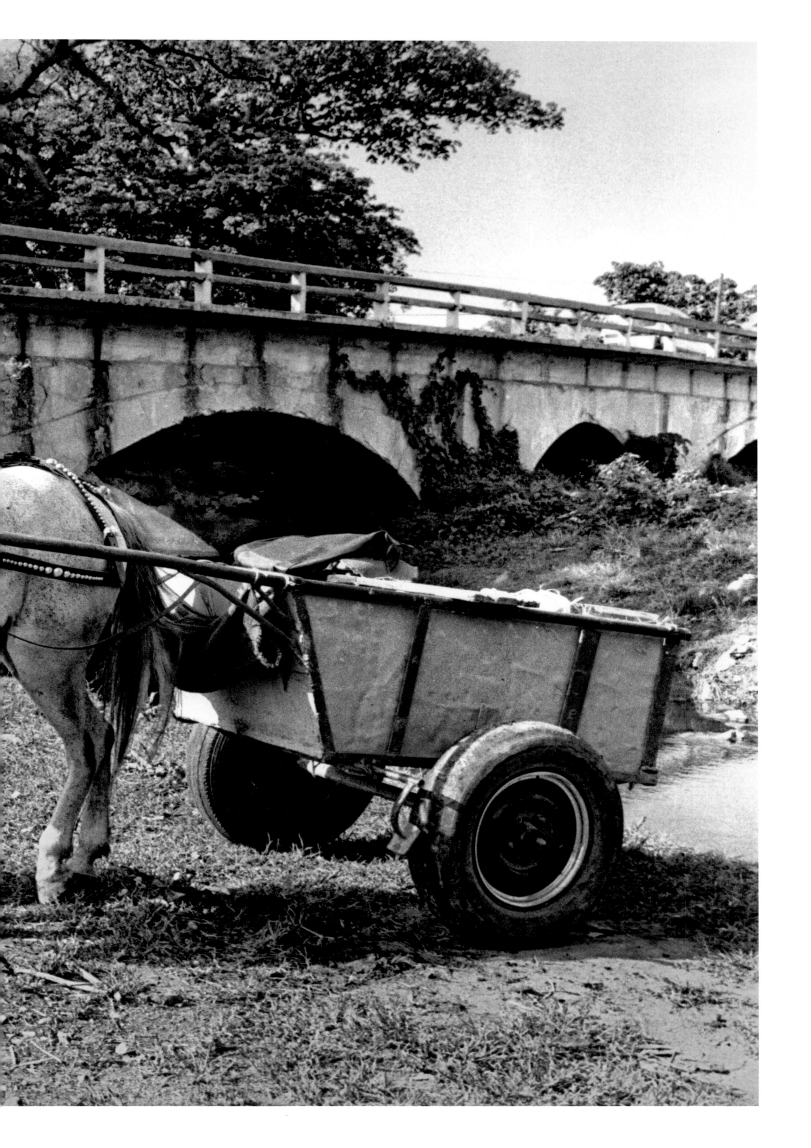

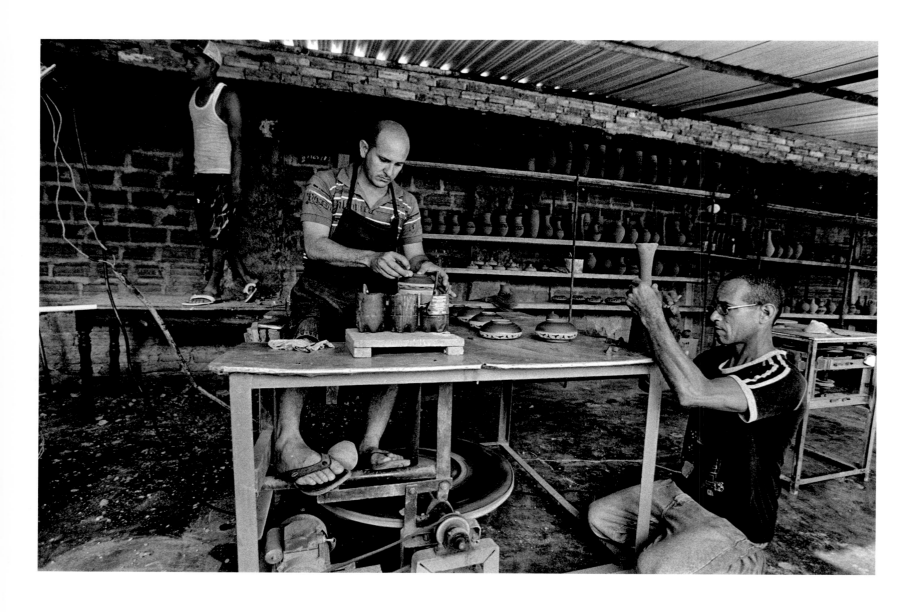

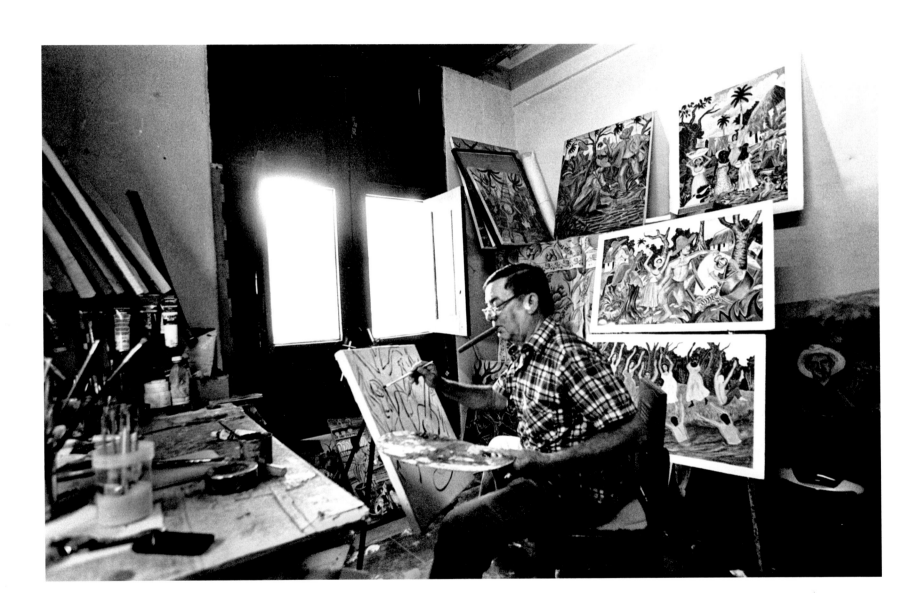

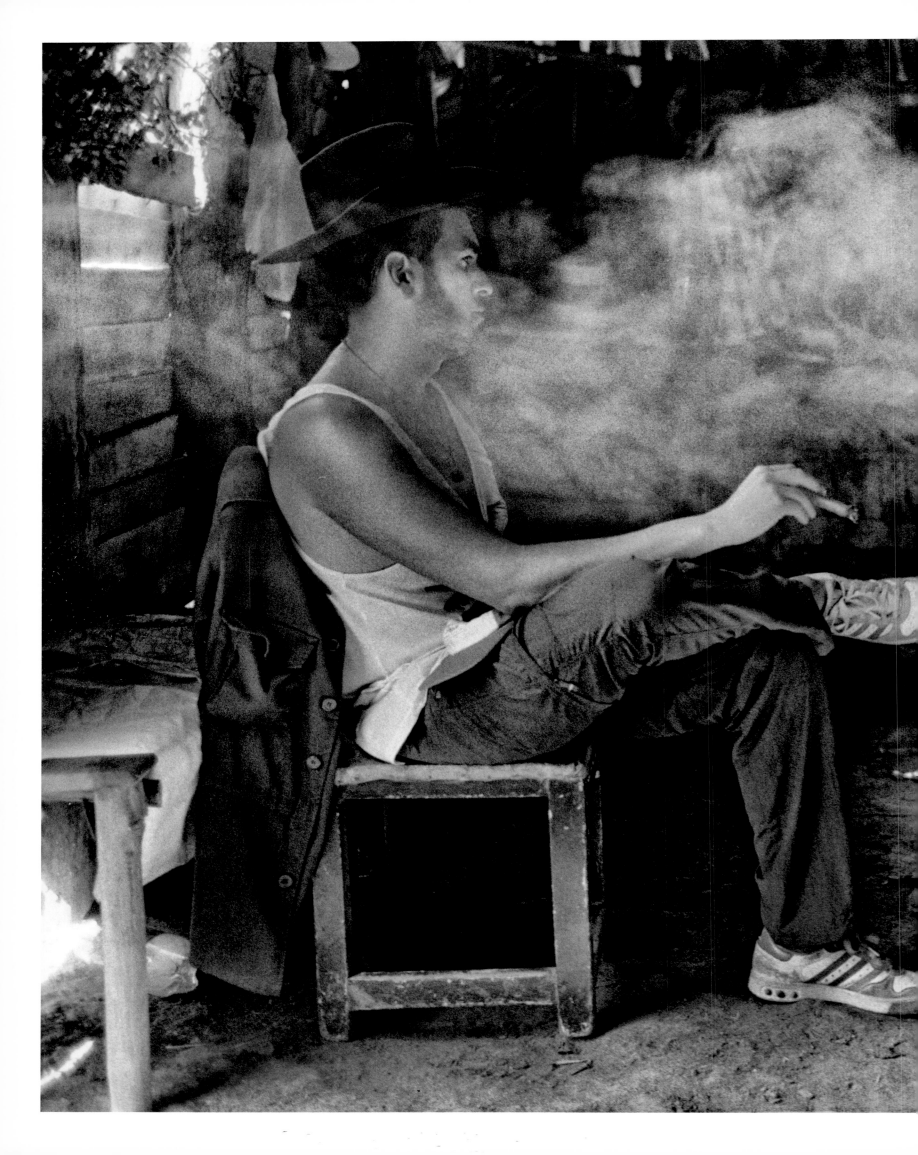

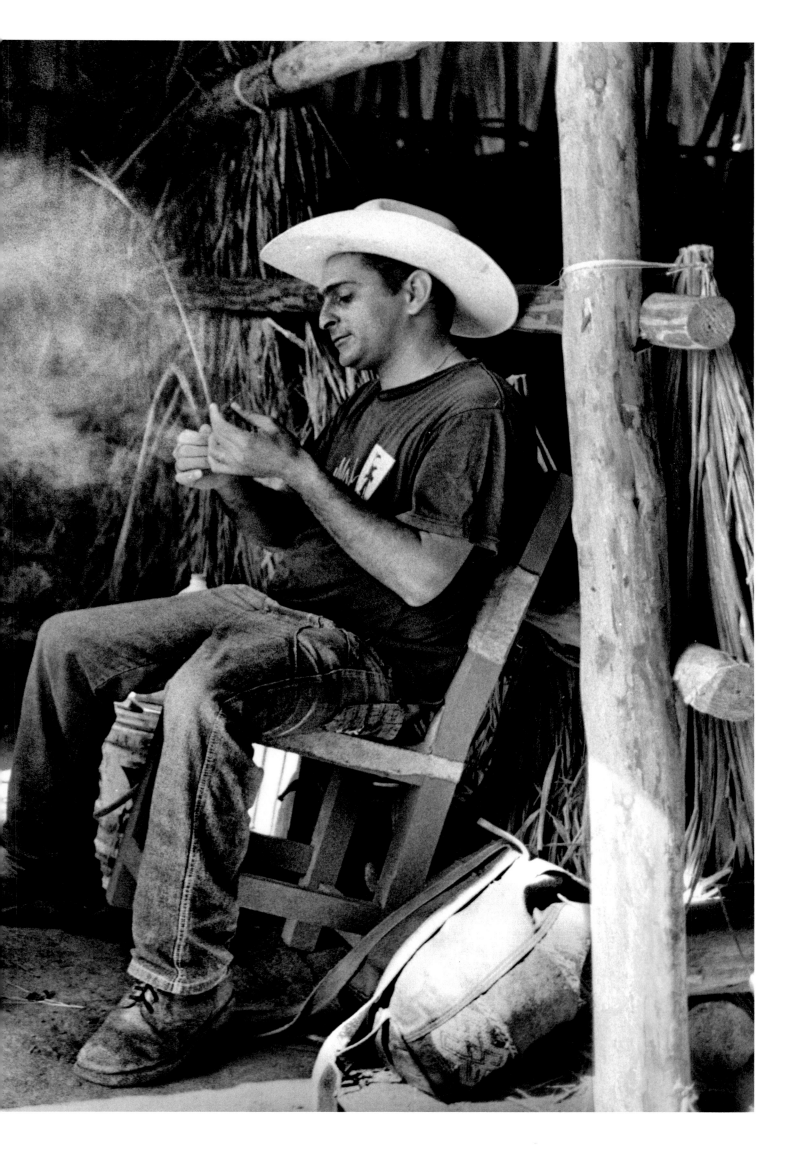

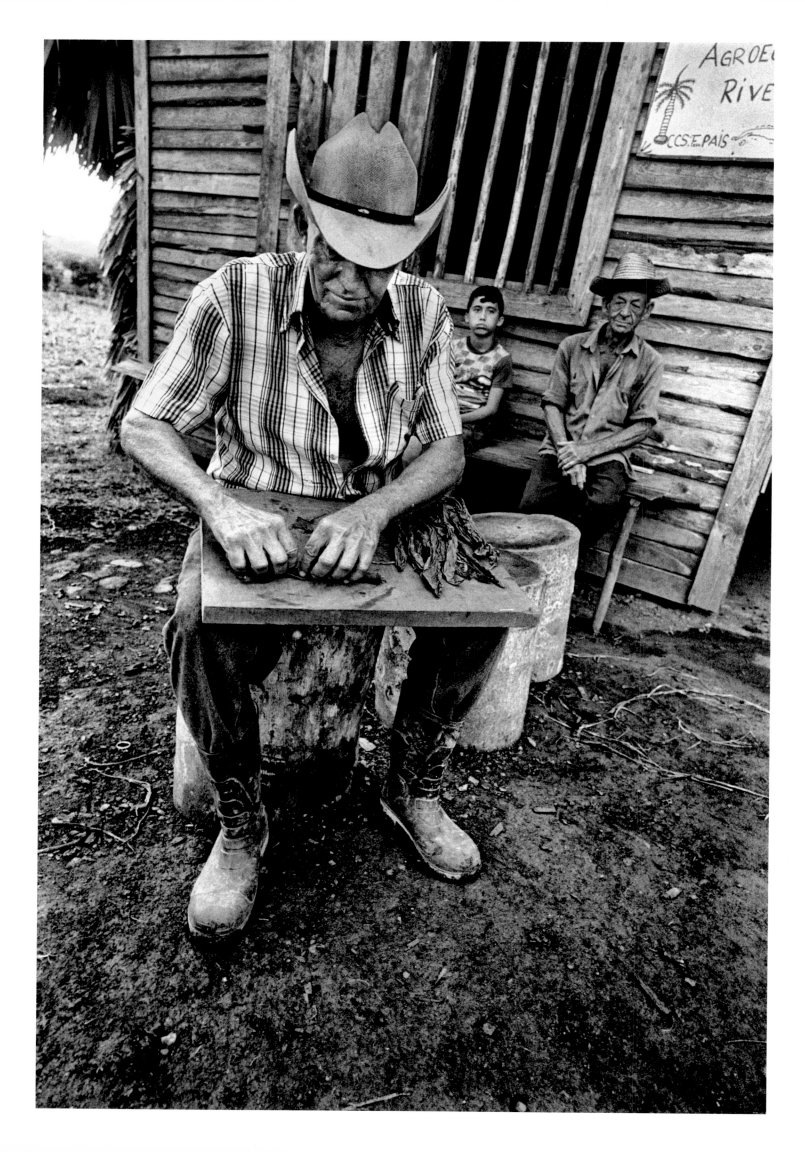

144

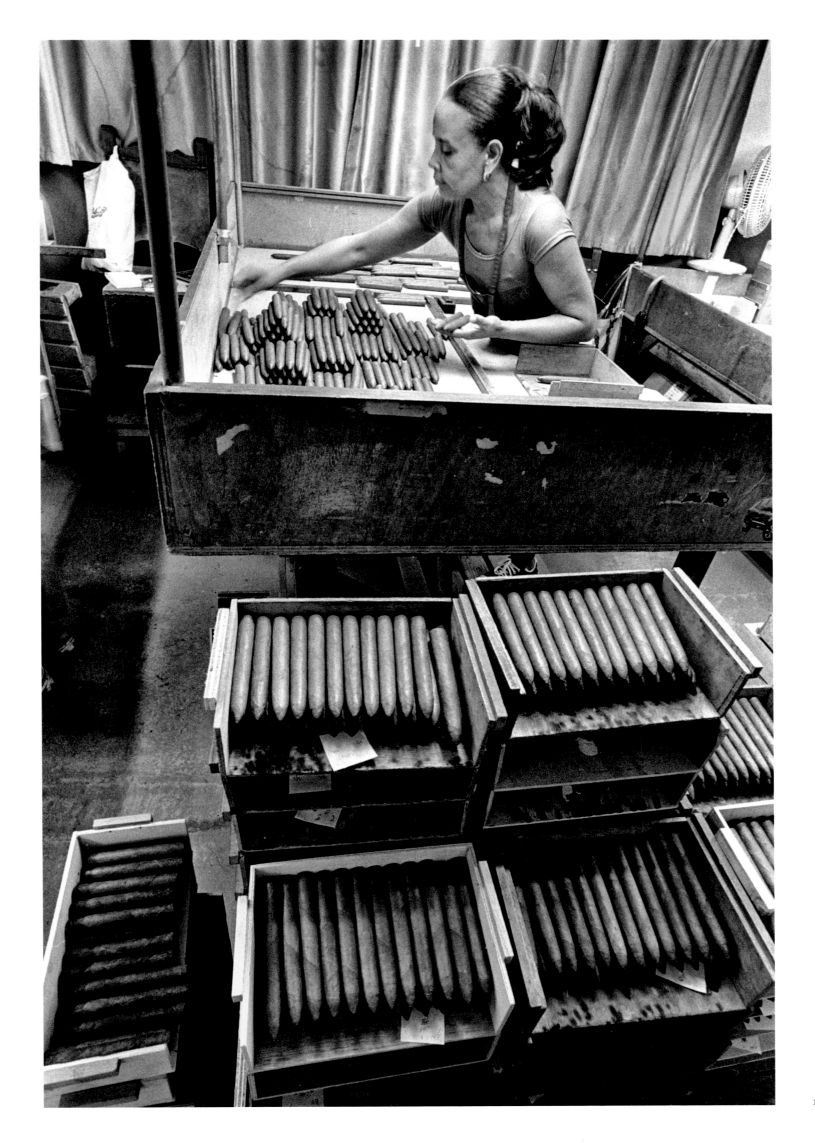

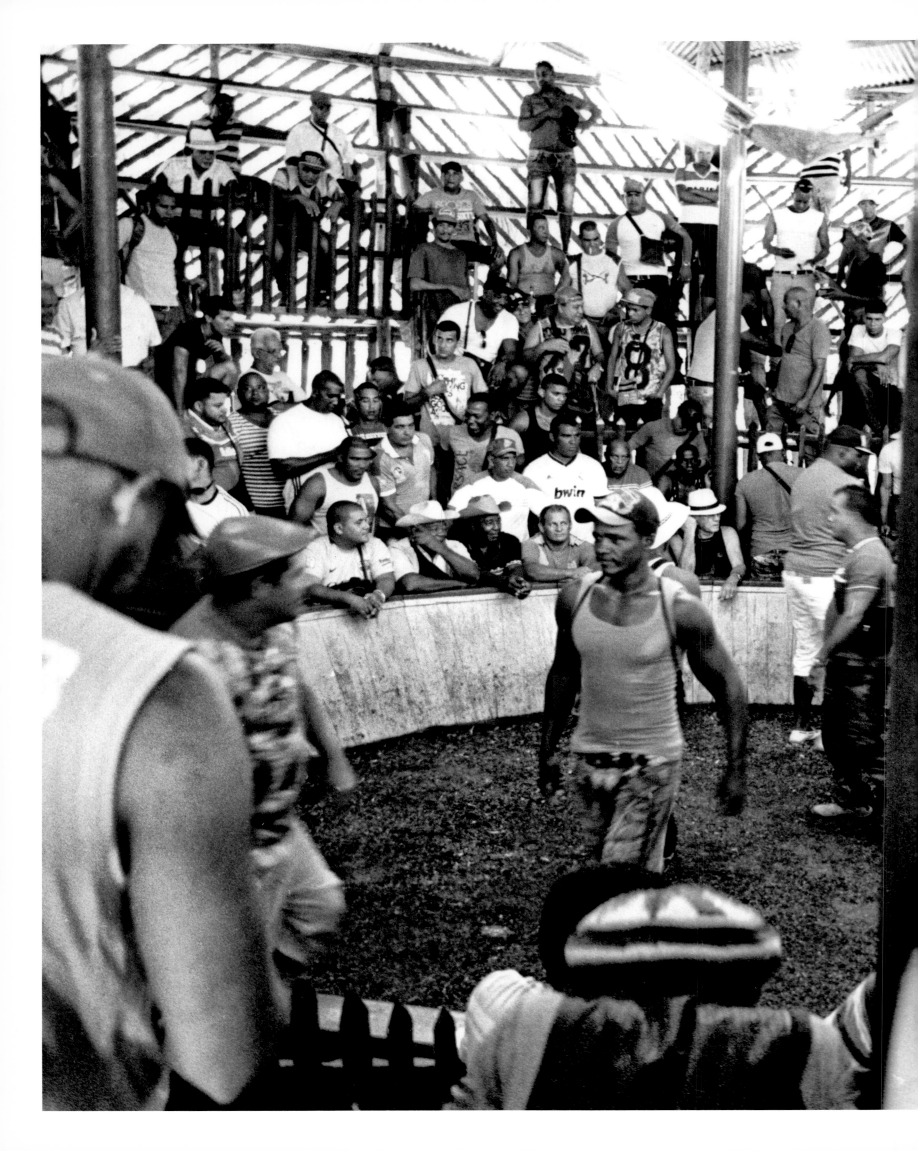

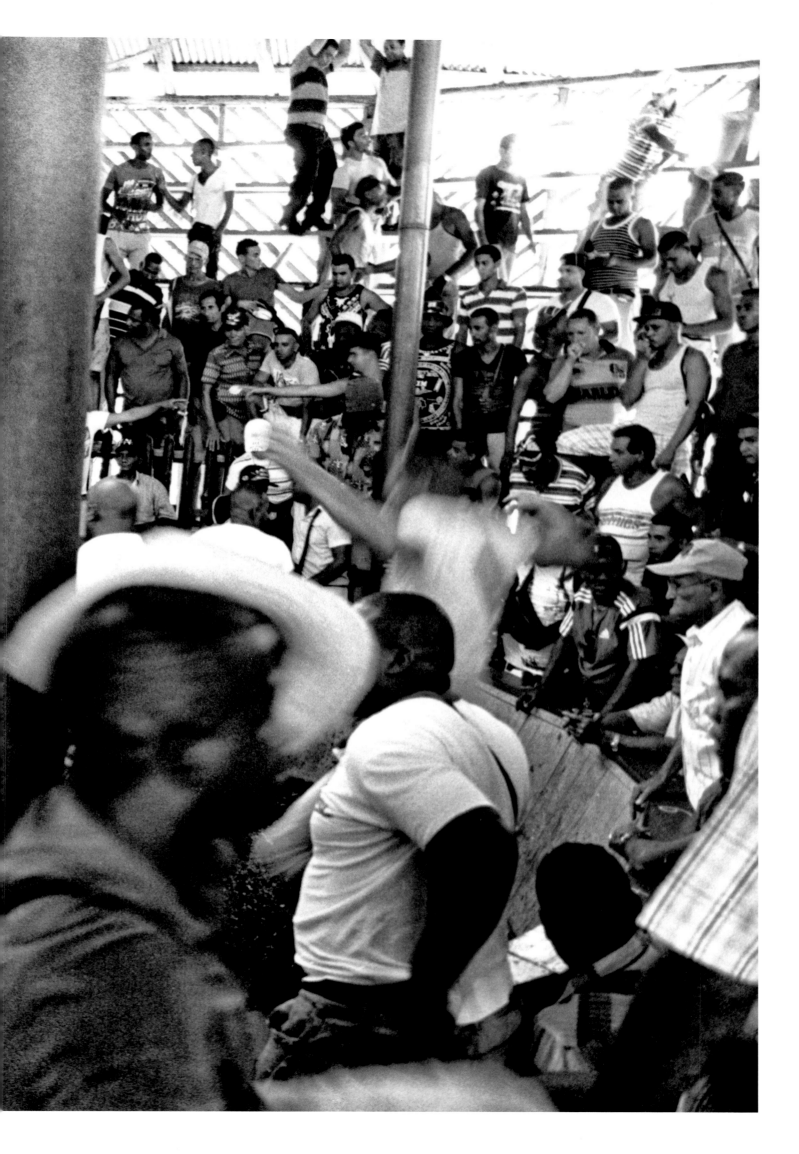

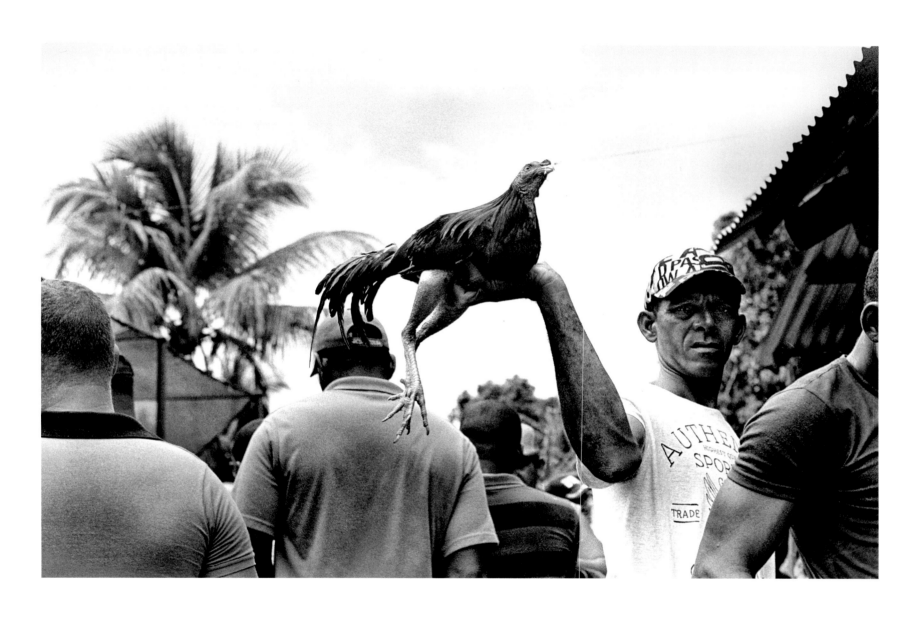

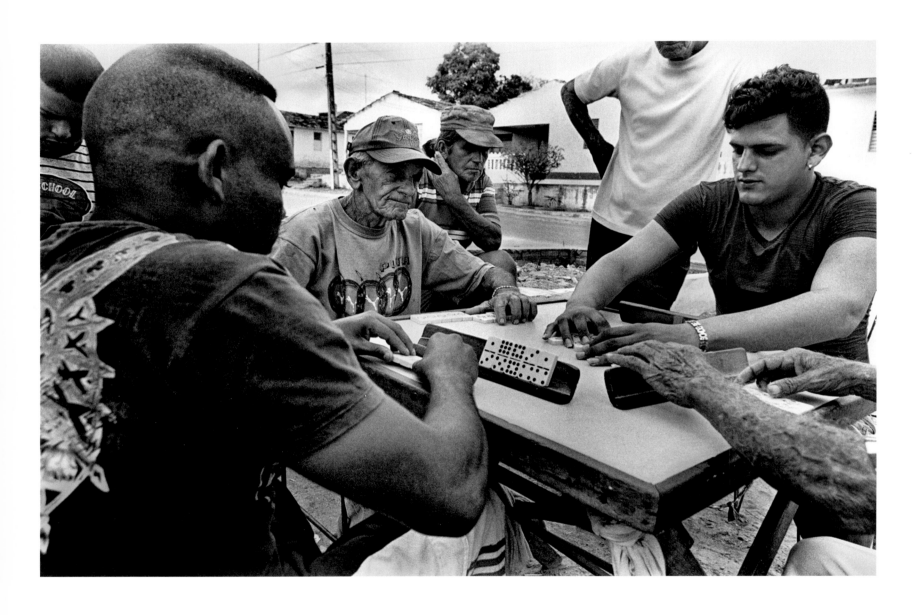

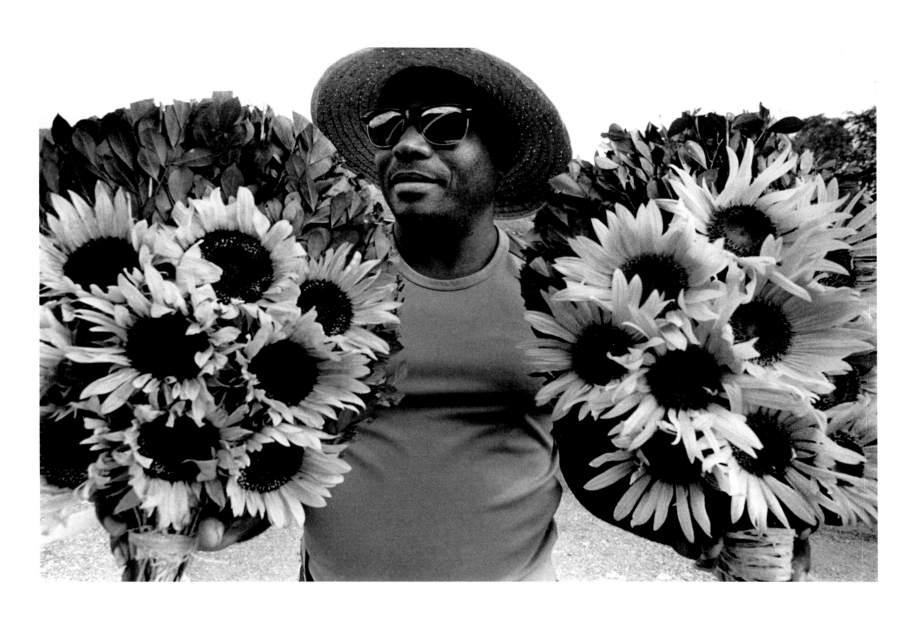

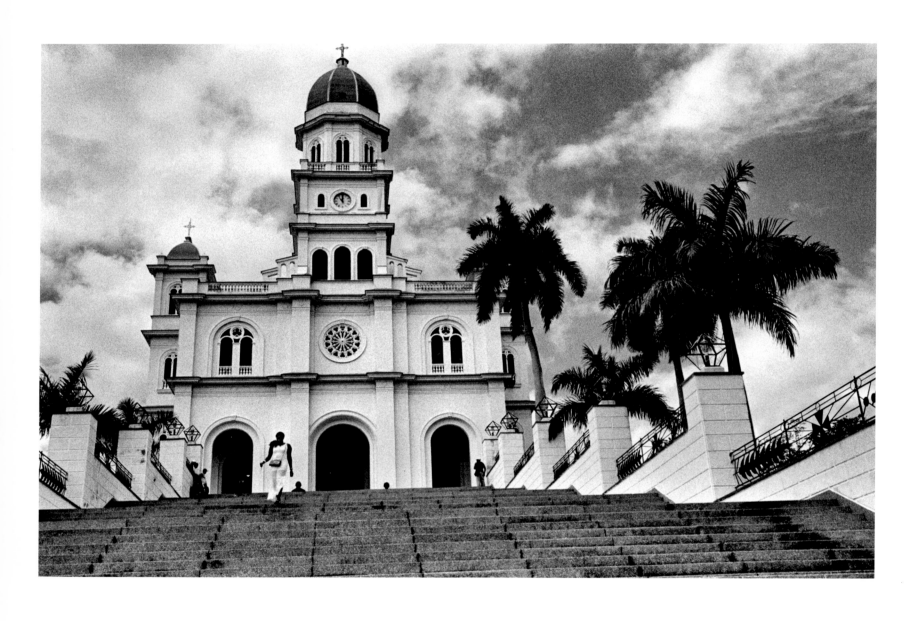

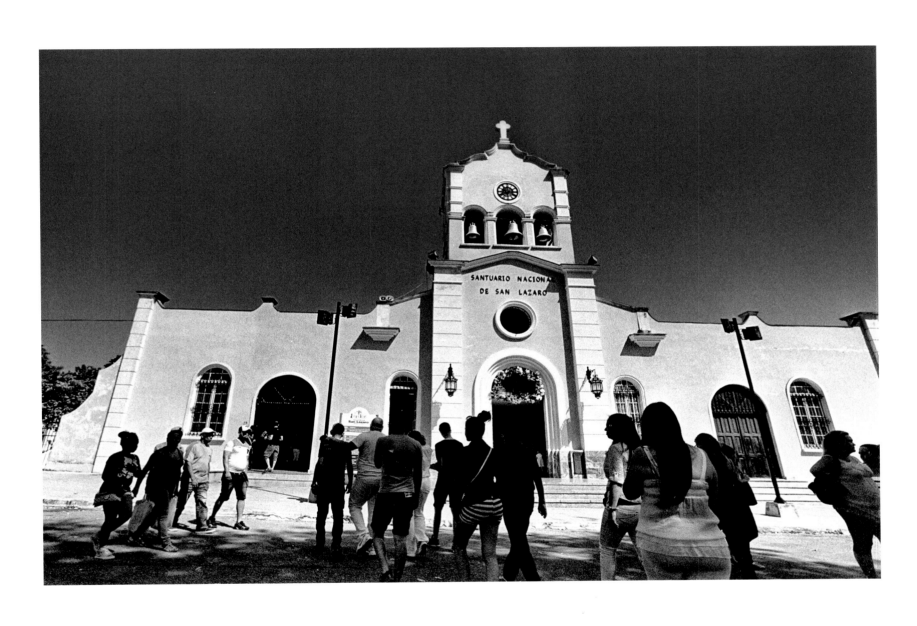

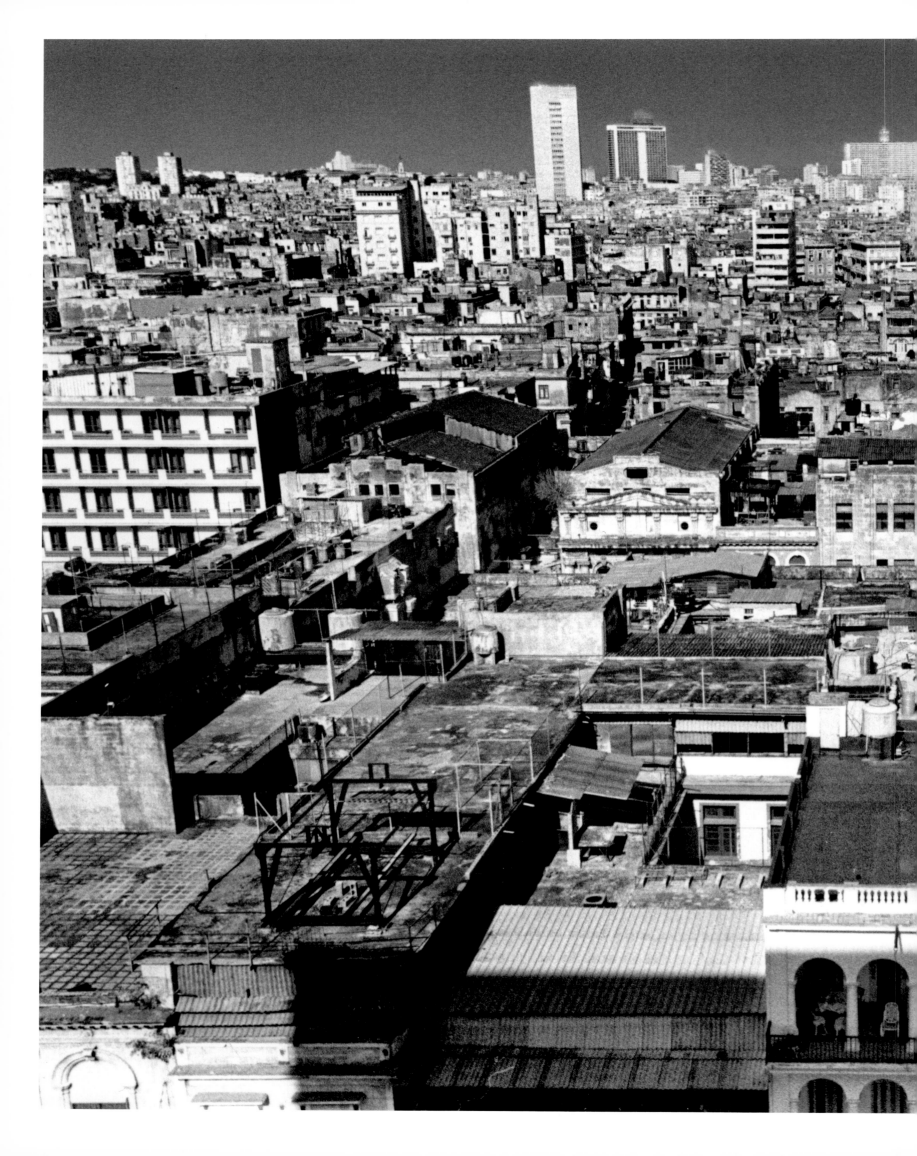

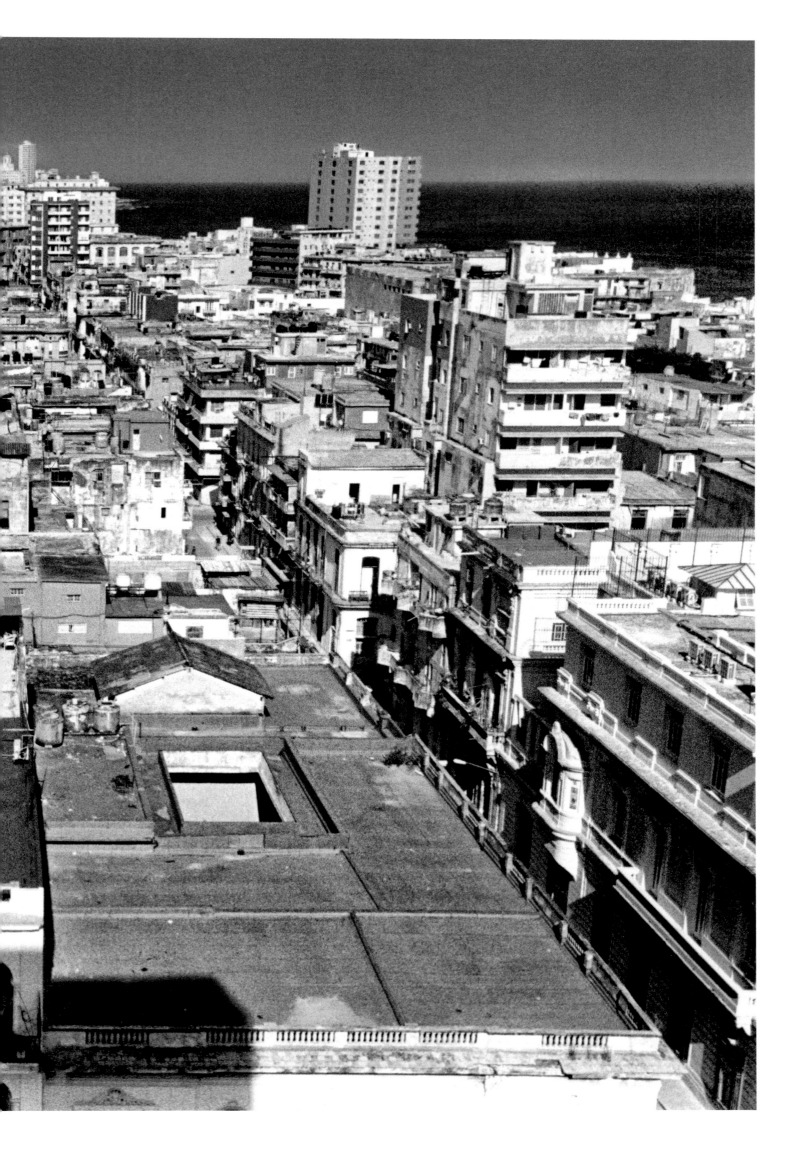

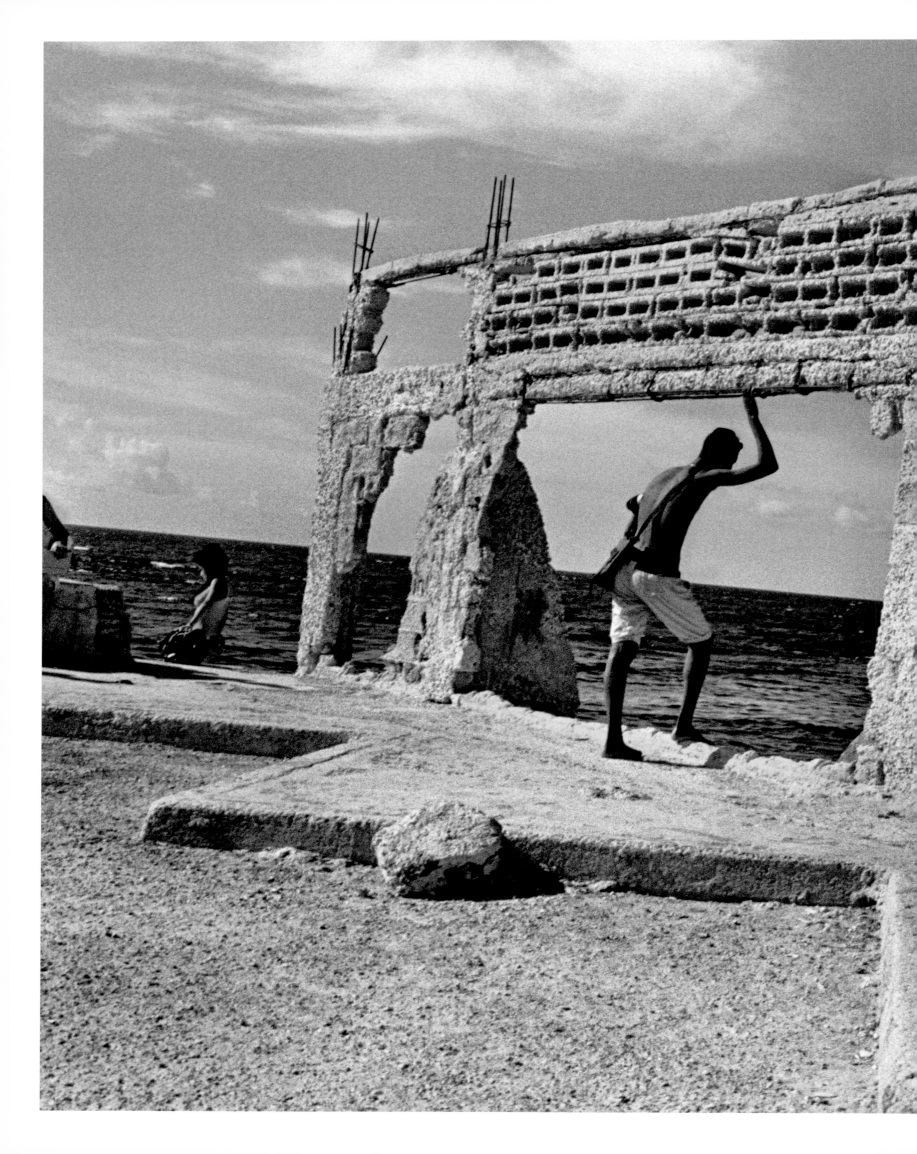

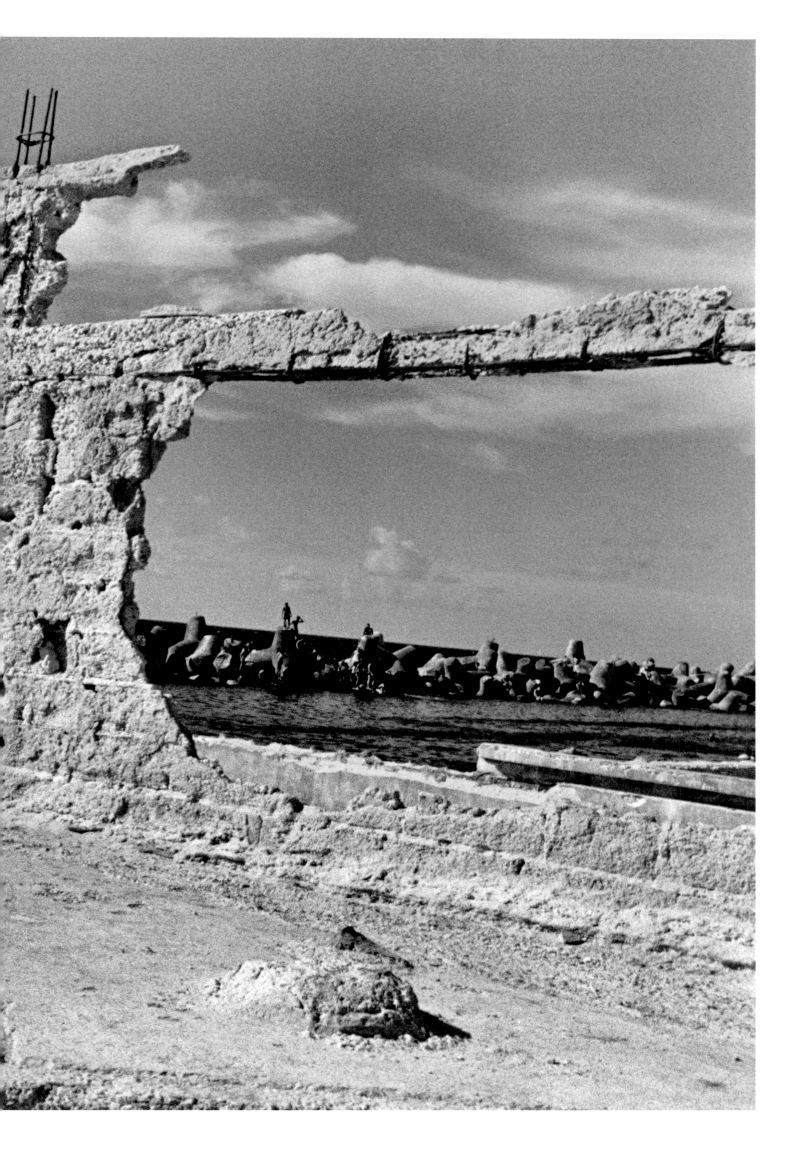

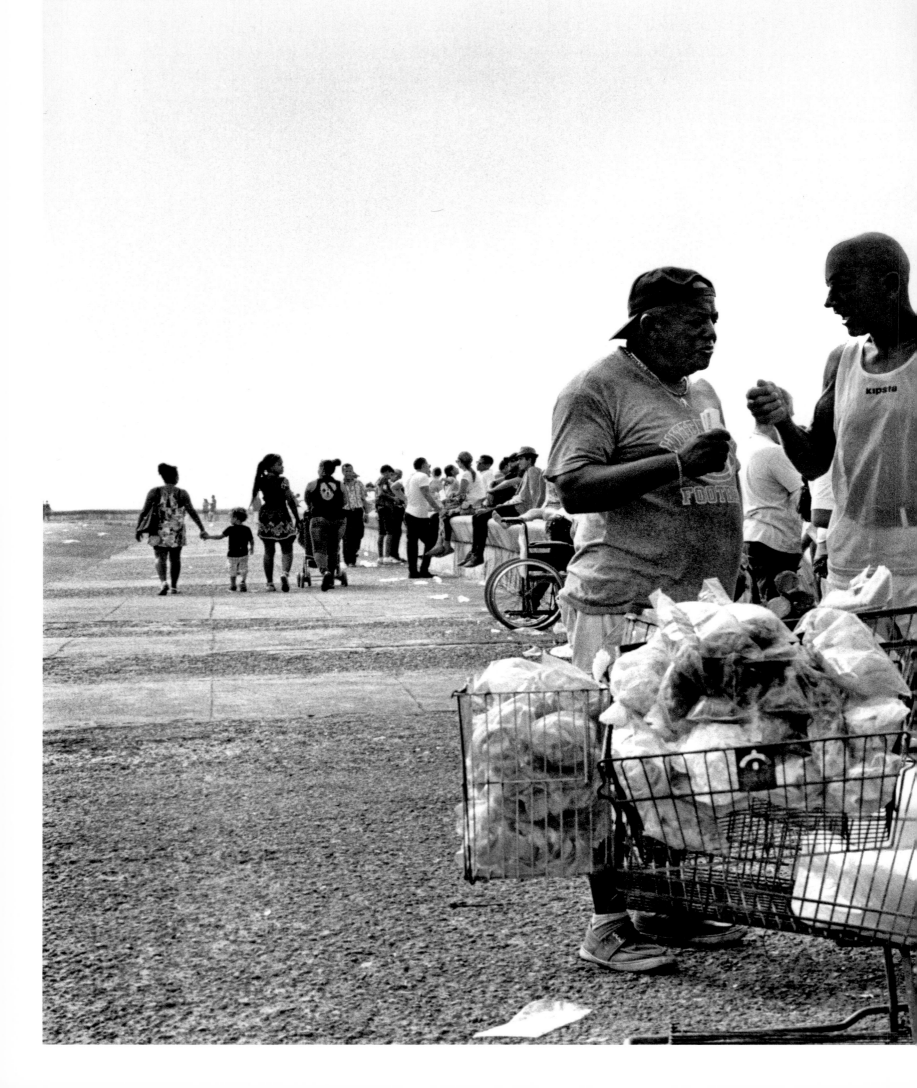

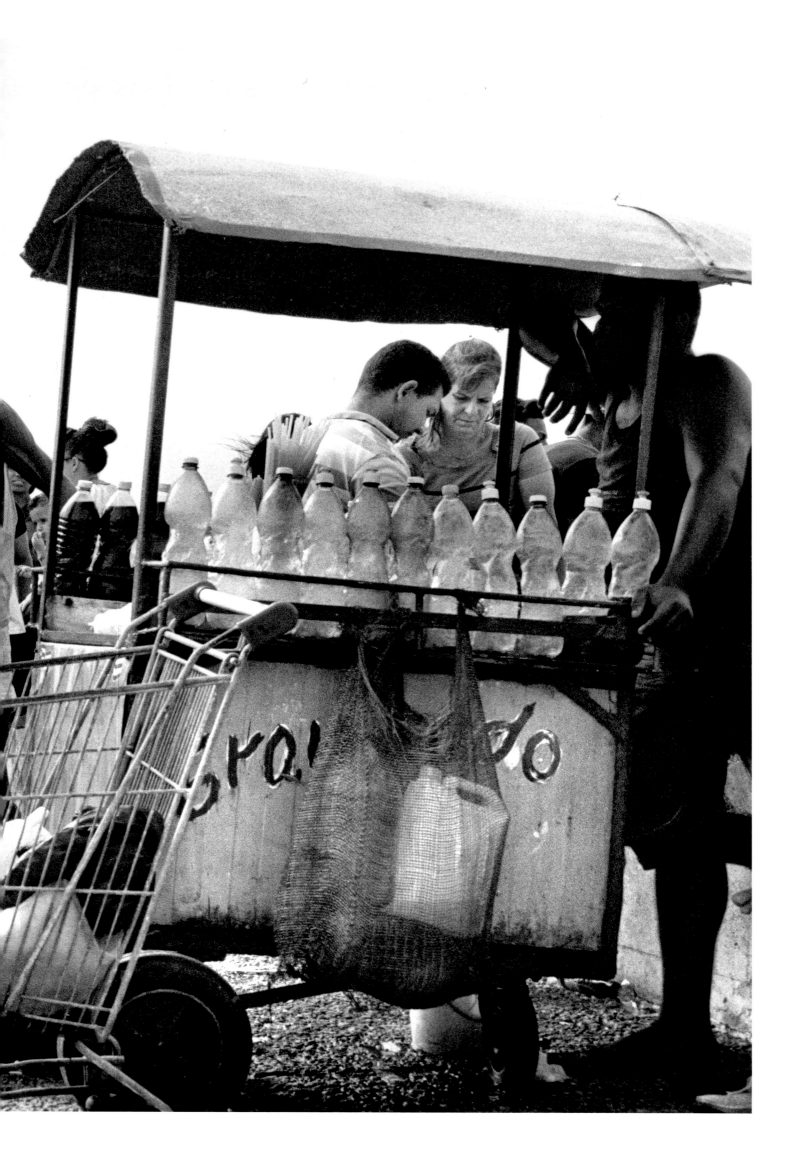

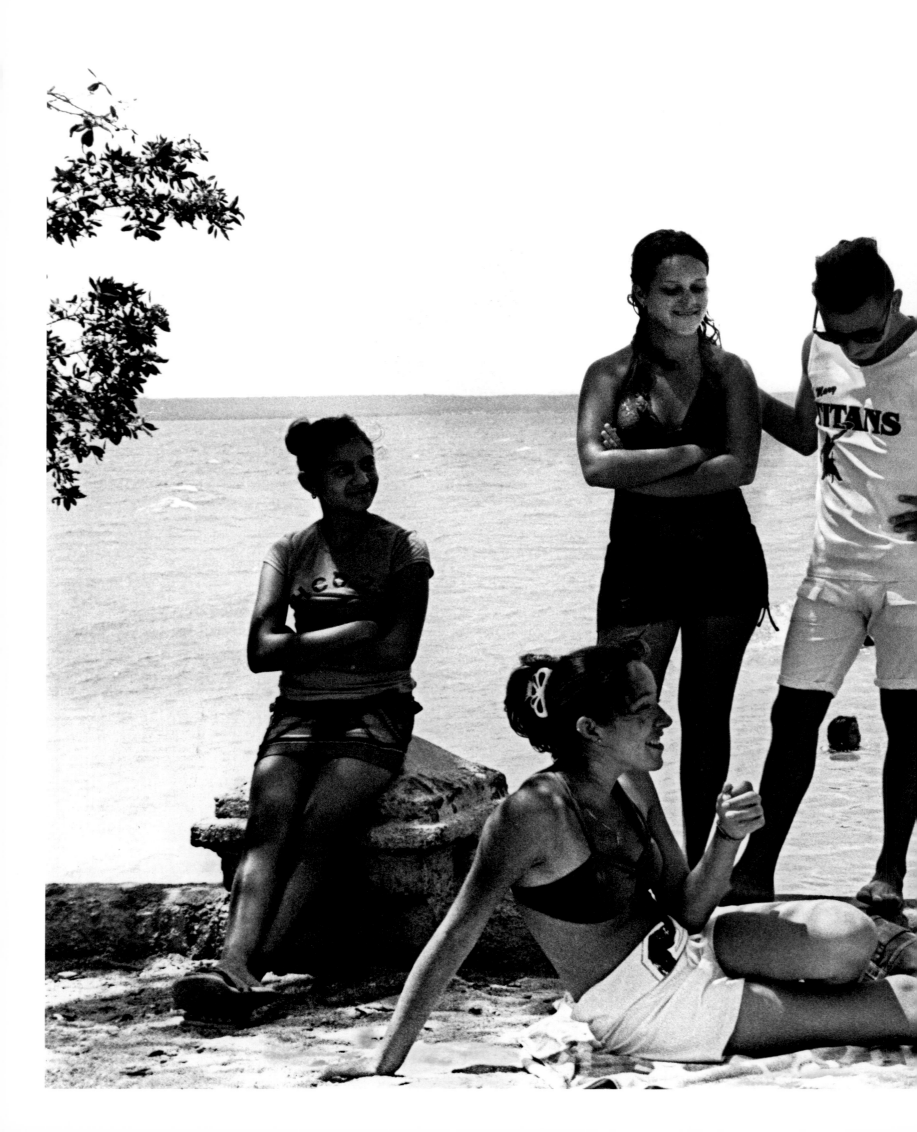

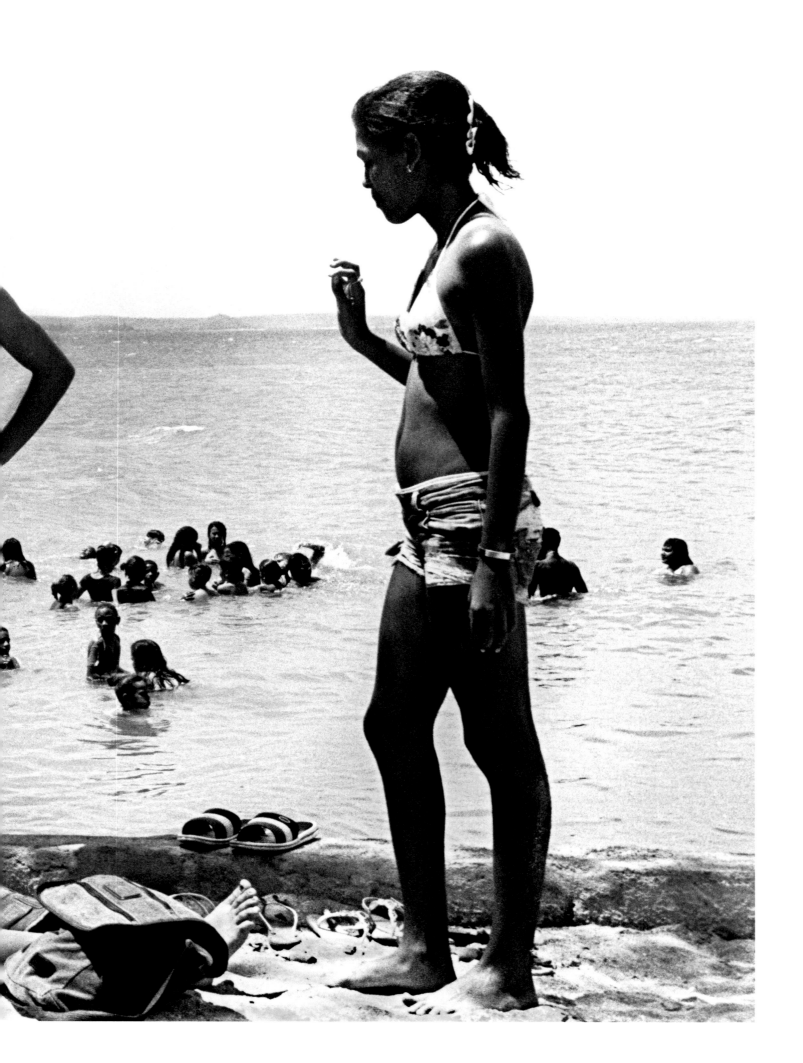

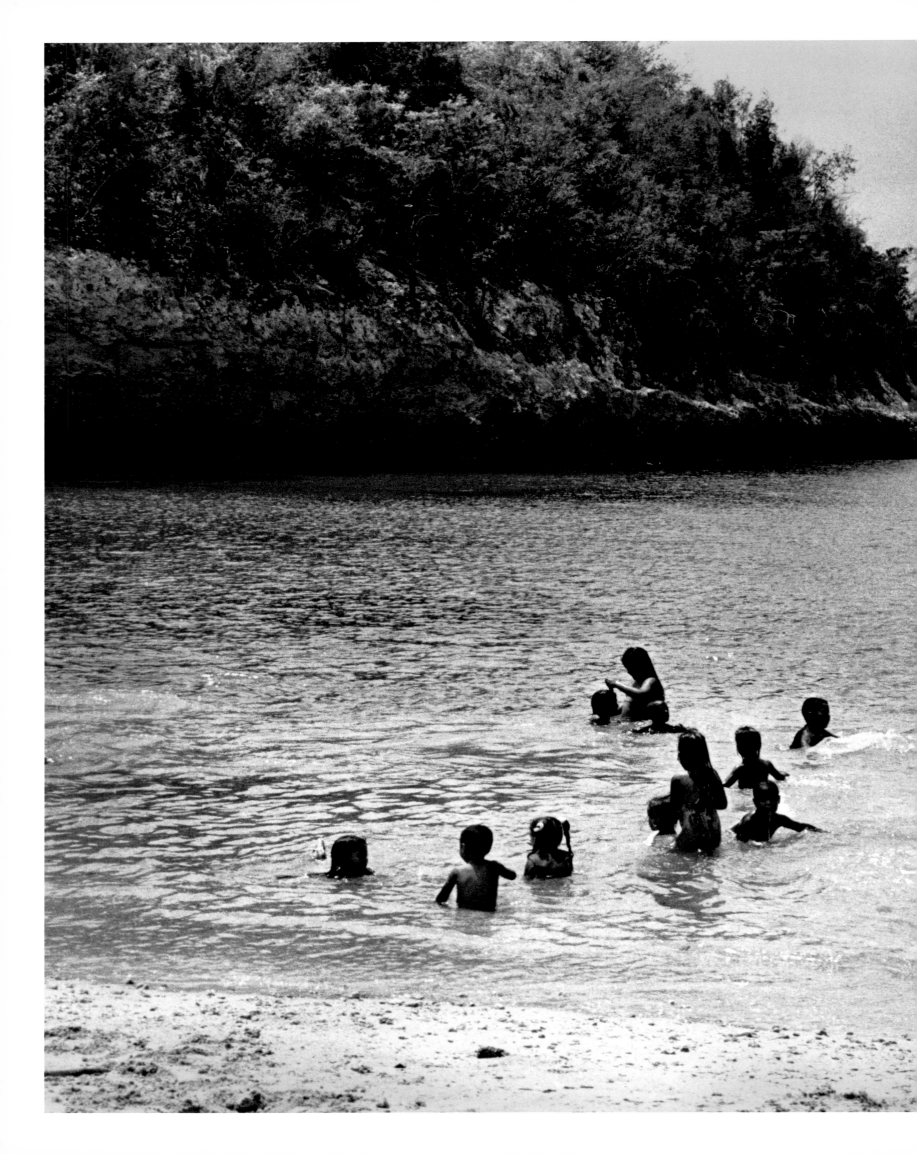

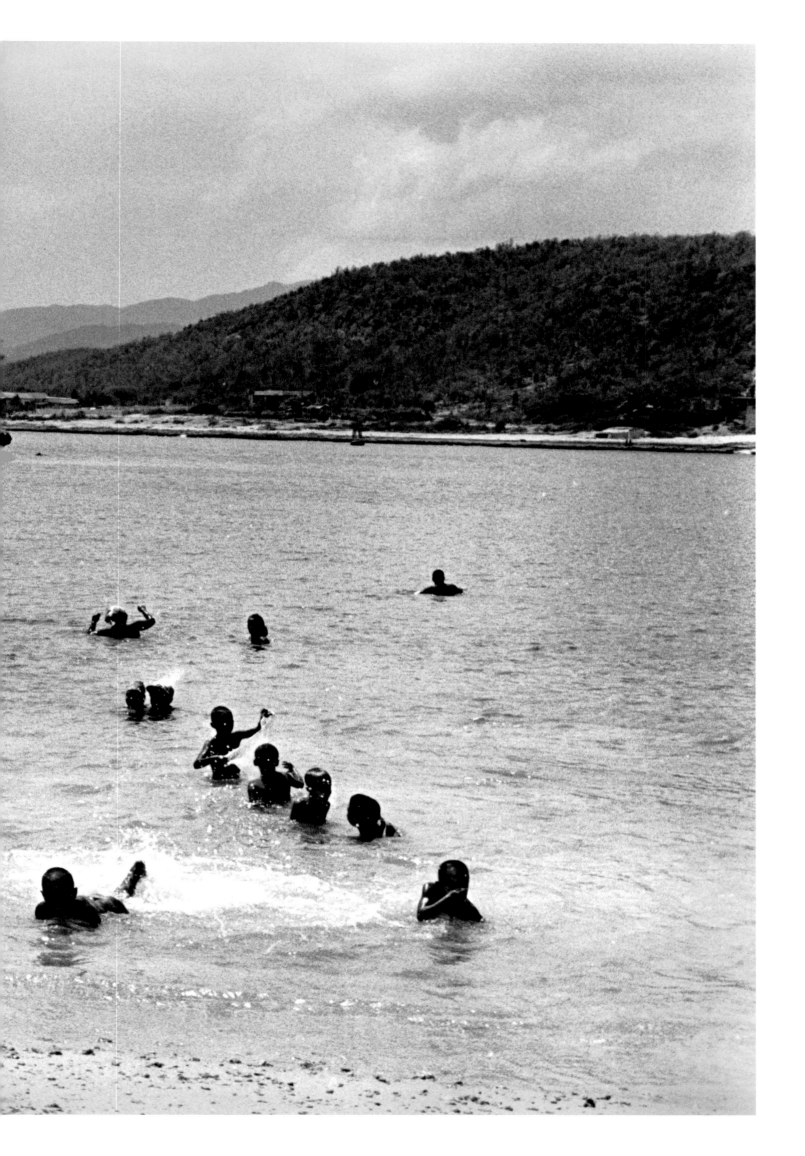

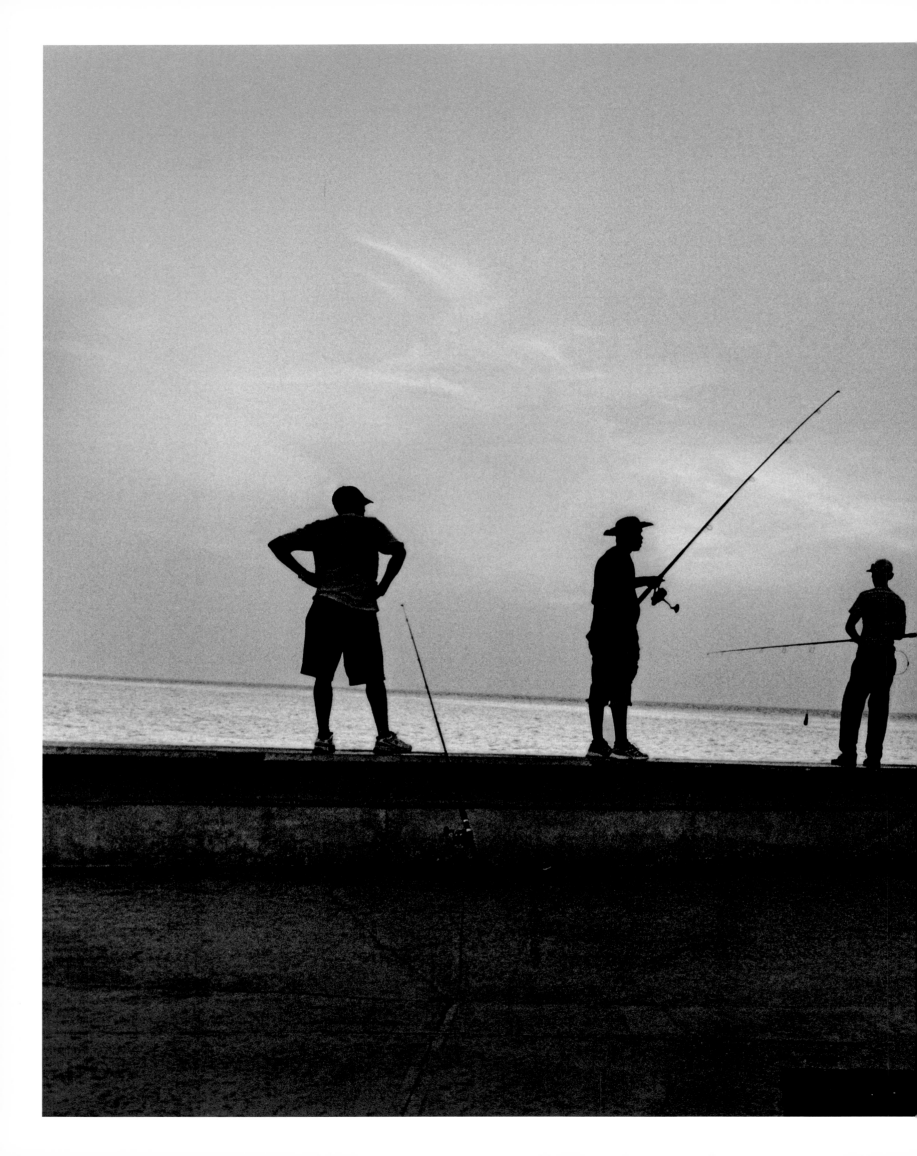

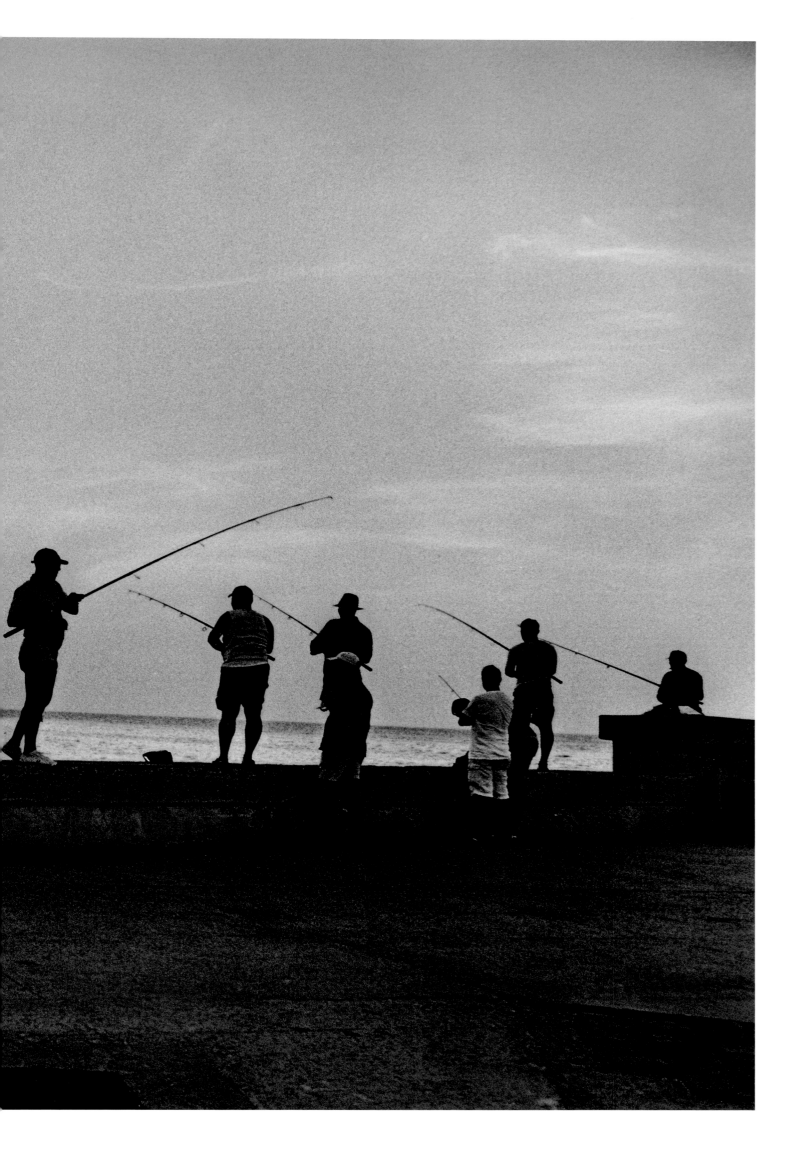

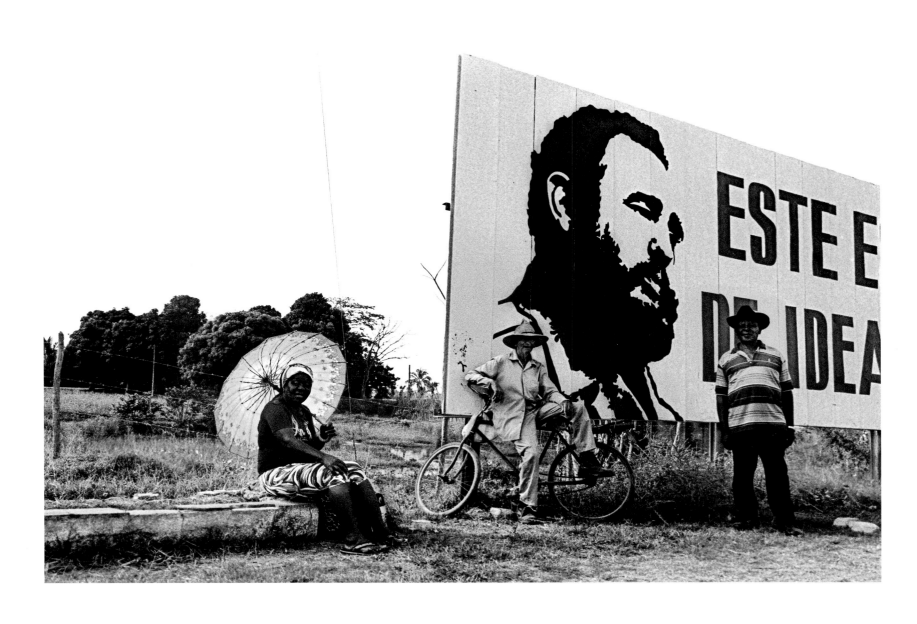

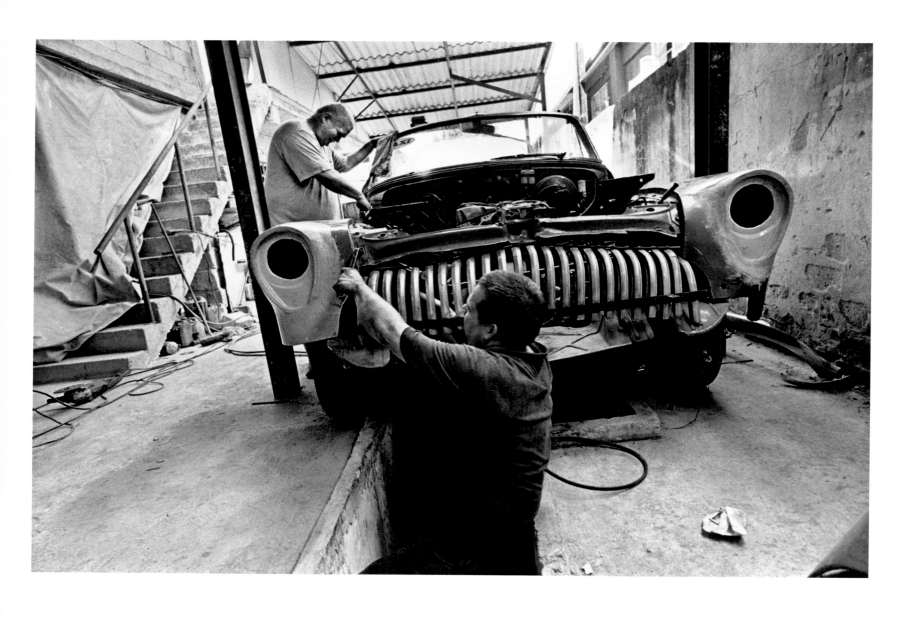

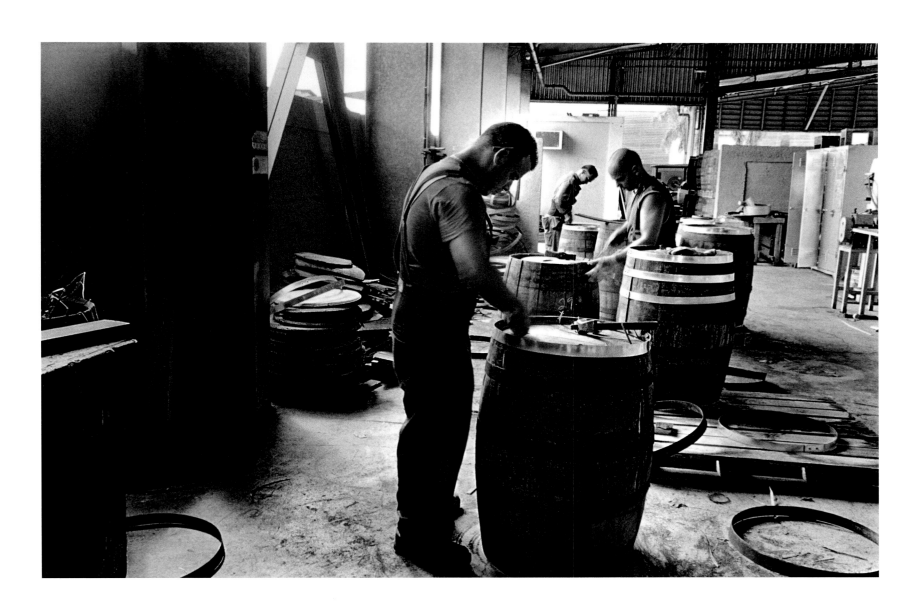

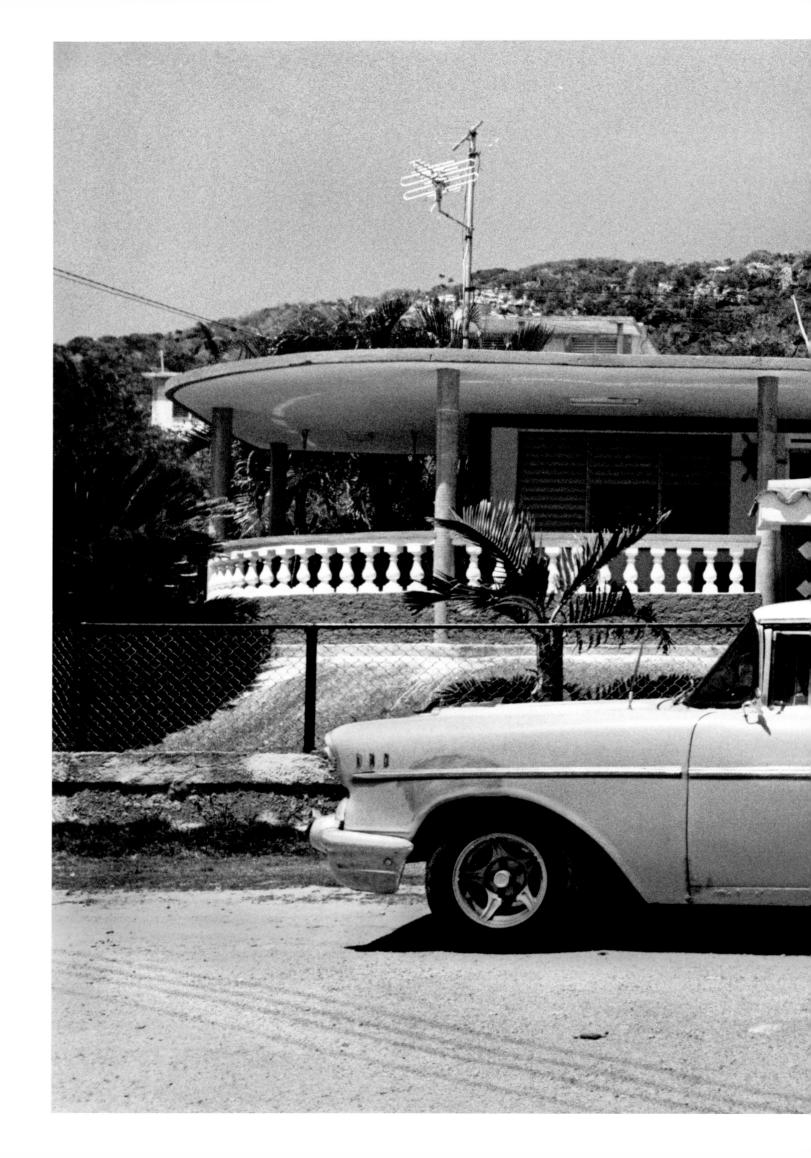

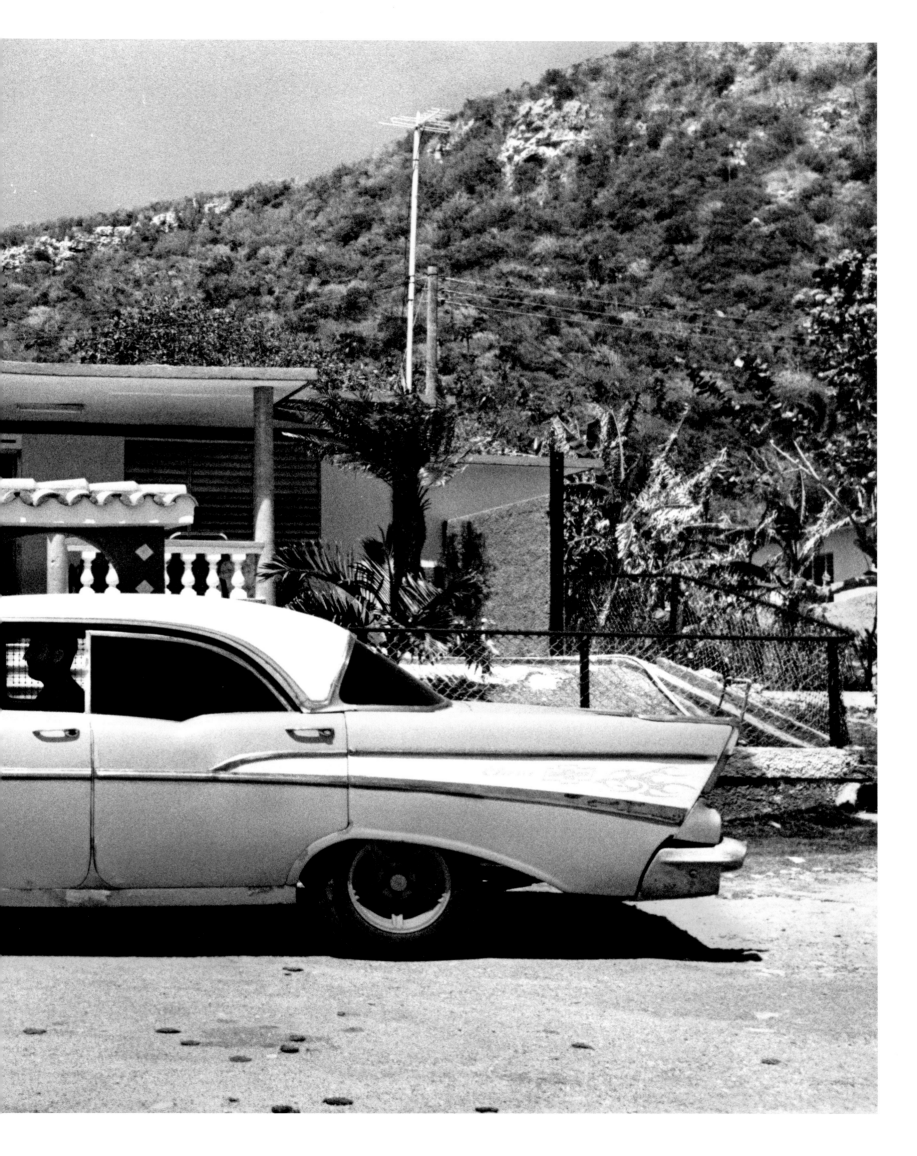

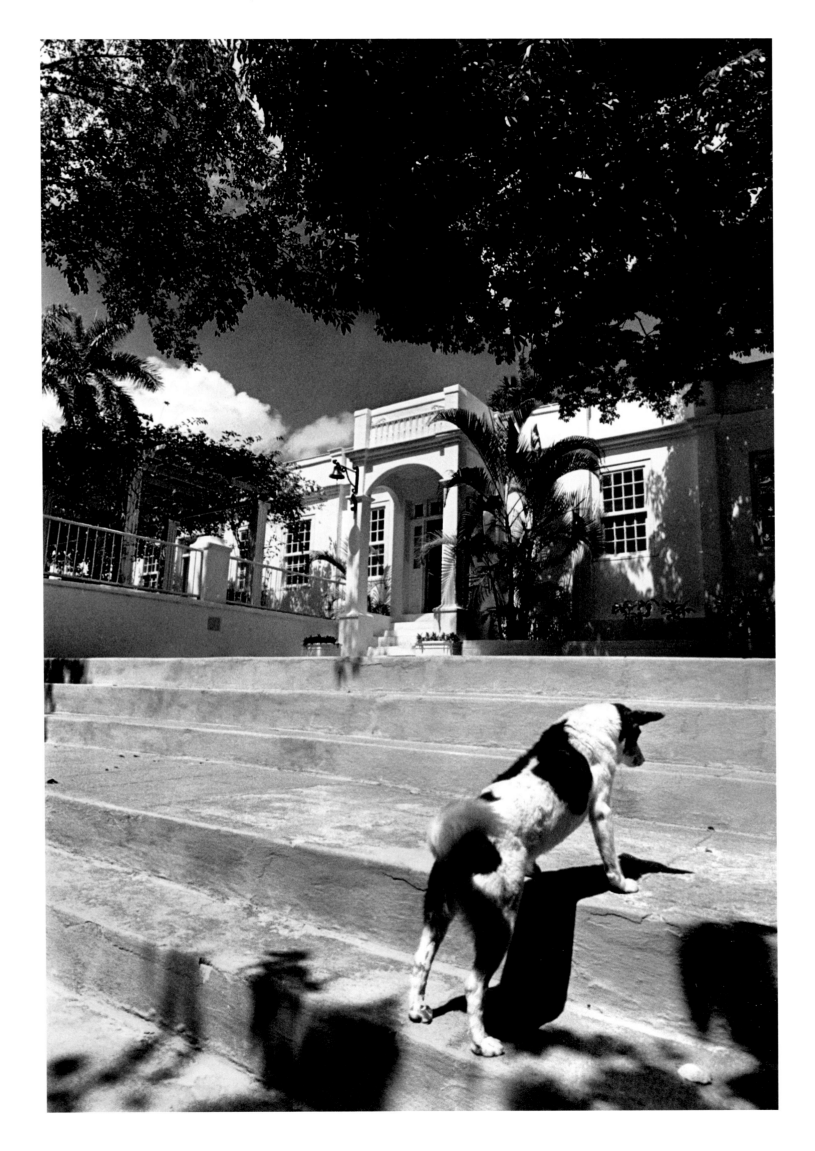

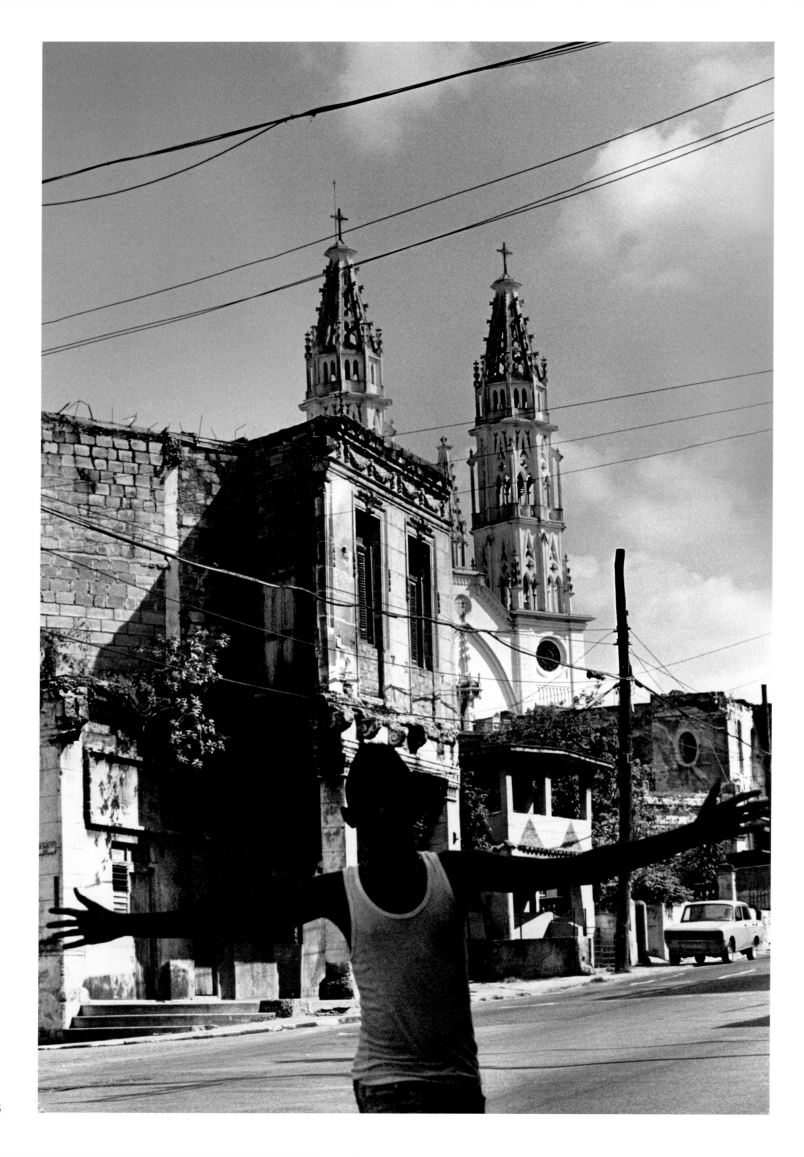

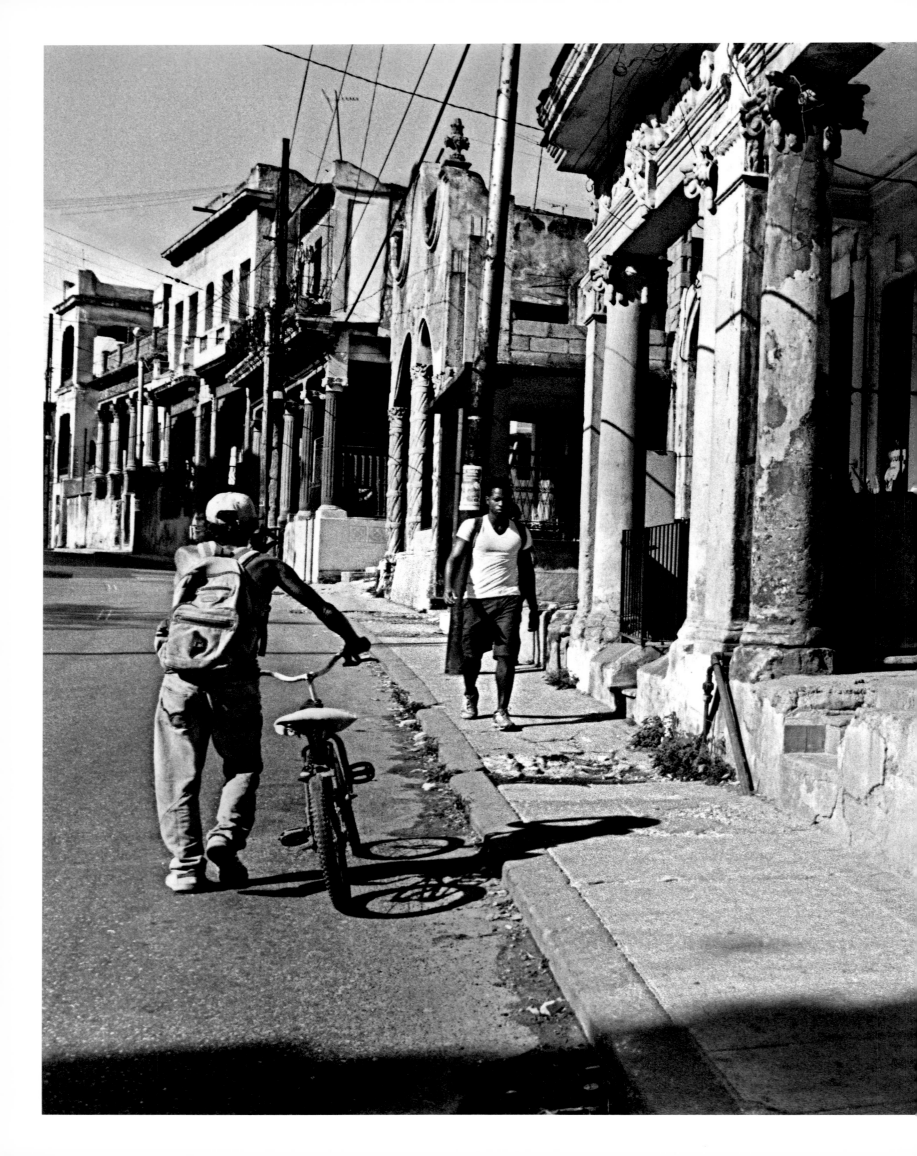

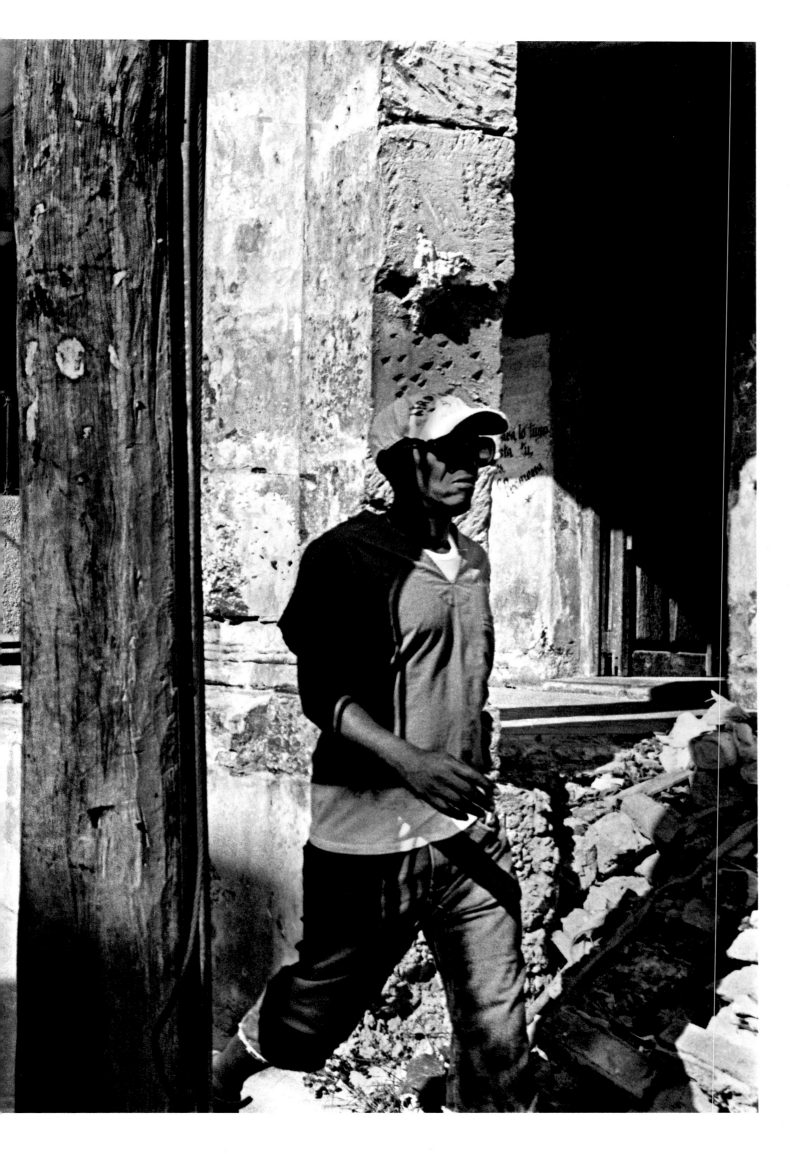

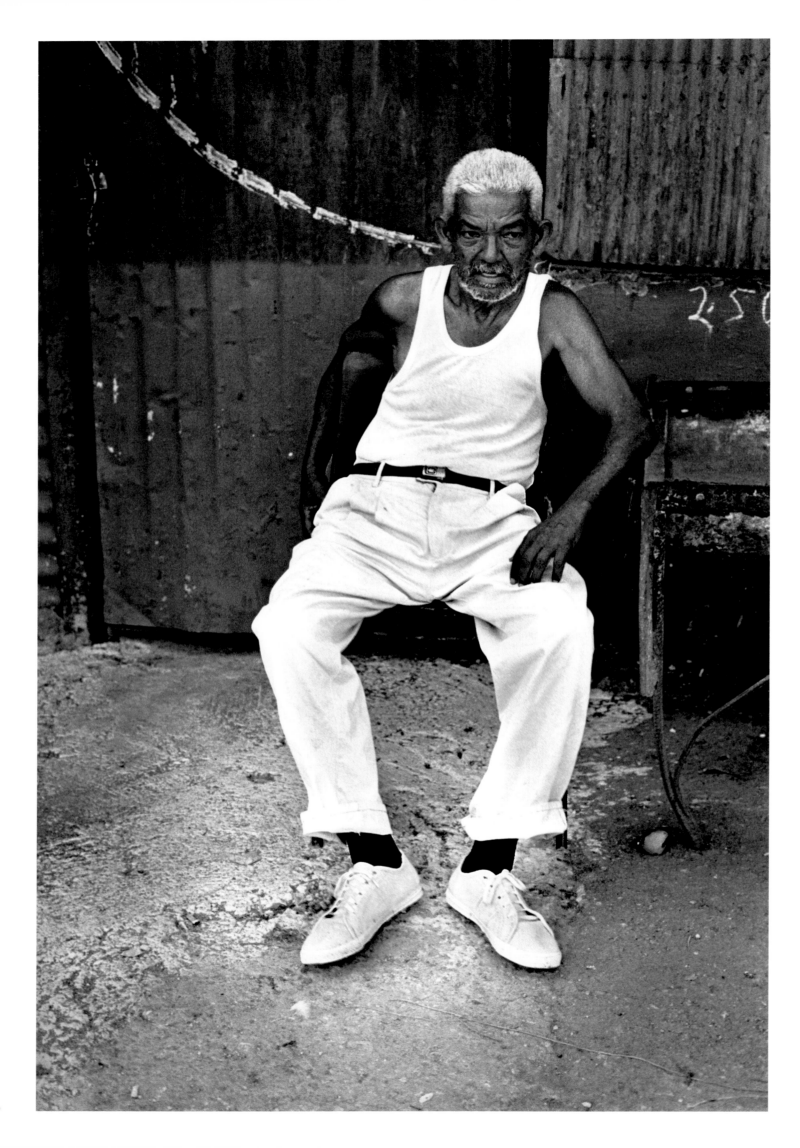

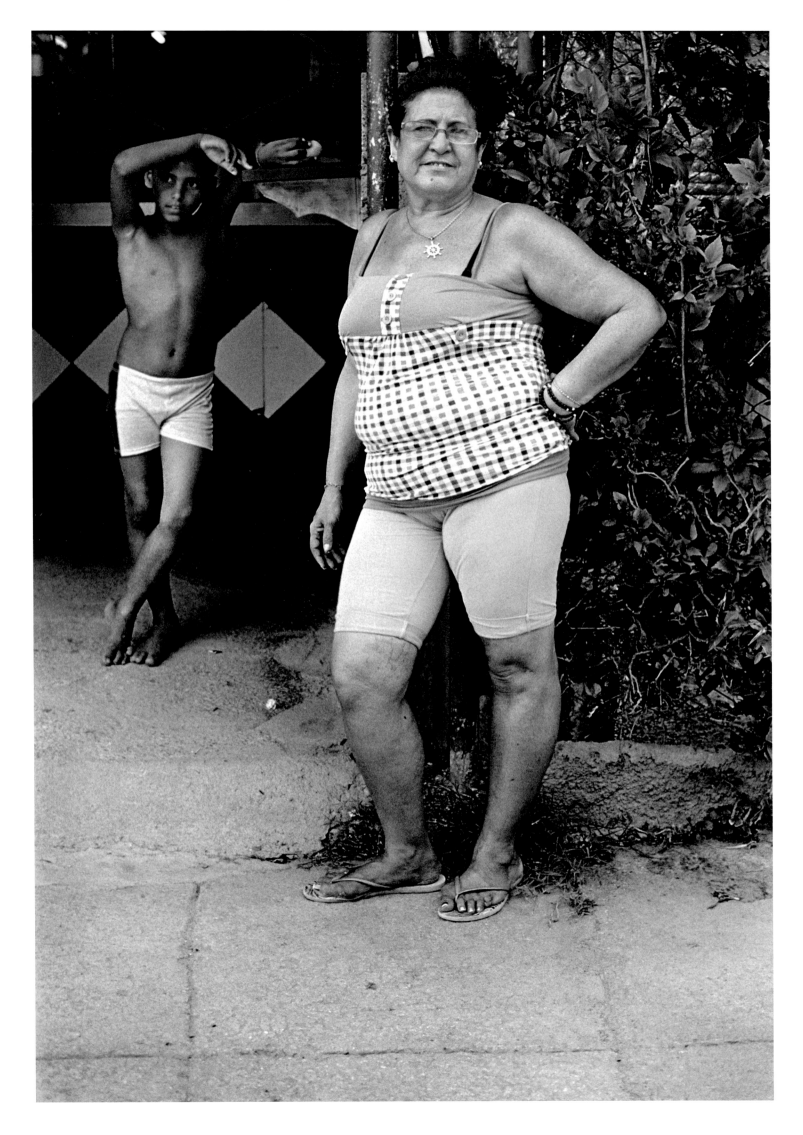

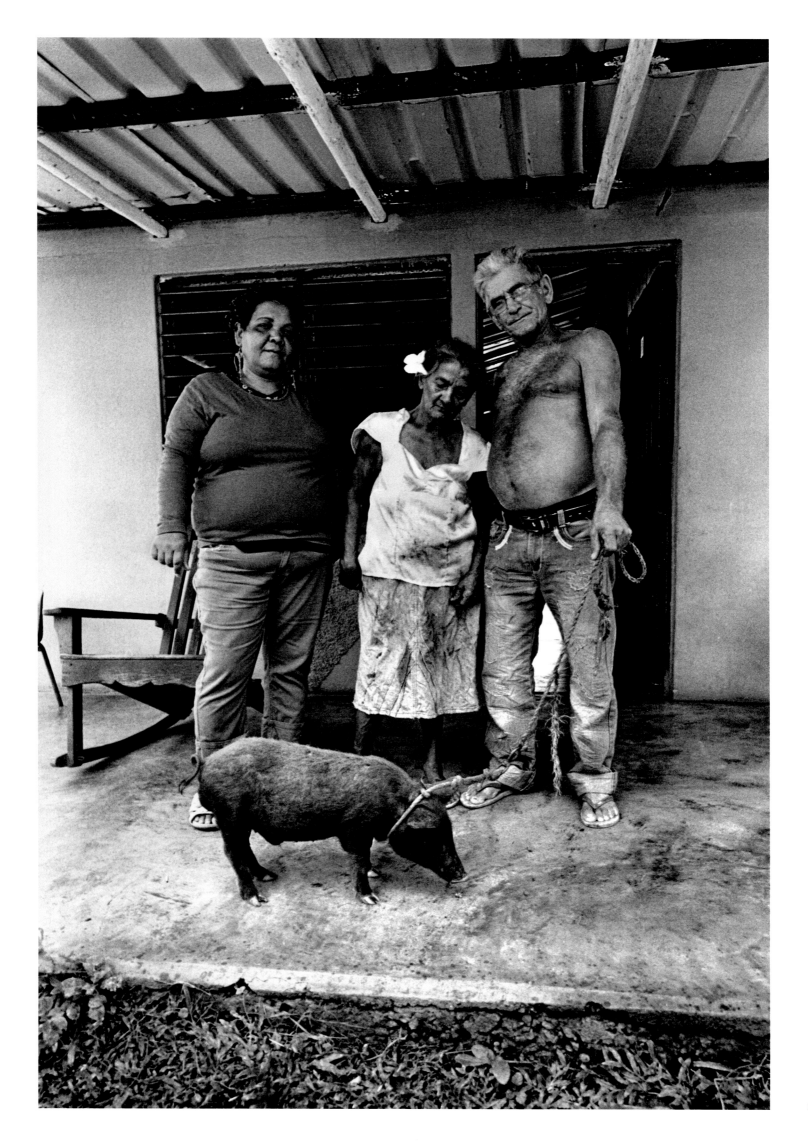

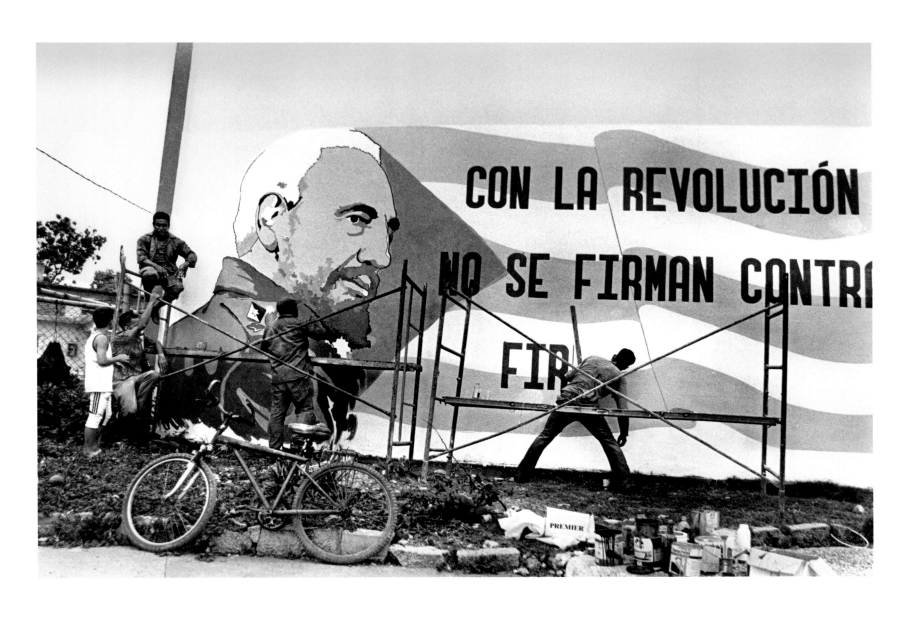

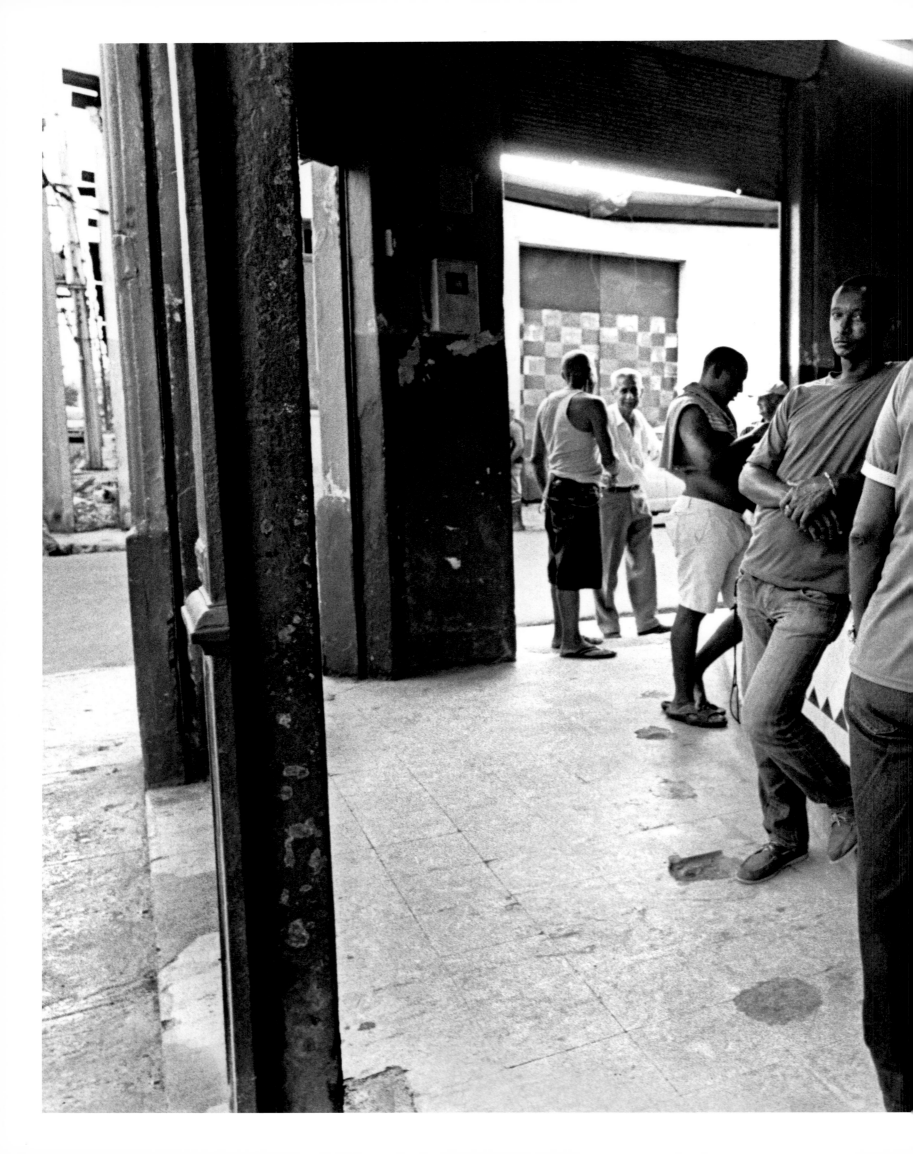

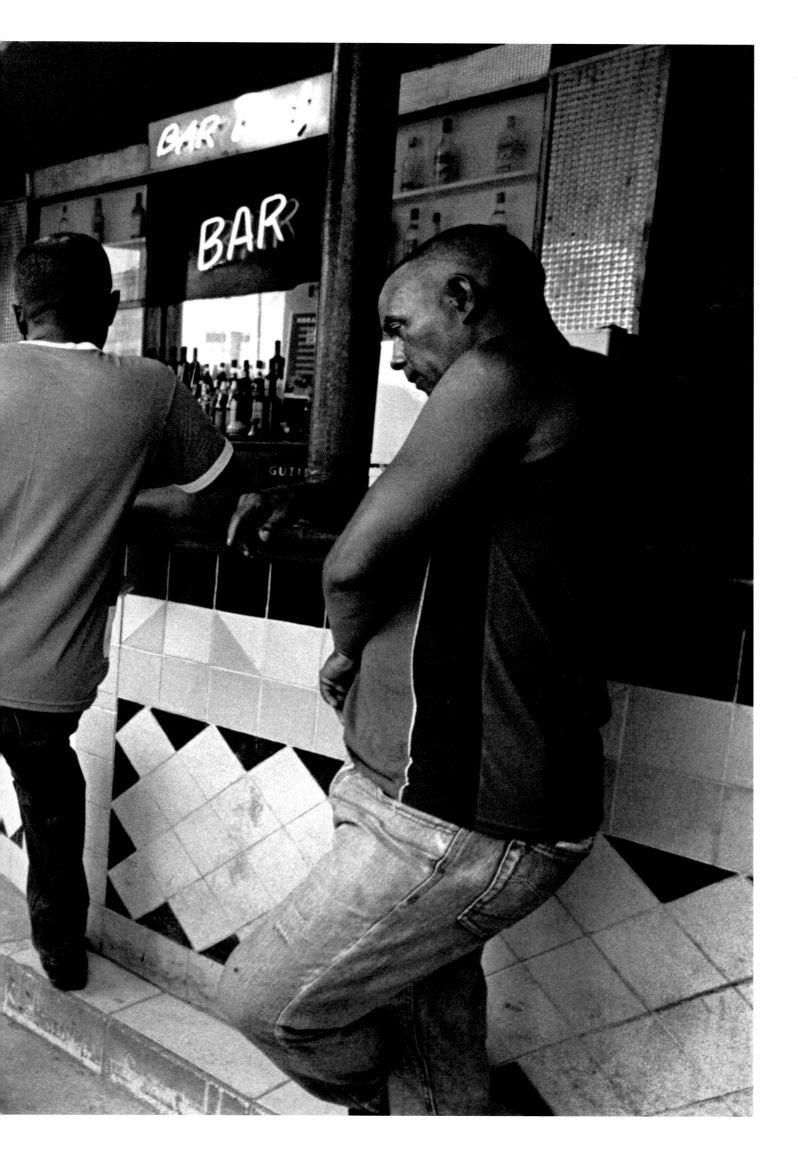

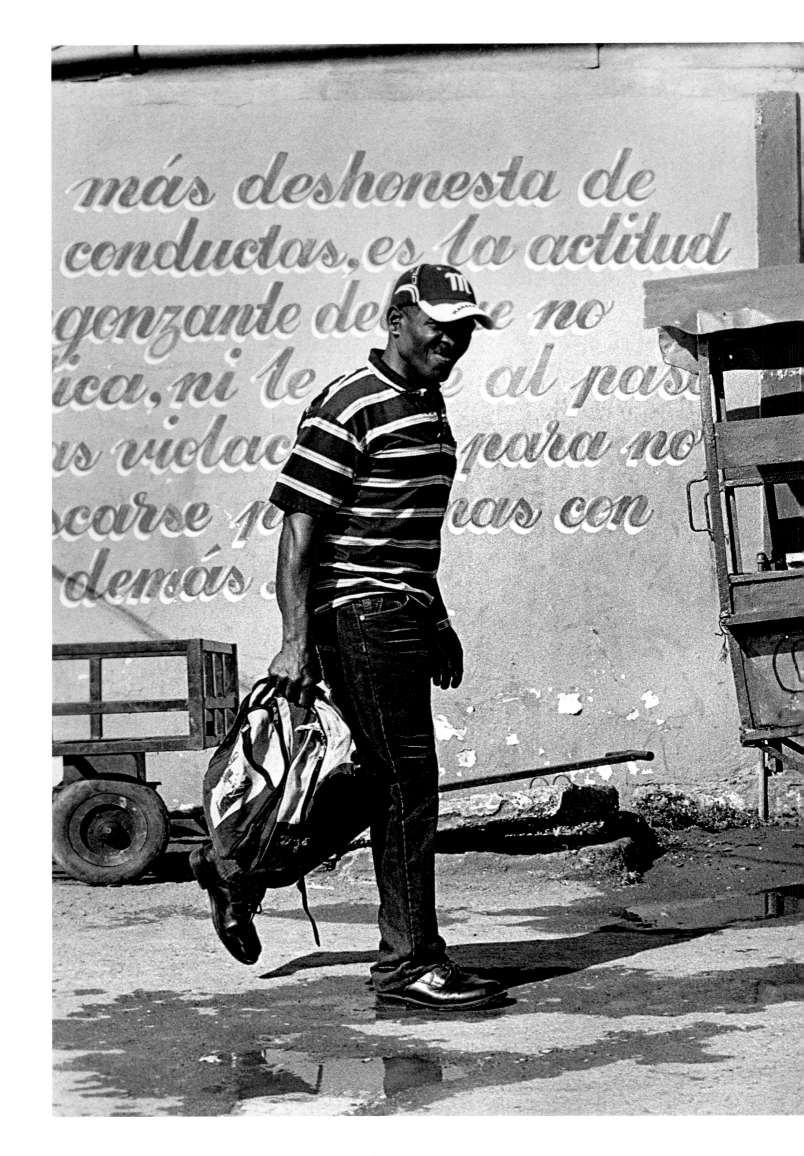

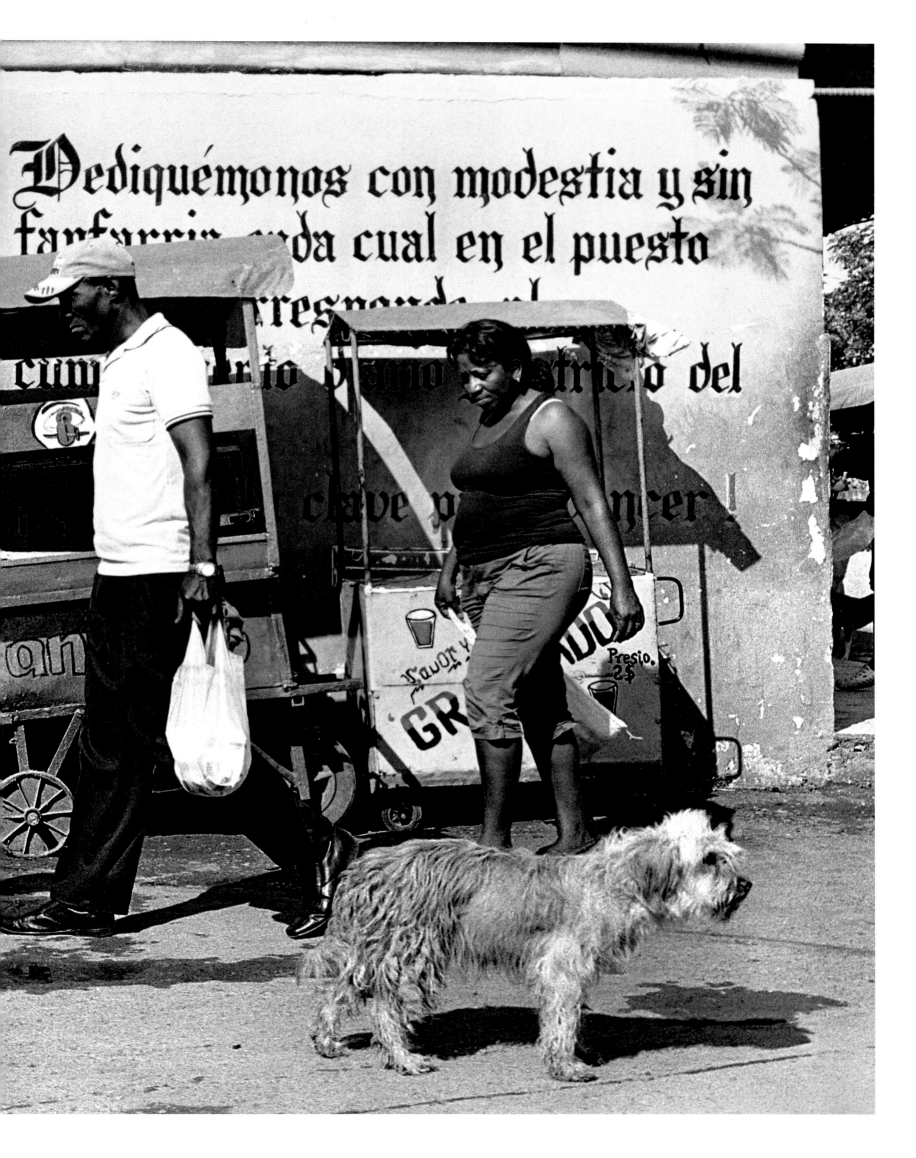

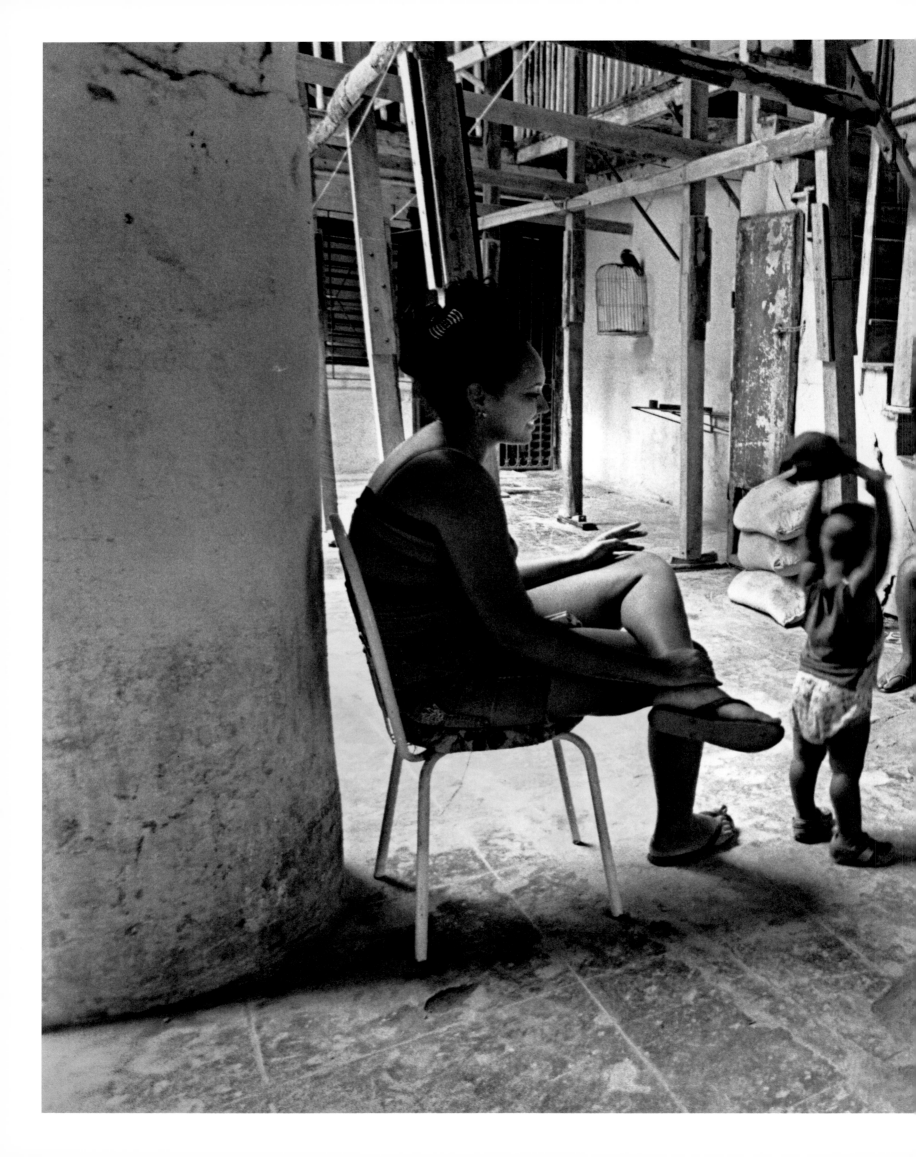

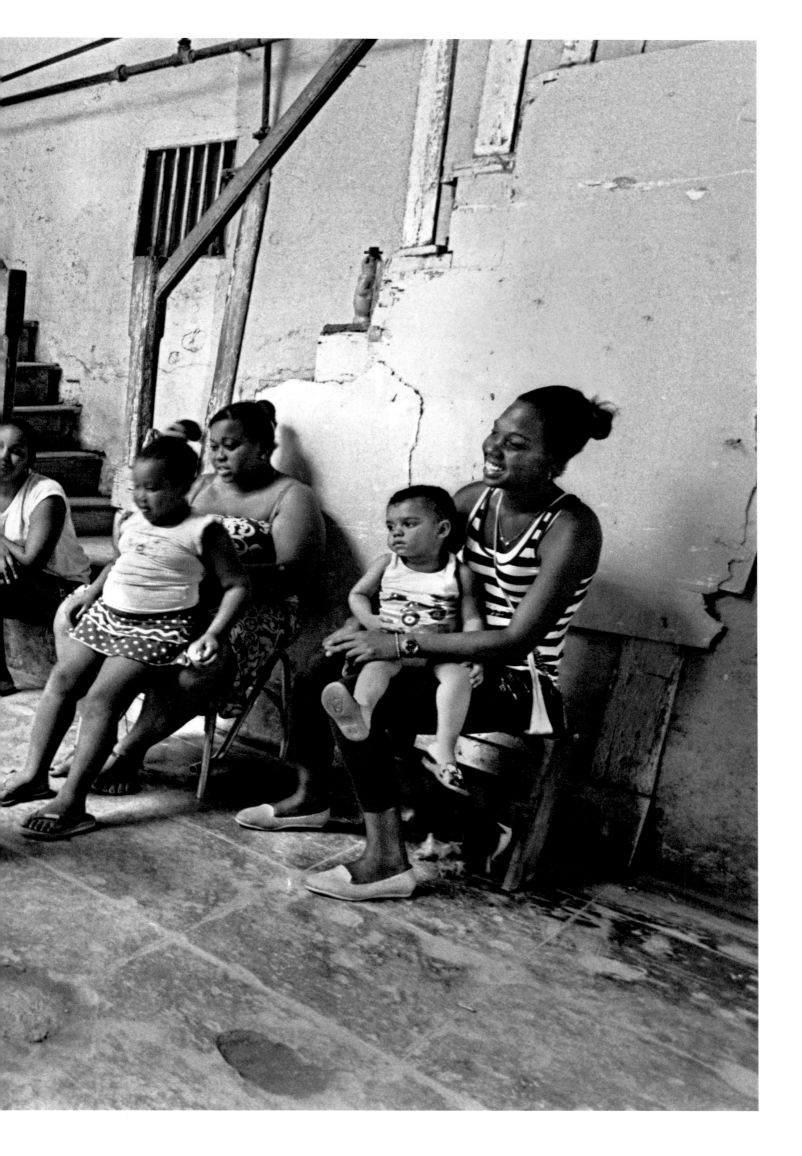

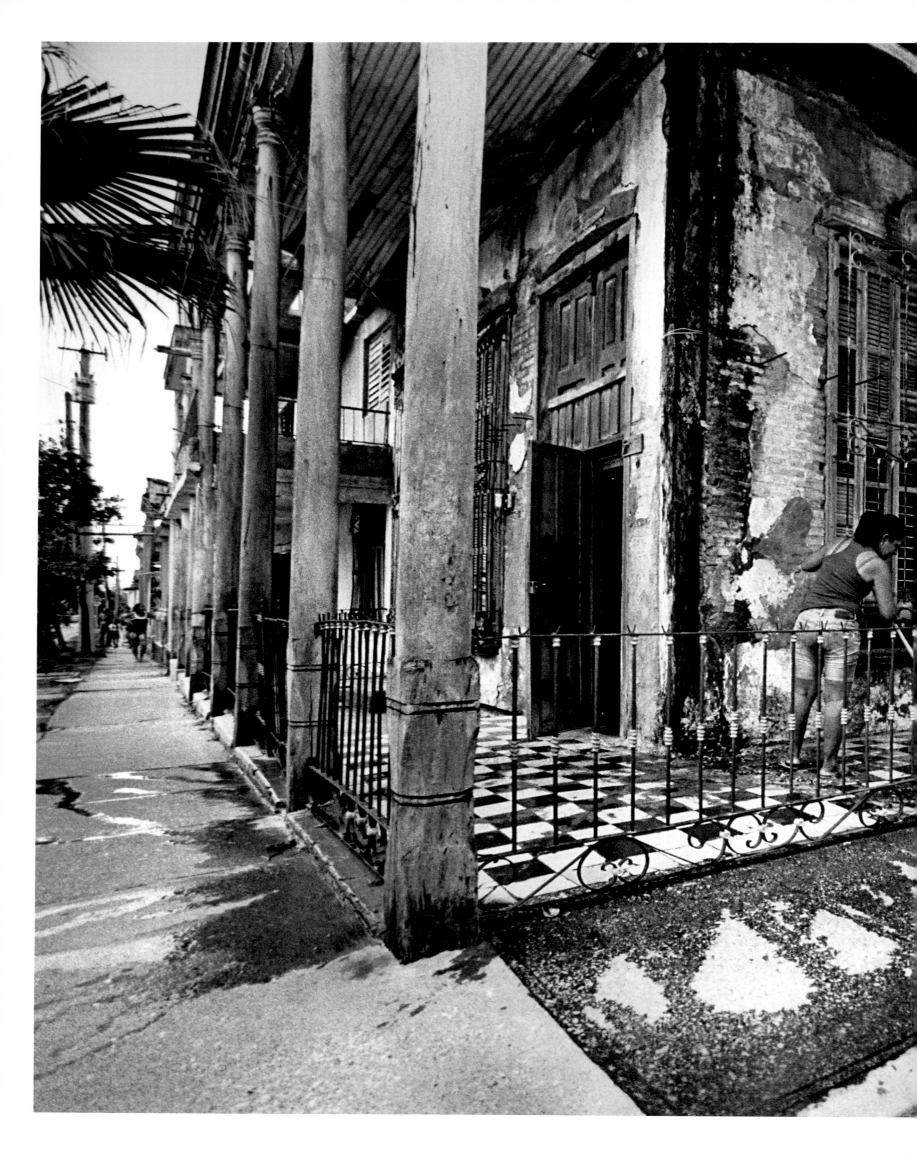

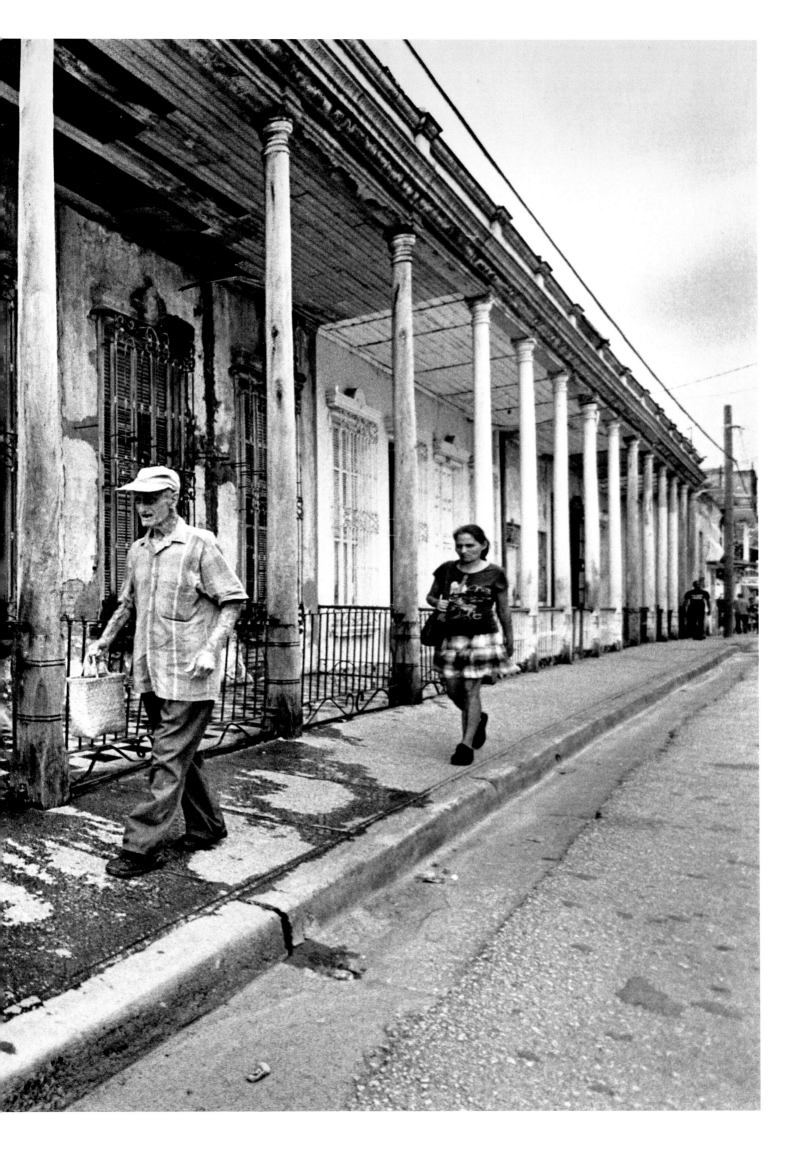

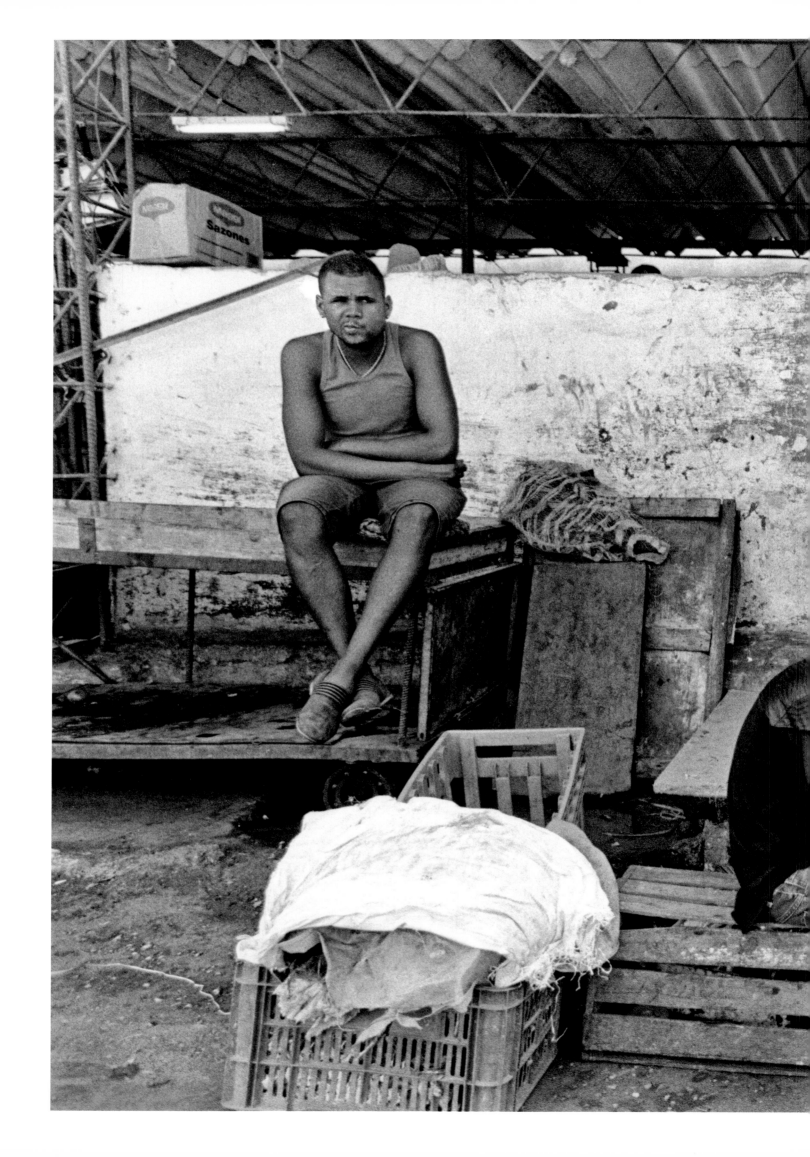

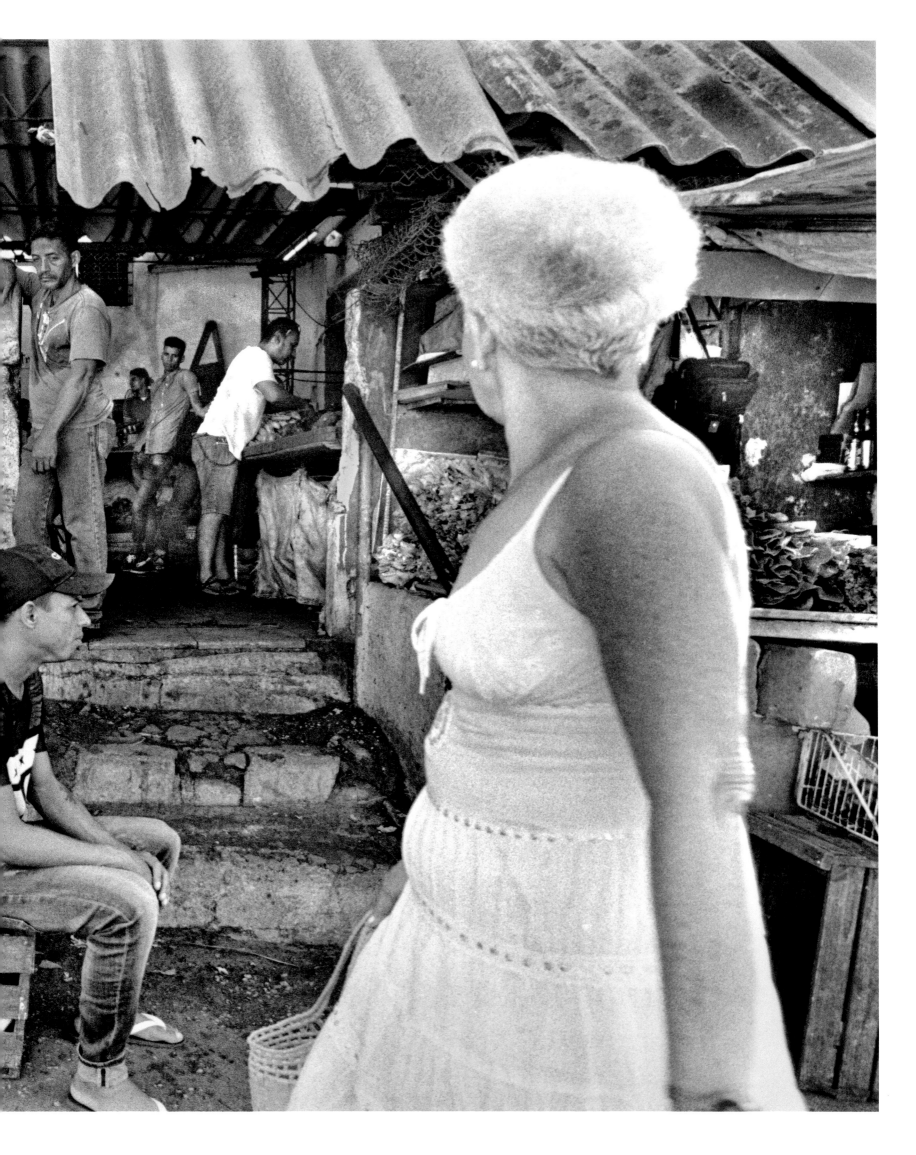

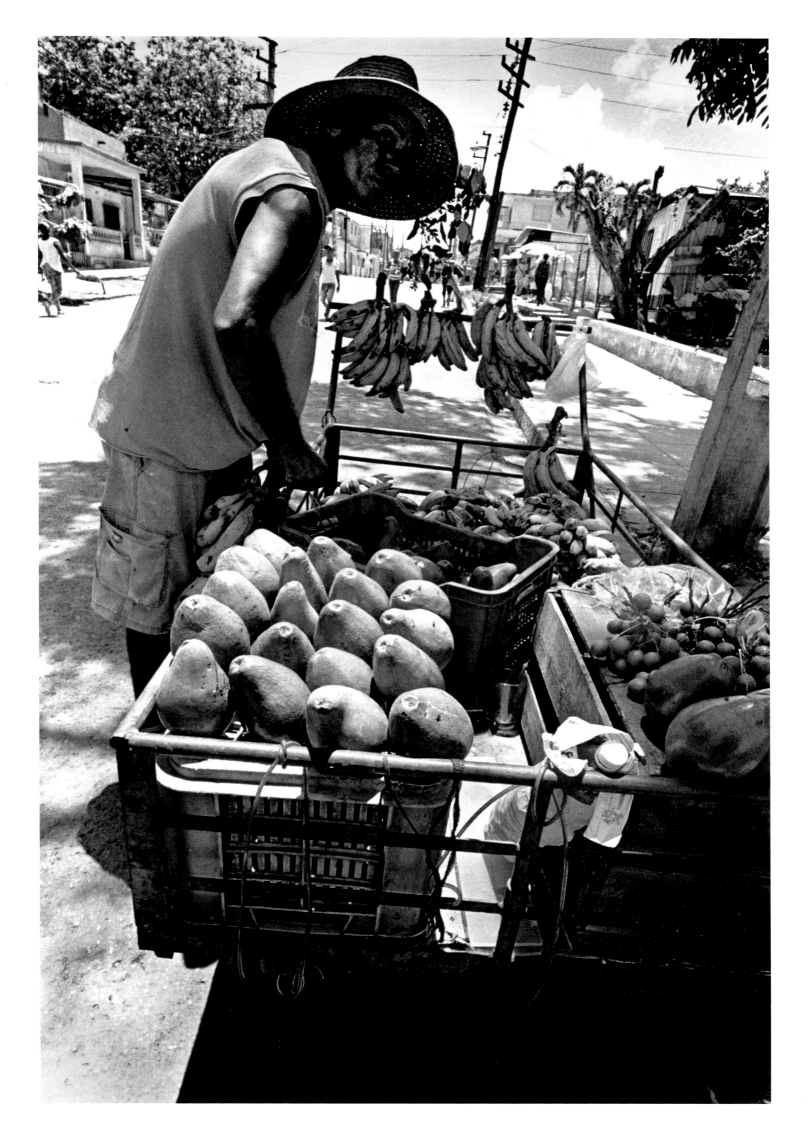

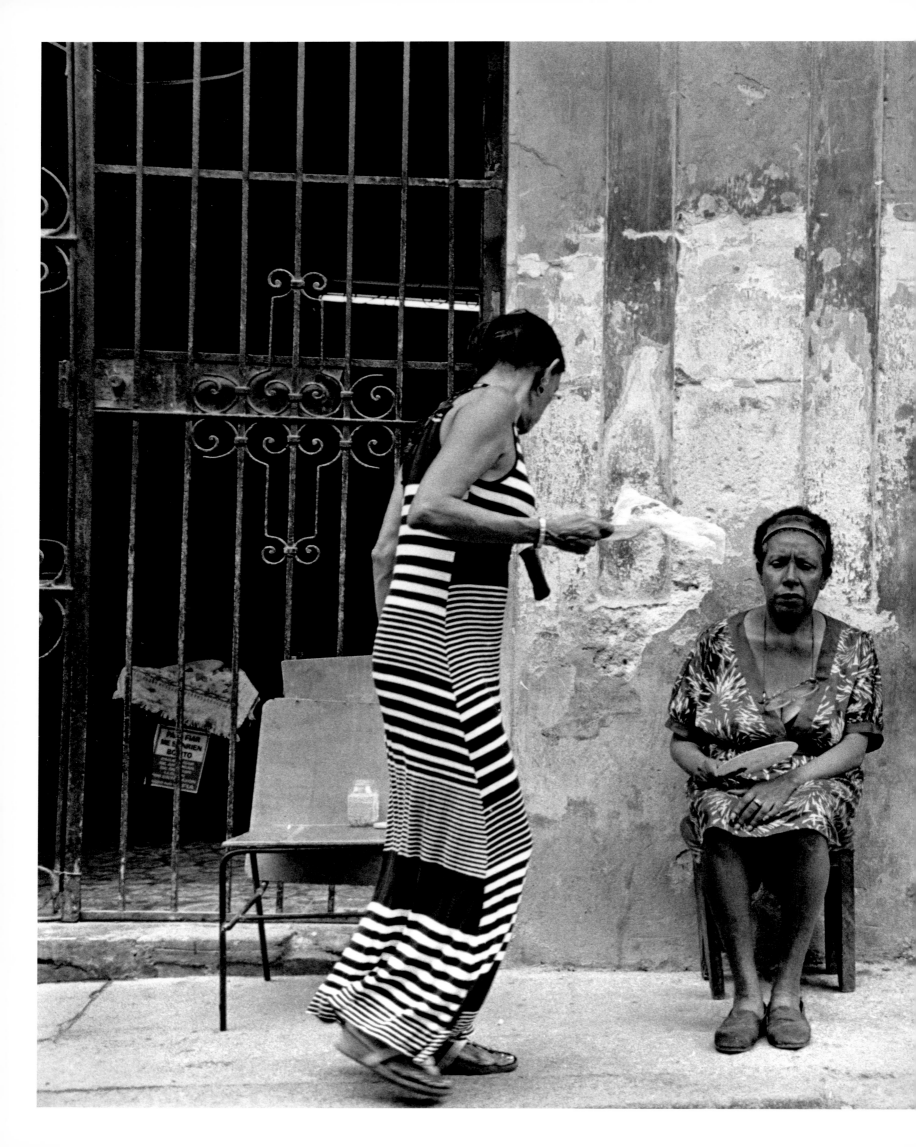

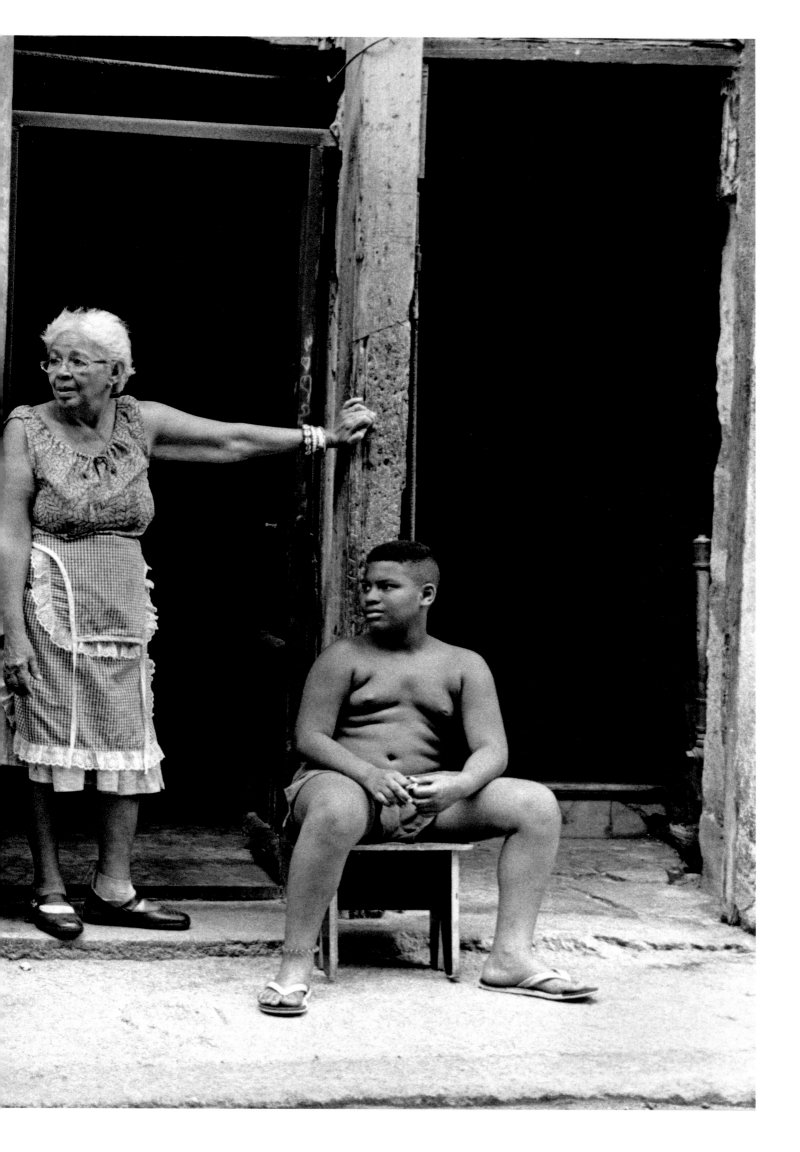

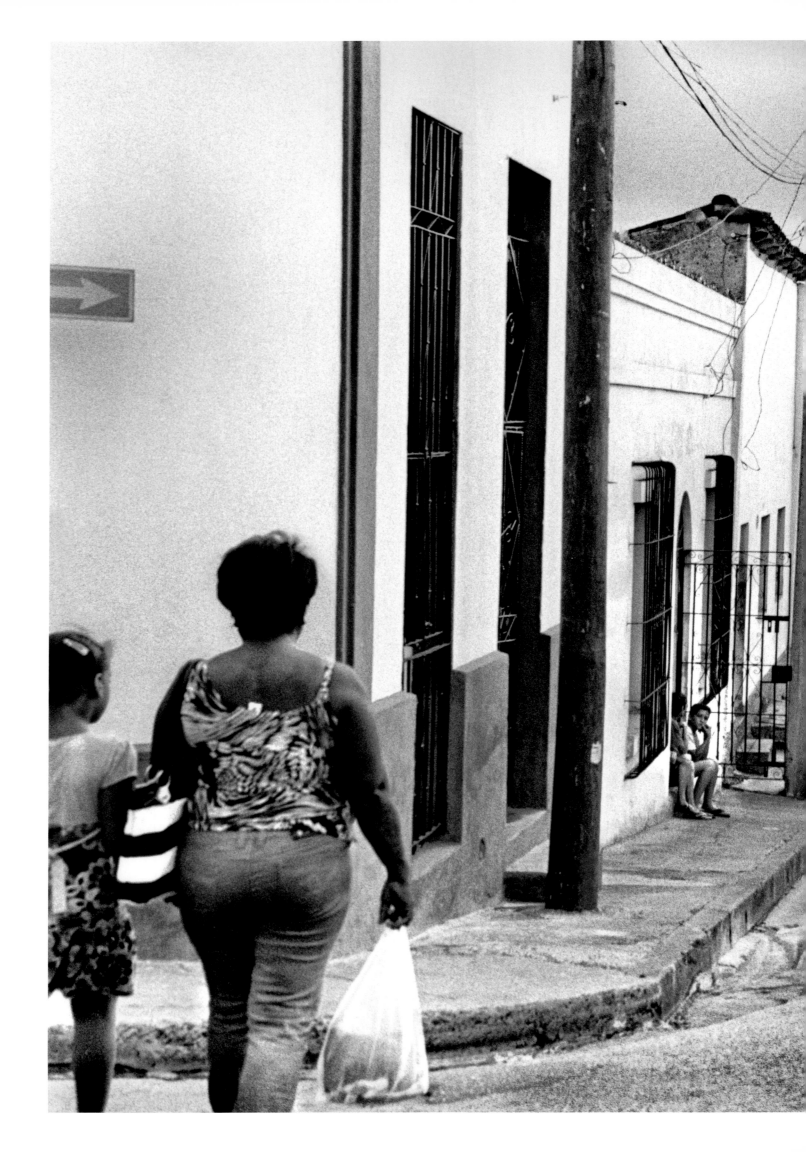

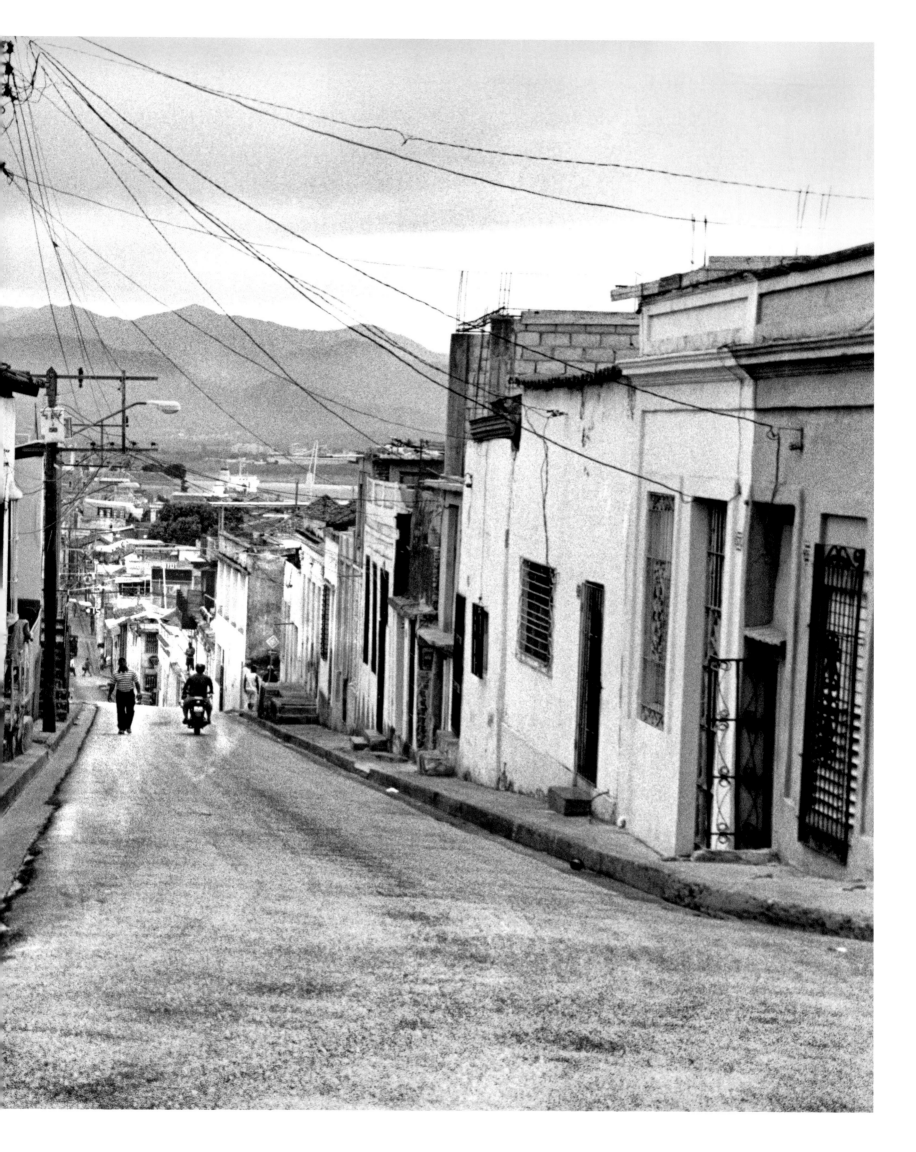

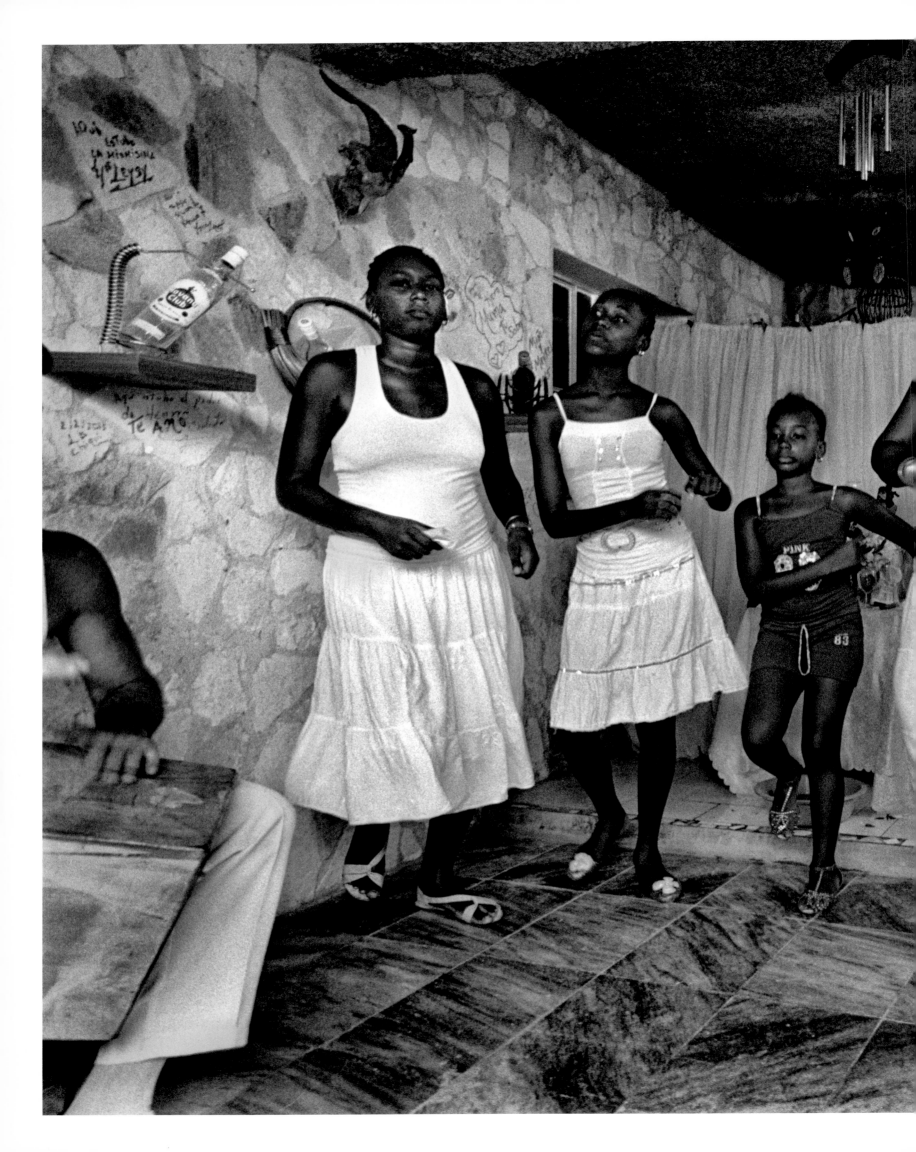

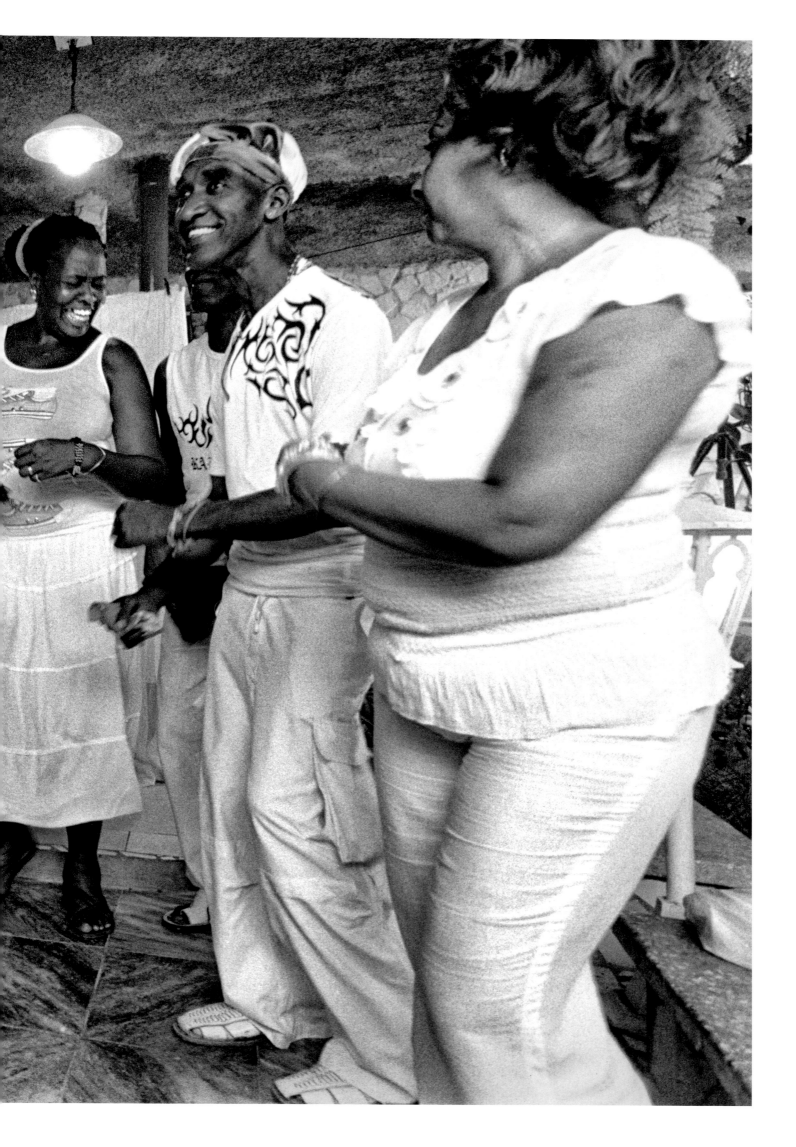

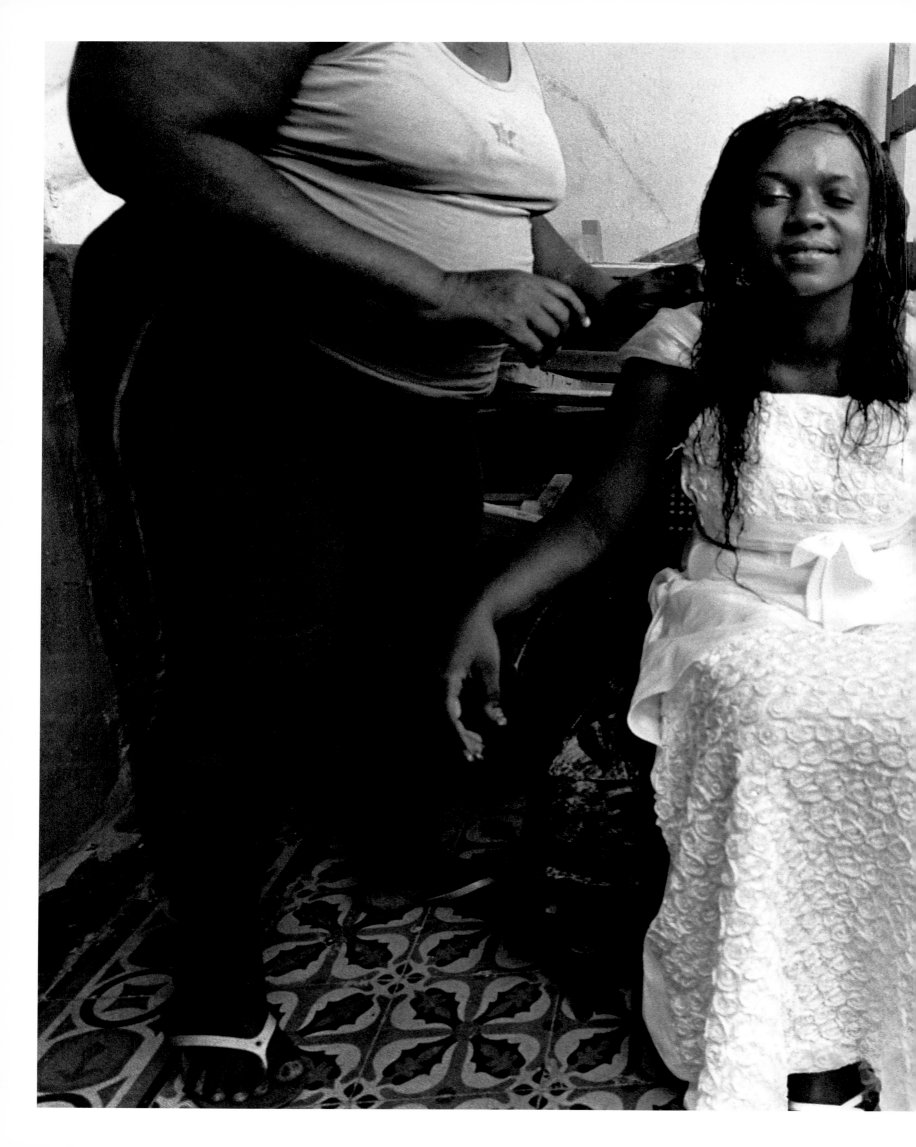

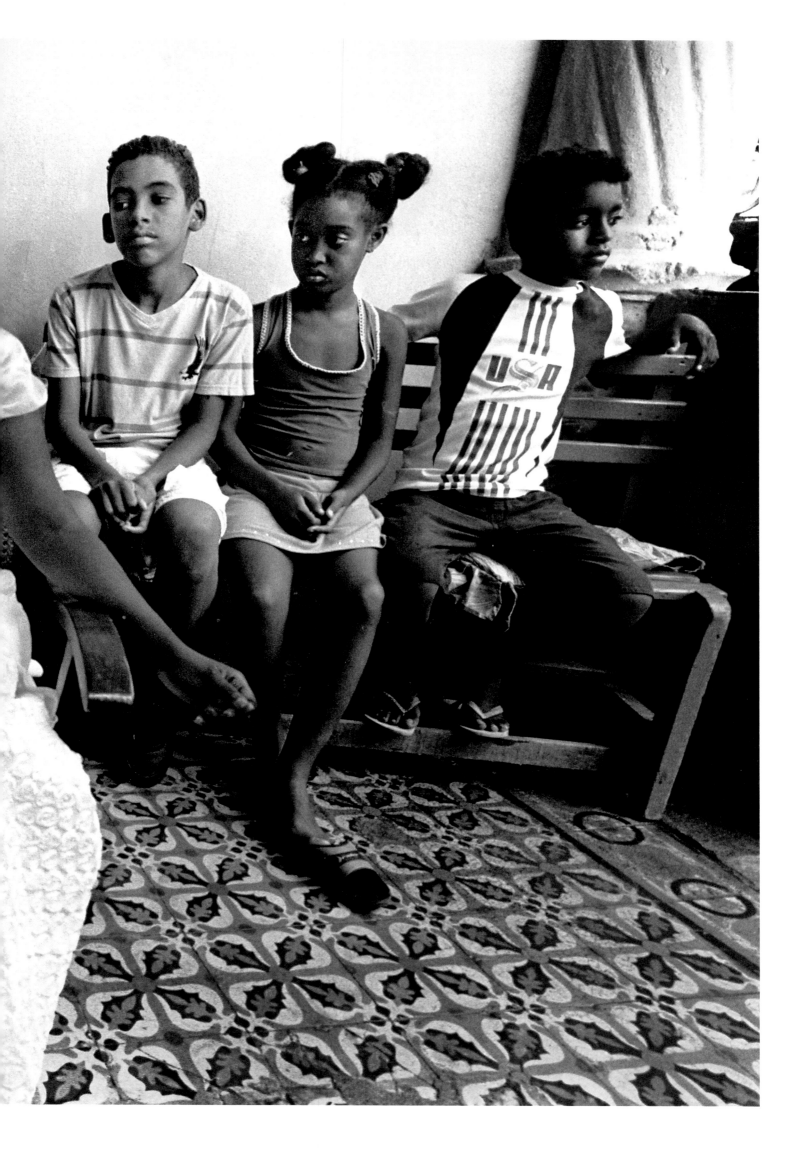

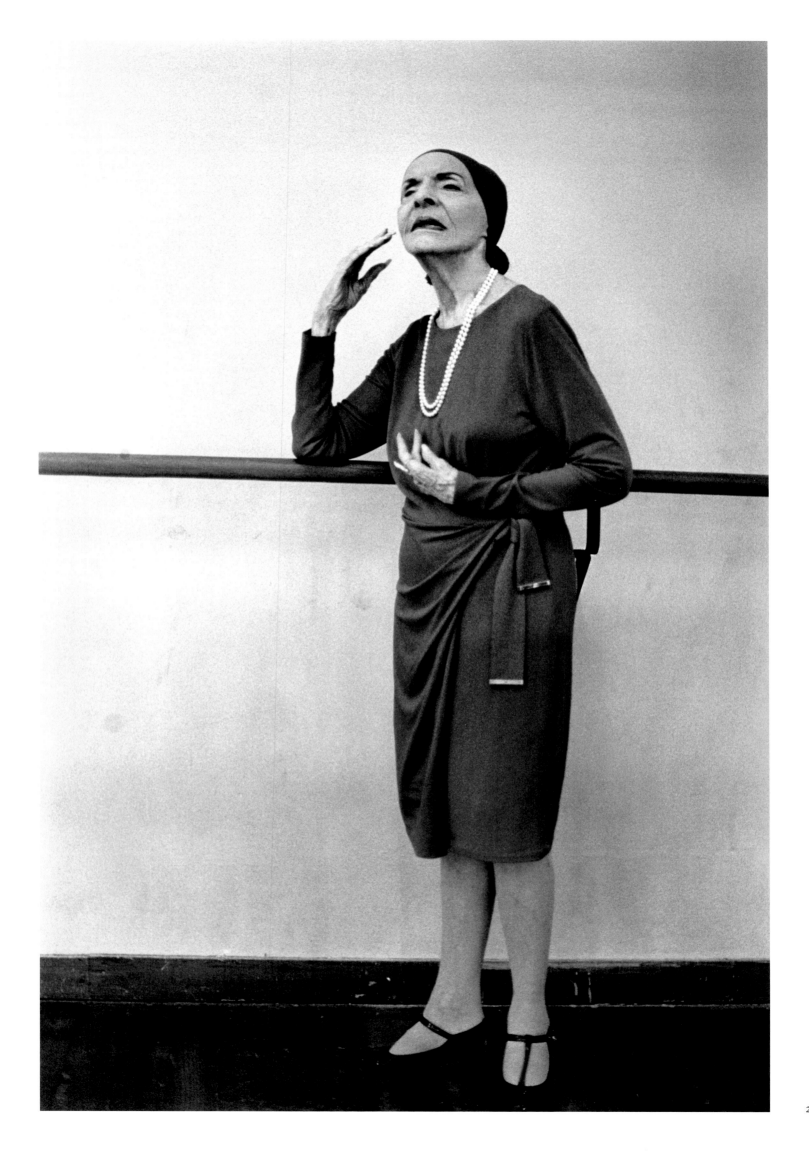

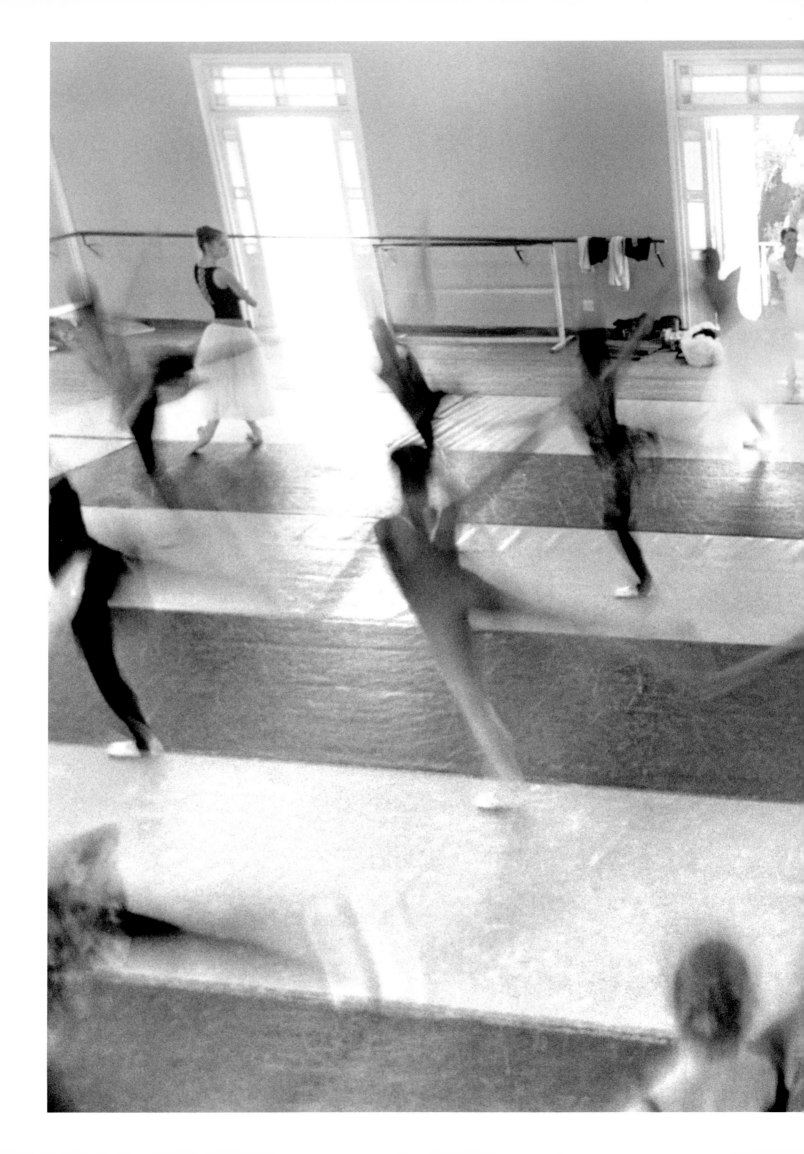

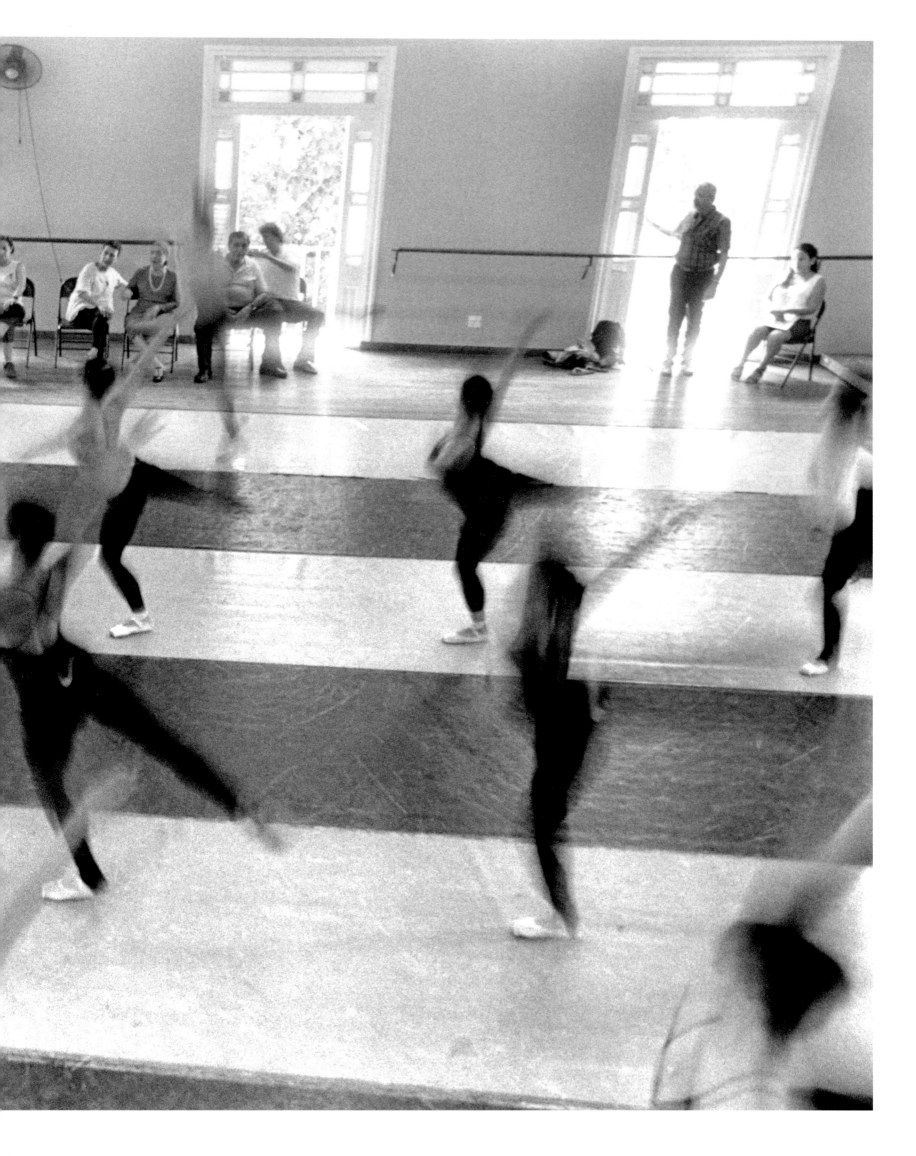

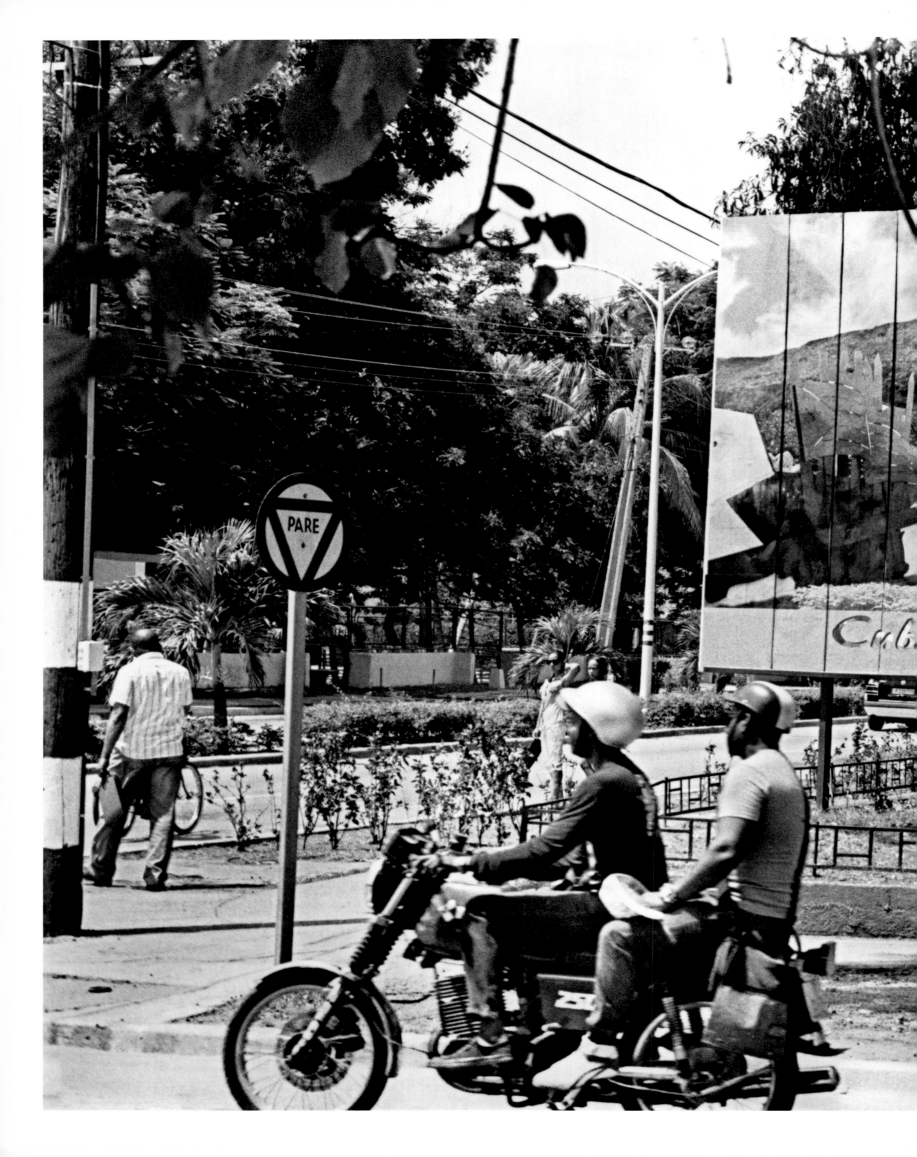

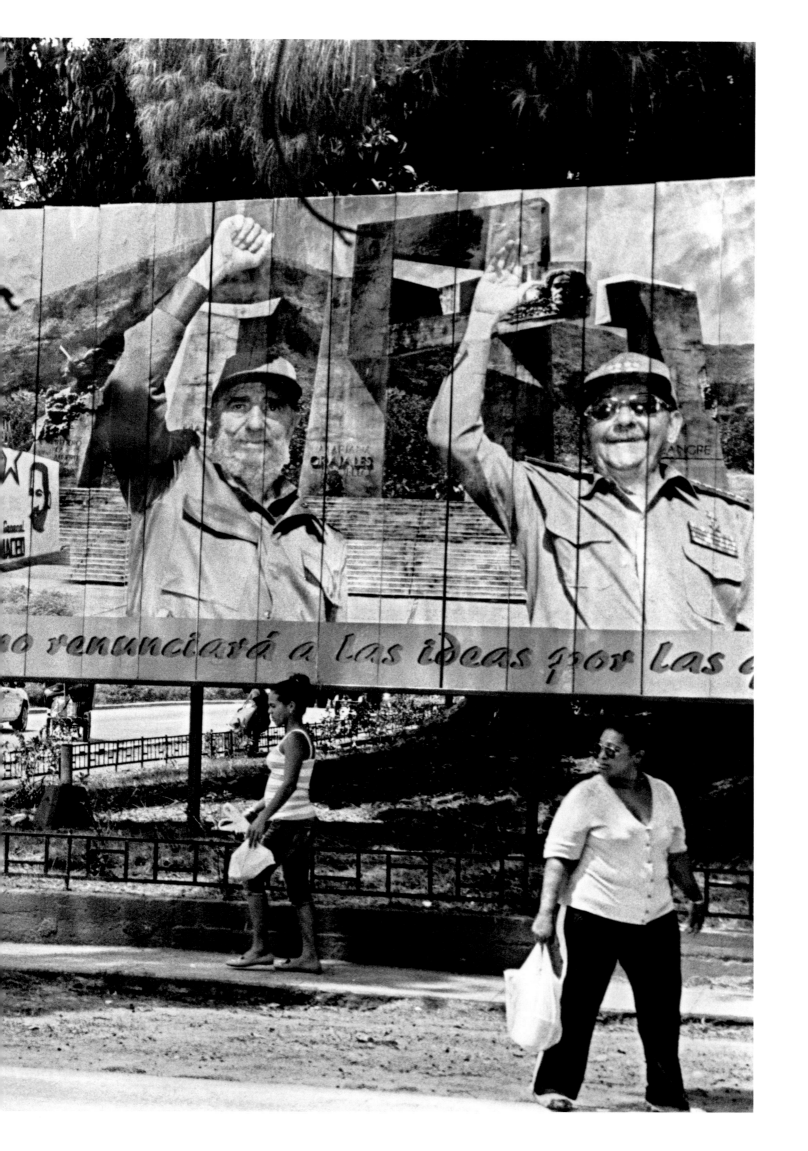

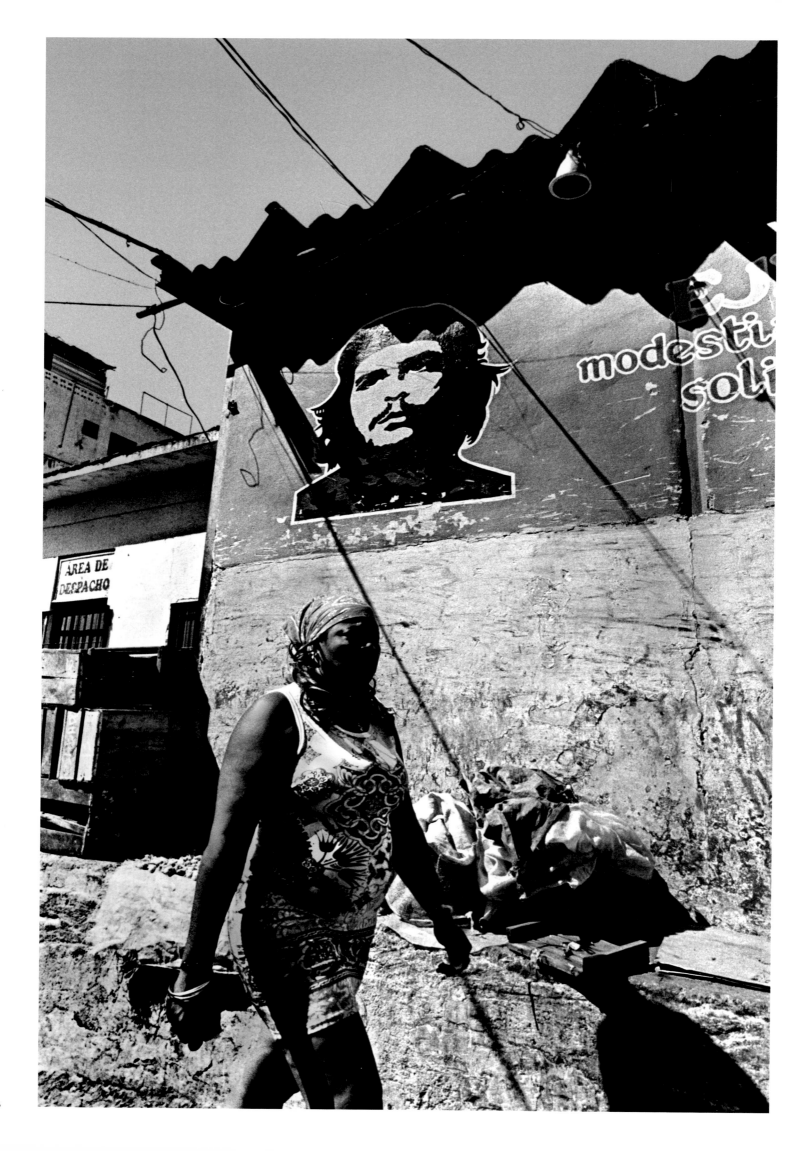

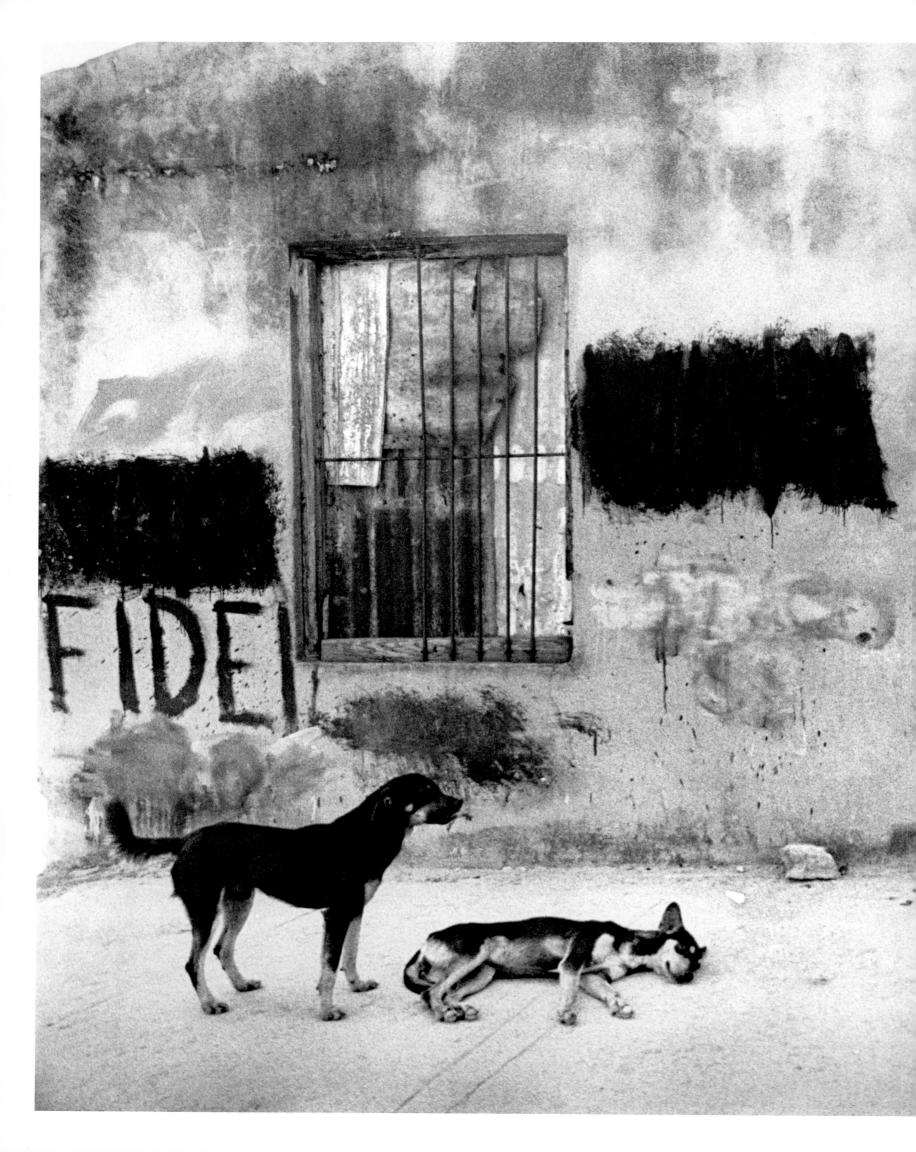

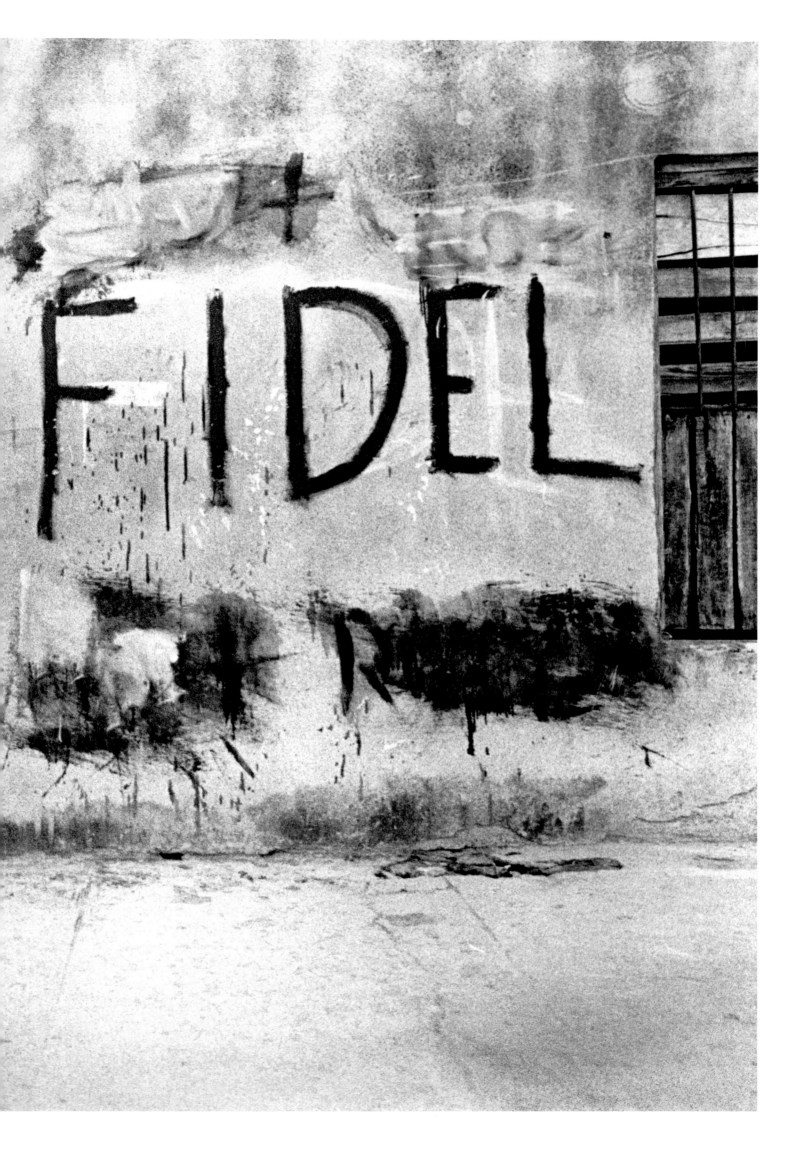

1 Looking over Havana from Hotel Sevilla, 1964

2 Museo de la Revolución, Havana, 2015

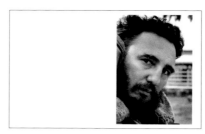

11 Fidel Castro, Havana, 1964

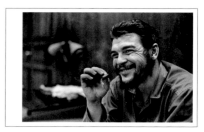

12 Che Guevara, Havana, 1964

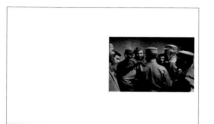

15 Fidel Castro with comrades, Havana, 1964

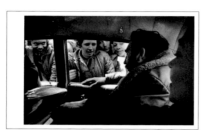

16 Fidel Castro, Havana, 1964

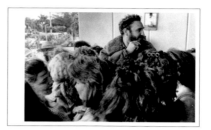

18 Students surround their leader. When they march to school, they chant "Comunismo, socialismo," Havana, 1964

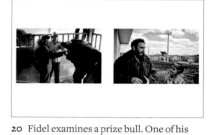

20 Fidel examines a prize bull. One of his pet projects was to build quality herds of cattle throughout Cuba, 1964
21 Fidel Castro visiting one of the housing projects reserved for army officers, a favored class in Cuba, El Vedado, 1964

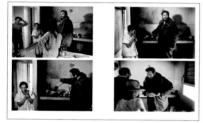

22 At the collective: Fidel talks to former sharecroppers who farm government land expropriated from estate owners, Havana, 1964

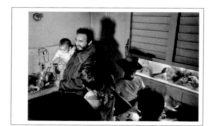

24 At the collective: Fidel talks to former sharecroppers who farm government land expropriated from estate owners, Havana, 1964

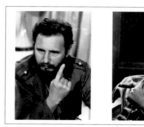

26 Fidel Castro, Havana, 1964
27 Che Guevara, Havana, 1964

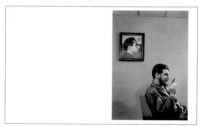

29 Che Guevara, Havana, 1964

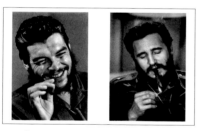

30 Che Guevara, Havana, 1964
31 Fidel Castro, who gifted Elliott Erwitt with a box of Cuban cigars following this photo session, Havana, 1964

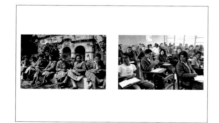

32 Agricultural school, El Vedado, 1964
33 Agricultural school, El Vedado, 1964

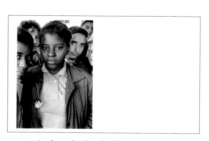

34 Agricultural school, El Vedado, 1964

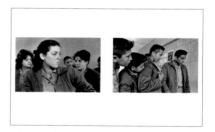

36 Agricultural school, El Vedado, 1964
37 Agricultural school, El Vedado, 1964

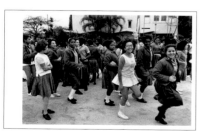

38 Agricultural school, El Vedado, 1964

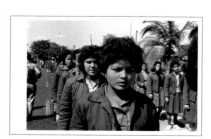

40 Students marching, Havana, 1964

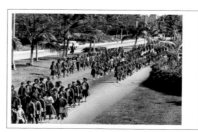

42 Students marching, Havana, 1964

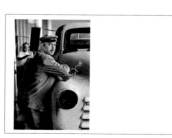

44 Havana, 1964

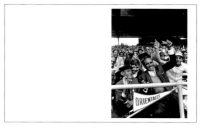

47 Baseball game, La Tropical Stadium, 1964

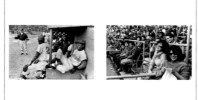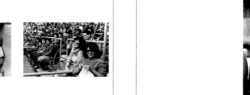

48 Baseball game, La Tropical Stadium, 1964
49 Baseball game, La Tropical Stadium, 1964

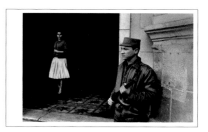

51 Havana, 1964

52 Havana, 1964

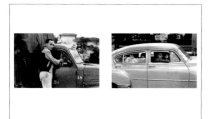

54 Havana, 1964
55 Havana, 1964

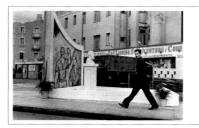

56 Havana, 1964

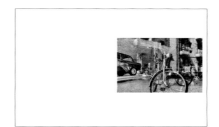

59 Havana, 1964

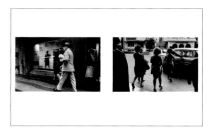

60 Havana, 1964
61 Havana, 1964

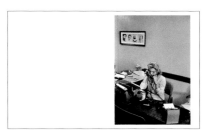

63 Havana, 1964

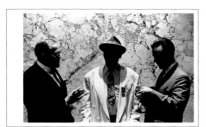

64 Havana, 1964

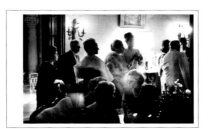

66 Havana, 1964

68 Havana, 1964
69 Havana, 1964

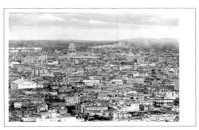

70 Looking over Havana from Hotel Sevilla, 1964

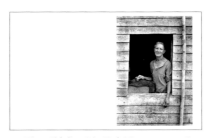

73 Finca Ildelisa, Pio Cuá, Matanzas, 2016

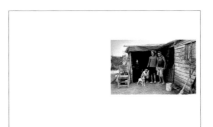

75 Ildelisa and her grandchildren, Pio Cuá, Matanzas, 2016

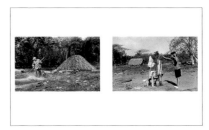

76 Preparing charcoal, Pio Cuá, Matanzas, 2016
77 Waterhole, Pio Cuá, Matanzas, 2016

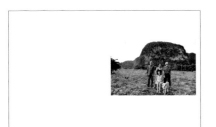

79 Peasant family, Viñales, Pinar del Río, 2015

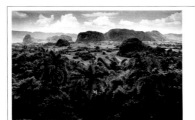

80 Viñales, Pinar del Río, 2015

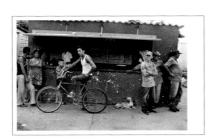

82 Cafe, road to Viñales, Pinar del Río, 2015

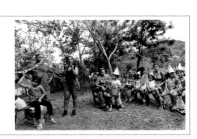

84 Children's birthday party, Bartolomé Masó, Granma, 2016

87 Children's birthday party, Bartolomé Masó, Granma, 2016

89 Parque Finlay, Bejucal, Havana, 2015

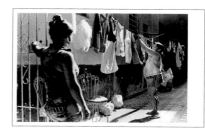

90 Solar, Old Havana, 2016

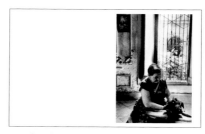

93 The Alonso family home, Yosi Alonso, El Vedado, Havana, 2016

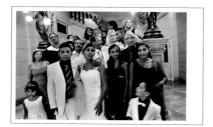

94 Palacio de los Matrimonios, Havana, 2015

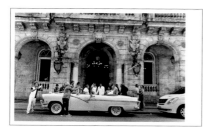

96 Palacio de los Matrimonios, Havana, 2015

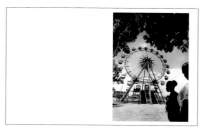

99 Star, Park of Dreams, Santiago de Cuba, 2016

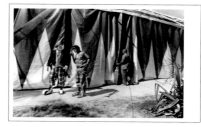

100 Circus "Trompoloco," Havana, 2015

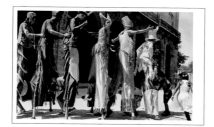

102 Stilts walkers, Plaza de Armas, Havana, 2015

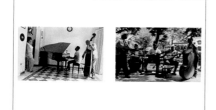

104 Cucurucho and Caturla, Piano and Bass, Miramar, 2015
105 Street musicians, Santiago de Cuba, 2015

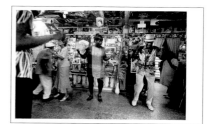

106 Santa Amalia senior dancers at William's place, Havana, 2015

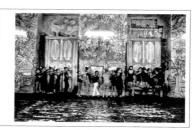

108 Habana Compás Dance school, Marianao, Havana, 2015

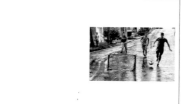

111 Diez de Octubre, Havana, 2015

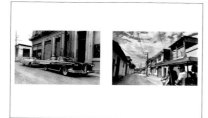

112 A Ford Edsel parked outside Rosy Bar, Centro Havana, 2015
113 Trinidad, 2016

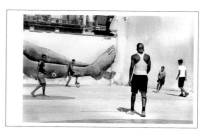

114 Sports center on Avenida Bélgica, Havana, 2016

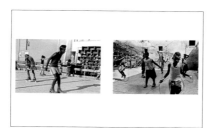

116 Ice rink, Havana, 2015
117 Gimnasio De Boxeo Rafael Trejo is the oldest and most prestigious boxing gym, Old Havana, 2015

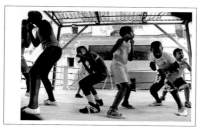

118 Gimnasio De Boxeo Rafael Trejo, Cuba Street, Old Havana, 2015

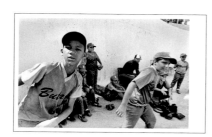

120 Kid's league baseball game in Baturi stadium, Havana, 2015

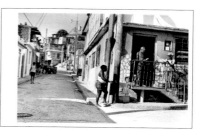

122 Barrio Vista Hermosa, Santiago de Cuba, 2016

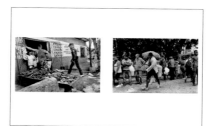

124 Agricultural market, San Miguel del Padrón, Havana, 2016
125 Agricultural market, San Miguel del Padrón, Havana, 2016

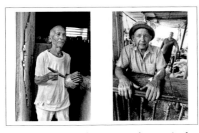

126 Cigar roller "El Guaje," Carlos Izquierdo, Havana, 2015
127 Falcón, urban agriculturist of medicinal plants, Havana, 2016

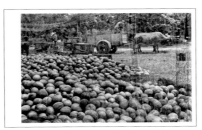

128 Fruit farm, road to Viñales, Pinar del Río, 2015

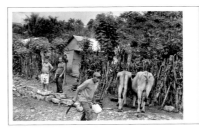

130 Santo Domingo, Santiago de Cuba, 2016

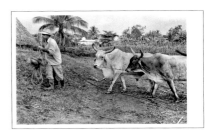

132 Ecological farm, Valle de Viñales, Pinar del Río, 2015

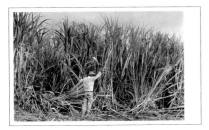

134 Harvesting sugar beet, Jatibonico, Sancti Spiritus, 2016

136 En route to Trinidad, 2016

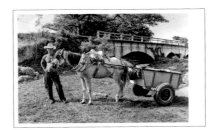

138 The Caney, Santiago de Cuba, 2016

140 Santander family continues to run "Casa Chichi" pottery house, Trinidad, 2016
141 Cornelio, Trinidad, 2016

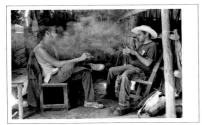

142 Tobacco shed, Finca Rene Rivera, Valle de Viñales, Pinar del Río, 2015

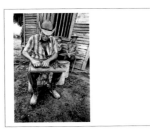

144 Rolling cigars, Finca Rene Rivera, Valle de Viñales, Pinar del Río, 2015

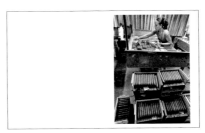

147 The Romeo and Julieta cigar factory is one of the last to remain, Havana, 2015

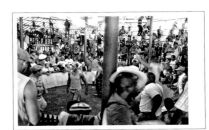

148 Cockfighting, Finca Oasis, Siboney, 2016

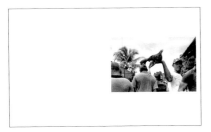

151 Cockfighting, Finca Oasis, Siboney, 2016

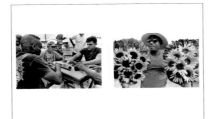

152 Santiago de Cuba, 2016
153 Sunflower seller, Copper Road, Santiago de Cuba, 2016

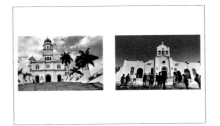

154 El Cobre Basilica, Santiago de Cuba, 2016
155 Santuario Nacional de San Lazaro in El Rincón is adjacent to and in the grounds of the old hospital on the outskirts of Havana, 2016

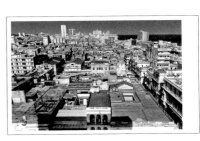

156 View from Hotel Capri, Havana, 2015

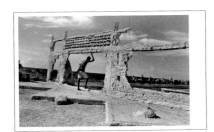

158 Miramar, Havana, 2015

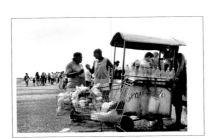

160 The Malecón, Havana, 2016

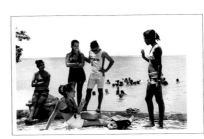

162 Public beach, Cienfuegos, 2016

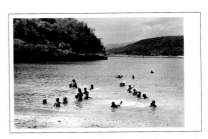

164 El Morro beach, Santiago de Cuba, 2016

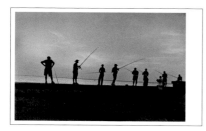

166 Fishing by the Castillo de San Salvador de la Punta, Malecón, Havana, 2015

169 Hoarding, Jatibonico, Sancti Spiritus, 2016

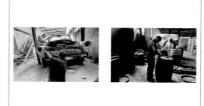

170 Car repair, Luyanó, Havana, 2015
171 The Havana Club distillery, Santa Cruz del Norte, 2015

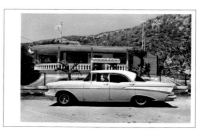

172 Playa Jibacoa, Santa Cruz del Norte, 2016

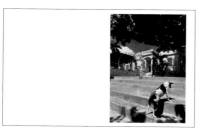

175 Museo de Hemingway, Finca Vigía, San Francisco de Paula, 2016

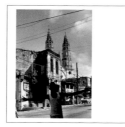

176 Diez de Octubre, Havana, 2016

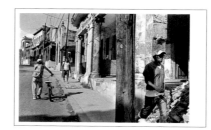

178 Diez de Octubre, Havana, 2016

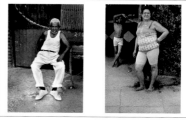

180 Parque Finlay, Bejucal, 2015
181 Parque Finlay, Bejucal, 2015

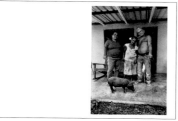

183 Peasant family, Viñales, Pinar del Río, 2015

185 Hoarding, Contramaestre, Santiago de Cuba, 2016

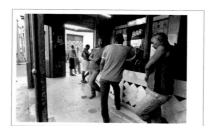

186 Rosy Bar, where you can drink rum for one Cuban peso (US 5 cents), Centro Havana, 2015

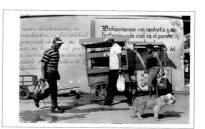

188 Market in front of Plaza de la Revolución, Santiago de Cuba, 2016

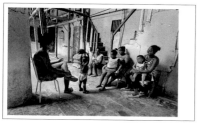

190 Solar, Old Havana, 2016

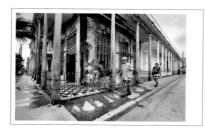

192 Guantánamo, 2016

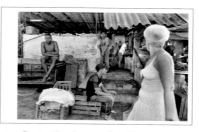

194 Cuatro Caminos market, Havana, 2016

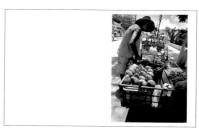

197 Havana, 2015

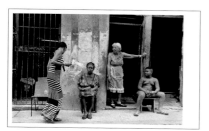

198 Old Havana, 2015

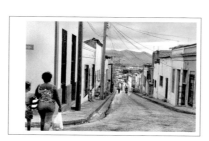

200 Santiago de Cuba, 2016

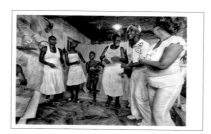

202 Santería celebration, Regla, Havana, 2015

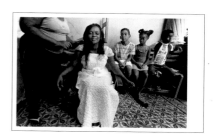

204 Malliet and her mother and sons (the girl is a neighbor), Diez de Octubre, Havana, 2015

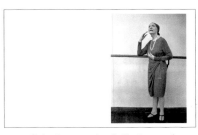

207 Alicia Alonso, prima ballerina assoluta and choreographer, Havana, 2015

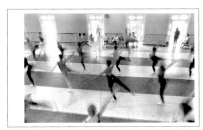

208 Ballet Nacional de Cuba rehearsal of *Giselle*, Havana, 2015

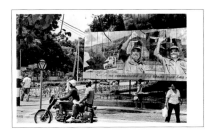

210 Guantánamo, 2016

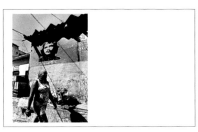

212 Cuatro Caminos market, Havana, 2016

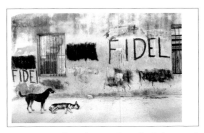

214 Veguita de Galo, Santiago de Cuba, 2016

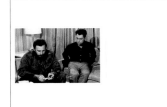

222 Fidel Castro and Elliott Erwitt, Havana, 1964

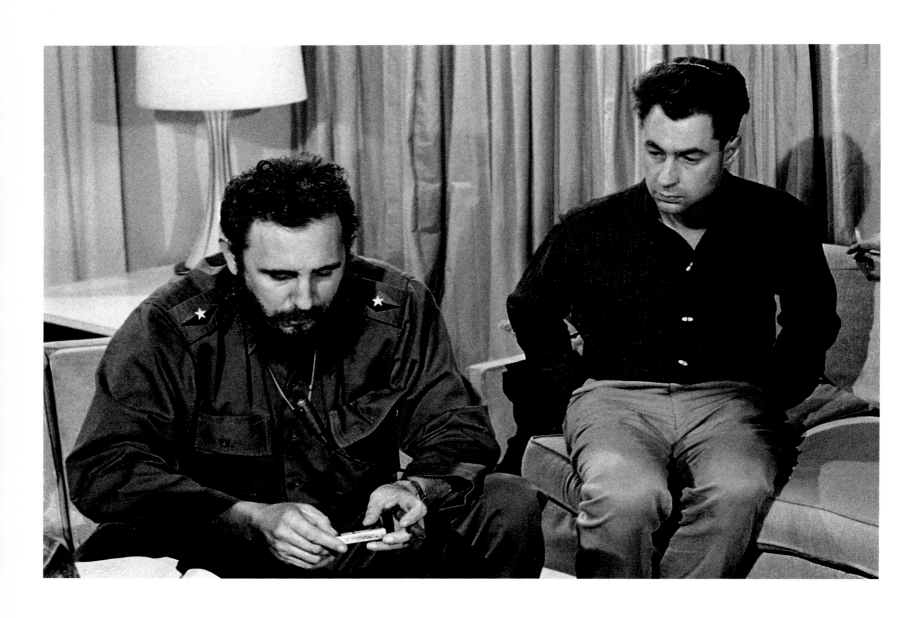

ELLIOTT ERWITT

A Brief Biography

Born on July 26, 1928, in Paris, Elliott Erwitt spent his childhood in Milan. His family moved back to Paris in 1938, and immigrated to New York the following year, then moved to Los Angeles in 1941. His interest in photography began while he was a teenager living in Hollywood. In 1948 Erwitt moved to New York, there he met Edward Steichen, Robert Capa, and Roy Stryker. After spending the year 1949 traveling in France and Italy, Erwitt returned to New York and began working as a professional photographer. Drafted into the army in 1951, he continued to take photographs while stationed in Germany and France.

Elliott Erwitt was invited to join Magnum Photos in 1953 by Robert Capa. A member of the prestigious agency ever since, Erwitt has served several terms as its president. One of the leading figures in the competitive field of magazine photography, Erwitt's journalistic essays, illustrations, and advertisements have been featured in publications around the world for more than fifty years. In addition to his work as a still photographer, Erwitt began making films in 1970. He has published several books and has had one-man exhibitions in numerous museums and galleries around the world including New York's Museum of Modern Art, the Smithsonian Institution, the Art Institute of Chicago, Paris' Museum of Modern Art, and Zurich's Kunsthaus.

Based in New York City, Elliott Erwitt travels obsessively. He likes children and dogs.

Eine kurze Biografie

Elliott Erwitt wurde am 26. Juli 1928 in Paris geboren und verbrachte seine Kindheit in Mailand. Die Familie zog 1938 zurück nach Paris und emigrierte im darauffolgenden Jahr nach New York. Später, im Jahr 1941, zog sie nach Los Angeles. Sein Interesse an der Fotografie erwachte, als er als Teenager in Hollywood lebte. 1948 zog Erwitt nach New York, wo er Edward Steichen, Robert Capa und Roy Stryker kennenlernte. Nachdem er 1949 einige Zeit durch Frankreich und Italien gereist war, kehrte Erwitt nach New York zurück und begann seine Arbeit als professioneller Fotograf. Als er 1951 in die Armee eingezogen wurde, fotografierte er auch während seiner Stationierung in Deutschland und Frankreich.

Elliott Erwitt wurde 1953 von Robert Capa eingeladen, für Magnum Photos zu arbeiten. Seitdem ist Erwitt Mitglied dieser angesehenen Agentur und hat mehrmals als ihr Präsident fungiert. Er ist eine der führenden Figuren auf dem stark umkämpften Gebiet der Magazin-Fotografie. Erwitts journalistische Essays, Illustrationen und Werbeanzeigen werden seit mehr als fünfzig Jahren weltweit veröffentlicht. Neben seiner Arbeit als Fotograf begann Erwitt 1970 auch Filme zu drehen. Er hat mehrere Bücher veröffentlicht und war mit Einzelausstellungen in zahlreichen Museen und Galerien auf der ganzen Welt vertreten, darunter das Museum of Modern Art in New York, das Smithsonian und das Art Institute of Chicago sowie das Museum für Moderne Kunst in Paris und das Kunsthaus Zürich.

Seinen Lebensmittelpunkt hat Elliott Erwitt in New York, aber er ist nahezu ununterbrochen auf Reisen. Er mag Kinder und Hunde.

Biographie succincte

Né le 26 juillet 1928 à Paris, Elliott Erwitt passe son enfance à Milan. Sa famille retourne à Paris en 1938, avant d'émigrer à New York l'année suivante. Elle s'établira à Los Angeles en 1941. Elliott Erwitt développe un intérêt pour la photo pendant son adolescence à Hollywood. En 1948, il s'installe à New York, où il fait la connaissance d'Edward Steichen, Robert Capa et Roy Stryker. Après avoir passé l'année 1949 à voyager en France et en Italie, Elliott Erwitt revient à New York, où il fait ses débuts de photographe professionnel. Incorporé en 1951, il continue à prendre des photos tandis qu'il est stationné en Allemagne et en France.

En 1953, Elliott Erwitt est invité par Robert Capa à rejoindre Magnum Photos. Depuis lors membre de cette prestigieuse agence, il en a été le président pendant plusieurs mandats. Acteur majeur de l'univers concurrentiel de la presse magazine, il publie depuis plus de cinquante ans des essais journalistiques, des illustrations et des publicités dans des revues du monde entier. En marge de son travail de photographe, Elliott Erwitt tourne son premier film en 1970. Auteur de plusieurs livres, il a exposé dans de nombreux musées et galeries de par le monde, notamment au Museum of Modern Art de New York, à la Smithsonian Institution, à l'Art Institute of Chicago, au musée d'Art moderne de Paris et à la Kunsthaus de Zurich.

Domicilié à New York, Elliott Erwitt est cependant constamment en voyage. Il aime les enfants et les chiens.

The Elliott Erwitt Havana Club 7 Fellowship was created in 2015 when Elliott Erwitt approached Havana Club 7 wishing to return to Cuba. Mr. Erwitt's inaugural images created a starting point for a new generation of photographers to relate to, to further develop their craft and help (re)define the genre in the 21st century.

Inspired by Elliott Erwitt, exceptional talents selected for the Fellowship will each create a unique body of work, capturing the soul of Cuba which will be shared with photography lovers worldwide. In the spirit of Cuba, seven photos of each fellow will be sold to support the next photographer joining the Fellowship and thus offering each photographer the opportunity to benefit the next in line to carry on the legacy.

Support the Fellowship on
www.havana-fellowship.com

This book is dedicated to my children and their children, with special thanks to: Christina Burns, charming editor; Stuart Smith, layout and design; Mio Nakamura, organizer and scanner; André S. Solidor, jolly advisor; Peter Bellamy, darkroom emergencies; Adriana Lopez Sanfeliu; Glenn Wassell; Monica Pita Santos; Eider Alexander Hernández Estrada; Christian Bengsch; Jens Jakobsen; Roderick van der Lee.

None of the photographs in this book have been digitally manipulated.

© 2017 teNeues Media GmbH & Co. KG, Kempen, Germany

Photographs © 2017 Elliott Erwitt/Magnum Photos. All rights reserved.

Design by SMITH, London, England
www.smith-design.com
Edited by Christina Burns

Foreword by Henry Louis Gates, Jr.

Translations by:
Dr. Kurt Rehkopf (German)
Christèle Jany (French)
Proofreading by Claude Checconi (French)

Editorial coordination by Arndt Jasper, teNeues Media
Production by Alwine Krebber, teNeues Media
Color separation and printing by
Editoriale Bortolazzi-Stei s.r.l., Verona, Italy

Published by teNeues Publishing Group

teNeues Media GmbH & Co. KG
Am Selder 37, 47906 Kempen, Germany
Phone: +49-(0)2152-916-0
Fax: +49-(0)2152-916-111
e-mail: books@teneues.com

Press department: Andrea Rehn
Phone: +49-(0)2152-916-202
e-mail: arehn@teneues.com

teNeues Publishing Company
7 West 18th Street, New York, NY 10011, USA
Phone: +1-212-627-9090
Fax: +1-212-627-9511

teNeues Publishing UK Ltd.
12 Ferndene Road, London SE24 0AQ, UK
Phone: +44-(0)20-3542-8997

teNeues France S.A.R.L.
39, rue des Billets, 18250 Henrichemont, France
Phone: +33-(0)2-4826-9348
Fax: +33-(0)1-7072-3482

www.teneues.com

teNeues Publishing Group
Kempen
Berlin
London
Munich
New York
Paris

teNeues

ISBN 978-3-96171-039-3

Library of Congress Number: 2017942042

Printed in Italy

Bibliographic information published by the Deutsche Nationalbibliothek
The Deutsche Nationalbibliothek lists this publication in the Deutsche Nationalbibliografie; detailed bibliographic data are available on the Internet at http://dnb.dnb.de.

FSC
www.fsc.org
MIX
Paper from responsible sources
FSC® C107556